# Readings in
# Latin American
# Modern Art

# Readings in Latin American Modern Art

**Edited by Patrick Frank**

Yale University Press
New Haven and London

Designed & set in Galliard and Matrix
types by Chris Crochetière, BW&A
Books, Inc., Durham, NC

Printed in the United States of America
by Vail Ballou Press, Binghamton, NY

Library of Congress
    Cataloging-in-Publication Data
Readings in Latin American modern art /
    edited by Patrick Frank.
        p.      cm.
Includes bibliographical references and
    index.
    ISBN 0-300-10255-0 (paperbound :
    alk. paper)
    1. Art, Latin American—20th century.
    1. Frank, Patrick, 1953– .
N6502.5 .R43 2004
709'.8'0904—dc22
2003023857

A catalogue record for this book is avail-
able from the British Library.

The paper in this book meets the guide-
lines for permanence and durability of the
Committee on Production Guidelines for
Book Longevity of the Council on Library
Resources.

10 9 8 7 6 5 4 3 2 1

# Contents

## 4. Major Architectural Projects

## 5. Non-Objective and Informalist Modes of Abstraction

## 6. Constructivist and Neo-Concrete Art

## 7. Postwar Figural Art

## 8. As a New Century Turns

# The Cuban-Chinese Cook

## Patrick Frank

Latin American modern art still does not get its due. Even after two decades of postmodernist deconstruction of grand narratives, efforts to institute multicultural inclusiveness, and mostly business-oriented "globalization," the canon of modern art history is still heavily tilted toward the art of Europe and North America. Students all across the United States still learn that most of the important innovations in art prior to about 1940 took place in Europe, and that after that date "the center of the art world shifted to New York, preparing the ground on which the nascent New York School would almost immediately seize the leadership of the avant-garde."[1] I have created this book in the hope that it will help to change that emphasis.

The criteria for inclusion in this canon of acceptable modern expressions have been too narrow. As one African-born curator recently noted, "While strong revolutionary claims have been made for the avant-garde within Westernism, its vision of modernity remains surprisingly conservative and formal."[2] In short, other modernities are possible.[3] Harold Rosenberg lamented the loss of Paris to the Nazis in 1940, bewailing the decline of the birthplace of modernism. Yet even he admitted that "despite the fall of Paris, the social, economic, and cultural workings which define the modern epoch are active everywhere."[4]

The basic problem that gives rise to the neglect of Latin American modern art is structural. The wealth and resources that support research and education about art are concentrated in Europe and the United States, but the human characteristics necessary for the creation of vital, compelling, and innovative art are much more widely dispersed. The countries with the greatest critical mass of infrastructure arrogate to themselves the rubric "mainstream," and relegate areas of lower strategic importance or thinner art culture to the "periphery." This imbalance of resources and creativity leads to strange lacunae. To mention just a few examples, there are many books about Georgia O'Keeffe, as there probably should be, but there are far fewer about Tarsila do Amaral, an equally passionate but probably more audacious artist. The dolls of Hans Bellmer have been much studied and even imitated, but the contemporaneous and equally multivalent dolls of Armando Reverón have received very little attention. It is easy to find information about Dan Flavin and Frank Stella, in-

novators in the use of neon and the shaped canvas, but Gyula Kosice and Raúl Lozza, who anticipated these developments by about fifteen years, are nearly invisible. Even postcolonial critics have not yet gotten around to studying the series of sixty paintings by Oswaldo Guayasamín on the theme of Frantz Fanon's *The Wretched of the Earth*.

To be sure, there has been some progress in recent years, often in the form of museum exhibitions and their accompanying catalogues.[5] The benefits of this increased interest have accrued mostly to the contemporary art world, as Latin Americans are now frequently represented in the international circuit of biennials and art fairs. Yet the neglect of earlier periods persists. As one curator recently noted, "Despite the increased mainstreaming of Latin American art in recent years, no major institution in this country is actively collecting it for permanent public display. And yet we need to stress it boldly: only by bringing these works to public and scholarly attention through exhibitions and publications can the long-overdue recognition of their aesthetic merit be obtained."[6] I believe, perhaps naively, that education can also help to solve this problem. If we continue to broaden and deepen the amount of information available, then more people will begin to sense the beauty, diversity, and searching urgency, not to say the quality, of a wide spectrum of Latin American modern art.

In gathering and presenting new information about this underrecognized area, I believe it important to let Latin Americans speak for themselves. Where important source writings existed only in Spanish or Portuguese, I have attempted to render them in English. Latin American art tends to be connected to other cultural expressions such as music and literature in a more integral way than in North America, so I have also included a few documents that show this affinity, most of them new translations. In general, this book favors primary sources, artists' statements, manifestoes, interviews, and other types of documents that give principal emphasis to the actual voices of Latin American artists and writers. This immediately raises the difficult question of who is a Latin American. The most obvious answer is a person who was born in or did most of his or her work in a Latin American country, but even this simple formulation is debatable.[7] For example, I have left out Marisol, Roberto Matta, and Lucio Fontana, believing that they are sufficiently represented in the "mainstream." At the same time, perhaps arbitrarily, I have included Julio Le Parc, Leonora Carrington, and Alfredo Jaar. There is even some disagreement about which countries constitute Latin America. I have omitted Anglophone Jamaica and included Francophone Haiti. On both of these questions, I have tried to choose a middle path from among the answers available in the present literature.

The novels of Severo Sarduy provide some of the best answers to the problem of Latin American identity, if indeed it is one. The protagonist of one of

these postmodern antinarratives is Louis Leng, a Cuban-Chinese who was born to the accompaniment of Afro-Cuban *santería* prayers in the small town of Sagua La Grande. A deft practitioner of the fusion cuisine of his region, Louis Leng was in such demand as a cook that he was lured to Paris, where he had to hire an apprentice:

> He trained the mulatto Juan Izquierdo, who added to the tradition an arrogant dash of Spanish cooking and the rich surprises of Cuban cuisine, which may seem Spanish but declared its independence in 1868. Upon the triumph of the Revolution, and more because of the lack of materials to make mutton stew in five ways than out of conviction or disappointment, the Chinaman and his pupil had emigrated to the Cuban eateries of Eighth Avenue. But disgusted with the demagogical abuse of soy sauce and the officious syrups and batters with which the Cuban cuisine tried to maintain its exuberance in exile, they had returned to Paris, where their mutual skill in marinating shrimp had found a well-deserved respect. He cursed in several dialects, sprinkled with caustic Havanisms from the fifties.[8]

This passage is no doubt slyly autobiographical, but it also alludes to Wifredo Lam, like Leng a Cuban-Chinese mulatto from Sagua La Grande who earned a well-deserved respect in Paris. The shifting cast of characters, jagged plot lines, and knowing allusions to many aspects of Latin American culture present in Sarduy's novels make them an aid to understanding the complexity of the question of identity.

Indeed, I hope that this book helps overcome the tendency to look for only one Latin American identity. The continent is too large, too polyglot, and too cosmopolitan. Each region has its own set of relations with its native past, the Conquest, its neighbors, and the rest of the world, and each country creates its own modernity out of this web of relationships. To put the point another way, if Paris is not the norm for the modern city, then neither is Buenos Aires or Quito. Incidentally, by the end of the novel, Leng is discovered to be an incarnation of the Buddha.

I hope this book is seen as a part of a wider effort to broaden our perspective on human artistic creation. I hope that someday most of us in the West will come to see with a more knowing and appreciative eye the aesthetic creations of artists and cultures across the globe.[9] In the modern period especially, as the world has gotten ever smaller, cultures are in greater proximity to one another with at times hostile and disastrous results. Sharing and studying each others' creations is not a foolproof antidote to more antagonistic forms of interaction, but doing more of the former will, I hope, help forestall some of the latter.

# Notes

1. Jonathan Fineberg, *Art Since 1940: Strategies of Being* (Upper Saddle River, N.J.: Prentice Hall, 2000), 21.

2. Okwui Enwezor, "The Black Box," *Documenta 11: Platform 5* (Kassel: Museum Fridericianum, 2002), 46.

3. Two recent attempts to forge a Latin American definition of modernism are: David Craven, "The Latin American Origins of Alternative Modernism," *Third Text* 36 (Autumn 1996): 29–44, and Gerardo Mosquera, ed., *Beyond the Fantastic: Contemporary Art and Criticism from Latin America* (Cambridge, Mass.: MIT Press, 1996). On Latin American postmodernity, see Elizabeth Armstrong and Víctor Zamudio-Taylor, *Ultra Baroque: Aspects of Post–Latin American Art* (San Diego, Calif.: Museum of Contemporary Art, 2000), and Nestor García Canclini, *La Globalización Imaginada* (Buenos Aires: Paidós, 1999).

4. Harold Rosenberg, "The Fall of Paris," *Partisan Review* (1940), quoted in Iwona Blazwick, *Century City: Art and Culture in the Modern Metropolis* (London: Tate Modern, 2001), 13.

5. A few recent examples that cover art of more than one country include *America, Bride of the Sun* (Antwerp: Royal Museum of Fine Arts, 1992); Waldo Rasmussen, ed., *Latin American Artists of the Twentieth Century* (New York: Museum of Modern Art, 1993); Edward J. Sullivan, ed., *Latin American Art in the Twentieth Century* (London: Phaidon, 1996); Fogg Art Museum, *Geometric Abstraction: Latin American Art from the Patricia Phelps de Cisneros Collection* (Cambridge, Mass.: Harvard University Art Museums, 2001); and Museo Nacional Centro de Arte Reina Sofía, *Heterotopías: Medio Siglo sin Lugar, 1918–1968* (Madrid: Centro Reina Sofía, 2001).

6. Mari Carmen Ramírez, Introduction to *Collecting Latin American Art for the Twenty-first Century* (Houston: Museum of Fine Arts, International Center for the Arts of the Americas, 2002), 15–17.

7. Ivo Mesquita has reflected meaningfully on this question in "Latin America: A Critical Condition," in Noreen Tomassi, ed., *American Visions / Visiones de las Américas: Artistic and Cultural Identity in the Western Hemisphere* (New York: ACA Books and Allworth Press, 1994).

8. Severo Sarduy, *Cobra and Maitreya,* trans. Suzanne Jill Levine (Normal, Ill.: Dalkey Archive Press, 1995), 221.

9. Recent efforts along this line include Apinan Poshyananda, *Traditions/Tensions: Contemporary Art in Asia* (New York: Asia Society, 1996); Wijdan Ali, *Modern Islamic Art: Development and Continuity* (Gainesville: University Press of Florida, 1997); Blazwick et al., *Century City;* and Okwui Enwezor, *The Short Century: Independence and Liberation Movements in Africa, 1945–1994* (Munich: Prestel, 2001).

# 1. Early Modern Currents

# Saturnino Herrán

## "Our Gods" Mural Project

**Jacinto Quirarte**

From *Mexico: Splendors
of Thirty Centuries*, 1990

*Saturnino Herrán died in 1918, leaving tantalizingly unfinished a mural project
for the National Theater in Mexico City. This essay traces its genesis and progress.*

Efforts to create a nationalistic art were intensified in Mexico following the
Spanish-American War of 1898 between Spain and the United States, which
strengthened the bonds between Spain and Mexico and led to an increased in-
terest in Spanish art. While they continued to explore their Precolumbian past
during the first decade of the century, Mexican artists also began to emulate
the Spanish styles of Synthetism, Symbolism, and Expressionism.

Saturnino Herrán was at the center of the cultural and artistic ferment that
culminated in the centenary celebrations of Mexican independence in 1910,
during which artists and writers explored and discussed their national her-
itage. He was a member of Ateneo de la Juventud (Atheneum of Youth),
founded in October 1909 by a group of young artists and writers who, in their
reaction against the positivist philosophy of the Porfiristas [followers of the
dictator Porfirio Díaz], advocates of modern technological advancement,
sought inspiration in the ancient Greeks. Beginning in 1906, they published a
number of articles in the journal *Savia Moderna,* in which they espoused na-
ture as the basis of Symbolist and Synthetist expression.

The search for a national art led Herrán and other artists to focus on in-
digenous subjects, but presented within the context of the Spanish-inspired
Symbolist manner. A generation earlier a similar movement had evolved dur-
ing the latter part of the nineteenth century, when Mexican artists used In-
dian subjects in historical works painted in a Spanish-inspired neoclassical
style. Examples of this style, in which the Indian subjects are presented as
idealized Greco-Roman figures, are *The Discovery of Pulque* by José Obregón
(1832–1902), *The Senate of Tlaxcala* by Rodrigo Gutiérrez (1848–1903), and
*The Torture of Cuauhtemoc,* 1892, by Leandro Izaguirre (1867–1941).

Herrán's unrealized mural project *Our Gods,* which he worked on from
1914 to 1918, the year of his death, in similar vein turns to the Indian as the
prototype of the indigenous race. Herrán's Indians move in a timeless, ideal-

ized past, actors in a mythological world emerging from a confluence of Spanish and Indian cultures to create a new national identity.

Herrán began *Our Gods* in response to a competition held at the Academy of San Carlos for a decorative frieze to be painted for the Teatro Nacional in Mexico City (today the Palacio de Bellas Artes), then under construction. The artist described his subject as an offering by a group of Indians before an Aztec god.

As the conception for the mural was elaborated by Herrán, the overall format evolved into a triptych, with the Aztec earth-mother goddess Coatlicue occupying the central panel and the subjects paying homage to the idol on each side, Indians on the left and Spaniards on the right. Herrán worked out the final segment of the project in 1918, when he superimposed a crucified Christ on Coatlicue to symbolize the coming together of the Indian and Spanish cultures, indigenous pantheism and Spanish Catholicism. The merging of the two races and cultures is thus symbolized by the central motif. The symmetrically balanced composition, with the dominant figure in the center and secondary figures at either side, has its origins in Precolumbian art.

The mural was never completed. What remains is a series of large studies in charcoal and the partially completed left panel.

The first study for *Our Gods,* done by Herrán in 1914, shows a group of Indians in poses of veneration before the Aztec deity Coatlicue, goddess of birth and death. She is known also as the Goddess of the Serpent Skirt and is portrayed with two serpent heads emerging from her neck, which symbolize the earthbound character of human life. Serpents also replace the hands and feet. Herrán used as his source for the image of Coatlicue the colossal sculpture of the deity in the Museo Nacional de Antropologia in Mexico City.

The wavelike pattern created by the three groups of Indians, which begins at the upper left and moves in a downward arc toward the center and then back up toward the deity on the right, is counterbalanced by the outline of a volcano in the distance, the famous Ixtaccihuatl, or Sleeping Woman, so named because the silhouette resembles the form of a reclining woman.

The compositional study for the right panel, done in 1915, shows three groups of Spaniards—friars, warriors, and townspeople. The group at the extreme right, complementing the Indians in the left frieze, carries a palanquin with the venerated Virgin of the Remedies, a statue that accompanied the expedition of Cortés to New Spain. In the background is the snowcapped volcano Popocatépetl, or Smoking Mountain.

The study for *Coatlicue Transformed* contrasts the ferocity of the Aztec goddess with the gentleness of the crucified Christ. Coatlicue, source of life and devourer of all things, is surrounded by flowers and skulls; the hard stone of the idol is contrasted with the soft flesh of the crucified Christ. Together they symbolize Mexico, the mixing of races and the blending of two different worlds, the indigenous with the European.

# Dr. Atl

**MacKinley Helm**

From *Modern Mexican Painters,*
1941

*D*r. Atl is pseudonym of the influential Mexican artist Gerardo Murillo. While this excerpt describes him primarily as a forerunner of the Mural painting movement, it also shows his innovative handling of paint and charcoal.

When Dr. Atl returned to Mexico in 1907, after a few years of study in Europe, he found the Academy of San Carlos in a state of turmoil because a new teacher, Antonio Fabrés, a Catalonian academician, had been imported by the Minister of Education over the protest of the director of the school. The public liked and bought the paintings of Fabrés, which were executed in the color-photographic style of [Spanish Impressionist Ignacio] Zuloaga, but the students were not happy in the atmosphere he created. Dr. Atl, who was then about thirty, promptly organized antagonisms into revolution; whereupon the usurper was presently retired.

The Doctor then undertook to lecture privately about the Impressionists whose work he had been seeing in Paris. He took a few student artists out-of-doors, away from the ateliers where they had been painting under artificial light, and encouraged others—among them the [future] Surrealist painter Roberto Montenegro—to continue the researches which they had timidly begun in the field of native colonial art. To show that he was a practical man as well, he organized exhibitions of the works of youthful painters in Mexico City: of Angel Zárraga, who later removed to Paris, so it is said, to produce religious canvases beyond the range of the satirical comments of his unholy friends; of Joaquín Clausell, a prolific but imitative Impressionist who had some success in the United States; and of a quite unknown young man, Diego Rivera, whose pictures he believed in and bullied his friends into buying. With the money from levies upon Dr. Atl's acquaintance, Rivera went for the first time to Europe.

In 1908 Dr. Atl made his first attempt at mural decoration. The place, a shabby gallery in the Academy of San Carlos; the purpose, the glorification of a gentleman from Puebla who had presented a collection of pictures to the State. Of a great array of mostly imitative art the chief treasure was an original work of the Spanish [Bartolomé Esteban] Murillo, whom Dr. Atl secretly de-

spised. Nevertheless, having arranged the permanent disposition of the pictures on the Academy walls, the artist proceeded to paint, in so-called Atl-color, a eulogistic mural. Working in solitude, according to his contract, he produced, in the Impressionistic style, a frieze of nudes disporting themselves above the gilded frames of the sacred pictures.

There are several stories about the ultimate removal of these decorations. Dr. Atl says they were painted out because they were shocking, but it is also said in Mexico that the artist himself removed the rosy nymphs in the nick of time, before their uncertain chemistry could cause them to disappear of themselves. This story might be suspected of being an invention of the later muralists, of whom one, in fact, repeated it to me; for some of the rude demonstrations of Atl-color which the inventor has made in times past on the walls of his studio have a dirty look of having survived there for years. However, decorations made in that medium in 1921 in a convent patio have practically flaked away.

Atl-color was invented for use, like pastel, on the surfaces of paper, wood, plaster, fabric and board. Composed of wax, dry resins, gasoline and oil color, it is manufactured in small bars like sticks of sealing wax. The color itself is apparently unalterable, although the substance can be dissolved in gasoline for spreading with brush or palette knife, and melted like wax for thickening and diversifying textures. A surface covered with Atl-color can be freely overpainted.

Dr. Atl has used his invention in a variety of ways ever since he first made experiments with it in Rome at the beginning of the century. Sometimes he dissolves it in gasoline and spreads it like water color on paper prepared with white of zinc. Frequently he paints with water color, superimposing Atl-color to enrich the textures. He also combines it with oil, a conjunction which is likely to produce harsh variations of surface textures because Atl-color, while brilliant, is hard.

Not long ago Dr. Atl saw, in a village *cantina* in the State of Michoacán, a small picture which looked familiar to him. It turned out to be his own first work in Atl-color. When he brought it home I went to have a look at it. It was Impressionistic in the manner of Pissarro, with period figures strolling across a shady plaza. Dr. Atl painted in this style, many years ago, a few portraits which have a way of looking abnormally loose at close view, and of rapidly tightening into form from a distance. Perhaps it would be more accurate to say, therefore, that Dr. Atl's Impressionism is not so much Pissarro as Sisley after Pissarro.

His later painting is tighter and less varied in both subject matter and treatment. Until quite lately he has invariably worked in his studio, relying upon his prodigious and well-trained memory for details of color, light and contour. Because he painted from memory and always used the same themes, Popocatépetl and Ixtaccihuatl and the Valley of Mexico, his studies were

bound to become monotonous. In the summer of 1939, however, he painted forty-eight small board and canvas pieces directly from nature. Done in oil and water color, many of these have the flexibility and fresh feeling and charm of his earlier work.

Like most of the Mexicans—Diego Rivera, Frida Kahlo and Orozco Romero are others—Dr. Atl has painted scores of self-portraits. A typical Atl for a comprehensive Mexican collection would be one of the self-portraits with Popocatépetl in the background. It should be executed in either Atl-color or charcoal, because in these media Dr. Atl does his most personal work.

One day in his studio, after a lunch of superb Mexican food cooked in Tarascan pottery vessels and served by the small daughters of his Indian cook, Dr. Atl gave me a demonstration of his charcoal technique. Rummaging around in a dark corner of the studio, he retrieved a small, smudged cardboard box from beneath a mound of galley proofs. In this container there was a collection of dirty and scarcely distinguishable objects which he described as his portable charcoal set. There was first of all a crumpled piece of chamois skin, encrusted with an accumulation of charcoal rubbings. The removal of this soiled and tattered fragment disclosed scatterings of charcoal and a small whittled stick about the size of a vest-pocket pencil.

"Now see," said Dr. Atl, "this is what I do." He crushed a broken stick of charcoal into dust, wrapped the chamois skin around his index finger, dabbed at the particles of carbon, rubbed the surface of a piece of paper, manipulated the masses of an impromptu composition with his finger tips, drew a few strong, sharp lines with the blackened tip of the little pointed stick, and behold! there was Popocatépetl looming up over the Valley of Mexico.

Any catalogue of the preachments which issued from the voice of Dr. Atl in the days when he cried in the Mexican wilderness should record that he was the first native painter to talk about Communism. Except for a tincture of Russian Communism filtering in chiefly from across the American border, the Mexican variety of communistic thought has been a local product, stemming not from Marx but from the Spanish legal tradition and the Indian way of life. Dr. Atl's Communism was in reality a kind of poetic, almost a biblical socialism. He persuaded his artist disciples to pool their interests in a *Centro Artístico,* an association in which they undertook to live according to a rule drawn from the life of the artisan classes. They painted houses and garden walls in provincial towns to earn money for tubes and brushes. Eventually they received a joint commission to decorate the walls of the *Anfiteatro Bolívar* in Mexico City, but the Revolution of 1910 made an end to this scheme; and when the project was revived, years later, Diego Rivera was freshly home from Paris to put it into execution himself.

Dr. Atl likes to think that the revolution in art began in the autumn of 1910, when he organized an exhibition of paintings in honor of the centenary of the Mexican Independence. He showed the work of his followers and of a

few solitary painters who wanted to identify themselves with the forerunners of the prospective school of nationalistic painting. The event seems to have been scantily recorded at the time, however, and I have not been able to discover that any tangible result came of it directly.

Revolution broke out in November of that year under the leadership of Francisco Madero, a rich young man who had been conventionally educated at the University of California before he went to study democracy in the then Republic of France. Provisional governments appeared in rapid succession; none of them with the means, had the intention been present, of patronizing the arts. The *Centro Artístico* was dispersed and most of the painters left the city to join one or another of the revolutionary armies. Dr. Atl went to Paris, where he was soon engaged in political intrigue, painting, as usual, in his spare time. For a few months he published a news sheet in opposition to the Huerta government which in 1913 invaded the National Palace and murdered Madero. He says his editorials spiked a French loan.

In the midst of political confusion, the change and interchange of governments, the counterpoint of innumerable private and interlocking revolutionary movements, there occurred a comic interlude from which some of the younger painters, with no discourtesy to Dr. Atl and his prophetic accomplishments, date the effective beginning of the revolution in art. There was a student strike in the Academy of San Carlos.

In spite of the immaturity of the strikers it must be admitted that their vaguely articulated objects anticipated the second—the finally secular—phase of the mural movement which was launched ten years later. However clumsily they expressed themselves, the students had correctly foreseen the inevitable relationship of art to politics during that stage of their country's development. What they obscurely wanted was new forms of both government and art to make the relationship fruitful. They had been suffering from an experiment with the Pillet system of teaching abstract painting, a method originally designed for use in the lower schools in France. They proposed for the directorship of the Academy a young man who had just come from Paris, where he had gone in for Impressionism and the out-of-door life of the Barbizon school,—the painter Alfredo Ramos Martínez, who has since wrought his improvisations on Monet themes in a cemetery in Santa Barbara.

The first of the youthful and not wholly clarified political objects of the strike was the "redemption of Mexican economy from imperialism." The program seems, at this distance, not a little ambitious for boys and girls in their teens, but they ripen young in Mexico, politically as well as physiologically. Art students had supported Madero in his time, although his administration had been a great disappointment. He seemed to have had no plan for directing the Republic through the reconstruction. Young revolutionaries everywhere were impatient to get on with the reforms the Revolution had promised: the expulsion of foreign capital, the seizure of *haciendas,* the distribution

of land amongst the peasants, in fact, the wholesale establishment of apocalyptic agrarian reforms.

The strikers, most of them children, held open-air exhibitions of the new political art and earnestly presented their case to the people at public meetings. Religious periodicals—the government was still cooperatively Catholic—met the threat to the financial security of an incredibly wealthy Church with editorials proving that the strike was subversive to the State. Under pressure from the clerical press, armed police conducted raids upon the youthful population. At one time more than a hundred Academy students were in jail: among them David Alfaro Siqueiros, who was then fourteen years old and hugely enjoying his first publicity. Siqueiros has described to me how, when they were released, they all went back to the Academy to throw eggs and tomatoes at the elderly director and draw obscene anticlerical compositions at their drafting boards. Out of such melodramatic, not to say malodorous, beginnings the new plastic forms of the Mexican revival gradually emerged.

# Untitled Statements

## Armando Reverón

Translated by the editor

*Venezuela's premier Impressionist, Armando Reverón, worked in solitude on the beach at Macuto beginning in 1921. By the middle 1940s he had become something of a curiosity, and journalists began to seek him out. These statements, while they may reflect something of his deteriorating mental condition, also show clearly the passion and determination with which he painted.*

### 1944

You and I are the canvas. You are the subject of my painting, and so am I.

On the palette all you need is white. In order to begin a drawing, first mark the boundaries of the subject nearly geometrically, and then draw and draw until the subject emerges.

Since you are here, I can't take my clothes off. I am the canvas, and the canvas must be bare. I do not accept the preparation of the canvas with sizing and priming. The canvas has to be in its natural state, because if it is first covered with primer, all intention is lost. Once you prime a canvas, you have already painted it. The painter has to approach the canvas as a bullfighter approaches a bull.

The light is a lady. I have never been introduced to her. Nobody knows her. The sun is everything. What a problem the sun is!

### 1949

I came here in search of simplicity, and here I clearly found myself.

I have been here painting for many years. I have succeeded in finding simplicity and the caress of austerity. I have been able to become familiar with the light. I am here because I am committed to light.

The sky is everything and it can't be avoided. It has within it all beauty. Goya painted many things by using his fancy, but here on earth we are drowning in anguish. I do what I can to save myself by painting. The world is really rather shabby. But on the other hand, there is already enough light even for magicians.

## 1953

Every person is a God. When I am talking I am God, and when you talk, you are God. God is in everything.

God is in color, can't you see? What a serious thing light is! How can we master the light? I have tried. This is my struggle. First we have to work on what we know.

What is painting? This is difficult to know. Painting is the true light. Light can blind you or drive you crazy or torture you because you cannot look directly at it.

Sources:
1944: from Reyna Rivas de Barrios, "Reverón y su Palabra," *El Nacional* newspaper, reprinted in *Imagen* no. 52, September 1944.
1949: from Joaquin Tiberio Galvis, "Armando Reverón," *Elite*, August 1949.
1953: from Oscar Yanes, "Reverón no Desmiente su Locura y Amenaza a la Municipalidad con el Santo Niño de Jesús," *Últimas Noticias*, 29 January 1953.

# Manifesto of Martín Fierro

From *Martín Fierro*,
15 May 1924

Translated by the editor

Martín Fierro *was the magazine of the literary and artistic avant-garde of Argentina during the middle 1920s. Despite the fact that the magazine was named for a famous nineteenth-century epic poem of gaucho life, this manifesto shows only a moderate level of nationalism, praising Swedish toothpaste, French towels, and Hispano-Suiza luxury cars as it urges the severing of all umbilical cords. The seemingly racist reference to "blacks" in the closing sentences is a slang term that also means "dolt."*

Faced with the elephantine impermeability of the "honorable public";
Faced with the funereal solemnity of the historian and the professor, who mummify all that they touch;
Faced with the cookbook which inspires the lucubrations of our most "beautiful" minds and the devotion to anachronism and imitation that they show;
Faced with the ridiculous necessity to bolster our intellectual nationalism, swelling up false values that pop at the first prick like balloons;
Faced with the widespread inability to contemplate life without first scaling the library shelves;
And above all, faced with the terrifying fear of making a mistake which paralyzes the very impetus of youth and which is more stultifying than any retired bureaucrat:

*Martín Fierro* feels the urgent need to define itself, calling out to whoever is able to see that we find ourselves in the presence of a new sensibility and a new understanding which, if we align ourselves with it, can lead us to unexpected horizons, new media, and new forms of expression.

*Martín Fierro* accepts the consequences and responsibilities of locating itself, because it knows that its health depends on this. Aware of its ancestors, its anatomy, and the meridian that it walks on, it consults the barometer and the calendar before going out to the street to live with today's nerves and mind.

*Martín Fierro* knows that "everything is new under the sun," if seen with refreshed eyes and expressed with a contemporary accent.

*Martín Fierro* therefore finds itself more at home on a modern transatlantic liner than in a Renaissance palace, and maintains that a good Hispano-Suiza is a much more perfect work of art than a sedan chair from the age of Louis XV.

*Martín Fierro* sees architectural possibility in an Innovation brand steamer trunk; a logic lesson in a telegram; a form of mental organization in a rotary press. Yet this does not keep us from possessing (as in the best families) a portrait album which it leafs through from time to time in order to find itself among its ancestors . . . or to laugh at their collars and ties.

*Martín Fierro* believes in the importance of the intellectual contribution of Latin America, after taking a scissors to all umbilical cords. To support and spread to other fields of endeavor the linguistic independence movement that Rubén Darío initiated does not imply for us that we are unaware that we still use every morning our Swedish toothpaste, French towels, and English soap.

*Martín Fierro* has faith in our phonetics, our way of seeing, in our habits, in our own ears, in our own ability to digest and assimilate.

*Martín Fierro* as artist rubs its eyes every moment in order to wipe away the cobwebs constantly tangling around them: habit and custom. Let us give to each new love a new virginity, and let today's excesses be different from those of yesterday or tomorrow! This is truly saintly creativity! There are so few saints!

*Martín Fierro* as critic knows that a locomotive is not comparable to an apple, and the fact that everyone compares a locomotive to an apple and that some choose the locomotive, others the apple, proves for us the suspicion that there are far more blacks out there than one might think. Only blacks cry out "Fabulous!" and think that they have said it all. Only blacks need to be dazzled by whatever sparkles, and are not satisfied if they are not dazzled by whatever sparkles. Only blacks have their palms flattened out like scales so that they weigh everything, and judge it by its weight. There are so many blacks! *Martín Fierro* only has appreciation for the blacks and whites who really are blacks and whites and have no intention of changing their color.

Do you agree with *Martín Fierro?*
Collaborate with *Martín Fierro!*
Subscribe to *Martín Fierro!*

# Don Pedro Figari

**Ricardo Güiraldes**

From *Martín Fierro,*
6 September 1924

Translated by the editor

*T**he author of this article is the novelist who wrote* Don Segundo Sombra, *a coming-of-age story of individualism and survival on the Pampas. Not surprisingly, some of the traits of the gaucho Don Segundo live on in the painter Don Pedro Figari. This essay is interesting for what it reveals about the popular musings of that time on the development of a national art in Argentina. There is a reference to José Hernández, author of the Argentine national gaucho epic* Martín Fierro, *for whom the magazine was named.*

A few days ago, the show of paintings by Pedro Figari ended its run; the press, particularly the large daily papers, took note of this artistic event.

The list of works shown this year was accompanied by a brief critical article which detailed the astonishment and enthusiasm that the great painter has earned in Buenos Aires, Paris, and Montevideo. This surprise and enthusiasm are completely justified. First, because Figari paints new subjects (elite salons, candombes, carriages, country dances) which are yet familiar to us. Second, because he treats these subjects with sincere originality, beautiful paint handling, and bold resolve, so that they merit the adjective masterful. . . .

Paintings like those of Figari create through their simple presence a series of influences that the artist has not necessarily sought. The mere fact of selecting as subject matter such a great variety of motifs that others have rejected shows that other artists have never known how to look at what was closest to them. Many times, I have heard voices of protest against our country that accuse us of lacking picturesque subjects, and I can cite a few things here that should sound familiar: "The Pampas can be the subject of music or poetry, but not painting." "Who would dare to put on canvas our horrible shacks and farm houses that are so lacking in grace and poetry?" "How can one paint where it is so hard to find even a model?" "Here there is no environment for the arts," etc.

Well, Figari has proved that the Pampas is indeed picturesque, and that one can paint our low shacks to great advantage. Here we have no lack of models,

since it is not necessary to seek out the classical nude reclining on a divan with a fan or a pear in her hand. Neither is the environment lacking, because the artist is the environment. What environment did José Hernández have?

To be an artist does not mean to have skill, nor even to make a work of art, because many persons everywhere do these things. To be an artist is to love, admire, and enjoy the things that life doles out, and to exert oneself to find the means to express this love, that admiration, or that enjoyment. To the degree that an artist is able to understand and express his feeling, there we will find his greatness, and this is not lessened by the incomprehension or bad will of any viewer.

Don Pedro Figari has lived in a world of love and intelligence, and this is what he gives us. Does he not have skill equal to Velázquez? Does he paint like [Ignacio] Zuloaga? Does his work resemble that of [Heinrich] Zügel? Of course not; he has the skill of Figari, he paints like Figari, and his work resembles that of Figari, for the simple reason that he finds all he needs within himself, without begging from those around him.

This does not imply that he is only trying to be different from others, nor that he favors or opposes any specific mode of painting. To make a painting with the only goal of being different from someone else is to remain attached to what one repudiates. There is none of this in Figari. What interests him is the life of his people and the land, the feeling of the surroundings, the happiness, the laughter, the tears, the love, and the death of men. This is what Figari takes within himself with so much affection; this is what he has consecrated his life to representing: what he has inside him. All who wish to experience life will feel the joy, sadness, and emotion in his works.

Yes, you will tell me, but what about the correctness of this or that detail? I say, sir, that I know nothing of details when it comes to matters of the spirit. Why search out the lack of detail with only the intent to belittle? This is the small-minded method against the great, the method of below from above, the method of the rust on the statue or the germ in the man.

For those who prefer to judge by such technical details there is plenty to keep one busy. If few painters are as pure before their own feelings as Figari, there are likewise few who are wiser in choosing the way to express them. Yet I do not believe that he works premeditatedly in this way; rather, it grows out of his deep-rooted intuition.

Figari laughs with his gamblers, groans over his deserts with their gauchos, wiggles with his childlike and pompous blacks, and curses with his portly matrons. Figari finds an extraordinary pictorial festival for showing off his rich resources. The finest gradations and the strongest contrasts are carried off with perfect equilibrium in each composition . . .

Let me pull away from his technique in order to focus on the surging humanity of his subjects. They form an extraordinarily diverse world, a synthetic condensation of all of life in a country that was waiting for its painter. As we

pass before Figari's canvases, we see ourselves in our landscape, in our own homes, our own ancestors, and we are hushed and grateful. He cares about us, and he has said so.

To close this poor reflection on what I have felt in his work, I thank Don Pedro Figari; I thank him for myself and on behalf of all who have washed their faces in the fresh and constant spring of his painting.

# Regional Autonomy

**Pedro Figari**

From *La Cruz del Sur*
(Montevideo), 31 May 1924

Translated by the editor

*P*ainter Pedro Figari argues eloquently here for a modern yet local culture in the River Plate region. (All boldface emphasis is in the original.)

We have lost our way. Cosmopolitanism has erased what is ours, replacing it with exotic civilizations, and we, blinded by the brilliance of the ancient and glorious culture of the Old World, have come to forget our own tradition. We have become accustomed to dragging ourselves along with the laziness of the chameleon, comfortably, as if it were not necessary, for reasons of dignity and conscience, **to create our own civilization,** the most authentic possible. All of this has forced us to live for many years a reflected and almost ephemeral life. From our own environment we kept only the echo. The traditional values, which are our spiritual essence and heritage, lay in oblivion, as values with little import, if not despised.

Some efforts and initiatives have been sustained by "the gaucho," be he rural or urban: for me the gaucho could be one or the other, as long as he maintains faith in the attitudes of the American race and considers it at least as good as any other, and always professes positive feelings about our environment and gratefulness to its progenitors. Some industrious champions of our tradition, working inorganically and thus against greater obstacles, have struggled for the preservation of the traces of the criollo legends. This will allow us to reconstruct the poem of America, and establish over the depths of this vein a civilization that is ours, and which, measured against the teachings of world experience, and as much as they may take advantage of them, will be able to equal them in brilliance, honors, and advancements while always keeping them as recognizably our own. This awakening of the autonomous conscience must reach its fullest development, so that it can reach a comparable plane of fertility, and so that one can feel its vibrancy.

It is not with pompousness that we have to create **the work of America;** it is with deeds, with enactments, with works that are judicious, effective, productive, progressive, and promising. Neither is it with hasty imitations that

we should color it with the best location in the world, but rather with study, work, and integrity; that is to say, effectiveness. . .

We must organize, thus, not by imitating, but by educating. Only by means of an **autochthonous consciousness** ready to investigate the factors in the environment and balance the most appropriate resources for a rich, firm, and positive prosperity, solidly founded on the features of our surroundings and in the aptitudes and modalities of our race: Only thus will we be able to undertake this fruitful enterprise with confidence in its results. Until we have shaken off the stupor that befogs us, we will not be able to perceive the beauties of our own earth and sky, nor the poetry of our own tradition, nor the greatness of our mission.

The Southern Cross must shine more brightly, according to the breadth of our accomplishment in individualizing our race and our region, and even more according to how attuned and rational have been the elements with which we individualize it. We must set to work, decisively and conscientiously.

# Emilio Pettoruti

## Xul Solar

From *Martín Fierro,*
9 October 1924

Translated by the editor

*In this article, which appeared at the time of Emilio Pettoruti's first Buenos Aires exhibition, Xul Solar stresses Pettoruti's preparation and effort. If he did this in anticipation of controversy, he acted wisely. There was a public disturbance at the opening that forced the owner of the gallery to eject the huge crowd out onto the sidewalk. Earlier in the day, however, Argentina's president visited the show all by himself. Such were the contradictions of what Xul Solar calls the "idiosyncratic modernity" of Argentina.*

Still very young, always electrified, shooting out sparks, he is a fermenting and exploding force in the life of his friends, and he surely will be thus for our country as well.

Our idiosyncratic modernity is complicated. Restless in its soul and serenely content in its art; passionate in reality, but fleeing from passion in its paintings; epicurean every day, it lives for the ideal of beauty.

Little respectful of precepts, Pettoruti studies and renews himself continuously. He did the arduous artistic apprenticeship on his own, by himself, and not by coldly accumulating recipes. Each stage of his development, even each technical advance, corresponds to a new stage of his soul. He searched deeply, meditated, and assayed. He soon arrived at what was most difficult, finding himself at the maturity that shows a second birth. And now, with a body of work already complete that guarantees his future, he plunges in anew to the fury of creativity. Correcting, adding a measure of his thought, taste, and purity to the most daring steps, showing the exuberance of the South. His free inventions are at times debatable, and rarely classifiable, but they do have life, and that one rare essence: beauty.

Always operating with the best of taste, Pettoruti invents things that, even though they fall outside the letter of the old law, acquire validity by themselves. Certainly they exist outside what has been called painting for centuries, according to the burdensome superstitions learned in museums by certain famous critics during the age that's now passing away, or in certain regions that

have always regarded themselves as the center of the earth. It is certain that art, even great art, is as old as humanity itself. The newest art is a product of contemporary culture that is as necessary and logical (and even deeper, more serious, and more fertile) as was any of the art that was done by and for princes and potentates of the Renaissance.

Pettoruti's new conviction has matured slowly, not only in times of furious creativity but also in periods of apparent quietude, of travel, or inner questioning, or doubt.

His lines, masses, and rhythmic energies respond to a musical urge that asks for release in a kind of lyrical despotism. The needs of composition led him to a greater emphasis on volumes and values, to the freeing of color, to an architectonic balance rare in nature, complex but extremely rich. Poetic necessity, in the end, demanded that he base the entire canvas on his chosen subject, and adjust all the elements and means in his employ.

As soon as all of this was made clear and distinct, our artist, admirably young (a virgin soul as true artists always are), created these new works in a burst of activity, almost surprising himself, guided solely and surely by his own gods.

We will see some arrays of colors, some cubes, some cylinders, and planes piled up: and a portrait will result. Or the tones will break apart, light will erupt, as the forms decompose further and turn as in a kaleidoscope: and we will see a poetic landscape. We will also see a few worrisome pictures with new unclassifiable glyphs that resemble the curiosities of some secret but very interesting laboratory: indicators of how far this painter will follow his unchained desire for fantasy and abstraction.

His works are already numerous, but they may be condemned by the public as "incomprehensible" or "off-kilter" when they are shown. Not because art of the past and the nostalgic art of today look more "natural," but rather because one needs less perspicacity to penetrate the old geometries, with their rhythms and colors and other mysterious values. If today's vanguard artists of all stripes refuse to go along with popular taste and public demand, if they do not adjust the appearance of their art to the externals of verisimilitude, it is just for this seeming lack of care that their works are immediately accessible—to those who want to see or already know how.

Pettoruti spent ten years in Europe, studying in Florence for a great deal of that time. He admired all of Rome; he worked for several years in Milan. He knows all of Italy as few Italians do, and he knows Italians as few foreigners do. He was in Germany for some months with the Expressionists; later in Paris he saw the most advanced art as a friend of Picasso, Gris, Archipenko, Chagall, Zadkine, Hernández, and many others. Pulled back by nostalgia, our Pettoruti returned to our land, accompanied by his art and a newfound faith.

Now that his work has already been ratified by more than thirty exhibitions in France, Italy, Switzerland, and Germany, the Buenos Aires public can

either admire or disdain him. But all will recognize his art as a great stimulating force and a point of departure for our own future artistic evolution.

Pettoruti has no intention of pressing this or that given style, trying to convince us of something through sheer force of his talent; his art already participates in the general spirit of the present century.

Although this is a time when art is more individual and arbitrary than ever, it would be a mistake to call it anarchic. In spite of so much confusion, there exists a well-defined tendency toward simplicity of means, toward clear and solid architecture, toward the pure plastic sense that protects and accents the abstract meanings of line, mass, and color, all within a complete liberty of subject and composition. These new and wide horizons, this serious effort of Pettoruti—a dissident in the last analysis—show us his fluency and liberation, just as much as his courage.

Let us admit, in any case, that among us now—if mostly still hidden—are many or all of the seeds of our future art, and not in museums overseas, and not in the homes of famous foreign dealers. Let us honor the rare ones, our rebellious spirits who, like this artist, before denying others, find affirmation in themselves; that instead of destroying, seek to build. Let us honor those who struggle so that the soul of our country can be more beautiful.

Because the wars of independence for our America are not yet over. In art, one of the strongest warriors is Emilio Pettoruti.

# The Situation of the Modern Artist

**Emilio Pettoruti**

From *Un Pintor ante el Espejo,*
1968

Translated by the editor

*This excerpt from Pettoruti's autobiography shows him as an essentially conservative painter who admired the Old Masters even as he painted in a Cubist style. At the same time, we see his loneliness as a forerunner of Modernism.*

I went in search of a solidly based art. Modern, yes, but consistent with the virtues of the art I admired most: that of the Quattrocento. I saw clearly that without exception each of those artists reduced his painting to the clearest and simplest elements. More than once, while looking at their works, I said to myself that if those artists had been born in our century, that they would be vanguardists. . . .

It must be said that the situation [neglect by the public] did not affect us. We always felt that this rejection was a tribute to be paid in exchange for the free exercise of our creative will and our dreams. As far as the critics were concerned, they did not bother us. I remember one day discussing this with Rojas Paz when he told me, "The critics ignore both you and me, I know it. . . . I feel sorry for the public, because they will die without learning of all that we have done for them."

It is not easy to convert the masses from their apathy and their nostalgia for traditional art, in order to win them over to new ideas. In Buenos Aires everyone kept talking about traditional art and classical forms as they criticized my paintings, as if the art of representing the real had always existed and should continue to exist, and as if they were ignorant of the fact that abstraction from reality began with art of the Stone Age.

It was necessary to explain always to the neophytes, both the real and fake ones, that it is not by starting from the real one arrives at a symbol, but rather the opposite, that the tendency toward abstraction—and this is confirmed afresh with each passing day's new discoveries—that the tendency toward abstraction existed from time immemorial. The cave painter valued expression above all else; all works of the human genius since the early Renaissance to the present are between abstraction and figuration. A battle painting by Paolo

Uccello is as abstract as it is figurative, and if we observe the composition and color masses with even a little care, we see that all great art of the past up to the present is the same, because the artist does not copy nature. Even though he may paint external reality, he puts into his work the wish to sublimate the real and thus he idealizes it, converting it into an unreality; this is true even in the case of Leonardo. Those whose approach to reality tends the most decisively away from abstraction are the so-called Little Dutch Masters, the Intimists, and others. I do not say this in a pejorative sense, but only to remind us of a few things that the aesthetes forget.

There was one other thing that I fought against whenever the opportunity presented itself: people's tendency to accept and take advantage of any new idea that would increase their comfort, but rejecting new ideas in all other areas, in this case in the arts. In the realms of technology and science we admit all possible transmutations as we praise progress, as long as certain other deeply rooted conventions are left in place. To put it another way, people appreciate the advantages of train travel over going in a cart, or they appreciate electric lights in place of candles; but they do not conceive in any way that the creative mind must also evolve at the same time. How to show them that new art, like new architecture and even atonal music were all manifestations of the same time, of a similar state of mind? I cannot recall how many times I pointed out these things. . . .

Without museums where I could take refuge and be alone with the great works of the past, with no artists of my tendency with whom I could consort to take a break from the constant confrontation; without advanced spirits with direct knowledge of the new expressive currents which allowed me, like sharpening a knife, to sharpen the edge of my sensibility; without a market and without buyers, my life as an artist was very difficult and lonely. This does not mean that the art environment of Buenos Aires did not change over time. Although the snow scenes, the gauchos, and the rural genre scenes remained the principal taste for most people, some of the artists who returned from Europe put forth their own shy advances against the official prolongation of academic taste. . . .

Only Modern art speaks to us from up close. Only Modern art moves and arouses us, saying lively things, things that are our own, things that show us the way to tomorrow.

# Anthropophagite Manifesto

**Oswald de Andrade**

*Revista de Antropofagia*
(São Paulo), May 1928

Translation reprinted from
Dawn Ades, *Art in Latin
America,* 1989

*In this uproarious manifesto, dated in accordance with "the year 374 after the swallowing of the bishop of Sardinia," poet Oswald de Andrade sets out a crucial concept for the relationship of Latin American to European Modernism: anthropophagy, or cannibalism. In order to fortify their own art forms, Brazilian Modernists will cannibalize Europe just as the native peoples cannibalized the first explorers. (There was one sentence in English in this document when it first appeared, paraphrasing Hamlet's "to be or not to be" with the substitution of the name of one of the cannibalistic tribes, the Tupy.)*

Only anthropophagy unites us. Socially. Economically. Philosophically. The world's only law. The disguised expression of all individualisms, of all collectivisms. Of all religions. Of all peace treaties.

Tupy or not tupy, that is the question.

Down with all catechisms. And down with the mother of the Gracchi. The only things that interest me are those that are not mine. The laws of men. The laws of the anthropophagites.

We are tired of all the dramatic suspicious Catholic husbands. Freud put an end to the enigma of woman and to other frights of printed psychology.

Truth was reviled by clothing, that waterproofing separating the interior from the exterior world. The reaction against the dressed man. The American cinema will inform you.

Children of the sun, the mother of mortals. Found and loved ferociously, with all the hypocrisy of nostalgia, by the immigrants, slaves and tourists. In the country of the giant snake.

It was because we never had grammar books, nor collections of old vegetables. And we never knew what urban, suburban, frontiers and continents were. We were a lazy spot on the map of Brazil.

A participating consciousness, a religious rhythm.

Down with all the importers of the canned conscience. The palpable existence of life. The pre-logical mentality for M. Lévy-Bruhl to study.

We want the Carahiba revolution. Bigger than the French Revolution. The unification of all successful rebellions led by man. Without us, Europe would not even have its meager Declaration of the Rights of Man. The golden age proclaimed by America. The golden age and all the girls.

Descent. Contact with Carahiban Brazil. Où Villeganhon print terre [*sic*]. Montaigne. Natural man. Rousseau. From the French Revolution to Romanticism, to the Bolshevik Revolution, to the Surrealist revolution and the technical barbarity of Keyserling. We continue on our path.

We were never catechized. We sustained ourselves by way of sleepy laws. We made Christ be born in Bahia. Or in Belém, in Pará. But we never let the concept of logic invade our midst. . . .

The spirit refused to conceive of the idea of spirit without body. Anthropomorphism. The need for an anthropophagical vaccine. We are for balance. Down with the religions of the meridian. And foreign inquisitions.

We can only pay heed to an oracular world.

Justice became a code of vengeance and Science was transformed into magic. Anthropophagy. The permanent transformation of taboo into totem. Down with the reversible world and objective ideas. Transformed into corpses. The curtailment of dynamic thought. The individual as victim of the system. The source of classic injustices. Of romantic injustices. And the forgetting of interior conquests.

Routes. Routes. Routes. Routes. Routes. Routes. Routes.

The Carahiban instinct.

The life and death of hypotheses. From the equation—me as part of the Cosmos—to the axiom—the Cosmos as part of me. Subsistence. Knowledge. Anthropophagy.

Down with the vegetable élites. In communication with the earth.

We were never catechized. Instead we invented the Carnival. The Indian dressed as a Senator of the Empire. Pretending to be William Pitt. Or appearing in Alencar's operas, full of good Portuguese feelings.

We already had communism. We already had surrealist language. The golden age. Catiti Catiti Imara Natiá Notiá Imara Ipejú.

Magic and life. We had the relation and the distribution of physical goods, moral goods, and the goods of dignity. And we knew how to transpose mystery and death with the help of grammatical forms.

I asked a man what Law was. He told me it was the guarantee to exercise the possible. That man was called Gibberish. I swallowed him. . . .

The determining of progress by catalogues and television sets. They are only machines. And the blood transfusors.

Down with the antagonical sublimations. Brought in caravels.

Down with the truth of missionary peoples, defined by the sagacity of a cannibal, the Viscount of Cairú:—A lie repeated many times.

But they who came were not crusaders. They were fugitives from a civilization that we are devouring, because we are strong and vengeful just like Jaboty.

If God is the conscience of the Universe Uncreated, Guaracy is the mother of living beings. Jacy is the mother of all plants.

We did not speculate. But we had the power to guess. We had Politics which is the science of distribution. And a planetary social system.

The migrations. The flight from tedious states. Down with urban sclerosis. Down with the Conservatoires and tedious speculation.

From William James to Voronoff. The transfiguration of taboo in totem. Anthropophagy.

The *pater familias* and the creation of the Moral of the Stork: real ignorance of things + lack of imagination + sentiment of authority towards the curious progeny.

It is necessary to start with a profound atheism in order to arrive at the idea of God. But the Carahiba did not need one. Because they had Guaracy.

The created object reacts like the Fallen Angel. After, Moses wanders. What has this got to do with us?

Before the Portuguese discovered Brazil, Brazil had discovered happiness.

Down with the Indian candleholder. The Indian son of Mary, godson of Catherine de Medici and son-in-law of Sir Antonio de Mariz.

Happiness is the proof of the pudding.

In the matriarchy of Pindorama. . . .

Down with Goethe, the mother of the Gracchi, and the court of João VI.

Happiness is the proof of the pudding.

The lucta [rupture] between what one would call the Uncreated and the Creature illustrated by the permanent contradiction between man and his taboo. The daily love and the capitalist *Modus vivendi*. Anthropophagy. Absorption of the sacred enemy. In order to transform him into totem. The human adventure. The mundane finality. However, only the purest of élites managed to become anthropophagous in the flesh and thus ascended to the highest sense of life, avoiding all the evils identified by Freud, catechist evils. What happens is not a sublimation of sexual instincts. It's the thermometric scale of the anthropophagous instinct. Moving from carnal to willful and creating friendship. Affective, love. Speculative, science. Deviation and transference. And then vilification. The low anthropophagousness in the sins of the catechism—envy, usury, calumny, murder. Plague of the so-called cultured Christianized peoples, it is against it that we are acting. Anthropophagi. . . .

Our independence has not yet been proclaimed. A typical phrase of João VI:—My son, put this crown on your head before some adventurer puts it on

his! We expelled the dynasty. We must expel the spirit of Bragança, the laws and the snuff of Maria da Fonte.

Down with social reality, dressed and oppressive, registered by Freud—reality without complexes, without madness, without prostitution and without the prisons of the matriarchy of Pindorama.

Piratininga, The year 374 after the swallowing of the Bishop of Sardinia

# Manifesto of the Grupo Minorista

## Havana, 7 May 1927

Translation reprinted from
Dawn Ades, *Art in Latin
America*, 1989

*Artistic Modernism arrived later to Cuba than to Brazil or Argentina, but it was more broadly based in its inclusion of poets, anthropologists, musicians, and even scientists. In the artistic realm, the alliance of vanguardism with political protest was also stronger in Cuba than elsewhere. This situation would continue into the post-Revolutionary 1960s.*

In response to a certain statement by a local journalist and essayist, Señor Lamar Schweyer, to the effect that the Grupo Minorista (Minority Group) does not exist, the undersigned, who consider themselves to be members of the said group, feel obliged to correct, once and for all, the misconception under which certain people, among them Señor Lamar Schweyer, are laboring.

What is the Grupo Minorista, how was it born, what is it, who belongs to it? Some years ago, on 18 March 1923 to be precise, a small number of intellectuals (artists, journalists, lawyers) happened to be present at the Academy of Sciences and joined in an act of protest and censure against the then Minister of Justice who was also present, thereby manifesting the general public's repudiation of the government's famous purchase of the Convent of Santa Clara contrary to the wishes of the majority of the population.

That action set a destructive, apolitical pattern of behavior for young people who wanted to participate honorably in civic life, and provided Cuban intellectuals with a formula for social sanction and revolutionary activity.

This nucleus of protesters used to meet regularly to assess material and books for a proposed anthology of modern Cuban poetry, so a link was forged between artistic collaboration and civic, even legal, responsibility.

From there, they tried to organize and expand the group, and proposed the creation of the so-called "Falange of Cuban Action." This form of organization did not prove effective, but almost all its adherents, together with a broader spectrum of dedicated sympathizers, joined the ranks of the associa-

tion known as the "Veterans and Patriots," which was planning an armed movement against administrative corruption and government incompetence.

What was this symptomatic of? Why these frequent spontaneous gatherings of usually the same people, almost all young, almost all connected with the arts? Why did the group's conversation revolve around mocking false values, jingoistic wheeler-dealers, monumental incompetents, official "geniuses"? Why did they criticize ignorance of Cuba's problems, the government's subjugation to foreign demands, electoral farce, and the sheep-like passivity of the average citizen? It all went to show that there was a left-wing intellectual group in Cuba, not a statutorily constituted body but an increasingly important group of people with identical ideals, a product of its environment, a historical factor inevitably determined by the social function which it would fulfill.

The fact that some members of the group met for lunch in a restaurant every Saturday explains why friends who were not actually comrades sat with them, and that is how the confusion arose which mistook the so-called Minority Group for an accidental heterogeneous gathering with no particular timetable or special activity of its own.

The Minority Group is a group without rules, it has no president, secretary, monthly membership fee, in fact, no symbols of any kind. But this is precisely the most viable type of organization for a group of intellectuals. What has failed in so many places in the past is the regimentation of analogous groups in which the imposition of a single criterion is all-important. The Minority Group does not have the drawbacks of a formal, external, and adjectival structure.

As the experience of other countries has shown, there is an undeniably new ideology and a shift leftwards in such groups. The Minority Group knows that it is a group of intellectual workers (men of letters, painters, musicians, sculptors, etc.). Its name, given it by one of its adherents, refers to its small number of effective members, but it is actually a majority group because it is the spokesman, platform, and index for the majority of the population. It is only really a minority as far as its artistic criteria are concerned.

In the course of the year, the group has interpreted and reflected Cuban public opinion by protesting against the invasion of Nicaragua, Washington's policy on Mexico, the ransacking by police of both the University and the house of Enrique José Varona. The fact that people who are not members of the nucleus sometimes appear at our demonstrations and sign our manifestos in no way detracts from the group's unity of being and purpose.

Collectively or individually, our nucleus has fought and is still fighting:

For the revision of false and outmoded values;
For popular art and, in general, new art in all its diverse forms;

For the introduction and dissemination in Cuba of the latest artistic and scientific doctrines, theory and praxis;

For educational reform. Against the corrupt system of University appointments. For University autonomy;

For Cuban economic independence.

Against Yankee imperialism.

Against political dictatorships throughout the world, in the Americas, in Cuba;

Against the excesses of our pseudo-democracy.

Against electoral farce.

For the people's effective participation in government;

For improved conditions for the farmer, the peasant, and the worker in Cuba;

For the friendship and unity of Latin American nations.

# 2. Figural Realist Styles

# Manifesto of the Union of Mexican Workers, Technicians, Painters, and Sculptors

From *El Machete*, 1923

Translation reprinted from
Dawn Ades, *Art in Latin
America*, 1989

*T*his militant document is the clearest statement of the ideology that fueled most
of the Mexican muralists. Penned by David Alfaro Siqueiros and signed by
*Rivera, Orozco, and others, it reflects the influence of the more radical factions of
the Mexican Revolution, together with a dose of Marxism from Russia.*

To the Indian race humiliated for centuries; to soldiers made executioners
by the praetorians; to workers and peasants scourged by the greed of the rich;
to intellectuals uncorrupted by the bourgeoisie.

COMRADES:
The military coup of Enrique Estrada and Guadalupe Sánchez (the Mexican
peasants' and workers' greatest enemies) has been of transcendental impor-
tance in precipitating and clarifying the situation in our country. This, aside
from minor details of a purely political nature, is as follows:
On the one hand the social revolution, ideologically more coherent than
ever, and on the other the armed bourgeoisie. Soldiers of the people, peas-
ants, and armed workers defending their rights, against soldiers of the people,
press-ganged by deceit or force by the politico-military leaders in the pay of
the bourgeoisie.
On their side, the exploiters of the people in concubinage with traitors
who sell the blood of soldiers who fought in the Revolution.
On our side, those who cry out for an end to an old cruel order—an order
in which you, the peasants on the land, fertilize the soil so that the fruit it
bears be swallowed by greedy profiteers and politicians while you starve; in
which you, the workers in the city, man the factories, weave the cloth, and pro-
duce with your own hands modern comforts to service prostitutes and drones
while your bones shiver with cold; in which you, the Indian soldier, in an

heroic selfless act, leave the land you till and give your life to fight the poverty your race has endured for centuries only for a Sánchez or an Estrada to waste the generous gift of your blood by favoring the bourgeois leeches who strip your children of their happiness and rob you of your land.

Not only are our people (especially our Indians) the source of all that is noble toil, all that is virtue, but also, every manifestation of the physical and spiritual existence of our race as an ethnic force springs from them. So does the extraordinary and marvelous ability to create beauty. The art of the Mexican people is the most important and vital spiritual manifestation in the world today, and its Indian traditions lie at its very heart. It is great precisely because it is of the people and therefore collective. That is why our primary aesthetic aim is to propagate works of art which will help destroy all traces of bourgeois individualism. We reject so-called Salon painting and all the ultra-intellectual salon art of the aristocracy and exalt the manifestation of monumental art because they are useful. We believe that any work of art which is alien or contrary to popular taste is bourgeois and should disappear because it perverts the aesthetic of our race. This perversion is already almost complete in the cities.

We believe that while our society is in a transitional stage between the destruction of an old order and the introduction of a new order, the creators of beauty must turn their work into clear ideological propaganda for the people, and make art, which at present is mere individualist masturbation, something of beauty, education, and purpose for everyone.

We are all too aware that the advent of a bourgeois government in Mexico will mean the natural decline of our race's popular indigenous aesthetic, at present found only in the lower classes but which was, however, beginning to penetrate and purify intellectual circles. We will fight to prevent this from happening. Because we are sure that victory for the working classes will bring a harmonious flowering of ethnic art, of cosmogonical and historical significance to our race, comparable to that of our wonderful ancient autochthonous civilizations. We will fight tirelessly to bringing this about.

Victory for La Huerta, Estrada, and Sánchez will be, aesthetically and socially, a victory for typists' taste; criollo and bourgeois approval (which is all-corrupting) of popular music, painting, and literature, the reign of the "picturesque," the American "kewpie doll," and the official introduction of "l'amore e come zucchero." Love is like sugar.

The counter-revolution in Mexico will, as a result, prolong the pain of the people and crush their admirable spirit.

The members of the Painters' and Sculptors' Union have in the past supported the candidacy of General Plutarco Elias Calles because we believed that his revolutionary fervor, more than any other, would guarantee a government which would improve the conditions of the productive classes in Mexico. We reiterate this support in the light of the latest politico-military events

and put ourselves at the service of his cause, the cause of the people, to use as it sees fit.

We now appeal to revolutionary intellectuals in Mexico to forget their proverbial centuries-old sentimentality and languor and join us in the social, aesthetic, and educational struggle we are waging.

In the name of the blood shed by our people during ten years of revolution, with the threat of a reactionary barracks revolt hanging over us, we urgently appeal to all revolutionary peasants, workers, and soldiers in Mexico to understand the vital importance of the impending battle and, laying aside tactical differences, form a united front to combat the common enemy.

We appeal to ordinary soldiers who, unaware of what is happening or deceived by their traitorous officers, are about to shed the blood of their brothers of race and class. Remember that the bourgeoisie will use the self-same weapons with which the Revolution guaranteed your brothers' land and livelihood to now seize them.

# Rockefellers Ban Lenin in RCA Mural and Dismiss Rivera

*New York Times,* 10 May 1933

*This is the newspaper report on the dismissal of Diego Rivera for painting a controversial head of Russian Revolutionary leader Vladimir Lenin in one panel of his mural for Rockefeller Center. The artist later created a nearly identical mural in the Palace of Fine Arts in Mexico City.*

Halted as he was at work last night on his scaffold in the Great Hall of the seventy-story RCA Building in Rockefeller Center, Diego Rivera, the celebrated mural painter whose communistic leanings have frequently enveloped him in controversy, was informed that the fresco on which he was engaged, and which he had regarded as his masterpiece, was no longer acceptable to the Rockefeller family.

Turning sadly with a few of his assistants and devoted friends to his "shack" on the mezzanine of the building, Señor Rivera found that his telephone had been cut off. He also found awaiting him a letter from Todd, Robertson & Todd, enclosing a check for $14,000, completing payment in full of the $21,000 he had been promised for three murals.

The letter expressed regret that Señor Rivera had been unable to come to some compromise on the paintings and said that the check was to be regarded as terminating his employment, although none of the three panels for which he had been contracted had been finished.

## Paraders Clash with Police

A crowd of about 100 art students and other admirers of the painting previously had been ushered from the hall by representatives of Todd, Robertson & Todd, the managing agents on behalf of John D. Rockefeller Jr., and mounted and foot police were on duty outside the building to prevent any demonstration when Señor Rivera was called away from his work.

No demonstration materialized immediately, but about 10 o'clock, two hours later, between 75 and 100 men and women sympathizers of the artist

paraded in front of the building, shouting "Save Rivera's art," and "We want Rivera." They carried banners on which similar sentiments were emblazoned.

The police and fifteen uniformed attachés of the building made no attempt to interfere as the demonstrators marched around the building three times. But on their last round they gathered in Sixth Avenue between Forty-ninth and Fiftieth Streets, blocking the sidewalks, and were ordered to disperse by the police.

Booing and jostling the policemen, the demonstrators refused. A crowd of waiting taxicab drivers took the side of the police, and a free-for-all fight developed. The policemen, brandishing their nightsticks, rushed the crowd, which resisted until two mounted patrolmen charged into their midst. Then they fled.

Meanwhile all doors of the Radio City Music Hall had been locked and patrons were compelled to wait for at least ten minutes until order was restored before they could leave. A traffic snarl had developed in Sixth Avenue, Forty-ninth and Fiftieth Streets meanwhile, but it was soon cleared by the police.

## Lenin Pictured in Painting

With an air of resignation rather than bitterness, Señor Rivera described in his broken English his design for the mural which, covering a space sixty-three feet long and seventeen feet high, was to have depicted "human intelligence in control of the forces of nature." A sketch of it had been shown to the Rockefeller family and approved by them, Señor Rivera said.

The entire scheme for the mural decoration of the Great Hall was worked out by Señor Rivera, with the approval of the RCA art commission. His panel, the only one in color, was to have occupied the central position, and was to have been flanked by Brangwyn's chiaroscuro on the left, and Sert's on the right. Señor Rivera intended to portray the emancipation of mankind through technology.

But when the actual painting began, objection was raised, he said, to a figure of Lenin joining hands of a soldier, a worker, and a Negro, which was to have topped the painting. In the background were crowds of unemployed.

Señor Rivera said that he had been told that Mr. Rockefeller and his advisors did not find the mural as "highly imaginative" as they had expected it to be, and that its effect was unpleasant. They also objected to the brilliant colors in the background, he said.

His first warning that his conception was no longer pleasing to the owners of the building came five or six days ago, Señor Rivera said last night. He added that he had desired to be conciliatory, and as a possible compromise had suggested that in one of the other panels he would portray the figure of Lincoln helping mankind.

## Artist Consults Lawyer

With his friends and assistants, Señor Rivera went from the building to the office of Philip Wittenberg, an attorney, at 70 West Fortieth Street, where they went into conference with Mr. Wittenberg and Arthur Garfield Hays to learn whether or not they had any legal recourse in the matter.

After hearing Señor Rivera's side of the story, Mr. Wittenberg said he had made no decision on whether any legal action would be taken on his behalf. He said that an artist's rights in such circumstances have never been fully determined by the courts.

Señor Rivera said the last thing he saw as he left the building, after the managing agent's men had called him from the scaffold on a pretext, was the erection of a screen in front of the mural. He said that he feared that the painting, which he had come to regard as his greatest, would be destroyed. A burlap covering was hung last night inside the Fifth Avenue door of the building, so that passersby could not see the painting.

## Nelson Rockefeller Wrote First

The first official remonstrance received by Señor Rivera came from Nelson A. Rockefeller, son of John D. Rockefeller Jr., in the following letter dated May 4:

36 Broadway, May 4, 1933.

Dear Mr. Rivera:

While I was in the No. 1 building at Rockefeller Center yesterday viewing the progress of your thrilling mural, I noticed that in the most recent portion of the painting you had included a portrait of Lenin. The piece is beautifully painted, but it seems to me that his portrait, appearing in this mural, might very easily seriously offend a great many people. If it were in a private house it would be one thing, but this mural is in a public building and the situation is therefore quite different. As much as I dislike to do so, I am afraid we must ask you to substitute the face of some unknown man where Lenin's face now appears.

You know how enthusiastic I am about the work which you have been doing and that to date we have in no way restricted you in either subject or treatment. I am sure you will understand our feeling in this situation and we will greatly appreciate your making the suggested substitution.

## Letter to N. A. Rockefeller

A letter from Señor Rivera to Nelson A. Rockefeller, dated May 6, read as follows:

"In reply to your kind letter of May 4, 1933, I wish to tell you my actual feelings on the matters you raise, after I have given considerable reflection to them.

"The head of Lenin was included in the original sketch, now in the hands of Mr. Raymond Hood, and in the drawings in line made on the wall at the beginning of my work. Each time it appeared as a general and abstract representation of the concept of leader, an indispensable human figure. Now, I have merely changed the place in which the figure appears, giving it a less real physical place as if projected by a television apparatus. Moreover, I understand quite thoroughly the point of view concerning the business affairs of a commercial public building, although I am sure that that class of person who is capable of being offended by the portrait of a deceased great man would feel offended, given such a mentality, by the entire conception of my painting. Therefore, rather than mutilate the conception, I should prefer the physical destruction of the conception in its entirety, but conserving, at least, its integrity.

"In speaking of the integrity of the conception I do not refer only to the logical structure of the painting, but also to its plastic structure.

"I should like, as far as possible, to find an acceptable solution to the problem you raise, and suggest that I could change the sector which shows society people playing bridge and dancing and put in its place, in perfect balance with the Lenin portion, a figure of some great American historical leader, such as Lincoln, who symbolizes the unification of the country and the abolition of slavery, surrounded by John Brown, Nat Turner, William Lloyd Garrison or Wendell Phillips and Harriet Beecher Stowe, and perhaps some scientific figure like McCormick, inventor of the McCormick reaper, which aided in the victory of the anti-slavery forces by providing sufficient wheat to sustain the Northern armies.

"I am sure that the solution I propose will entirely clarify the historical meaning of the figure of a leader as represented by Lenin and Lincoln, and no one will be able to object to them without objection to the most fundamental feelings of human love and solidarity and the constructive social force representing

by such men. Also it will clarify the general meaning of the painting."

## Final Appeal to Artist

Señor Rivera received two letters yesterday from Hugh S. Robertson, president of the Todd, Robertson & Todd Engineering Corporation. The first letter, which reached the artist early in the day, was a final appeal to him to change the mural. In said in part:

"The description you gave us in November last of the subject matter of your 'proposed mural decorations' at Rockefeller Center, and the sketch which you presented to us about the same time, both led us to believe that your work would be purely imaginative. There was not the slightest intimation, either in the description or in the sketch, that you would include in the mural any portraits or any subject matter of a controversial nature.

"Under the circumstances we cannot but feel that you have taken advantage of the situation to do things which were never contemplated by either of us at the time our contract was made. We feel, therefore, that there should be no hesitation on your part to make such changes as are necessary to conform the mural to the understanding we had with you.

"The understanding was that slight coloring would be used, the bright colors have therefore provoked considerable discussion, but that is a matter we mention now only for your information."

After Señor Rivera had replied, refusing to make any concession, Mr. Robertson sent a final letter, which was not received by the artist until after he had been called from his scaffold. Enclosing the check for $14,000, the letter said that "much to our regrets," the agents had no alternative except to request Señor Rivera to discontinue his work.

## Dismissal of Rivera

A statement issued by Todd, Robertson & Todd, and Todd & Brown, Inc., managing agents of Rockefeller Center, follows:

"Rockefeller Center announced last October that murals by three foreign artists—José María Sert of Spain, Frank Brangwyn of England, and Diego Rivera of Mexico—would decorate the great hall in the RCA building. These three artists, the announcement continued, 'are joining hands to produce a unified decorative theme.'

"The murals of Sert have been completed and are now in place. The completion of Brangwyn's murals has been delayed by the artist's illness and will not reach the United States for some time. For several weeks Rivera has

been painting his fresco on the elevator bank at the eastern end of the great hall.

"Rivera's fresco has now reached the stage where it is clear that neither in general treatment, nor in detail, will it fit into the unified decorative theme planned for the great hall. In other words, irrespective of its merits as a painting, it is artistically and thematically incongruous. These facts were called to Mr. Rivera's attention and he was requested to make certain changes which would bring his fresco into harmony with the artistic and architectural conception of the great hall.

"This he was unwilling to do; consequently, Mr. Rivera has been paid his contract price and the fresco is no longer in public view."

## Rivera Admits Red Leanings

The shaggy-haired, huge-bodied painter, who only two months ago was engaged in a similar controversy in Detroit, where it was charged that murals he had just completed on the walls of the Detroit Institute of Arts were blasphemous, is not a member of the Communist party. He was expelled from the Mexican branch of the party several years ago, but he frankly admits that his sympathies are communistic.

In the Detroit controversy his paintings were accepted by Edsel Ford, their donor. Señor Rivera explained his viewpoint and his attitude at that time as follows:

"The official Communist party has expelled me from membership, and now the conservative element attacks me. However, my public is made up of workers—the manual and intellectual workers. The religious are attacking me because I am religious: I paint what I see."

Señor Rivera's assistants who were with him when he was ousted last night were Ben Shahn, Hideo Noda, a Japanese; Lou Bloch, Lucienne Bloch, Sánchez Flores and Arthur Niendorff.

Harvey Wiley Corbett and Raymond Hood, the architects who, with Reinhard & Hofmeister, have been entrusted with the design of the entire Rockefeller Center project, both said last night that they had not been informed of the disapproval of the mural.

Two previous disagreements on artistic conceptions for the great Rockefeller Center project have become known publicly in recent months. Robert Edmond Jones, one of the foremost American scenic designers, resigned as art director of Radio City, although he declined to discuss his reasons for his action.

S. L. Rothafel, better known as Roxy, barred two nude statues from the Radio City Music Hall before its opening last December, but so much interest developed in the works that they were restored to their original places in March. They were William Zorach's "Spirit of the Dance" and "Eva" by Mrs.

Gwen Lux. Robert Laurent's "Goose Girl," which was reported at first to have suffered official disapproval, never was removed from its position on the first mezzanine promenade.

## Brought Here by Museum

Señor Rivera came to New York from Mexico in the Fall of 1931 under the sponsorship of the Museum of Modern Art, of which Mrs. John D. Rockefeller Jr., one of the founders, is now treasurer, and with her son Nelson is a member of the board of trustees.

Although examples of Rivera's work were shown in the Eastern United States as long as ten years ago in one of the annual exhibitions of the Society of Independent Artists here, it remained for the Museum of Modern Art to bring him to New York and present his work retrospectively and extensively. The artist came to New York at the invitation of the museum, which provided a studio for him to paint a series of murals for the exhibition.

Those familiar with his revolutionary work saw an element of the bizarre in the situation, since John D. Rockefeller Sr. was one of the capitalists whom Rivera caricatured in what is perhaps his most famous series of murals in Mexico City, those in the Ministry of Education.

Last Winter the Museum of Modern Art issued an elaborate portfolio of reproductions of Rivera's frescoes in Mexico, and when Rivera's recently completed murals in the Detroit Institute of Arts were attacked by religious organizations of that city as communistic, the Museum of Modern Art here issued a statement supporting the Mexican artist.

Señor Rivera has explained here frequently his revolutionary beliefs. A short time after he began his murals at Rockefeller Center he delivered an address at the Rand School in which he expressed his revolutionary convictions and told of his belief that "art should be propaganda." In fact, he asserted that "art which is not propaganda is not art at all."

# Diego Rivera's Mural in the Palace of Fine Arts

**Rafael Ángel Herrerías**

From *Diego Rivera's Mural in Rockefeller Center,* 1990

Translated by Herrerías

*This is a fairly close description of one of Diego Rivera's most famous murals. After the original version at Rockefeller Center in New York City was rejected, Rivera executed a very similar mural in the Palace of Fine Arts in Mexico City.*

The composition and the theme of the mural which Rivera painted in the Palace of Fine Arts in Mexico City in 1934, is similar to the one he started to paint in March, 1933 at Rockefeller Center, and which he never finished. Because these events occurred in New York City, which was the largest publicity center in the world, news of Rivera's dismissal, and the destruction of his mural, traveled to all corners of the world, and the artist obtained more publicity than any artist had ever dreamed possible. The enormous amount of printed material which Irene Herner found buried in the "Morgues" and in the newspaper libraries of New York and Mexico City, is testimony to this fact.

We will not go into a description of what this work of art was, or was going to be, even though it must have influenced the painter tremendously, since he attempted to reproduce the destroyed mural in his own country. We feel that the work of a painter should be judged by way of a thematic and formal analysis of the finished work, not on proposals or intentions, because a real artist transmits his authentic feelings with every stroke of the brush; that is, following the theory that states that "creation is parallel to the process of creating the work of art."

Diego Rivera's mural in the Palace of Fine Arts in Mexico City, is not actually done on the wall of the Palace, but on a steel frame which measures 4.85 x 11.45 meters, and which is covered with wire and metal which sustains a mixture of cement, lime, sand, and marble dust, over which the fresco is painted. It is done this way to avoid that the fresco cracks or splits if the building should suddenly shake.

The composition of the mural is based on Renaissance sketches. We be-

lieve that the basic sketch of Rivera's mural was based on the composition of the Last Judgement by Michelangelo in the Sistine Chapel. The wall of the Sistine Chapel is divided into two overlapping spaces and a third space which depicts underground scenes. In the center of the upper space is the Supreme Judge surrounded by the figures of those to be judged. Included in this space is also the Garden of Eden with the men on the right and the women on the left. In the lower space, in the center, a group of angels play a fanfare; to the left the blessed rise and to the right the damned fall. In the third space, which is an underground scene, to the left, those who have resurrected depart and to the right the damned, struck by the oars, are taken from Caronte's ship and delivered to the gates of hell. Rivera divided his composition and placed his figures in a similar way, which is by contrasting themes. In the Last Judgement, the just or the blessed are on one side and the damned or condemned on the other; Rivera placed his figures in a way which follows this Manichean philosophy: the good on one side and the bad on the other; the Russian followers and the army; the bourgeois and the proletariat, etc.

The composition which Rivera took advantage of and combined in his singular and complicated structures, is divided into two spaces by way of overlapping levels, each one divided into different sections, drawn and balanced with geometric perfection. A third space is an underground scene.

The iconographic elements are represented by a large number of material and natural forms, the majority of which are used symbolically and with which the "sponge man," as Rivera called himself, filled all the parts of the mural, by way of drawings and colors made by a brush which was guided by a masterful and precise hand.

In the left part of the space, or upper level, an army moves forward; the soldiers wear gas masks and carry rifles with bayonets; other soldiers at the front shoot flame-throwers, and tanks and planes take part in this war. In the right section an orderly group of Russian men, women and children march toward the soldiers. The women's heads are covered with red scarves; groups of men carry red flags, and they are all singing, possibly "The International," the hymn of the proletariat.

In the lower space or level, two enormous lenses separate the left and right sections from the center section. In the center section, the main feature is two large ellipses which cross in front of the main figure in the composition—a blonde man dressed as a factory worker, wearing gloves; with one hand he moves a lever and the fingers of the other hand are on a control panel. There is an enormous hand in front of the factory worker, which is grasping a sphere in which there are many different instruments which could be used for measuring natural, social and technical phenomena. The device which is below the sphere could possibly be used to receive cosmic energy.

In the back part of the central figure, there are sections of an enormous piston, of a large dynamo and a huge wheel and axle. These elements appear

to be a symbolic synthesis which represents the most notable products of technology.

In the lower part of this symbolic figure, are many of the principal agricultural plants: sugar cane, a rubber tree, cotton, pineapple, wheat, barley, potatoes, corn, grapes, sugar beets, etc. The roots of all these plants are visible. There is also a spring of water and one of oil, and below this, the different layers of earth can be seen, in which there are many forms of raw materials and a few precious stones. A T-pipe carries a multi-colored liquid to the lowest layers of the earth.

To the left, between the ellipses, but within one of the segments, in the form of a lunette, from the stator of the dynamo, there is a group of people dressed in formal attire; in the front, four ladies are playing cards; in the back, some of the people are dancing; and, in the center, others are drinking champagne. J. D. Rockefeller is holding a glass and appears to be proposing a toast to the woman who is in front of him, while holding the hand, with a distasteful look on his face, of an unseen woman. It is important to point out the expressionless faces of all the figures, which the artist painted to show how a select group of the bourgeoisie from New York City amuses itself.

In the right-hand segment, there is a portrait of Lenin, who is surrounded by children, women and workers, whose hands he covers with his own; a soldier with an angry look on his face is observing this scene. In the vertex of this segment, a woman is nursing her baby, and both the woman and the baby are exposed to the effluvia of the dynamo. In these two segments, which are drawn in the shape of lunettes, Rivera has represented the classical "contrasts": the bourgeoisie and the proletariat, with their corresponding leaders.

The microscope which is placed over the ellipse in the upper left hand part indicates that the ellipse is covered with micro-organisms. In the vertex of the ellipse which penetrates the upper space, where the soldiers are armed with flame-throwers, there is a healthy human tongue, followed by another which is diseased. To the left are two spermatozoa, which possibly symbolize sexual inversion because of their different colors and the fact that they are going in opposite directions. Below the figure of a vagina, and to the right of the figure of the tongue, there are intracellular gonococci and pale spirochetes, which are directly related to venereal diseases. The rest of the space is filled with the germs which carry other diseases: bacillus of diphtheria, tuberculosis, typhoid, tetanus, etc., and other parasites. Rivera was explicit in stating that the proliferation of these diseases is a consequence of war. In the lower right-hand part of the ellipse there is a representation of menstruation and pregnancy.

In the other ellipse, the lower part is covered by the sun and moon, and the upper part, by the stars and nebulae as seen through a telescope.

In the far left section of the mural there is a statue of Aristotle. He is seated, and there is smoke coming out of his beard. His hands are mutilated

and he has a rosary with a cross around his neck. The philosophy of Aristotle, which is the basis of scholasticism, which is in turn the basis of the Christian religion of the Middle Ages, appears to be represented as decadent in this symbolic figure.

Under the statue, a man with a white beard rests one of his hands on the end of a large ruler, which a salamander is climbing up. A monkey is sitting with his tail hanging down the side of an aquarium which contains starfish, sea horses, ammonites and lower marine organisms. The monkey has the palm of his hand on the ruler and the other hand is in the hand of a small, nude child who is crawling near two dogs, a snake (which is underground) and a turtle, all of which are next to the aquarium. Besides the ruler a black boy with a parrot in his hand, is staring at a skull. Charles Darwin's theory of "Evolution by natural selection" appears to be represented here. But the man with the white beard is pointing at the parrot with his index finger while his thumb points to the fluorescent screen which shows the skull of the man behind it, and to the instrument which is placed over the cancerous breast of a woman lying on a table. The fact that the man is pointing to these things makes us relate it to "Social Darwinism."

To the right of this group of figures, a group of young people sitting in front of the lens is listening attentively to the man in front of them, who is standing besides the lens. Right beside the young people is a group of workers who are protesting in the streets of the banking center of New York. The names "Wall Street" and "2nd Avenue," which can be seen on the corner, identify the location of the protesters. They are carrying signs with messages, most of them referring to unemployment. Police on horseback, armed with clubs, hold back the crowds of protesters.

On the far right there is another statue of a seated figure, with the same proportions as the one on the opposite side. This battered statue has no head. It is holding a fascist symbol and a swastika between its legs. Two women aviators and one Russian aviator are sitting on the statue's head, which is on the floor. It is important to point out that this mural was completed before the beginning of World War II. The artist, therefore, foresaw the destruction of the Nazi-fascist dictatorships by Russian aviators.

A group of men, including Trotsky, Engels and Marx, who are standing below the statue, are holding a red flag with the following message in various languages: "Workers of the world unite in the IV International." Marx holds an open book in which the following can be read: "The liberation of the workers may only be the work of the laborers themselves." Below this group of men, three workers, sitting on a pipe and two women aviators and one Russian aviator, sitting on the head of the statue, are looking at the lens, to see what Trotsky is saying.

Behind the statue, in the left-hand segment, there is an uprising of workers, in which the soldiers are intervening. One sign, which stands out, says,

"Stop Farmers' Holiday." In the right-hand segment, a wounded woman is being carried. Between the lens and the segment where Lenin is portrayed, a group of young girls dressed in sportswear are running.

Diego Rivera, a man of his times, used a language which was very much his own, very personal, to express his conception of the cosmos and the ideal creation of his world. The composition is created according to themes, through the use of figures, some of which represent the painter's ideology, and others which go against his beliefs, placing them in some cases on a horizontal line and in other cases on a vertical line, following a simple Manichean philosophy.

All of the sections, segments or groups are in balance with each other: In the upper space which is skillfully created as a second level, the army in operation is in balance with the manifestation of the Russian laborers; the segment skillfully done as a lunette, which depicts the select bourgeois group, is in balance with the group surrounding Lenin; the statue of Aristotle is in balance with the statue which symbolizes the Nazi-fascist dictatorships. In all of these sections, the themes are carried out from the bottom to the top. In the first section, evolution will destroy decadent philosophies, and in the second section, Russian aviators will destroy the Nazi-fascist dictatorships. Technology is idealized, as can be seen by the dimensions and the location of the mechanical parts which form part of the symbolic grouping. The artist, through his art, has also achieved excellent aesthetic grouping.

It must be pointed out that the figures are all skillfully depicted on the mural; the forms and the multi-colored dyes are delicately contrasted and perfectly harmonious. Among the portraits that appear, the one which stands out is that of Lenin. The others are all descriptive portraits. There is unity in the composition, in the forms and in the themes. Each figure is clearly represented, as is its relationship to the other figures. All of the figures are placed around a central figure—the blonde man dressed as a laborer.

The ideal world of Rivera, materialistic, mechanist, will become a reality with the triumph of the laborers who follow the teachings of Lenin, Trotsky, Engels and Marx, and should be controlled through the interaction of man and technology. This man, also ideal, is symbolized by the figure of a worker, but not just any worker, who could have been represented in a more abstract way, without racial characteristics, but by a worker who has a light complexion and blonde hair (a Russian?). This worker is represented in this way to achieve the duality man-machine, as the generator, motor, principle and control of the universe and of life.

This mural, in which the balance of composition, form, colors and faces is carried out with severity, gives us a sensation of peace, of serenity, of something static, without movement, as if the force of energy has been cut off, leaving the man-machine duality inert, and the artist's dream limited to an extraordinarily beautiful mural.

# Orozco "Explains"

**José Clemente Orozco**

*Museum of Modern Art Bulletin,*
August 1940

*O rozco visited the Museum of Modern Art for ten days in 1940, where he exe-
cuted a portable mural in fresco titled* Dive Bomber and Tank. *The mural
consisted of six panels, each three feet by nine feet, which Orozco said could be
arranged in any order. The museum set him up in an open studio so that visitors
could watch him at work. While he was glad to get the commission, he did not enjoy
the public performance of painting. For example, he went to a banquet with the
MOMA trustees, and one of them asked him, "What are you doing here in New
York, Mr. Orozco?" He responded, "I am working as a clown in a circus." He did
not like explaining his art either, as this excerpt shows. The quotation marks around
the title word* explains *were put there at his insistence. (Boldface and capitalization
appear here as in the original.)*

The public wants explanations about a painting. What the artist had in
mind when he did it. What he was thinking of. What is the exact name of the
picture, and what the artist means by that. If he is glorifying or cursing. If he
believes in Democracy.

Going to the Italian Opera, you get a booklet with a full account of why Rigo-
letto kills Aida at the end of a wild party with La Bohème, Lucia di Lammer-
moor and Madame Butterfly. The Italian Renaissance is another marvelous
opera full of killings and wild parties, and the public gets also thousands of book-
lets with complete and most detailed information about everything and every-
body in Florence and Rome.

And now the public insists on knowing the plot of modern painted opera,
though not Italian, of course. They take for granted that every picture must
be the illustration of a short story or of a thesis and want to be told the enter-
taining biography and bright sayings of the leaders in the stage-picture, the
ups and downs of hero, villain, and chorus. Many pictures actually tell all that
and more even, including quotations from the Holy Scriptures and Shake-
speare. Others deal with social conditions, evils of the world, revolution, his-
tory and the like. Bedroom pictures with *la femme a sa toilette* are still very
frequent.

Suddenly, Madame Butterfly and her friend Rigoletto disappear from the stage-picture. Gone, too, are gloomy social conditions. To the amazement of the public the curtain goes up and nothing is on the stage but a few lines and cubes. The Abstract. The public protests and demands explanations, and explanations are given away freely and generously. Rigoletto and social conditions are still there but have become abstract, all dolled up in cubes and cones in a wild surrealist party with La Bohème, Lucia di Lammermoor and Madame Butterfly. Meanings? Names? Significance? Short stories? Well, let's invent them after-wards. The public refuses TO SEE painting. They want TO HEAR painting. They don't care for the show itself, they prefer TO LISTEN to the barker outside. Free lectures every hour for the blind, around the Museum. This way, please.

"The Artist must be sincere," they say. It is true. He must be sincere. The actor on the stage commits suicide to thrill or frighten the public to death. The actor feels exactly what a suicide feels, and acts the same way except that his gun is not loaded. He is sincere as an artist only. Next week he has to impersonate St. Francis, Lenin or an average business man, very sincerely! The technique of painting is still in its infancy after ten thousand years of civilization, or whatever it is. Even college children know this fact, for abundant literature about the subject is on hand.

It seems incredible that science and industry have not yet provided the artist with better materials to work with. Not a single improvement through centuries. The range of colors available is still extremely limited. Pigments are not permanent at all in spite of manufacturers' claims. Canvas, wood, paper, walls are exposed to continuous destruction from moisture, changes in temperature, chemical reactions, insects, and germs. Oils, varnishes, wax, gums, and tempera media are dirty substances darkening, changing, cracking, and disintegrating all the time.

Fresco painting is free from the inconveniences of oils and varnishes, but the wall upon which the painting is done is subjected to many causes of destruction, such as the use of the wrong kind of building materials, poor planning, moisture from the ground or from the air, earthquakes, dive bombing, tanking or battleshipping, excess of magnesia in the lime or the marble dust, lack of care resulting in scratches or peeling off, et cetera. So, fresco must be done only on walls that are as free as possible from all these inconveniences.

There is no rule for painting *al fresco*. Every artist may do as he pleases provided he paints as thinly as possible and only while the plaster is wet, six to eight hours from the moment it is applied. No retouching of any kind afterwards. Every artist develops his own way of planning his conception and transferring it onto the wet plaster. Every method is as good as the other. Or the artist may improvise without any previous sketches.

## "The Dive Bomber," or Six Interchangeable Panels

A painting is a **Poem** and nothing else. A poem made of relationships between forms as other kinds of poems are made of relationships between words, sounds or ideas. Sculpture and architecture are also relationships between forms. This word **forms** includes color, tone, proportion, line, et cetera.

The forms in a poem are necessarily organized in such a way that the whole acts as an automatic machine, more or less efficient but apt to function in a certain way, to move in a certain direction. Such a machine-motor sets in motion our senses, first; our emotional capacity, second; and our intellect, last. An efficient and well-organized machine may work in very different ways. It can be simplified to its last elementals or basic structure, or may be developed into a vast and complicated organism working under the same basic principles.

Each part of a machine may be by itself a machine to function independently from the whole. The order of the inter-relations between its parts may be altered, but those relationships may stay the same in any other order, and unexpected or expected possibilities may appear. Suppose we change the actual order of the plastic elements of the vaults in the Sistine Chapel. . . .

A linotype is a work of art, but a linotype in motion is an extraordinary adventure affecting the lives of many human beings or the course of history. A few lines from a linotype in action may start a World War, or may mean the birth of a new era.

# Francisco Goitia

## Tata Jesucristo

**Hayden Herrera**

From *Mexico: Splendors
of Thirty Centuries*, 1990

*This well-known painting depicts two women kneeling on the ground weeping at
a wake. This discussion of the circumstances of its creation indicates some of the
attitudes that influenced the Indigenist movement.*

When Goitia finished his ethnological drawings at Teotihuacán about 1925,
Manuel Gamio sent him to make studies of the Zapotec Indians in Oaxaca.
Before he left, Gamio asked him how much money he would need. Goitia
said that he required no more than what the Indians had to live on. "To paint
them well," he explained, "I must live with them so that they will have
confidence in me. I must be one of them, know their customs, analyze their
tastes, eat with them. In a word, be like them."[1] It was this attitude that led to
the frequent comparisons between Francisco Goitia and his namesake and
idol, St. Francis. When Goitia was teaching at the Academy of San Carlos in
Mexico City in 1929, the year Diego Rivera took over the school's director-
ship, Goitia told his students: "An artist who does not live his own work, who
does not realize its content, . . . who does not give life and feeling to the peo-
ple in his work, does not succeed in becoming an artist."[2]

In Oaxaca, Goitia painted his masterpiece, *Tata Jesucristo,* a painting of a
wake that so beautifully captures the sorrows of the Mexican people that it is,
in effect, a Mexican pietà. The canvas depicts two women dressed in white sit-
ting on the earth and mourning over a body that lies in front of them but out-
side the picture space. The woman on the left hides her grief with her huge
brown hands and her long hair. The woman on the right tries to stifle her wail
by holding her sleeves against her mouth in a gesture of extraordinary
poignancy To enhance the impact of the image, Goitia placed the mourners
close to the picture plane—the bare foot of the woman on the left seems al-
most to push against the canvas surface. And he made his own and the
viewer's vantage point identical with the spot where the dead person lies.
Thus we are drawn into the wake not only by empathy, but because we feel
the mourners weeping over us.

Also serving to bring the viewer into the scene are two yellow *cempoalxochitl* flowers (marigolds), which are strewn on the ground and cut off by the canvas edge. Between these blossoms (which since pre-Conquest times have been associated with ceremonies to the dead), a half-burned candle indicates that the women have been watching over the dead body for many hours. Tipped in its primitive clay candlestick, it accentuates the unbalanced feeling of grief. The flame casts a yellow glow on the women's white garments but does little to illuminate the room. The space behind and between the figures is filled with a thickened darkness that leaves no escape from despair.

The woman who bends forward, covering her face with her hair and hands, is a pared-down image of suffering that brings to mind the contemporaneous murals of José Clemente Orozco at the Escuela Nacional Preparatoria in Mexico City. Orozco is said to have been influenced by Goitia's painting *El Baile Revolucionario*, 1913, which depicts simplified figures of soldiers and *soldaderas* dancing. Often they are faceless, like Goitia's mourner in *Tata Jesucristo*. Both artists' use of expressive gesture and sparely articulated figures reveals their admiration for Giotto. A quite different source for Goitia's *Tata Jesucristo* is pre-Columbian art, which Goitia studied, drew and loved. With her squared-off shoulders and with the solid mass of her bent knees forming her base, the kneeling figure on the right resembles an Aztec idol. A third possible source for Goitia's mourning women is Kathe Kollwitz's images of suffering working-class women.

Goitia's empathy for his subject came from personal experience. During the Revolution, he recalled, he saw many women weeping over their lost men. Their grief reverberated throughout Mexico, and he heard it again and again.

When he arrived in Oaxaca, he found his way to a mountain town called San Andrés, where he decided to stay because he found a subject he wanted to draw, an Indian girl wearing beautiful clothes and carrying a machete across her shoulder. A hut was built for him and a woman hired to look after his cooking. "At about eleven at night . . . I would always hear the distant weeping of a woman. It was a bitter, sad crying. Every night it was the same, around eleven, and I never knew who wept. But this prepared for me the atmosphere I needed."[3] The town had a small, half-built chapel, where women wearing white huipils would go to pray and to tell of their sorrows to Christ. "From far away," Goitia remembered, "you could hear their cries and pleas. . . . They wailed and supplicated to Christ, calling him 'Tata Jesucristo! Fulfill our needs and pardon our sins.' From this, . . . my painting was born—from this chapel and these people."[4]

At the chapel Goitia met an old woman whom he associated with the cry of the unknown weeping woman. He asked her to pose for him, and she became the figure on the right. "She looked like a Prehispanic sculpture, a Pre-Columbian god," he later said. But he had difficulty painting her. "I wanted to

portray her crying: I already had my conception of the painting. And imagine the work it took to convince her to cry: she couldn't. I pleaded: cry . . . but she did not cry . . . I began to paint the rest of the body . . . leaving the face for later. Meanwhile, the month of November arrived. And on the second, the Day of the Dead, we were working as usual, when all of a sudden, perhaps because she remembered her dead ones . . . , she began to cry and could not stop. . . . I began to paint the face. And in something like ten minutes, I finished. . . . I did not touch the face again."[5]

During those ten minutes, the woman on the left began to cry as well. Writhing, she pushed her left foot forward, turning it up in a spasm of anguish: "Then I knew I had it!" Goitia recalled. "Those hands and feet gave their grief the genuine form. . . . They weep the tears of our race. . . . All the sorrow of Mexico is there."[6]

Those few moments of final, furious work were typical of Goitia's creative process. He often deliberated about the problems in his paintings for long periods of time, and then suddenly something in the motif would be altered and he would experience a kind of pictorial epiphany that enabled him to finish the work very quickly. While painting the women's faces, Goitia wrote, he felt almost "unaware of myself. I worked feverishly almost pathologically and I did in minutes what I had not done in months. And those minutes are the ones that have saved many of my works."[7]

Goitia spent six months in San Andrés, two researching and drawing for Gamio and four painting *Tata Jesucristo*. When the painting was completed, he recalled, "I felt great happiness, as if a huge weight had been taken off me, and at the same time a general bodily exhaustion. So I decided to rest. And that's what I did. I stopped working for four months."[8]

## Notes

1. Antonio Luna Arroyo, *Francisco Goitia Total* (Mexico City, 1987), 213.
2. Ibid., p. 226.
3. Ibid., p. 461.
4. Ibid., pp. 203, 461.
5. Ibid., pp. 461–62.
6. Anita Brenner, *Idols Behind Altars* (New York, 1929), 298.
7. Luna Arroyo, *Francisco Goitia Total*, p. 204.
8. Ibid.

# Los Tres Jircas
# (The Three Peaks)

**Enrique López Albújar**

From *Cuentos Andinos,*
2d ed., 1924

Translated by the editor

*T*his story shows the parallel interests of Indigenist painters and writers. Just as artists such as José Sabogal and Jorge Vinatea Reinoso of Peru elevated indigenous and mestizo lifeways in their paintings, so did López Albújar in stories such as this. "Los Tres Jircas" depicts the indigenous person as somewhat mysterious, a possessor of secret knowledge that is unavailable to outsiders. Unlike most Indigenist paintings, which frequently depict mestizo styles of architecture and dress, this story portrays indigenous people as if the conquest had never happened, preserving their traditional rituals and customs. Sabogal knew of and supported the writing of López Albújar, for he drew the cover for the book from which this story was taken.

*Marabamba, Rondos* and *Paucarbamba:* Three masses, three summits, three guardians who stand around the city of Caballeros de León in Huánuco: the three *jirca-yayag* (father mountains), as the Indians call them.

*Marabamba* has apparent geometric regularity, crowned by three peaks, the classical cone of geologic eruptions, its silhouette the least complicated, its simplicity affecting the other masses which live in perpetual desire for height. It is something like the triangular sail of a ship lost among the waves of this stony sea called the Andes.

Marabamba is sad and beautiful at the same time, with the beauty of giants and the sadness of solitary souls. On its granite slopes we do not see the green of plants, nor the white fleece of snow, nor the red of roof tiles, nor the smoke of the hearth. It is perpetually gray, with the melancholy gray of dead and abandoned mountains. By day, during the hours of sunlight, it unleashes all the pride of its wildness; it shakes, reverberates, encloses, and crackles. The ghost of isolation strolls along its slopes. In the moonlit nights, its sadness grows until it is reflected in the soul of the observer, causing him to dwell on the tragic silence of things. It seems predestined to never feel the knowing

claw of the plow, nor the fertilizing plasma of the stream, nor the germination of the benevolent seed. It is one of so many useless things that nature has placed before humanity in order to defeat his pride and test his intelligence. But who knows if Marabamba is really useless; who knows if in its innards dwells some metal that the insatiable greed of humanity will change tomorrow into coins, rails, machines, or instruments of life or of death.

*Rondos* stands for disorder, confusion, tumult, a gathering of blind and brute force which hates order, rectitude, and symmetry. It is the cresting of a rabid wave of fury, condemned forever to never know the release of the wave that breaks on the beach. Rather, Rondos is movement, life, hope, love, richness. Streams run and split in its wrinkled, sinuous, and deep folds, all the while humming their crystalline and monotonous songs amid the cliffs and rocks. The streams break down with grinding force all obstacles as they shoot toward the valley as waves of mud on stormy days, milling enormous rocks as they let out a terrified gallop like a passel of maddened elephants.

Rondos appears to be one of those artificial and fanciful hills that spring from the imagination of the faithful in Christian homes at Yuletide. There you see clear, babbling waterfalls and patches of great wheat sprigs; sheep that wander leisurely among the hills; shepherdesses who spin the wool yarn like a bracelet about their wrists; caves topped with ferns that forever weep pure diamantine, transparent tears; bulls who sharpen their horns on the rocks and purge their impatience with guttural mooing; steers who tug resigned and teary-eyed, slowly and pensively, marching as if weighed down by nostalgia for their lost potency; goats who leap indifferently over the peak of a high escarpment; trees bent low by the weight of succulent, delicious fruit; cornfields that resemble rows of Indians in feathered caps; cacti like hydrae, like octopi, like snakes. And in the middle of it all, the human presence, forever human, represented by red and white houses, which smoke by day and glow by night, like candles floating on a sea of ink. And there is even a decrepit old church, which the inclemencies of the weather and the neglect of the Indians tainted by incredulity combine to urge inexorably toward collapse: dilapidation that the waters of time will soon dissolve.

*Paucarbamba* is unlike Marabamba and unlike Rondos, probably because it was unable to resemble the latter and had no desire to imitate the former. Paucarbamba is a harsh, aggressive, and turbulent peak, formed as if in a fit of arrogance. It takes on devilish shapes, threatening moods, with rock formations that threaten to crush anything that lives, great shattering earthquakes, creases that conceal dangerous abysses, and summits that jut into the sky. From time to time it turns green and flowers, trickling its clear blood onto the plain. It is the sharpest, steepest, and most austere peak. If Marabamba seems a seated giant, and Rondos a reclining giant with crossed arms, Paucarbamba is a standing one, scowling and threatening. We might say that Marabamba thinks, Rondos sleeps, and Paucarbamba stands watch.

These three colossi surround the town, all equidistant, defending and threatening it at the same time. When cloudy weather tries to come down the valley on cold gray days, the three attract, caress, and entertain it with mysterious gestures. Later, with the invisible hands forged by daydreams, they turn the clouds into robes, necklaces, and crowns. The three peaks spur and encourage the fury of the winds up the slopes, just as they warm the biting and betraying winds from the summit, and as the storms loose their pack of thunderbolts, the peaks bend the flashes of lightning toward the heights.

They are a threat as well; today, tomorrow, and forever. They threaten convulsion, destruction, and disaster. Because who can say that they will not tomorrow continue their march? The mountains are resting caravans, paused evolutions, restrained tantrums, arrested birth pains. Yesterday's plain is today's mountain, and today's mountain will tomorrow be the valley or the abyss.

This is to be expected. Marabamba, Rondos, and Paucarbamba are still geologically young. Sometimes they murmur, sometimes a tumult of hushed voices seems to want to escape and say something to humanity. And these voices are not the silvery ones of their veins of metal, but voices from the deep, from the hollows, from telluric gestations, from forces that seek eternal rest through violent outburst.

Therefore, one afternoon when I was seated atop Paucarbamba, nostalgically contemplating the plain before me, as the sun was setting beyond the peak of Rondos, I stood up aroused by the shaking of a temblor. Pillco, the oldest, most astute, most superstitious, most rebellious, in a word, the most Inca of the Llicua, said to me with a certain grave fear:

"*Jirca-yayag* wild. *Jirca-yayag* hungry, sir."

"Who is *Jirca-yayag?*"

"Paucarbamba, sir. Father Paucarbamba wants lamb, pineapple, cookies, and sweets."

"Ah, so Paucarbamba eats as people do, and he has a sweet tooth like children! And he wants cookies and sweets?"

"*Au* [yes], sir. If he goes a long time without eating, Paucarbamba *piñashcaican*. When he eats, *cushiscaican.*"

"I don't understand you, Pillco."

"*Piñashcaican*, bad mood. *Cushiscaican*, happy, sir."

"But Pillco, do you really think that the mountains are like people?"

"*Au*, sir. *Jircas* eat. *Jircas* speak. *Jircas* are gods. By day they are silent, they think, they muse, or they sleep. By night they walk about. Pillco not look at *jircas* at night; cause harm. Cloudy nights, *jircas* walk more, eat more, speak more, sir. They gather and converse. If I told you, sir, why *jircas* Rondo, Paucarbamba, and Marabamba exist . . .

# II

And here is what he told me, the oldest, most astute, most superstitious, most rebellious of Llicua, only after forcing me to follow him around for several days, to offer him money which he loftily disdained, to give him many fistfuls of coca leaves, and to promise on the souls of all the *jircas* of the Andes, to keep the secret, so that the legend would not suffer the profanations of the white person's language, nor the implacable anger of the *jircas* Paucarbamba, Rondos, and Marabamba. "Above all," he told me mysteriously, "do not tell Paucarbamba. I live below him, sir." And he continued:

*Maray* [Rock], *Runtus* [Gray-head], and *Padúcar* [Flower] were three warriors who came from three faraway regions: Padúcar came from the jungle; Runtus from the sea, and Maray from the mountains. Of the three, Padúcar was the youngest and Runtus the oldest. The three were about to meet in battle one day, attracted by one power: love. *Pillco-Rumi* [Red Stone], a chief of the Pillco tribe, had a girl, that is to say an *orcoma,* after having fifty sons, and he never had any more children. The new child thus became the object of all his affections, all his pride, and his love was such that as she grew up he thought her more worthy for Pachacamac than for any mortal. She was born so fresh, so exuberant, and so beautiful that he immediately called her *Cori-Huayta* [Golden Blossom]. And Cori-Huayta was the pride of all the chiefs of the tribe, the quarry of all the men, the dream of all the priests, the happiness of Pillco-Rumi, and the pleasure of Pachacamac. When she went out on her litter to gather flowers and grain for the feast of *Raymi,* followed by her maids and servants, people stuck their heads out of their doors to see her pass by, and the gentlemen stopped their commotion and watched spellbound, to later remain mute and jealous for several days.

Pillco-Rumi knew of these things and he also knew, according to the laws of chieftainship, that his daughter had to be given in marriage to some man. If sterility was considered a curse among the Pillcos, voluntary chastity was considered a sign of pride which had to be put down, on pain of being sacrificed to the gods. And the law of the Pillcos dictated that the men should contract matrimony at the age of twenty, women at eighteen. Pillco-Rumi was not in agreement with the law. Pillco-Rumi rebelled inwardly against it and began to hate the law and think of ways to avoid complying with it. From his standpoint, Cori-Huayta was above the law. The law never stated that when a father had an *orcoma* that he had to marry her off. When one has several daughters, all could be given in marriage except the one which he held back to care for him in his old age. And when there is only one daughter, such as Cori-Huayta, thought Pillco-Rumi, no man alive has the right to take her.

Besides being a loving parent, Pillco-Rumi was a resolute and purposeful man. He swore before his father the Sun that Cori-Huayta would not be given to any man, but rather to Pachacamac.

# III

The day came when Pillco-Rumi had to celebrate in the town square the betrothal of all the young people that came of age that year.

The night before, Pillco-Rumi had called to his palace *Racucunca* [Thick-Neck], the high priest, and *Karu-Ricag* [Far-Sighted Mind], the wisest of the *amautas* [wise men], to consult with him on how to avoid complying with the matrimonial laws.

The *amauta* said, "For a chief, wisdom lies in complying with the law. He who complies most fully is the wisest, and also the best father to his children."

The high priest, who preferred not to speak first, said, "There are only two ways to avoid compliance: sacrifice Cori-Huayta or dedicate her to the service of our father the Sun."

Pillco-Rumi quickly objected, "Cori-Huayta turns eighteen tomorrow. She has passed the age at which she can be dedicated to the service of Pacha-camac."

Racucunca replied, "For our Father, all maidens are equal. They must only be youthful."

And the high priest, who for years had restlessly desired to commit various sacrileges with Cori-Huayta, seemed to read Pillco-Rumi's mind. He said, "There is no man in your realm who is worthy of Cori-Huayta."

The *amauta,* who in turn knew the thoughts of Racucunca, stated solemnly, "Beauty is fleeting; it is worth much less than bravery or wisdom. A brave and wise young man could make Cori-Huayta happy."

In the face of such sententious language, which for Racucunca was a reproach and for Pillco-Rumi a warning, the former replied, hiding his true feelings, "Tomorrow at the hour of the sacrifices I will consult the innards of the llama."

And while Racucunca, frowning and solemn, left by one door, and Karu-Ricag, grave and calm, left through another, Pillco-Rumi, his heart crushed by anguish and hope, remained meditating on his predicament.

On the afternoon of the fateful day, a happy mood was spreading about the city, and in the square the hearts of the suitors were distilling the pure honeyed happiness of their hopes. The warriors, crowned with plumes of tropical birds, came with their compact squads brandishing their shiny-pointed spears, balancing their bows, waving their heavy clubs, scraping swords and arrows, shouldering their slingshots and waving their motley flags; and the chanters, stationed at the three corners of the plaza, sang their tenderest erotic songs to the sound of the strident copper gongs. And the future brides, dressed in red, crowned with flowers, their necks embraced with collars of herbs and coins of gold, wrapped in floating white robes, turned slowly, hand in hand, around the great stone of sacrifice. And Cori-Huayta, ignorant of her fate, waited for the hour of the nuptials. Pillco-Rumi, stand-

ing at his western tower, arms crossed over his chest, his curved and energetic nose flared and throbbing, his mouth contracted into a clench of gravity and resolution, and his forehead surrounded by the invisible terrain of somber thought, as the sun reddened his face like the questioning of destiny, made this prayer, a mixture of impiety and panegyric:

"What is a man against Pachacamac? Would you not, Father Sun, blind with your own eyes the eyes of any who would attempt to contemplate the enchantment of Cori-Huayta? Can you never forget the law of the wise, of the priests, of the gentlemen? I wish for Cori-Huayta to be the joy of my old age; I want in the mornings, as you come and bathe with the gold of your loving rays the humility of my temple, that Cori-Huayta would be the first to bathe in them. But far from the gaze of the men charged in your service, because this would awaken in them the irresistible desire to possess her. Lord, Cori-Huayta is worthy only of you. Free her from the desires of men!"

And Pillco-Rumi, calmer after his prayer, turning his face toward the multitude that surged and clamored ever louder, looked down on them with an indefinable glance of scorn. And he looked over at Racucunca, who at that moment held a huge concave mirror of burnished gold which gathered enough rays of the sun to ignite a snowy ball of cotton, which would light the holy fire of the sacrifices, as he raised his massive fist, spat in the air and from the arc of his mouth leapt out like a poisoned arrow these words: "Cori-Huayta will not be yours, traitor. I also, like Karu-Ricag, saw your thoughts. First I will kill Cori-Huayta."

But *Supay,* the bad spirit who always goes about troubling any tranquil waters and any happiness just for the fun of seeing them churned and turbulent, began to stir up the general festive mood. The songs and clangs of copper suddenly died away, the dances stopped, the *amautas* stood up embarrassed, the maidens trembled, the concave mirror which lit the sacred fire fell out of the high priest's right hand, and the crowd broke into an immense cry that wrung the heart of Cori-Huayta, just as she pointed to several points on the horizon, shouting, "Enemies! Enemies! They are coming for our maidens. Where is Pillco-Rumi? Defend us, Pillco-Rumi! Defend us, Pachacamac!

Three enormous columns of dust as high as the heavens appeared at three points on the horizon, and they advanced and advanced. Soon the word circulated: They were *Maray,* from the Pasco tribe; *Runtus,* from the Huaylas, and *Páucar,* from the Panataguas, the most ferocious and warlike of all. Each had announced his arrival to Pillco-Rumi on the first day of the equinox, intending to fight for the hand of Cori-Huayta. Pillco-Rumi had ignored these warnings, confident of his power and misled by the predictions of his soothsayers.

The three arrived, followed by their armies. They had marched for many days, crossing chasms, battling storms, cutting down forests, tramping down plains. And the three arrived at the same moment, determined to yield to nothing and nobody. Runtus, as he marched thought thus: "My age has made

me wise. Wisdom has beautified my face and given me the skill to put down youth in the struggle for love." Maray: "Strength will seduce and overpower the weak. Women are weak, and they love strength." And Páucar: "Youth can accomplish anything; it can triumph over both wisdom and strength."

Then Pillco-Rumi, who had seen from the tower of his palace the three plumes of dust as high as heaven appear on the horizon from the armies of Runtus, Páucar, and Maray, understanding why they had come, in a shudder of supreme desperation exclaimed, praying anew to Pachacamac: "Father Sun, Pillco-Rumi speaks to you for the last time. Burn the city, flood the valley, or kill Cori-Huayta before the horrible duty falls on me."

In the face of this prayer from deep in Pillco-Rumi's heart, Pachacamac, from his place at the top of the rainbow, had been watching disdainfully the intrigues of Supay as he attempted to create a conflict that would bloody the earth. Pachacamac took up a mountain of snow and threw it at the feet of Páucar, who was just then entering the city. The snow became a mighty river that forced Páucar to stop. He next threw another white mountain in the path of Maray with the same result, and Maray also stopped. Since Runtus was the least impetuous and was the furthest behind, Pachacamac only threw a strong gust of wind at him. Next Pachacamac fixed his gaze on each of the three warriors and changed them and their armies into giant mountains. Still not satisfied with his deeds, he next looked upon Cori-Huayta, who had run frightened to her father's side, and looking lovingly at her, he shouted, "*Huáñucuy* [Die]!" And Cori-Huayta, more beautiful, spirited, and seductive than ever, collapsed in the arms of Pillco-Rumi.

Faced with this cataclysm, the tribe of the Pillcos was terrorized and fled. They established themselves in another region, where they founded another city called Huáñucuy, or Huánuco, in memory of the great imperious shout that they had heard from the mouth of Pachacamac.

And ever since, Runtus, Páucar, and Maray remain just where the wrath of Pachacamac stopped them. They wait for his anger to ease, so that the Huallaga and Higueras Rivers return to their snow-covered peaks, and the daughter of Pillco-Rumi returns as the golden blossom of the great spring valley of the Pillcos.

# Latin America Faces the Quincentenary

## An Interview with Oswaldo Guayasamín

**Fred Murphy**

From *Latin American Perspectives*, summer 1992

Translated by Fred Murphy

*T*his is an interview with one of the continent's leading Social Realist painters on the occasion of the quincentenary of the landing of Columbus. The Ecuadorian artist expresses some basic beliefs of Indigenism here: distrust of the conquerors, upholding of preconquest cultures, and hopes for reunification of the continent.

Interviewer: What position should Latin American intellectuals take toward the Quincentenary?

Oswaldo Guayasamín: I think any talk of celebrations is really mistaken. How can we celebrate an event that was, at its own historic moment, so terrible and damaging for all our great pre-Columbian cultures? The humiliation, the slaughter of millions of Indians who were the owners of this continent makes this clear.

I: Some people are talking about the "encounter of two worlds" . . .

OG: Yes, but that's all just phraseology to justify the disastrous events for the continent.

I: What would be the proper term for it?

OG: I haven't thought about that, but the point is that America is fortunately now reacting in a powerful fashion. I have news from Mexico, Central America, Argentina, Bolivia, and Peru about persons who are working intensely to see that this event is not celebrated.

I: Isn't such a critical, emancipatory position going to cause problems for the official celebrations headed by Spain?

OG: It could cause difficulties. Here in Ecuador, for example—several years ago I made an immense statue of Rumiñahui, a hand-embossed bronze sculpture 8 meters high. We're now making the

columns that will be placed behind this figure, columns nearly 20 meters high and covered with bronze, and a movable sun. Rumiñahui is one of the greatest heroes of the pre-Columbian epoch; he defended the land, America's land, and carried on a fierce resistance from Cajamarca to Quito. For Latin America, Rumiñahui is one of the most important figures, and we're trying to inaugurate this monument in 1992. The idea of the Ministry of Education and Culture is to invite groups from all over the continent, from each country—dance troupes, music groups—not to celebrate but to protest, to integrate America, to realize once more the memory of what America was before the Spaniards arrived.

I: Do you think there is still any possibility of integrating America in the spirit of Bolívar's great vision—"América, la patria Grande"—or do you think that moment is gone forever?

OG: I think there was a moment more important than Bolívar's: Tahuantinsuyo, the immense empire that covered nearly all of South America. Bolívar's idea came later and involved the five countries of the southern part of the continent. But all of these antecedents are important. Above all, the idea of Tahuantinsuyo could be revived as a form of Latin American integration.

I: In your paintings, you nearly always present a certain tragic, dramatic, sad vision of Latin America. Is that the face of our identity?

OG: What I paint is not just linked to Latin America. The Age of Anger, [a series of works] which includes some 250 paintings, expresses all the tragedies of this century—the concentration camps, World War II, the Spanish Civil War, the atomic bombs—but it also includes events in Latin America—the dictatorships of the Southern Conc, of Argentina, the one in Chile, the one in Uruguay. I am of course very much concerned with expressing these things as a rejection of all the violence that the incalculable forces of money have created in this world.

I: If you were to try to define Latin American identity, how would you do it?

OG: The basic idea for me is to begin slowly doing away with borders. I know that's quite a difficult thing, but at least reducing their importance ought to be the first step we take toward the integration of Latin America. We all know about the partition that occurred in America at Independence: this continent was cut into pieces, as if they were the private property of the independence figures of the time. Ecuador's border with Peru, with Colombia; Bolivia's border with Colombia—this is all badly done. We have the same cultural identity, but we are cut up.

We followed the example of Europe, where borders were truly necessary—say, between Spain and France, between France and Germany, entire peoples with different languages, different conceptions of the world. Nonetheless, there they have practically done away with their borders.

We, who have had a cultural unity for 8,000 years from the Rio Bravo to Patagonia, remain divided. We speak the same language, we have the same religion from top to bottom, our aspirations as a continent, our poverty—that whole identity is cut in pieces. For me, the first step is to try to reduce the importance of borders and hope that someday they may disappear.

I: Do you think that brotherhood really exists among the Latin American peoples?

OG: With the borders in place, they teach us from childhood on to hate those on the other side, but that is a new and superficial lesson compared with teaching us to love our neighbors. It's virtually the same throughout the continent—Colombians and Venezuelans, Ecuadorians and Peruvians, Peruvians and Chileans—in the end, everyone has some artificially provoked grievance, and the armies of Latin America bear much of the blame for this disunity.

I: What sectors do you think make up the vanguard in building identity?

OG: I think there is much goodwill in Peru, and also in Bolivia and Ecuador—indeed, throughout the continent, because the unity arising between Brazil, Uruguay, and Argentina is a marvelous example of cooperation, for the moment commercial, but let us hope that it will become spiritual as well. In Ecuador, Peru, Bolivia, Colombia, and Venezuela, unity isn't working because interests created since the empire prevent it from developing. But now one begins to believe that the unity of Latin America is absolutely indispensable.

I: What is the role of art in the creation of, or the search for Latin American identity?

OG: Being concerned with our own problems dates back to the early days of this century, with the advent of the great Mexican painters—Orozco, Rivera, Siqueiros—who were the first to concern themselves with Latin American realities. I think that while their styles were quite basic in plastic terms, there is now a continental movement with different expressions appropriate to our continent; there are numerous creators of art not only in painting but also in music: Villa-Lobos in Brazil, for example—all his great compositions are deeply linked to his people. The same can be said of Ginastera in Argentina and of the Mexicans who are involved in music, literature, and architecture. The great literary figures of our continent are being read and translated into nearly all the languages of the globe.

# 3. Fantasy and Surrealism in the Mid-Twentieth Century

# Haitian Art . . .
# How It Started

**DeWitt Peters**

From L. G. Hoffman, *Haitian Art: The Legend and Legacy of the Naïve Tradition,* 1985

*The founder of the Centre d'Art in Haiti here recounts its founding and early years. The author claims perhaps too much by hinting in the title that art began in Haiti with his endeavor, because there certainly was art being made in Haiti at that time. But there is no doubt that Peters's efforts helped to bring about a rebirth of painting in that country.*

When, in February of 1943, I found myself flying into Port-au-Prince over the desolate but poetic and beautiful mountains of Haiti, probably the thought furthest from my mind was that of founding an art center. A painter, and my father a painter before me, I had been sent down by United States Federal Security as one of a mixed group to teach English to Haitians. This was something new to me and I approached the matter very earnestly, working at the government Lycée [High School] at Port-au-Prince until the end of the term in July. Now began the long summer vacation, and in the evenings I used to sit on the balcony of my hotel and watch the city below me and the marvelous formations of clouds along the tops of the mountains across the great bay. It was sometime during these ruminative sessions that the idea of starting an art center occurred to me. There had never been one in Haiti except for a short-lived *Ecole des Beaux Arts* started under President Geffrard in the mid-nineteenth century; indeed, as far as I could see there was no art in Haiti. And this seemed to me extraordinary in a country of very great natural beauty, with a clarity of atmosphere comparable to that of southern Italy, inhabited by a charming people rich in folklore and tradition. At about this time it was my good fortune to meet a number of young Haitian intellectuals and with these I discussed my idea. Most of them had recently returned from sojourns and studies abroad and thus possessed the wider vision and understanding of the traveled person. They were all enthusiastic.

But of course it took much more than our collective enthusiasm to make the project a reality. To facilitate getting down into town from my hotel on

the hill, I acquired a bicycle and could be seen every day pedaling through town calling on first this person and then that. Quite by accident one day I happened to pass a large private house in the center of the city with an expensive but neglected garden in front. The street gates were padlocked and a soldier stood on guard. As I peered through this gate I thought to myself that this would be the perfect location, but I was far from sanguine about the chances of getting it. Time was beginning to pass with nothing definite realized, and I had been consulting with the Cultural Attaché of the United States Embassy about the various problems we were encountering, particularly that of finding a suitable locale. About this time he had arranged a most important rendezvous for us—an interview with the then President of Haiti, Elie Lescot. The President, a man of great personal charm and one personally interested in art, showed immediate interest in the project. When the question of the locale came up I mentioned the house I had seen. I will never forget the thrill and relief I felt when he lifted the phone on his desk, called his secretary, and commanded him to secure the building for us. We were finally getting somewhere. The next day an appointment to see the building was made and the great padlock on the front door opened. The place was in an indescribable state of neglect, but at a glance we could see that the disposition and dimensions of the rooms would suit us perfectly. Furthermore, the Government had accepted to pay the rent on the building. This was the first of a series of generous gestures on the part of the Lescot government and on that of subsequent regimes which have continued to this day.

With the small group of more or less amateur Haitian painters and a few newcomers we opened, on May 14th, 1944, the first comprehensive group show of Haitian painting ever organized in the Capital. The President came with his entourage and the climax was reached when, with a good-humored flourish, he cut the red and blue silk ribbons which were stretched across the main entry and entered, followed by a huge and eager crowd. Interest ran high and we were quite astonished at the rapidity with which pictures sold, for a record total of $550 the first day. After this initial success we settled down, of course, to the hard work of organizing classes, holding them, maintaining and improving the building and, really, learning the business of running an art center. However, no really serious mistakes were made and our membership increased steadily. Financially we ran in the red for a number of months until the Haitian government increased the monthly subvention to $200, which was shortly thereafter equaled by the United States Department of State. Since that time the budget for running the institution has never exceeded $400 per month.

About six months after we opened, an apparently unimportant event took place; a painting was sent in to us from Philomé Obin, an artist working in the northern part of Haiti. It was a peculiar picture, depicting in childish perspective but meticulous craftsmanship the arrival of Franklin Roosevelt in

Cap Haitien to lift the American occupation of Haiti. [The United States Marines controlled Haiti from 1915 to 1934.] But the sending to us of this picture was the opening gun of what subsequently and rapidly developed into one of the most extraordinary artistic phenomena of modern times—the discovery of the Haitian primitives. At the time we received the painting, I was not at all interested in primitive art. However, and by a fortunate chance, we bought the picture (for $5 worth of art materials and $5 cash!) and wrote an encouraging letter to the artist. His grateful reply was an immediate clue to the integrity of the man who, it appeared, had painted all his life in spite of the mockery of most of his neighbors, and whose two ambitions had always been to be the historian of his country in paint and a teacher of painting to the young. With remarkable fidelity he has been able to realize both ambitions.

In Haiti news spreads by word of mouth with a rapidity which exceeds the telegraph. It cannot be said precisely that this was the force back of the next "discovery," but not long after the receipt of the painting by Obin, a young man came in with a crude earthenware vase delicately decorated with roses; he said this had been painted by another person and that he was merely asked to bring it in to see if we would buy it. We did, and by another happy chance gave the man a piece of cardboard and asked him to get the decorator of the vase to paint a picture on it. He took the cardboard and vanished, reappearing with the painting some time later, after we had quite forgotten him. It represented a bridge over a stream with some ducks swimming and a charming suggestion of a Haitian landscape with palm trees. We asked him the price of the picture and, after a little hesitation, he took the plunge and said $2. In a moment of what can only be called inspiration we gave him $4. Plus several much larger pieces of cardboard and a friendly pat on the back which he was to transmit to the artist whom we had not yet met. Within a space of some weeks he was back, but this time with four extraordinary strange and poetic pictures—an unbelievable advance over the first. In our enthusiasm we now insisted that he must bring the artist in immediately. It now appeared that there was not one artist but two; we said bring them both in. Doubtfully, he said he would try and went off down the stairs. In about ten minutes he was back, but without the artists. Where were they? They didn't exist. He himself was the artist of all the pictures, but he had been too doubtful and timid to admit it. Rigaud Benoit is now recognized as one of the most delicate and charming of all the Haitian popular painters, with an impressive great mural to his credit in the Episcopalian Cathedral in Port-au-Prince.

There was now about to appear from the miserable starvation and obscurity of his middle years the greatest of Haitian primitive painters, Hector Hyppolite. But the story of his emergence is different. Once, the year before, as the truck on which I was returning from a visit to Obin in the Cape, careened through a country village of Mont-Rouis, I caught, out of the corner of my eye, the gaily painted doors of a small bar. There was no time for any

details and, in later years, I have thought that it was a miracle I saw them at all; was there some latent and powerful force in those simple designs which hypnotized? In any case, on my return to Port-au-Prince I far from forgot them and when, some time later on, my good friend Phillipe Thoby-Marcelin, most distinguished of Haitian novelists, was going to pass through Mont-Rouls on his way to St. Marc, I asked him to try and locate the artist. When Phito returned he said he had been able to find him. He was, he told me, a strange, mystic person with a head of great dignity and beauty, a voodoo priest. He had painted the doors many years before and then had made the mistake of settling in the small provincial town of St. Marc as a house painter. There he had virtually starved for over fifteen years, doing occasional paintings with left-over house paint, using chicken feathers for brushes. Immediately Phito and I, accompanied by Ira and Edita Morris, the novelists, who were then in Haiti, traveled on the picturesque little narrow-gauge train which follows the lovely coastline to St. Marc. We were going to meet Hyppolite.

When we finally found the miserable hut he lived in with his young mistress and two little orphan girls he had adopted, we were told that he was not in. Languidly, from the pallet on which she lay and which protruded from the single window of the shack, the young and starving woman told us she did not know where he had gone. But at this moment I saw him—unmistakably—far away down the street and coming toward us. As he approached we noticed indeed the nobility of his carriage and the serene and luminous expression of his face. His jet black hair with its innumerable small waves was parted in the middle and worn long to the shoulders. As he came up to us we rose. Greeting us with a poised and ceremonial curtsy he told us our visit was no surprise. He had known of it long before from a vision he had had in a dream. Later on we were to have many other examples of this visionary second sight. Soon, with a new lease on life and encouraged by sales which we were beginning to make for him, Hyppolite left St. Marc forever, moving himself and his small family to Port-au-Prince. And now began that period of great creative activity; he worked constantly. Always a rapid and passionate painter, he moved through phase after phase, periodically bringing in to us all of his production. Not a pure primitive painter in the sense that Obin is with his meticulousness and infinite preoccupation with detail, Hyppolite is a much bolder, freer and more poetic artist. His finest work, executed just before his tragic death from a heart attack in 1948, is characterized by an imagination and a boldness and richness of design and color rarely equaled in contemporary painting. The celebrated French critic André Breton, originator [sic] of the Surrealist movement in art, was so moved by it that he is reported as having said that if Hyppolite were known to the young contemporary painters of France he could, single-handedly, change the whole course of painting in that country.

For reasons of economy I had moved out of the small house I had rented in the hills and was living in one of the upstairs rooms of the *Centre*. The young man I had employed as houseboy in the country was now the house-boy in the *Centre*, Castera Bazile. Fascinated by the creative activity of young painters coming in and out, bringing in their work, painting etc., it was not long before he approached me and asked if he, too, could try his hand at painting. I told him he might but that he must finish his housework first. His first painting, which is now in my possession, was a delight; it was a scene of a religious procession in the country, full of light and color and charming naiveté. Bazile has for long now been a painter only and his three impressive murals in the Episcopalian Cathedral mark him as the most naturally talented muralist of all the Haitian popular painters. Tall, calm, religious, with a beau-tifully expressive face, Bazile has made the transition from servant to artist with all the dignity of the world.

Just as the celebrated murals in the Cathedral are the culmination of the work of the Haitian popular painters working as a group, the recently com-pleted *Earthly Paradise* by twenty-two-year-old Wilson Bigaud is the summit of individual realization by a Haitian painter. This now famous canvas, 36 by 48 inches, took five and a half months to complete. It is the first Haitian painting ever to be invited to be shown at the great Carnegie International Exhibition to be held this Fall in Pittsburgh and San Francisco. To date two major museums have wished to purchase it as well as innumerable private col-lectors. But the painting is being reserved for the Carnegie, the most impor-tant international exhibition of painting held in the United States. Young Bi-gaud, a protégé of Hyppolite, is the most objective of all the Haitian popular painters and the only one who can tell you precisely how he achieves his mar-velous effects of luminous color and plastic depth. In spite of his great success he remains quite unspoiled and continues to live with his pretty young *placée* wife and their two children in his minute one-room house in a slum section of Port-au-Prince.

We have gone with some detail into the stories of five of the leading artists of the current art movement in Haiti; there are at least twenty-five other artists who stand out. Amongst these are Toussaint Auguste, Fernand Pierre, Adam Leontus, Préfete Duffaut, Gesner Abelard, Dieudonne Cedor, Enguer-rand Gourgue, Louverture Poisson, Seneque Obin (brother of Philomé), and amongst the "advanced" or non-primitive artists, Maurice Borno, Luce Turnier (leading woman painter of Haiti), Pierre Monosiet, Max Pinchinat, Roland Dorcely, Luckner Lazard, Lucien Price etc. Antonio Joseph should be cited especially, for not only is he a brilliant watercolorist but his murals at the hotel Ibo Lele are outstanding amongst the murals executed by artists of the modern, or advanced group.

What is the future of art in Haiti? After nearly nine years it is clearly evi-dent that Haitians are strongly individualistic and almost all of the artists are

evolving along their own individual paths. A few amongst the popular painters have retrogressed due, ironically enough, to the fact that they have had a little more formal education than their comrades. Easel painting is well established, mural painting very vigorous; ceramics were introduced at the *Centre* last Winter by the distinguished American ceramist Edith Weyland, and interesting results have been achieved. The technique of clay modeling, first taught at the *Centre* by the young American sculptor Jason Seley, continues to have a few devotees amongst whom may be cited Hilda Williams, Antonio Joseph, Jasmin Joseph. The latter is unique as he is an illiterate former worker in a brick factory and is thus one of the few primitive clay sculptors. I have been told by experts in the field that some of his work is reminiscent of that of the sculptors of the Han Dynasty, approximately two thousand years ago. On the whole, wood sculpture is not progressing; the craftsmanship is excellent but the taste of the artists has for the most part been channeled for the tourist trade. There is one exception, André Dimanche, an agricultural worker in the South. He alone is inspired by the natural form of the trunks of trees; his work is baroque but with a strange power. Four of the leading artists of Haiti, Luce Turnier, Max Pinchinat, Luckner Lazard and Roland Dorcely, are now in Paris working. It well may be that when they return modern painting in Haiti will have a new impulse and a new vitality. But on the whole Haiti may be proud of what her artists, starting from scratch, have achieved in less than a decade.

# A Visit with Hector Hyppolite

**Selden Rodman**

From *Renaissance in Haiti*, 1948

*H*ector Hyppolite was one of the most important Haitian painters affiliated
*with the Centre d'Art. Both Wifredo Lam and André Breton bought works
from him when they passed through Haiti in 1943. Breton also arranged an exhibi-
tion for him in Paris in 1947, because, he said, Hyppolite's work would "revolution-
ize European painting. And it needs a revolution." This article comes from a book
by one of the major promoters of Haitian art. Hence the prose is somewhat effusive,
but Hyppolite's work tended to arouse such enthusiasm.*

Visitors to the shack of Hyppolite—they come almost every day, and from
every part of the world—approach the district, known with some justice as
*"Trou de Cochon"* [Pig's trail], on foot along the track of a narrow-gauge sugar
railway. Threading their way toward the waterfront through a labyrinth of
jerry-built shacks alive with busy, chattering people, they come upon the en-
trance to the painter's palm-thatched home.

If Hyppolite is not at work they will probably find him standing in the
doorway, surveying the crowded scene with his sweet but tired smile. He will
be clad, as likely as not, in striped pajamas or in a purple bathrobe bearing the
gold-embroidered insignia of the United States Navy on its pocket; his feet
encased in a pair of gilded sandals; his wiry hair, parted in the middle, shaved
around the ears, and then flaring sidewise untrimmed—with somewhat the
effect of a dusty, magnetized crown. He is very black, but his features seem more
Indian than African—the nose aquiline, the cheekbones high and sharp, the
mouth rather compressed. Only his eyes, shifting between expressions of pa-
tient benevolence and remote concentration, reflect the anonymous decades
of wandering that preceded the artist's three years of fame.

In the spacious *tonnelle* [attached shed used for ceremonies], open to the
alley, Hyppolite sleeps, paints and holds infrequent *Vodun* ceremonies. The
floor is dirt. The roof is loosely woven wood and palm thatch. Rafters are dec-
orated with cut-out paper stars, balls of tinsel and ragged, uneven strips of
red, white and brown confetti or tissue paper. Paintings, finished and un-
finished, line the walls and crowd the tables. In the corner is a great cross,
dedicated to Baron Samedi and flanked with offerings of food and wine. Fac-
ing the doorway is a double-bed covered with mosquito netting.

The back of the house, separated from the *tonnelle* with strips of banana-bark and covered with a tin roof, contains a chamber in which Hyppolite's three servants will generally be found cooking, and the *houmfor* [Vodun altar] itself. The altar is piled high with painted calabashes, votive lights, rum bottles, fetishes, amulets and cheap prints of the Catholic saints, in the exact center of which stands a small, framed, academic portrait on glass, of the artist himself. To one side hang Hyppolite's ceremonial robes and flags, to the other, on a chair and under gauze, are two dressed-up puppets representing the spirit-figure of the sea, flanked by a golden crown heavily encrusted with cut-glass jewels, and the detached headlamp of an abandoned car.

Tall, almost emaciated, Hyppolite in the doorway will indicate with the gesture of a Hebrew prophet that further mysteries lie beyond. He opens the back "door" to a clamor of sawing and hammering; on stilts and blocks stands the unfinished hull of a large sailing vessel. The ribs are fashioned of gnarled saplings, incredibly held together with cord, but the longitudinal strakes are of well-seasoned lumber, nicely fitted. With a sweep of his hand that takes in the ship, the shipwrights and the diminishing piles of pitch and nails, Hyppolite offers the opinion that Peters is only now beginning to understand that this grandiose project, far from detracting from his painting, will provide the security and spiritual well-being by which his art will rise to heights undreamed of. "Maîtresse La Sirène," he says, [referring to a Vodun water goddess] "went to my friends and told them it wasn't true my imagination would suffer. Then they believed me and gave me the money. So now I am building my boat and my imagination is better than ever. The colors have suddenly become more lively."

To Edith Efron Bogat of Port-au-Prince, Hyppolite confided the details of his relationship with the Water Goddess:

"I'm married, you know, to my protective spirit, so I can't marry anyone else. When I was a child, my grandfather, a great priest of Vodun, married me to La Sirène, and she has always been my mystic wife. But I have three mistresses. That's not very many. Usually I have seven. But lately I've been getting disgusted with women. They're always getting into trouble. So I have only three now. They live well together. They're not jealous. Why should they be? It's a great advantage to them to be my mistresses, after all. . . . They eat regularly, sleep regularly, and I'm an expert in love matters. So altogether they have little to complain about. I have several children outside, but they're all grown up now; they're big and they're ambitious and they're just waiting for me to die so they can inherit from me. But my new baby—ah, she's different. I shall bring her up in my own way. Her name signifies love. So when she's a grown woman and a man calls her by her name, he will be saying to her: You are my love."

Hyppolite went on to say that while his painting changed in accordance

with the changes in his view of life, and that he could be sad one day and gay another, he invariably painted three hours in the morning.

"I'm always in the mood to paint. It's because of Saint John the Baptist. He inspires me. He's always with me, always stimulating me. I finish about two pictures a week. I used to paint on cardboard with Sapolin house paint, but now I mix in real oils and I work on celotex, plywood, masonite, all sorts of things. I've painted ever since I can recall. And I've always been inspired. Both La Sirène and Saint John take care of me. La Sirène helps me to earn money and Saint John gives me the ideas for my painting.

"I haven't practiced vodun for a while," he went on. "I asked the spirits permission to suspend my work as a *houngan,* because of my painting. Also you know, there are so many false priests around today that it saddens me. The spirits agreed that I should stop for a while. I've always been a priest, just like my father and grandfather, but now I'm more an artist than a priest. When people ask me now what I am, I say that I am an artist."

In the course of a typical working day, Hyppolite will rise at six, wander into the Centre d'Art—"to pay my respects to Mr. Peters"—and paint steadily from nine o'clock to noon. Afternoons he is apt to take in a movie at the Rex Theater in the Champ de Mars with Rigaud Benoit, his inseparable companion. "I like all kinds of movies," he says, "American, French, Spanish . . . as long as they're about love. Love pictures inspire me. Love is very important to an artist. You know the way one caresses a beautiful young girl? That's the way I caress a painting."

# A World Created by Magic

## Excerpts from a Conversation with André Pierre

**Edited by Donald Cosentino**

From *Sacred Arts of Haitian Vodou*, 1995

Translated by Donald Cosentino

*A*ndré Pierre is one of the most important Haitian artists. Here he discusses the Vodou religion, which is the most important source for his imagery.

The Vodou religion is before all other religions. It is more ancient than Christ. It is the first religion of the Earth. It is the creation of the World. The World is created by Vodou. The world is created by magic. The first magician is God who created people with his own hands from the dust of the Earth. People originated by magic in all countries of the world. No one lives of the flesh. Everyone lives of the spirit.

People who are not aware of this are not profound in their studies. They write and they read, but their study is not profound. It is not sufficient to read from a book. You must study nature. You must study people. You must study your neighbors. You must study that all is dust, and will return to dust. You must study that people possess nothing. One should eat well. Drink well. Sleep well. Enjoy your soul. Wait for the last day.

My life is very simple. I've been alone since I was five. I have no father. No mother, no grandfather nor grandmother. I have been the master of my personality since the age of fourteen. I am the protector of my life: Me, God, the Spirits and the Dead.

I paint to show the entire world what the Vodou religion is. Because three fourths of the terrestrial globe thinks that the Vodou religion is diabolical, I paint to show them that Vodou is not diabolical.

The Vodou religion is purely Catholic, apostolic, but not Roman. It is not directed by men. It is directed uniquely by God. Since all people are liars, no one is a Catholic. Only God and his spirits are Catholic. The spirits of Vodou are the limbs of God. God is the body and the spirits are the limbs. To use Vodou, you must be an honest man. One who likes his neighbor. Because it is your neighbor who is God. You receive nothing from God. You receive everything from your neighbor. God passes everything through the hands of your neighbor. If you do not know your neighbor, do not put your faith in your God who loves you. To love God, you must pass through your neighbor.

Love, love. Those who do not love are nothing. Love of God. Love of neighbor. Love of work. Love for doing some good. When we have to do something, love of doing it well. You must not judge anyone. One does not know. For God told you, "You will not see me, but you will see the poor always with you." When they come to your home to ask for charity have the courtesy to say, "I have nothing this morning. Pass by in a few days and I will leave something for you." But don't ignore them. Don't deceive them. Why not love the poor? Why do you not have the poor live with you? It is only Vodou which welcomes the poor.

Vodou allows you to walk with your head held high. Religion makes you walk with your head low. But with Vodou you can fight any war. All men are warriors. But with religion, No. Men are slaves. It is always, Yes, Yes. You don't have the right to say anything but "Yes" to everything they tell you. Slaves of slaves. You don't have a personality. But with Vodou, you keep your personality: "I want," or "I don't want." But in religion, there is neither "I want," nor "I don't want." That's what personality is: The return of the Guinea spirits.

After Haiti's independence, in 1804, they returned, guided by the Star of the Messiah. Guided by the Star, and the Cross of Christ, Judah's tribe, the roots of David. Ogou returned with a red and blue flag. And the woman saint brought the Kongo packet. Ogou took away the white, and left a bi-color. He changed the country. He took the white away from the French flag. He said, "I am giving this land back to you, and I am coming home."

> I am going with my big horse behind me
> The river brought me and will take me back
> Two feet and two arms led my horse
> My bags are packed and tied
> And my flag is deployed
> My bongo is on my back
> Forward, riflemen!

Before I paint, I take this canvas and I put it on the easel. I wait for an inspiration, before describing it on earth. Then an inspiration comes. I sing a song, and then I describe what I sang. I describe the song on the canvas.

Hell is on earth. Paradise is on Earth. Purgatory is on Earth. All is on earth. Nothing is in the sky. Nothing was made in the sky. No one needs to speak of the sky. Instead of talking about the sky, talk instead of the earth. God has said, "If you don't believe me when I tell you about terrestrial things, how will you believe when I tell you about celestial things?" God does nothing in the celestial. Even to create the sun and the moon he put his foot on earth, all was created on Earth.

For me, the mother of the terrestrial is the Virgin Mary. Honor the saints. Honor the relics of the Saints. But honor the holy Virgin more than the angels and the saints. The Virgin Mary is Ezili Danto. Not Freda, for she is the mother of pain, going up to Calvary. The mother of suffering. Freda is Elizabeth. The Mother of John the Baptist. John the Baptist is the Word. The Breath which comes out of the mouth of God. All the saints are *lwa*. St. John the Baptist is Ti-Jean Petwo, called "Bacalou Baka." I am married to Ezili Danto. I sleep at her altar on Tuesdays:

> Ezili Danto, lend me the chick of your black hen
> I am going to make my magic work
> It is you who walks
> It is you who sees
> Ezili Danto, lend me the chick of your black hen

I have confidence in the spirits. I love the spirits. I live with the spirits. I respect the spirits. I do what I want with the spirits, and they do what they want with me. Because they have confidence that I will never betray them. That is why I have confidence in the spirits.

# Frida Kahlo's Bus Accident

### Martha Zamora

From *Frida Kahlo: The Brush of Anguish,* 1990

Translated by Marilyn S. Smith

*Frida Kahlo's life was decisively shaped by an accident that she suffered at the age of eighteen. The subject of much myth and legend, it is here recounted by a reliable source.*

On September 17, 1925, Frida and Alejandro [Gómez Arias] spent the afternoon wandering among the colorful street stalls set up for Mexican National Day celebrations. On boarding a train to return to Coyoacán, Frida discovered that she had lost a little toy parasol Alejandro had just bought for her. They retraced their steps, and when it couldn't be found, they bought a *balero,* a cup-and-ball.

A bus happened by, a brightly painted new one with two long benches along the sides. Frida and Alejandro felt lucky to catch it. The driver, rushing to cross the busy city on the way out of town, boldly tried to pass in front of a turning streetcar. He didn't succeed: the heavy streetcar moved forward and collided with the bus, pushing relentlessly into its side and pressing against the benches where the passengers sat.

Gómez Arias still marvels at the elasticity of the vehicle, remembering that he felt his knees pressing against those of the person sitting across from him, just before the bus shattered to pieces. He regained consciousness underneath the streetcar, with the darkness of the metal chassis above him and a terrible fear that it would continue moving and mangle him. When he was able to sit up, he noticed that the front of his coat had somehow disappeared. He set out to find Frida.

At the moment of the accident, Frida was more concerned about the loss of her new toy, which had flown out of her hand, than she was with the seriousness of the collision. Alejandro found her bathed in blood, without her clothes, virtually impaled on the rod of a metal handrail. A bag carried by a passenger had spilled gold powder all over, and Frida's bloodied body was sprinkled with it. Curious onlookers cried, "help for the little ballerina!"

An overall-clad worker, whom Alejandro thought he recognized as an em-

ployee of the Prep. School, looked at Frida and said, "That has to be taken out of her." With no more ado he pulled the metal rod out of Frida's body to the terrible sound of breaking bones. Alejandro, horrified, carried her to a pool hall across the street, put her on a table, and covered her with the shreds of his ruined coat. They waited for an ambulance as Frida screamed in pain.

The wounded victims were taken to a nearby Red Cross hospital and divided into two groups: those who would receive immediate medical attention and those who, because of their grave condition, were considered beyond help. Frida was placed in the second group, and only after the shaken Alejandro pleaded with doctors, begging them to help, did they attend her.

A description of the wounds Frida suffered in the accident was compiled by her doctor in a clinical history years later: "Fracture of the third and fourth lumbar vertebrae; pelvic fractures; fracture of the right foot; dislocation of the left elbow; deep abdominal wound produced by a metal rod entering through the left hip and exiting through the genitals. Acute peritonitis; cystitis with drainage for several days." In other versions Frida added injuries, such as fractures of a cervical vertebra and two ribs, eleven fractures in the right leg, and dislocation of the left shoulder.

Frida always maintained that the metal rod pierced her uterus and emerged through her vagina. "[That's when] I lost my virginity," she said. Gómez Arias says that "the wound was much higher up and hit the pelvic bone; the invention of the point of exit was to hide other things." She would also identify the accident as the cause of her inability to bear children, but it was only one of her many explanations for that condition.

Frida told Alejandro, "In this hospital, death dances around my bed at night." But Frida's youth and characteristic vitality pulled her through. She was able to return home after a month, although she was almost completely immobilized by splints protecting her various fractures. Friends from school visited her frequently at first, but the long distance to her home in Coyoacán eventually discouraged regular visits; she began to feel out of touch. Although her health might have allowed it, Frida never resumed her studies.

While confined to bed, Frida began to paint, using a small lap easel her mother had ordered for her. Overhead, in the canopy of her bed, she positioned a mirror so she could use her reflection as a subject, an arrangement signaling the beginning of her focus on self-portraits. As she recovered and was up and around more, Frida also intermittently painted larger pictures, posing friends, relatives, and children as well as herself.

# Leonora Carrington

**Marie-Pierre Colle**

From *Latin American Artists
in Their Studios*, 1994

*T*his artist left her native England in 1937 and landed in Mexico in 1942, where
she has lived ever since. Often associated with the Surrealist movement, her re-
lationship to her adopted country is of perhaps greater interest. Here she discusses
this and other issues.

"The only person present at my birth was our dear faithful old fox
terrier, Boozy and an x-ray machine for sterilizing cows."
—*Leonora Carrington*

When I left for Leonora Carrington's studio in Tlalpan, in Mexico City's
southern section, I anticipated seeing unicorns jumping out of windows,
erotic winged beings, and paintings hanging from the walls, all enveloped in a
hyena's odor.

I found a house that was not *The House of Fear*, but only a small house in a
row of houses. Nor did a horse try to open the door with his left hoof, the
tiles on the roof were not gold finish, and there were no turquoise inlays on
the floors. In the queen's bathroom, sponges did not swim in a tub of goat's
milk. One doesn't enter through passageways painted like marble, with Greek
bas reliefs and ceilings à la Medici. In the kitchen the cabbages were not fight-
ing. Leonora, woman-child, was not watering the rug's knitted flowers.

Instead of a robe made of bats, the woman of fantasy received me in a long
skirt as blue as the intense look in her eyes. Her skin and English coloring, her
curly hair in a bun, and her antique pendants, gave her the demeanor of a
queen. At seventy-six Leonora is a handsome woman full of energy. Her
hands are those of a woman of strength, one who has made an epic out of her
life, crossing this land of shadows and anxiety. Her painting and her books
find their identity in the perplexity of a world of real things, in the animals
and the flora of dreams. She explores the form with which the mind provokes
the outside world, probing the causality of time, the nature of spirit, magic,
and enchantment.

But at the same time, she is a lady who is apparently frail and devoid of the
security that objects can give to one's life. I don't see any pictures, souvenirs,

porcelain cups, cushions, or rugs; no pets. Her friends say that her homes were always like garages; that instead of a tablecloth she uses newspapers, and prefers candles to electric light.

Leonora has been living in this house for only a few months. Furniture is sparse. She sits on a serape-covered sofa. When I ask her if she is happy living here she answers, "Sometimes I am and sometimes I'm not, but it is not the house's fault." For Carrington, her house is her study, her refuge, and her hell, all three things, and maybe something more. Her frank voice is full of candor, she speaks slowly, selecting her words. With a strong British accent she goes from English to Spanish without difficulty. She is very determined when she talks about the power and capabilities of women.

In 1942, prompted by war, Leonora came to stay in that Mexico which André Breton called "the surrealist country par excellence." Since then, she has been a muse, a heroine, and the link between the European world with all its fantasy and the Mexican world with all its magic. With her work she has created a language in which European words conjugate in a syntax molded by the occult tongue of Mexico. "I am a Mexican painter, I paint in Mexico, I am a naturalized Mexican. But I was born in England, I am half Irish and half English. This is the base, this is what I am. Of course I have absorbed a lot from Mexico, although it doesn't mean I know Mexico. It is a mysterious country. Here I feel more at home than any other place. After all, I have lived here for fifty years."

Leonora Carrington was born in Lancashire, of a prosperous family. Her mother was Irish; her British father was an entrepreneur in the textile industry. She always painted. From the beginning, they tried to discourage her. They told her it was a profession only for homosexuals and criminals, an activity that didn't accord with the good manners and style of the upper class.

In 1937 in London, Leonora attended the Ozenfant Academy. "What I needed was technique. I didn't want ideas. Each one of us has those. Technique, however, is something that is learned. That is why I went about acquiring the recipes for painting. For me it was very important." There she met Max Ernst, who was giving a conference, and followed the artist to Paris, and then to the south of France. She found the way to express her own world without the influence of others. Carrington won recognition as a writer as well as a painter.

With the Nazi invasion, Leonora took refuge in Andorra, then in Madrid, ending up in Santander, in a psychiatric clinic. The doctors found her more inspired than crazy, only weakened by the pressures of the war, and they released her. She fled to Portugal, where Leduc offered to marry her as a way to escape. The marriage did not last more than two years, but it allowed her to get to Mexico. Later she married the Hungarian photographer Emerico "Chiki" Weisz. They had two children, Pablo and Gabriel.

The war made other intellectuals seek refuge in Mexico. Benjamin Péret,

Pierre Mabile, and Remedios Varo were among them, and here Leonora found friendship. When asked if she found in the magical life of Mexico a resonance with her own life and work, she answers, "The Mexican tradition of magic and witchcraft are fascinating, but they are not the same as mine, do you understand? I think every country has a magical tradition, but our approach to the unknown is peculiar to our ancestry. It is something that has to do with birth, your blood, flesh, and bones."

Leonora Carrington was touched by the fantastic Celtic myths heard in her infancy. I ask her to talk about the beings and animals that inhabit her work. "They are creatures that surface from that so called space-mind, in an atmosphere that belongs to them. I don't know really where they live or where they come from, but they have nothing to do with nightmares." Does she see the creatures she paints as phantoms or real beings? "Real beings, of course," she says. When Leonora starts working, she concentrates on ridding herself of the images that have blinded her mind.

"We have a human soul, but also that of an animal. The Mayans say there is an animal soul, and that which belongs to Chac, the god of rain, and another that belongs to the sun. I have always loved animals and if I don't have one now, it's because I travel a lot and there is no one to take care of them. Animals suffer from loneliness; and this includes human animals."

> *How do you fight against loneliness?*
> "Against it? What I try to do is to understand it. You can't accept
> something you don't understand. When I say *understand*, I mean
> to understand with my whole being, with the vital centers that
> we have, sensations and emotions. I have many ideas on the sub-
> ject. I don't like loneliness."
> *Is death present in the subjects you paint?*
> "Of course. Death is always present; since the moment you came in,
> Marie-Pierre, an hour ago, we are both closer to death."
> *But I feel livelier for being with you.*
> "Thank you, but who knows if death is less lively than certain ways
> of life?"
> *Are you afraid of death?*
> "Yes, very much so."

I ask Leonora about her connections to surrealism. "First of all you would have to define what you mean by surrealism. Are we talking about a surrealist group or of surrealism as a movement, as a philosophy? The group emerged spontaneously, by the consensus of talent at a given moment." Edward James, the English philanthropist and writer, and patron of surrealists, said, "Of all the artists I have ever met and known, Leonora has crossed more frontiers and passed over more mountain ranges than any other."

About her work, he comments: "Leonora's paintings are not merely

painted. They are brewed. They sometimes seem to have materialized in a cauldron at the strike of midnight, yet for all this they are no mere illustrations of fairy tales. Hers are not literary paintings, rather they are pictures distilled in the underground caves of libido, vertiginously sublimated. Above all (or below) they belong to the universal subconscious." Leonora confirms: "I don't know how much is mine or from which part of me it surges."

For me, Leonora's images are an alchemy to refine mystery. Like the work of lamas and shamans, their task is to decipher and illuminate. In a world where the dominant culture displaces such knowledge, her work takes us to that place where everything is possible, where logic has been put to sleep.

In the simplicity of her home, and absence of objects, Leonora centers her life around ideas, books, and her search for truth. She shows me her current reading, *The Tao of Physics,* which demonstrates the correlation between Hinduism, Tao, Zen, and the latest scientific discoveries about the cosmos and the subatomic universe.

*Do you feel your work is cosmic?*

Leonora pauses and regards me. She lights a cigarette. "Everything is cosmic. I don't know why people think that earth is not a celestial world. You are cosmic, this table, my hand, the door, and if we see painting from a subatomic point of view, it is also a cosmos."

Leonora gets up and goes for a portfolio of drawings from the last twenty years. We look at them on the round dining room table. "Sometimes I draw during the day, sometimes at night," she says. After a long look, I ask her to show me her recent painting. "Marie-Pierre, don't look at them here," she says. "Go see them at the gallery."

*Leonora, tell me about the different periods in your work.*
"I have not looked in that way at the things that I've done; certain paintings have a specific tendency, they correspond to a particular place, a certain psychic state."
*What do you mean by that?*
"Just what I said. I cannot explain what I mean, you have to understand it and I think you can.

Moments later, Leonora wants to share something very personal, a token of accord between us. Retrieving a wrapped object from her bedroom, she descends the staircase, and with great care she unwraps from a piece of white linen fabric, a doll of dark cloth that she had sewn and embroidered by hand. "It is something I do when I am in search of peace." The doll's chest is a small mirror and the torso is embroidered with nine radiating points of bright thread. The embroidered spine of the doll seemed to represent a twig, a root. The back of the head holds a mirror, also.

"The doll represents the virgin," Leonora says. "She has two faces. She
    lives alone.
They will come, or will not come. At times they abandon me."
*Who?*
"The beings."
*Do you consider that your paintings could be children's stories, Leonora?*
"Yes and no," she answers. "It depends on the children."
*I see in your work a great freedom, a great coherence.*
"Freedom? I change the definition of freedom all the time. Coher-
    ence? To be coherent you are supposed to know and I do not.
    But it is like your individuality, your fingerprints; we all have
    fingerprints, but we are all different."

I feel happy to have been touched by her truth, a truth which is reinvented
every day. I leave the woman with the bat robe under her threshold which is
covered with climbing raspberries. Beneath a star-studded sky, you hear a
crow caw and see the smile of light blue eyes through the fog.

# Two Theories of Contemporary Mexican Painting

**Marta Traba**

*Prisma* (Bogotá, Colombia), January 1957

Translated by the editor

*T*his article sets out the artistic and philosophical differences between Diego Rivera and Rufino Tamayo, both of whom were still alive when it was written. While much information is given about both sides of the debate, Traba favored Tamayo's side.

When in 1920 Cabinet Minister José Vasconcelos offered to let Diego Rivera decorate the Ministry of Education building with frescoes (three hundred square meters), then began a new order in mural painting that has had worldwide resonance . This innovation put forth not only a new aesthetic, but also a new purpose for art. This aesthetic projected a gigantic and overwhelming protagonist: the people. The muralist project had a clear and explicit socio-political intent. The public remained dazzled by the power of this movement, which carried along multitudes who admired its boldness and political goals. The demonstration of pure brute power and moral boldness that came from the gigantic frescoes of Rivera astonished the Americas, but it also seems to have affected everyone's balance of judgment.

Since 1920, the fame of the muralists has remained as established as any slogan. Whether or not one knew the actual works of these Mexicans, this impact appeared as an impressive unfolding of a new art form, and even now it is considered one of the most extraordinary that Latin America has produced. Yet, at thirty-three years' distance, it should not seem irreverent to analyze its attitudes and results. . . .

About a month ago, two of Mexico's greatest artists, Diego Rivera and Rufino Tamayo, gave interviews in the press. One was published in Bogotá and one in Mexico City. This confrontation proves highly interesting if we wish to get to know the state of today's Mexican painting, and to evaluate the

progress of the last thirty years. I have extracted the principal themes that each interview took up, in an effort to set their views in contrast.

Rivera said that the gigantic figures and dimensions in his murals are intended to *converse* with the people (to whom he must apparently speak in a loud voice), and he explains that the success of the mural movement can be counted "among the millions of human beings who already live under socialist systems, or are rapidly heading in that direction."

Rufino Tamayo declares that the majority of people, who are called "el pueblo" and for whom the murals are intended, have never seen them, because they are in public buildings to which they have no access. He also says that "the important thing, in order to be in contact with the people, is to make works that can situate themselves in homes, and which are easy to acquire, such as prints, lithographs, and the like."

When Rivera counts among his millions of admirers those who live under a Communist system, he of course rejects any notion of aesthetic pleasure, since aesthetics cannot really ally itself with either politics or economics; thus Rivera has changed the category "art" into something purely didactic. If art exists in order to transmit a predetermined teaching, it has already lost the ability to provoke aesthetic feelings; it limits itself only to the teaching. Therefore, according to Rivera's own statements, those who admire his works will never feel such aesthetic feelings; communication will come only between those who give or accept the teaching.

Regarding Tamayo's statement that popular art should get to the people through their homes, he seems to be driven more by the common belief that art should be for the people, not from any conviction of his own. It does not seem that Tamayo creates in order for people to buy, no matter how low his works are priced, because his complex and fantastic works give pleasure only to those of refined education and those who have followed and understand the revolutionary alternatives of the Modern spirit.

Rivera: "The current tendency in our art and in that of Eastern Europe is toward Realism, in all the forms it may take. In decadent Europe (that is, non-Communist), their abstract movement is only the creation of works that will not ruin the digestion of the upper and middle classes."

Tamayo: "I protest against those who say two things: First, that art has to be realistic, particularly in the sense of 'descriptive' which is most often used. Second, I energetically protest against the view that would make of Realism the principal characteristic of all Mexican art. I don't understand how, in a country like ours which is so rich in visual traditions, not only in terms of sheer amount of production but in terms of the limitless variety of pre-Columbian styles, how they can pretend in the name of patriotism to say that art must be realistic, and thereby reduce Mexican art to such a narrow framework."

It is clear that the Realism of our century, now as at other times, is the only

style that can be easily put at the service of some political cause and to elevate, with lots of details, the spectacle of a fruitful economic future. The disdain that Rivera feels for abstract art comes from the fact that only abstract art is truly free, and comes from an individual artistic will. It is paradoxical that he believes that abstract art does not "ruin the digestion of the upper classes," when in reality the situation is exactly the opposite. Those classes are quite far from approving of abstract art, which demands an aesthetic education that they still lack. Even though it seems a cruel irony, they hang in their kitchens works of the most realist and naturalist type. . . . Tamayo's statement undercuts all of Rivera's belief in a nonexistent Mexican Realist style; there seems no better proof of this than pre-Columbian art, with its limitless imagination and tremendous fantasy.

With regard to "Mexicanism," Rivera claims that his painting is based on the root philosophy of Historical Materialism of Marx, Engels, and Lenin, adapted, of course, to local Mexican realities. This, then, is painting that comes not from aesthetics but from philosophy, economics, and politics. . . . Thus he has put his art at the service of things other than art. Such a shackling of the spirit of the individual is a fearful prospect, because it naturally leads to frustration. Tamayo seems to understand this clearly when he says, "Speaking of patriotism, the most natural thing would be to leave our artists as free as possible, since freedom is a characteristic of Mexican art that predates all of us." It is ridiculous to think that patriotism can be textually transcribed or attached to some specific philosophical position. From all of this battle of categories and ideas, art alone emerges intact, since it is one of the purest emanations of the human spirit.

Says Rivera: "The true revolutionary message of Mexican mural painting is in the content more than the form of the works, although the latter is not lacking in interest, and the form is the natural result of the content. Mexican mural painting liberated itself from servitude to Modernist intellectualizing aestheticisms which, however enchanting they may seem, originated in Paris."

Tamayo: "Culture must aspire to a universal feeling. This issue interests me wherever it is found on the earth, and I believe that culture is the result of the experience of all peoples worldwide. . . . Therefore, when I speak of painting, I insist on striving for universal value."

Recognizing that the true value of Mexican mural painting lies more in the content than in the form, Rivera continues to insist on the value of content or meaning over form; this is what Bernard Berenson calls "mere illustration." Moreover, this domination of content over form has never been the source of great art. Looking at Giotto's paintings of the life of St. Francis, we don't admire the stories that the works tell; rather we see how Giotto transcended mere storytelling through compelling form and composition, to go beyond the mere illustration and arrive at humanistic greatness. Likewise, it does not matter to us that Masaccio has told for the hundredth time the story of Adam

and Eve Expelled from Paradise; rather we admire the new form, startlingly moving, with which he gave the story a new dramatic vision. And this same example of Masaccio serves well to refute Rivera's assertion that "form always follows content." If it really were that way, all artists who took on the same subject—be it Adam and Eve, or to be more modern, the still life—would have done it in mostly similar ways. But we know that between a still life by Matisse, one by Soutine, and another by Giorgio Morandi, for example, there are major differences. It happens this way because a great artist is a genius at creating new forms, which on repetition create a new style. This new style communicates through the same simple content a different meaning; this is artistic meaning beyond mere description or storytelling. Perhaps this is what Rivera was referring to when he scornfully mentioned "intellectualizing aestheticisms." In contrast, we understand aesthetics as a mental activity with nothing bad in it. What is absurd is when he pretends to make a style on the margins of aesthetics. . . . Tamayo too reflects on these issues of form and content when he says that he bases his art on a universal quest. All his work, committed as it is to the fantastic, the monstrous, and the sense of mortality which form the base of the Mexican artistic tradition—all his work is tied to the beliefs of transnational Modernism and it benefits from the formal discoveries that gave it birth.

Tamayo: "My influences have been, first, the art produced in my country before the Conquest, and, second, from a technical standpoint, I have taken advantage of all the teachings of the most representative artists of our Modern era."

Rivera: "My only influence is a Marxist one, in order to make my work precise and clear, so that its effects are politically desirable."

Thirty-five years ago, when Rivera painted the walls of the Ministry of Education, he filled his works with images of the Mexican people in order to create a socially productive art. But there is a difference between being committed, sincere, or engaged, on the one hand, and being "politically desirable" on the other. The artist who tries to make something politically desirable makes use of a cold calculation in his art that suppresses feeling. The true ideal of art remains excluded: that is, the discovery and play of forms. Rivera deliberately ignores the Modern aesthetic world in which Tamayo moves. Everything in Rivera is beyond art: his intention, his creative process, his intended results. Therefore, while Tamayo tries to arrive at the "essence of things" through abstract means that are always evident, Rivera refuses to care about the aesthetic development of his work and he indeed confuses his art with his political plans. Moreover, for the future Rivera declares that "we are now ready to work for our release from prehistoric and barbarian capitalism, in order to truly enter into history and set out on our long road to a truly human solution to its problems." We must ask: Among this turbulent juggling of historico-political goals, what will happen to his painting? Will he continue enslaving

it to an extra-artistic ideal, choking off its only true source of life—the aesthetic—and reducing it to a faded and impoverished political necessity?

Rivera feels the duty of the artist in only a light-handed fashion. He said: "All across the world the Art Academy has tried to convert the living gains of genius into stable forms: this is its principal defect. We struggle against this defect, and we will continue to do so at a national and international level." How ironic it is that this is Rivera who speaks of defending the gains of genius against the Academy! Could it be that his style, with its political norms, amounts to an Academy even more rigorous? Rivera himself has fallen into the worst academism by dictating norms, not only of style but of meaning. By eliminating freedom, formal inventiveness, plastic creativity, and the autonomy of the artist, he not only mocks the "living gains of genius" but does away with them completely. It is inexplicable how Rivera does not comprehend that we cannot both impose the Marxist academy and save individual genius; we cannot both condemn and save the victim. In contrast, Tamayo says, "I feel affinity and even admiration for any searching artist. Those who are not stuck in one mode of expression, but are constantly searching to find another more appropriate for their personality." For any Academy that would impose a norm, this is the true antithesis: the triumph of the individual's solitary and free spirit.

The confrontation of the statements of Rivera and Tamayo sum up the true state of Mexican art today. It is notable that Tamayo has been allowed to speak freely in a magazine in Mexico, even though some call him a traitor. Can this mean that truer aesthetic delights are taking over from the enormous mistake of political painting? Art cannot be "managed" nor can it be made to revolve around any other pole than people themselves. . . . It is sadly small-minded of Rivera to think that a certain political stance can change the course of Modern aesthetics. The Modern aesthetic embodies a spirit born from the efforts of artists in their free creations. Tamayo, who has created a reputation for himself in the face of Mexican mural art, has been called foreign. Raising himself against the greats with only his unconquerable art, he is seizing the banner of glory that is ever less firmly held by the great muralists.

# Syncretism and Syntax in the Art of Wifredo Lam

**Lowery S. Sims**

From *Cross-Currents of Modernism: Four Latin American Pioneers,* edited by Valerie Fletcher, 1992

*The importance of painter Wifredo Lam's encounter with his Cuban roots is widely known, but this essay tells the story with thorough documentation and references to specific works. The author is one of the leading scholars on the subject.*

Since the early twentieth century, the connection between modernist pictorial modes and the indigenous cultures of Africa, the Americas, Asia, and Oceania has been defined from a "primitivist" perspective. The term describes a particular appropriation of the art forms of those cultures, as well as an attempt to participate in the spiritual traditions and mythologies that support them.[1] The presumptions of this primitivist view relegate non-Western cultures and their purveyors to the realm of nostalgia, invariably laced with exoticist nuances—a view that also requires a reactive avoidance of "contamination" with Western norms, disparaged as threats to the "purity" of those cultures.[2] Establishing a one-sided power relationship between what are now called the First World and the Third World, this attitude has effectively obscured the contributions of artists of color who have engaged modernism in a fruitful dialogue that incorporates specifics from their own cultures. This state of affairs has a direct bearing on the place in history attained by painters such as Wifredo Lam and many other artists from non-European countries.

The work on which Lam's reputation is based reveals a peculiar medley of Cubist and Surrealist vocabularies with references to the cosmology and practices of Santería, the religion of the Cuban descendants of the Yoruba and Fon peoples who call themselves Lucumi.[3] Nurtured in the mélange of cultural traditions of his birthplace, Lam inherited not only European and African traditions but also Chinese-based value systems. Inevitably Lam had to confront the dislocation particular to colonized peoples—the dichotomy between asserting the integrity of one's racial or cultural identity and being assimilated into the dominant culture.[4]

By early adolescence Lam had made a crucial choice about the direction he would pursue in life. He decided not to follow the wishes of his godmother, Mantonica Wilson, a Santería religious leader, that he become a *babalao* (high priest). This separation was reinforced when he expatriated to Europe in 1923, remaining there for nearly twenty years.[5] It was not until he returned to Cuba in 1941 that he would reconnect with the traditions in which he was raised.

> I went to Europe to escape from my father, the symbol of the "father" [establishment]. I thought this journey would resolve everything. But in Europe I encountered other problems as oppressive as those I left behind. . . . My return to Cuba meant, above all, a great stimulation of my imagination, as well as the exteriorization of my world. I responded always to the presence of factors that emanated from our history and our geography, tropical flowers, and black culture.[6]

The stylistic character of Lam's response to "la cosa negra" after his return to Cuba was prepared in various ways by his experiences in Spain and France during 1923–41. Politically, he had become aware of social attitudes and ruthless domination during the Spanish Civil War and subsequent world events. Artistically, he had become familiar with a broader range of European art sources such as the works of Hieronymus Bosch and El Greco, as well as African art and that of antiquity. His subsequent involvement with the French avant-garde exposed him to the creative freedom and unconventional imagination of Cubism and Surrealism. When Lam reconsidered the mutable, animistic universe of Santería, his mind had already been primed by the Surrealists' interests in mythology and esoteric knowledge. Lam had probably read John Frazier's *The Golden Bough* (1922) in the 1920s and had also become interested in alchemical ideas, which André Breton had identified as a central concern of Surrealist exploration. Certainly Lam's interest in the work of Bosch, with its grotesque and fantastic hybrid creatures, was the beginning of this alchemical focus. In addition, Lam's second wife, Helena Holtzer, had an active interest in the incantations and rituals of alchemy.[7] Furthermore, Marta García Barrio-Garsd has attributed the recurrence of specific symbols — the crescent moon, wheel, snake biting its tail — as an indication of Lam's interest in "the idea of perpetual metamorphosis or transmutation inherent in the alchemical process."[8] These symbols coincide with those of Santería and indicate the complex syncretism that characterizes Lam's creative process in the 1940s. Finally, the particular stylistic character of Lam's work of the 1940s, in which he allowed forms to permutate even as they were being created — like a continuous line spontaneously inventing itself as it moves through space — indicates more than just a symbolic expression of metamorphosis.

Perhaps most important, the Surrealists did more than pay formalist lip service to the Parisian primitivist vogue, and their attitude set the framework

within which Lam's work could evolve in a distinctive manner. Although the Cubists and German Expressionists had been curious enough about non-European cultures to appropriate aspects of each for their own modernist works, the Surrealists were the first to appreciate the psychological framework of those cultures and to condemn the colonialist attitudes that denied their validity.[9] Seeking to free themselves from the social and intellectual stultification of European bourgeois capitalism, the Surrealists urged that those in the West emulate the values inherent in non-European cultures. In essence, the Surrealists suggested a paradigm by which non-Western, non-technological cultures and their values could be recognized as complete economic, political, social, philosophical systems comparable rather than inferior to Western rationalism. Breton dubbed this distinguishing quality "the marvelous," that is, "an impassioned fusion of wish and reality, in a surreality where poetry and freedom are one."[10] By 1940 the Surrealists had completed their survey of where the marvelous could be found: in the vision of the emotionally disturbed, the literalness of folk art, the art of children, and that of what have been termed "primitive" cultures.[11]

Lam's particular synthesis of Cubism and Surrealism resulted in a visual vocabulary that correlated with—in an incredibly complementary way—the Syncretism of Santería and other New World African-based religions. The most pertinent characteristic of Santería in relation to Lam's art is that the various African *orishas* (deities) in Santería are masked by the *santos* (saints) of Roman Catholicism—a subterfuge that evolved to hide the persistence of African observances among black slaves in Cuba and throughout the Caribbean and South America.[12] Lam declared his intention to achieve a similarly Syncretic relationship to Western modernism by using a vocabulary familiar to his European-American avant-garde contemporaries to celebrate a belief system that was not readily accepted in cultivated circles in Cuba, or at least not admitted to at that time.

> I knew I was running the risk of not being understood either by the
> man in the street or by the others. But a true picture has the power
> to set the imagination to work even if it takes time.[13]

Lam's masterpiece, *The Jungle* of 1943, is populated with hybrid creatures often endowed with prophetic accouterments that herald the presence of a different world order. The rigid angles and clean geometry of pure Cubism have been supplanted by a lush tropical environment, an animistic realm where figural and plant forms merge and evolve in an endless linear invention celebrating a pan-cosmic energy. In *Omi Obini* of 1943, the human forms seem inextricably interrelated with their vegetal surroundings, as Lam used Cubist "passages" as transitions from leaf to fruit to flowing hair. The bulbous *fruta bomba* (papayas) serve as visual puns for breasts and, indeed, in this painting have a dual identity that reinforces the integration of the female form with

the landscape—a long-standing symbolism in both European and African traditions. Furthermore, Lam's transsexual figures may well reflect hybrid sources in Santería. While the associations between an African *orisha* and Catholic *santo* often arose from one-on-one comparisons of metaphysical qualities and powers, the association could also rest on such prosaic elements as comparable color attributes and accouterments, which accounts for the gender crossovers of such Santería pairings as Shango and Santa Barbara.[14] Such non-literal transgendering is reflected in Lam's work in the recurring hermaphroditic character of his figures. The overall effect of paintings such as *The Jungle* and *Omi Obini* expresses Lam's "conception of . . . the natural world not in terms of its appearance, but in its manner of operations . . . that reconciles opposites and metamorphoses all things."[15] Lam described them as "beings in passage from a vegetal state to that of an animal still charged with vestiges of the forest."[16] Various one-footed elements (both human and cloven) in both works suggest the early incarnation of Lam's "horse-woman," who personifies the devotee who is literally "ridden" by the possessing *orisha* in the Santería *toque* (drum rhythm). She appears full-blown by 1950 in many paintings. Lam's use of a free-flowing linearity to generate his forms had arisen from "exquisite corpse" drawings, a method he learned from the Surrealists in Marseilles. After a brief transitional period of experimentation in 1940–42, that approach distinguishes his work from 1942 on, as seen in *The Third World* of 1966.

In *The Idol* (also known as *Oya*) of 1944, Lam's watchful goddess appears divorced from her jungle home. Here his monochromatic color, freely applied, even splashy, provides an interesting correlation to technical issues being explored by New York artists such as Jackson Pollock and Mark Rothko, which were also grounded in Surrealism's automatist spontaneity.[17] *The Idol* incorporates a number of Lam's Cuban motifs: a rhomboid-headed entity with horns in the upper right, a bulbous chin with wispy goatee, an arched supine form in the center (which may refer to the artist's wife), a dislocated hand holding up a head, clusters of papayas with palm fronds, a small horned imp, and a round-headed rooster in the lower right. All these elements refer to Santería symbology and provocatively allude to Catholicism's propensity to view deities from other religions as opposing, rather than complementing, the Christian Godhead.[18] This metamorphosed imagery was a benchmark for Surrealist thought, and Lam drew on many sources as his imagery evolved, creating a hermetic totality that ultimately escapes definitive explication because it was unique to his world view and experience.

Despite the richness of imagination in Lam's work, many of the details of this multi-referential world are empirically based. Photographs of the artist in his house show the roster of elements in his paintings: the palm trees, bamboo, and papaya in his garden and his burgeoning collection of African art. In one sense, the jungle in Lam's works reflects his immediate physical environ-

ment, yet it is also a private imaginative world that has no real relationship to an ecological phenomenon. In Lam's jungle, invisible forces and Spirits are evoked in recognition of the unique character of each element in nature. In his role as interlocutor, Lam is at once believer and philistine. He calls on the powers at hand but dares not risk breaking taboo by using sacred symbology in a profane context. Rather, his intention was to synthesize the varied knowledge he had accumulated from forty years of living into a cohesive statement of syncretist identity. In a way analogous to Cuba's several overlapping syncretist religions, Lam's art appropriated from several sources whatever he regarded as most necessary to achieve his artistic vision.[19] Lam brought the cycle of appropriation full round: African art had originally inspired modernist primitivism, and by virtue of his existence and vocation Lam endowed that posture with a new validity.

Breton recognized Lam's singular position when he wrote that Picasso found in the Cuban an affirmation of his own interests in primitive cultures, not merely as sources for visual styles but as a new kind of perception. That perception, when conjoined with European erudition, could result in the highest level of artistic consciousness. Breton thought that because Lam "drew upon the marvelous primitive within himself," Picasso turned to him as a means to reattain that type of perception "in order to be revitalized by the marvelous."[20] Recognizing the dilemma of primitivism, Breton ultimately admitted its intrinsic failure. He wrote:

> Unfortunately, ethnography was not able to take sufficiently great strides to reduce, despite our impatience, the distance which separates us from ancient Maya or the contemporary Aboriginal culture of Australia, because we remain largely ignorant of their aspirations and have only a very partial knowledge of their customs. The inspiration we were able to draw from their art remained ultimately ineffective because of a lack of basic organic contact, leaving an impression of rootlessness.[21]

Lam's achievement in presenting the reverse side of the primitivist stance has generally been overlooked, partly because few critics have recognized the significant distinction. Even during the past decade, when artists of color who assert their cultural values into a modernist dialogue have emerged in increasing numbers around the world, attitudes have changed little. Rather than "primitivist," these artists could more accurately be termed "indigenist"—a term used for some of Lam's Mexican contemporaries (such as Frida Kahlo, Diego Rivera, David Álfaro Siqueiros), who also had been inaccurately categorized by biased critical delineations.[22] Although in this context the term implies an art characterized by figuration and a propagandistic orientation, it has, as Michael Newman notes, a "distinctly nationalist component" that distinguishes it from "the more generalized 'primitivism' of European and

United States avant-garde art movements where it is supposed that tribal cultures have access to deeper currents of feeling or a 'collective unconscious.'"[23] Lam's act of restoration was complementary to the Negritude philosophy of the poet-statesman Aimé Césaire, whom Lam met in Martinique in 1941. In a comparable way, this act of cultural self-definition was explored by Lam and several of his contemporaries in Cuba (the folklorist Lydia Cabrera and the poet Nicholas Guillen, for example) in their celebration of Cuba's non-European cultures.

This reclamation of mythic concepts and images relative to specific cultures took on a particular urgency with the advent of the World War II. The widespread chaos and destruction on the European continent seemed to demonstrate so painfully the bankruptcy of "high" cultures and the ineffectiveness of international modernism in blunting nationalist differences. Intellectuals, the Surrealists chief among them, were literally driven to search for more enduring and basic values within the "marvelous." This search flowered in postwar artistic movements such as the CoBrA artists (a coalition of younger artists from Copenhagen, Brussels, and Amsterdam working in Paris), who adopted Lam as their mentor. At the same time, the Abstract Expressionists in New York pursued a comparable quest for "new counterparts to replace the old mythological hybrids who [had] lost their pertinence."[24] As Lam's work was first widely seen in New York during the 1940s, its fascinating distinctions from Cubism, Surrealism, and European primitivism would seem to have offered a new direction and artistic ideology. But New York artists did not rise above the primitivist hegemony, and their increasingly formalist stance during the 1950s aborted any nascent interest in artists of color declaring their cultural integrity.[25]

But with the burgeoning multicultural rubric of the 1980s and 1990s, particularly today's increasing interest in Latin American culture, Lam's work has again been validated. While this turn of events has added luster to Lam's work, it has paradoxically also served to minimize his influence on postwar European and American art. Lam's dual status as authentic primitive (or Indigenist) and primitivist tends to get confused, resulting in diminished recognition of him as a true modern master. This continues to have repercussions in assessing modernist and postmodernist artists from African, Asian, Native American, and Latin American cultures. Of the four artists in this exhibition, Lam—perhaps more than Torres-García, Rivera, or Matta—has been subjected to this identity crisis. He was more intimately and primarily grounded in the African and Chinese cultures of his parents, whereas the other three artists belonged more to the Europeanized middle class of their Latin countries.

As important as Lam's work is for evaluating the conventions of primitivism, it also deserves note for revitalizing the formalist malaise of European art during the late 1930s and early 1940s. Georges Bataille reviled the French art world for having "sanitized" art with excessive formalism. He noted that

using symbols from specific cultural contexts had become problematic because their "transpositioning" negated their primordial symbolism.[26] What Lam achieved in his paintings of the 1940s was a resynthesis of form and symbol without resorting to ritualistic nostalgia. Indeed, he infused old hybrids with new meaning, and his efforts had great import for the next generation of artists who matured in the context of the School of Paris after the war, specifically the CoBrA group and individual Latin Americans. With a greater comprehension of the exact nature of Lam's contribution, his significance comes increasingly to light. As an intermediary between the Old World of formalist modernism and the New World of primitivist-Indigenist iconographic modernism, Lam can now take his rightful place in the pantheon of twentieth-century masters.

## Notes

1. See William Rubin's disclaimer for his use of the term "*tribal*" in his "Modernist Primitivism: An Introduction," in William Rubin, ed., "*Primitivism*" *in 20 Century Art: Affinity of the Tribal and the Modern* (New York: Museum of Modern Art, 1984), vol. 1, p. 1. Even James Clifford's adroit critique of the presumptions of ethnographic privilege by the West does not challenge the hegemonic position of Europe and America but merely points out the folly of its presumptions. See James Clifford, *The Predicament of Culture: Twentieth-Century Ethnography, Literature, and Art* (Cambridge, Mass.: Harvard University Press, 1988), pp. 21–41.

2. Edward Said has described this syndrome eloquently in *Orientalism* (New York: Vintage Books, 1979), p. 318. Said himself has been the subject of such treatment by James Clifford, who attempted to discredit Said's position as a postcolonial critic by asserting that "it is increasingly difficult to maintain a cultural and political position 'outside' the Occident from which, in security, to attack it. . . . Locally based and politically engaged, [such critiques] must resonate globally; while they engage pervasive postcolonial processes, they do so without overview, from a blatantly partial perspective" (Clifford, *The Predicament of Culture*, p. 11). Clifford's remark seems surprisingly naive about the "blatantly partial perspective" of the West and denies Said, who represents the Third World, an identity that encompasses not only the richness and point of view of his own culture but also the analytical tools and processes of the West.

3. The term "Santería" has sometimes been incorrectly used to include several Afro-Cuban religions, whereas each has its own beliefs and practitioners. They derive from different tribal and geographic regions in Africa.

4. In Cuba that absorption meant a double dose of Western European values: primarily Spanish colonial mores but also those of the United States, which exerted strong influence over Cuban society and politics during the first two decades of this century.

5. "He would not be a sorcerer . . . because he felt he was not sufficiently gifted.

'The trouble,' he says now, 'is that I'm fifty-percent Cartesian and fifty-percent savage.'" Lam, cited in Max Pol Fouchet, *Wifredo Lam* (Barcelona: Ediciones Poligrafa, 1976), p. 45.

6. Lam, in an unpublished interview in Lam Archives, Paris. I am grateful to Lou Laurin Lam for making this text available to me (translated by the author).

7. This was conveyed to me by Esteban Cobas Puente during an interview in October 1989.

8. Marta García Barrio-Garsd, *Wifredo Lam: Dessins, gouaches, peintures, 1938–50* (Paris: Galerie Albert Loeb, 1987), unpaginated.

9. See René Crevel, "Colonies," *Le Surrealisme au service de la revolution* 1 (July 1930): 9–12; and Crevel, "Bobards and fariboles," *Le Surrealisme au service de la revolution* 2 (October 1930): 17. See also J. M. Monnerot, "A partir de quelques traits particuliers à la mentalité civilisée," *Le Surrealisme au service de la revolution* 5 (May 1933): 35–37.

10. André Breton, cited in René Passeron, *Phaidon Encyclopedia of Surrealism,* translated by John Griffiths (New York: E. P. Dutton, 1978), p. 261.

11. The Surrealists even modified the existing map of the world to emphasize those areas they considered important. They aggrandized the proportions of Africa, Alaska, Mexico, Latin America, and Oceania over the geopolitical powers of the time (mainland United States does not appear at all, but Hawaii and Alaska do, the latter on a scale with Russia). See Rubin, *"Primitivism" in 20th Century Art,* vol. 2, p. 556.

12. See Roger Bastide, *The African Religions: Towards a Sociology of Interpenetrations of Civilizations,* translated by Helen Sebba (Baltimore: Johns Hopkins University Press, 1978).

13. Lam, cited in Fouchet, *Wifredo Lam,* pp. 188–89.

14. I am grateful to Marta Moreno Vega, director of the Caribbean Cultural Center, for discussing these concepts with me (June 1991).

15. Lam, "Oeuvres recentes de Wifredo Lam," *Cahiers d'art* 26 (1951): 186.

16. Ibid.

17. See Lowery Stokes Sims, "Wifredo Lam and Roberto Matta: Surrealism in the New World," in Dawn Ades et al., *In the Mind's Eye: Dada and Surrealism* (Chicago: Museum of Contemporary Art; New York: Abbeville Press, 1985), pp. 91–103.

18. See Julia Herzberg, "Wifredo Lam," *Latin American Art* 2 (Summer 1990): 18–24.

19. Several Afro-Cuban religions have some structures or orishas in common. Marta Vega has noted that religious leaders are often adept in more than one religion and would use different ceremonies depending on the situation. If, for example, a particularly strong intervention was required, Palo might be chosen rather than Santería (conversation with the author, June 1991).

20. Breton, *Le Surrealisme et la peinture: Suivi de "Genese et perspectives artistiques du surrealisme" et de "Fragments inedits"* (New York: Brentano's, 1945), pp. 181–83.

21. Breton, cited in Evan Maurer, "Dada and Surrealism," in Rubin, *"Primitivism" in 20th Century Art,* vol. 2, p. 584.

22. Michael Newman, "The Ribbon Around the Bomb," *Art in America* 17 (April 1983): 160–69. See also Dawn Ades, *Art in Latin America: The Modern Era, 1820–1980* (London: South Bank Centre, 1989), pp. 195–213. Ades uses "indigenism" as implying a special sociopolitical propaganda that Lam would not have tolerated. While Lam was committed to social change, he refused to place art in the service of propaganda: "In my opinion political art is not art, it is a transaction between a form of expression and an ideology" (Lam, in an unpublished interview in the Lam Archives, Paris). This freedom included both the modes of expression and what was expressed, as Lam believed that the artist had to be unfettered by all concerns except his own expression.

23. Newman, "The Ribbon Around the Bomb," p. 164.

24. Mark Rothko on Clyfford Still, cited in Irving Sandler, *The Triumph of American Painting: A History of Abstract Expressionism* (New York: Praeger Publishers, 1979), p. 67.

25. See Dore Ashton, *The New York School: A Cultural Reckoning* (New York: Viking Press, 1972), pp. 114–33.

26. Georges Bataille, "L'Esprit moderne et le jeu des transpositions," *Documents* 8 (1930): 48–52.

# 4. Major Architectural Projects

# Aula Magna Hall

**Paulina Villanueva**

From *Carlos Raúl Villanueva,*
2000

*The Aula Magna (1951) is part of the Central University of Venezuela, one of the most important Latin American architectural projects. The interior is decorated with a large installation by Alexander Calder.*

Aula Magna Hall is a true architectural, sculptural, and human space. Modern and stark, it is stripped to the bare essentials. As Sibyl Moholy-Nagy wrote, it is "a festive and lyrical celebration of space . . . an intended appeal to individual mood." The interior both dazzles the senses and inspires awareness. Bruno Zevi and Villanueva both believed that "the specific expression of architecture is built space." In the Aula Magna, space has been measured and proportioned in a clean, direct way that lacks neither grandeur nor monumentality and creates a dense and full atmosphere.

According to Villanueva: "From the essential invention of space as the key of the entire project, the volumetric enclosure articulates itself. It defines and harmonizes the third architectural element, which is structure."

The Aula Magna is a space to be discovered, strongly protected by the structure that acts as its skeleton, sustains it without intrusion, and guards an interior of immense and finely tuned resonances. Villanueva's space is augmented by the work of Alexander Calder, whose colorful floating clouds, "flying saucers" as he referred to them, fill the auditorium, radiating waves of sound in this culminating work of the "Synthesis of the Arts" project.

The Aula Magna is the largest and the most important of the university's fifteen auditoriums. The wide, fan-shaped floor plan has seating capacity for more than 2,500 people between the orchestra stalls and the interior balcony that sweeps over them—without actually touching the side walls—in an airy and defiant curve. The acoustic shapes designed by Calder and adapted by the engineer Robert Newman hang from the ceiling and lean against the side walls; suspended in space, they seem to rise and fall with the varying intensity of the double fluorescent and incandescent lamp reflectors in the ceiling. These eyes of light create an atmosphere of blue, and cast a warm light over the orchestra stalls, and together with the sculpture, augment and expand the space into a universe that is already present in Calder's first *Constellations.*

Aula Magna Hall is connected to the Covered Plaza by a system of double doors between the hall and the vestibule area, and by a large circular corridor with two pairs of ramps leading up to the exterior balcony. This large, curved arc together with the cantilevered roof that covers this area is connected to that of the plaza, leaving a line of light over the modeled concrete surface of the roof. The light and shadows that project over both the surfaces and the people create a space of movement and an atmospheric sculpture made of emptiness and transparencies.

The roof was designed in the shape of a seashell by the Danish engineering firm Christiane Et Nielsen. It has twelve inverted-L columns with 45-meter spans that lean on a large structural frame with the "drawing" of the exposed structure showing on the beams and the side walls. The rough connection of several blind bodies on the outside stands in contrast to the fluid and l ucid unity of the interior, a latent space guarding a large stabile in perpetual movement.

When referring to the architectural framework that gave birth to the "Synthesis of the Arts" experience, Villanueva used to say that "the final result always reflects the unique meaning of an exceptional piece . . . an unrepeatable combination of propitious conditions."

# Olympic Stadium

**Paulina Villanueva**

From *Carlos Raúl Villanueva,*
2000

*When Venezuela's Central University was completed, it drew worldwide atten-tion. Here was a large, state-funded Modernist project of innovative nature that incorporated decorative projects by leading artists.*

The airy lightness of the Olympic Stadium along with the modest ano-nymity of the Baseball Stadium adjoining it act as counterweights to the heavy presence of the University Hospital located at the other end of the cam-pus, with their social function serving to create a common area on the limits of the site shared by the university and the city alike.

The elegant simplicity and powerful scale of the Olympic Stadium are ar-ticulated in two separate volumes: the shell of the covered grandstand and the half-oval structure of the bleachers. These forceful elements sit opposite each other in a tense yet balanced composition. The whole structure is raised above the ground, where it rests on almost invisible columns that are barely percep-tible against the deep shadow of the underside. From this perspective, the body of the central grandstand seems to float above slim columns like the braces of a sail straining in the wind—an effect resulting from the lack of pro-portion between the twenty-four large V-shaped space frames, placed every 5 meters and joined by a thin 115-meter-long slab, and the small ground sup-ports, which are hidden by the large balcony platform that is also suspended above the ground and connected to the access area by means of light concrete ramps.

According to Sibyl Moholy-Nagy, "in the general context of Villanueva's development, the stadiums signify the transition from the experimental use of reinforced concrete to full mastery over it." This is exemplified by the struc-tural lightness of the bleachers and the unsurpassed elegance of the can-tilevered roof over the grandstand, in which the stressed parts of the structure and the plasticity of the concrete are fully exploited to create a beautiful form. Crowned by the rhythmic sequence of the concrete cantilevered beams and underlined by the running slab of the balcony that acts as the main access plat-form, the cylindrical shell of the covered grandstand rises in all its majesty

against the silhouette of Mount Avila to the north and the profile of the city's high-rises to the east.

As in the interior of the Aula Magna Hall, in the stadium the two faces of the folded roof and the bleacher structure fulfill the same objective—that of shaping space on a large scale with a single gesture, without superfluous expressive concessions.

Like the Olympic Stadium, the Baseball Stadium has a seating capacity of 30,000 spectators. However, the continuous ring of concrete that encloses the baseball diamond and the cantilever over the grandstand, which is polished on the outside and has the structure exposed on the underside, differentiate it from the Olympic Stadium and give it a distinct personality.

Despite the fact that they are truly functional works designed for heavy-duty use, each stadium has an indisputable character and appeal that stem from the clear geometry of the design and the frank use of structures and materials. In the pronounced and repeated body of the Olympic Stadium and, later, in the Swimming Pool Complex, the marked contrasts of light and shadow clothe the entire building, forming part of the space. Form is rooted in construction. However, true and beautiful form must be endowed with great expressive freedom, like the single shell of the grandstand in the Olympic Stadium—the constructional clarity of an architectural idea.

# Modernity in Mexico

## The Case of the Ciudad Universitaria

**Celia Ester Arredando Zambrano**

From *Modernity and the Architecture of Mexico*, edited by Edward R. Burian, 1997

*T*his essay examines the transformation of the heritage of Modern architecture in Mexico under the impact of social and political conditions there.

> "He knew that temple was the place that his invincible purpose required . . . he knew that his immediate obligation was the dream."
> —*Jorge Luis Borges,* "The Circular Ruins"[1]

Modernity, more than a period of time or an architectural style, was a deep-rooted belief in the power of architecture and the conviction that Modern architecture could transform society.[2] Modernity would produce a new environment that would create an ideal man. This ideal man, like the dream man described by Jorge Luis Borges in his short story "The Circular Ruins," wasn't the product of an everyday dream. He had been so carefully crafted and passionately desired that he magically came to life and became real.

International modernity and Mexican modernity, although both inspired by the need to create a new man, had different versions of what that ideal man might be. International modernity's ideal man was a universal man with one identity and one spirit. Mexico, on the other hand, conceived a man that would bridge the nation's contrasts and differences through a new national identity. Even though the conceptions of these two men are not the same, in both cases their power would be such that it would transform their world and their society.

Borges describes the genesis of a dream man as the product of the long painful labor of a magician who reached the circular ruins of an old temple and recognized it as the appropriate place to create his dream. According to this tale, there are two essential elements that must be present in this magical

event, time *(chronos)* and place *(topos)*. Mexican modernity, in its quest for the ideal man, had to achieve the adequate combination of these two elements. Post-Revolutionary Mexico offered the appropriate time frame that could generate the need. Now, a place, a circular ruin, was needed to evoke the dream and give it life. This mythical place was the Ciudad Universitaria [University City, or CU].

The Ciudad Universitaria was the mythical *topos* for the creation of the new Mexican. It was the environment where a modern society would be born; therefore, it had to represent its ideals and aspirations. Its architecture represented the Mexican contradiction of attempting to be modern while representing a national identity.

The phenomenon of modernity in Mexico was determined by the circumstances of the time and by Mexico's particular characteristics as a nation. This is in direct contradiction with the principles and doctrine of the Modern movement, which endorsed an eternally present and international architecture, analogous to the timelessness and universality of Classicism. Nevertheless, this contradiction was not apparent at the time, since both modernity and Mexico shared the same dream.

To understand modernity in Mexico it is crucial to understand this contradiction. Mexico took the ideal of a new man from European modernity. European modernity, born after the First World War, envisioned a man that would unite all nations. This universality was viewed as a means to obtain international unity and peace in an environment where no national, ethnic, or social differences would be apparent.[3] Modern aesthetics and Functionalism seemed the ideal representation of that environment.

Post-Revolutionary Mexico needed to create a new man that would reunite all Mexicans into one nation, in an attempt to reconcile its own abysmal differences and contradictions. Mexico, longing for unity, welcomed the idea of a new man and a new environment and even embraced the aesthetic language of modernity. However; it did not long for an *international* unity but for its unity as a nation. Mexico's dream man represented the paradox of being both modern and Mexican, both international and national.

Nationalism was the solution to the dilemma, since it was viewed as a continuation of the revolutionary process through which social, economic, and political difficulties would disappear. It also represented the economic development needed to achieve international stature. As Roger Bartra explains: "The nationalism unleashed by the Mexican Revolution . . . holds that the wheels of progress and history have begun rolling toward a future of national well-being."[4]

This nationalism allowed the nation to remain Mexican while accepting wholeheartedly the notion of progress. Mexican modernity became synonymous with nationalism, and the dream of the universal man was replaced by a dream man that represented this national identity.

The void felt after the Revolution in terms of unity and national identity generated an imperative need to create the image of a new Mexican that would accomplish social change. Mexico's intellectuals knew the time was right, and like the magician in Borges's story, they searched for the appropriate place. In this case, the ideal place had to be created, and architecture played an important role in this task, responding to the modernist notion that believed in the power of the built environment to transform social behavior.

The Ciudad Universitaria, or CU as it is known, represented this perfect *topos*, the site where a new Mexican identity would be born. Constructed between 1950 and 1952, the CU was the product of a collaboration of a team of over 150 architects, engineers, and landscape architects, led by Mario Pani and Enrique del Moral. Besides being the place for some of the most important examples of Modern architecture in Mexico, it was also the mythical place where dreams would turn into reality. The importance and significance of the Ciudad Universitaria as part of Mexico's history and destiny was passionately expressed in a speech by Carlos Lazo, director and general administrator of the project, in the ceremony for the laying of the first stone of the CU in 1950:

> Mexico, a geographic crossroads, has been historically possible
> thanks to the collaboration of diverse forces and cultures. . . .
> Mexico has been built stone by stone. . . . And this [CU] is one
> of them. This is a moment for Mexico. In this same site where the
> Nahuas and Olmecas met in the Valley of Mexico, in the pyramid of
> Cuicuilco, the most ancient culture of the continent appeared from
> the contemplation of this land and this sky. We are building a University in its most ample sense, integrating the thought, the hope
> and the labor of all, through culture. We are not laying the first
> stone of the first building of Ciudad Universitaria, we are laying
> one more stone in the fervent construction of our Mexico.[5]

CU represented a tribute to Mexico's past and a promise toward its future. Its importance was to be always linked with its past and its national vocation. The mythical connection between past and present established by Lazo in his discourse was also part of CU's historical origin.

CU was constructed on the lava-covered ruins of Cuicuilco, a pre-Hispanic city dating from approximately 600 B.C.[6] This impressive site, which included lava formations and exotic landscape, was abruptly abandoned during the eruption of the volcano Xitle, between 300 and 200 B.C. According to legend, its people vowed to return to reinstate the lost culture with a new and stronger one. Although CU was a new built environment, it was nevertheless sited so as not to destroy its only surviving temple.

This decision to site the university in relation to the ruins of Cuicuilco reminds us of Borges's magician and his return to the circular ruins in search of their mythical power. This same power can be attributed to Cuicuilco, since

its legend was united with modern and national ideals in an attempt to produce the return and the restitution of its lost culture.

Although CU was created *ex novo* [completely new], it was not created *ex nihilo* [from nothing]. Its newness was interwoven with the historicity of the site, demonstrating the nature of Mexican modernity and the possible coexistence of opposites. By analyzing CU's built form and design concepts, it is possible to establish this paradox in its role of creating the new Mexican.

The urban composition of CU, in contrast with its mythical origins, responds to the principles of modern urbanism. The super block, the separation of circulation systems, and the zoning of activities determined the site strategy of the campus. This strategy is closely related to the functional-determinist aspects of the modern city, but it was much different from Mies van der Rohe's scheme for the IIT [Illinois Institute of Technology] campus, in which the buildings were placed within a highly rational, determined grid. But like IIT, CU was built as, and still remains, an isolated portion of the city for the exclusive use of pedestrians. The campus was divided into four parts by its road system. The main campus, located to the north, contains all the schools and their facilities. The sport facilities were to the south, while the Olympic Stadium and the dormitories were to the west and east, respectively.

The first scheme for the campus responded to rational-functional organizational principles. Common activities were centralized and expressed according to their function, which would be available to every school. However, the final scheme responded to the traditional strategy of organizing each school in its own individual buildings. Pedro Ramírez Vázquez criticized this arrangement[7] when he stated that it was as if the old schools scattered in the center of Mexico City were only relocated to this new campus. The buildings themselves were designed as freestanding elements by an interdisciplinary group of architects, engineers, and artists. The functional integration of the buildings presented a problem due to the site's uneven terrain. This was resolved by the use of walkways, grand staircases, and terracing reminiscent of pre-Hispanic architecture. On the other hand, the modernist aesthetics utilized in the composition of each building gave unity to the complex.

Modernist principles and historical references are interwoven in the design and conception of CU. The main campus, for example, has a certain regularity to it provided by a central axis and a great plaza. Yet it avoids being symmetrical by the interlocking arrangement of its buildings, alternating mass and void, along the periphery of the scheme. Although these characteristics are modern, the composition of the main campus is also similar to some pre-Hispanic cities. Its central axis resembles the Calzada de Los Muertos [Way of the Dead] at Teotihuacán in the sense that it axially steps up the site, while its great plaza reminds us of the plaza carved into the mountaintop at the pre-conquest city of Monte Albán. In fact, CU bears a great resemblance to Monte Albán, since

in both cases the composition is that of an asymmetrical equilibrium achieved by the relationship between built form and open spaces.[8]

Rational and mythical concepts seem to merge in the site design of the campus. The disposition of the main buildings located on the great plaza and central axis responds to both their functional and symbolic importance. The Rector's Tower (Mario Pani, Enrique del Moral, Salvador Ortega Flores) is set on the highest, most predominant part of the campus, close to the main highway, and acts as a gateway and welcoming element in the composition. The Main Library (Juan O'Gorman, Gustavo M. Saavedra, Juan Martínez Velasco), with its multicolored mural by Juan O'Gorman, depicts Mexico's past and present wisdom available to the new Mexican. The School of Science (Raúl Cacho, Eugenio Peschard, Félix Sánchez Bayltin) with its mural, located in the center of the scheme, represents the evolution of scientific knowledge that is available for Mexico's development. This organization reveals that even though the campus was inspired in relationship to a modern city, a symbolic arrangement seems to prevail in the composition.

The buildings of the CU, although abiding by the tenets of the International Style, also reveal local idiosyncrasies and formal contradictions. Nevertheless, it is in the design of these individual buildings that the modern language is eloquently used, demonstrating the knowledge and comprehension of modern aesthetics and compositional principles. Enrique Yáñez gives an insight into this understanding of Modern architecture when he states: "Design the modest, the useful and the economic and from these characteristics obtain beauty . . . "[9]

This is a modern interpretation of the ancient Roman components of architecture: *firmitas, utilitas, venustas*.[10] Juan O'Gorman was also aware of this academic interpretation of the Modern movement when in 1968 he stated: "According to my judgment, it is indisputable that during this time, Mexico has established a new Academy of modern architecture as obtuse and closed as was the old Academy of San Carlos, constituted in the manner of the so-called Classicism of the School of Beaux Arts of Paris."[11]

Clearly the modernist style was interpreted as a new formal order. Hence, the buildings, in their proportions and regularity, responded to modern compositional principles[12] that emphasized form and volume. This was demonstrated by the expression of single volumes, such as the Main Library, or articulated volumes, such as the School of Medicine (Roberto Alvarez Espinosa, Pedro Ramírez Vázquez, Ramón Tortes, Hector Velázquez). These volumes are also organized in an asymmetrical manner, such as that which occurred in the Rector's Tower facades. Horizontality was not only sought as a modern aesthetic; it was also exaggerated as a formal and technical feat, as is evident in the Humanities Building (Vladimir Kaspé).

Functions are organized and fully expressed within the structural grid of

each building. Floor plans are composed to articulate the rational distribution of the programmatic functions, which in turn are expressed on the facades. Modern materials, such as glass, concrete, glass block, and breeze block, are used to define and emphasize volume, structure, and functions.

By the same token, this interpretation of modernity manifested in the buildings is also evident in the urban design scheme. Even though the buildings and the site design respond to modern dictates, they do not seem to be created as part of the modern urban vision as in Le Corbusier's garden city. The open spaces are not really gardens or parks; they are plazas or walkways, which not only link each building but also have a symbolic meaning and a sense of place. The buildings, although conceived as autonomous elements, do not relate to their surroundings as in a modern city, where horizontal windows and corridors allow for a visual integration with the garden and the horizon. Horizontality is not viewed as an integration between interior and exterior as expressed by Le Corbusier's *fenêtre longuer* [bands of windows], nor was it meant to streamline the buildings and their "silhouette against the sky."[13]

It is not my intention to question the theoretical knowledge or design ability of modern Mexican architects. On the contrary, I wish to establish the need they had to respond to their *topos* and *chronos* and the commitment they felt in creating the dream man, the new Mexican, through the design and construction of the CU. To accomplish this task, it was necessary to simultaneously embrace inherent contradictions, such as the rational aspects of the Modern movement and the emotive qualities of the new Mexican dream man, through aesthetic and even mythical values. This struggle between function and emotion is the main dichotomy of Modern architecture, and according to O'Gorman, is impossible to solve, as he expressed in the following statement: "This problem will never be resolved by Modern architecture. The contradiction persists related to the function of utility and the function of emotion or aesthetics."[14]

In spite of these contradictions, CU remained within the tenets of the International Style. The unorthodox elements used seem to appear in a rather unconscious and almost naive manner. I believe that the architects of the campus were aware of their mission to create an architecture for a Mexico that simultaneously looked to the past and future, while utilizing the language of the Modern movement to create a coherent vocabulary for the campus. There is no real attempt to create a unique, personal "signature architecture," except for perhaps the Cosmic Ray Laboratory by [Jorge González] Reyna. CU strived to endorse modernity as a way of life and also as the new Mexican identity. Yet, by using the language of Functionalism—a language that denies nationalism—it faced the difficulty of expressing a national identity. Nothing could be more inherently contradictory than the desire to express a national

spirit through an autonomous architecture that attempts to liberate itself from social, cultural, and political references and achieve meaning in its own right, responding only to its own inherent values.

In spite of this contradiction, or perhaps because of it, the unstable mixture of Functionalism and nationalism was necessary to produce the new national identity. Mexican characteristics were linked to modern ones in an attempt to make modernity authentically Mexican. This was not the first place or time where this was done. When Walter Gropius first arrived in England, he appealed to the theories of John Ruskin and Henry Cole in an attempt to make modernity British.[15] In Mexico's case, the Bauhaus principle of *gesamtkunstwerk* [a work that includes all art forms] was utilized in order to achieve this authenticity. The integration of artists, artisans, and architects proclaimed by the Bauhaus was the logical way in Mexico of introducing the nation's spirit and cultural values through the participation of its artists.[16] This became an objective at CU, where architects and artists were called on to form part of an interdisciplinary design team. It was through this collaborative effort that modern and national values would successfully unite, remaining faithful to both.

Unfortunately, this artistic integration did not mature into a theoretical or conceptual approach, and the participation of the artists was limited to the creation of murals on the blank walls allocated by the architects for this purpose.[17] The theme of each mural expressed the mission of each school and its educational intent. Murals were previously used in modern buildings by [Reinhard] Baumeister and [Amadée] L'Ozentfant, as discussed by Hitchcock and Johnson.[18] These artists used an abstract language that harmonized with the abstraction of Modern architecture. Mexican artists, on the other hand, preoccupied with the didactic aspects of the Revolution and Mexico's historical past, transgressed the International Style by resorting to murals that were representational, metaphoric, and symbolic. The murals, like those of ancient times, graphically depicted a cultural message.[19] Although heavily criticized and ridiculed (particularly by Bruno Zevi, who referred to them as "*grottesco messicano*"[20]), they served an important social and aesthetic purpose.

Besides the controversial murals at CU, there are two other exceptional buildings on the campus that were more successful in expressing national values. These are the *frontones* (Alberto T. Arai) and the Olympic Stadium (Augusto Pérez Palacios, Jorge Bravo, Raúl Salinas). During an interview, Ramírez Vázquez stated that both of these buildings have accomplished an exceptional historical and contextual integration. The *frontones,* or handball courts, are the most important elements in the sport area at CU. They were designed to mimic the neighboring hills of the Sierra de las Calderas located to the east. The intention was to create a sense of perspective by placing each *frontón* on a different plane. Alberto T. Arai eloquently integrated both techni-

cal and tectonic elements. He used a concrete structure of columns and slabs to support walls made of volcanic rock that are wider on the base than on the top, giving the appearance of the ancient pyramids.

The stadium's design has also been praised for its harmony with the site and its original construction and tectonic system. The height of the structure was diminished by creating a slope on the periphery, similar to [Tony] Garnier's Olympic stadium at Lyon. Ramírez Vázquez has inadvertently suggested that the stadium has a mythical origin, for he believes its shape implies that it has always been there. He feels that the site cannot be conceived without it being there, and that the slopes, with their cladding of volcanic stone, appear very Mexican.

The project of the CU is one of the largest projects of social content in Mexico, and many intellectuals, such as Carlos Lazo, considered it one of the most important manifestations of Mexican modernity. But for others, such as Ernesto Ríos González, who considered it "a sad example of decoration and integration,"[21] or Manuel Rosen Morrison, who called it "architecture of State, of propaganda and of national exaltation,"[22] the CU may not be the project that best illustrates the success of modernity in Mexico; they would probably have chosen buildings that closely resemble the international models of that time. In spite of this, the CU illustrates the struggles and shortcomings of the International Style in producing both an emotional and functional, as well as a traditional and modern, architecture according to the dream man the architects wished to create. Perhaps CU's most important accomplishment was that it truly accepted the challenge of building an ideal environment where a new man and nation would be born. It valiantly expressed this mission in spite of its contradictions and, at times, in spite of the architects themselves. In the CU it is possible to see Mexican modernity and humankind's faith in architecture become a physical, social, and cultural reality.

Mexican modernity is not real for us anymore, because we do not share the same dream. It belongs to another time and place. Yet it was real enough to produce a new nation, a new concept of space for human activity, and our present reality was created and influenced by that vision of modernity.

Borges's magician, at the end of the tale, realizes in horror that he, like his dream man, is only an illusion and a dream that someone has dreamt. We Mexicans may also be surprised by our true identity. When we understand that we are only a product of someone else's imagination, the realization that we are only a dream may produce anxiety and confusion at first. However, later we may feel liberated to take life less seriously or we may reach a sense of awareness that may allow us to understand our limitations and responsibilities. In any case, we, like the dream that gave us life, have the responsibility of dreaming a new, alternative existence, part of a never-ending cycle of invented dreams, in which modernity played only a part.

# Notes

1. "The Circular Ruins" in *Fictions* (New York: Limited Editions Club, 1984); Spanish edition: J. L. Borges, "Las ruinas circulares," in *Ficciones* (Buenos Aires: Emece Editores, 1956; Mexico City: Alianza Editorial, 1991), p. 62.

2. M. Tafuri and F. dal Co, *History of World Architecture* I, p. 113. The avant-garde movements like German Expressionism or Holland's De Stijl believed in the transformation of society through architecture and the built environment. This was certainly true for architects like Paul Scheerbart and Bruno Taut, since both believed that glass architecture had the power to transform humanity into "a super mankind dedicated, through love for its own inner freedom, to a symbolic fusion between culture and nature."

3. U. Conrads, *Programs and Manifestoes on 20th-Century Architecture,* p. 39. The transformation of the world into a united society through architecture was viewed, by the De Stijl movement in particular, as the ideal solution for humanity. As they explained in their Manifesto I of 1918, they desired to destroy the old ways of the "domination of individualism," and turn toward the universal by the "international unity in life, art and culture."

4. R. Bartra, *The Cage of Melancholy: Identity and Metamorphosis in the Mexican Character,* p. 114.

5. C. Lazo, "Piedra sobre piedra" in *Pensamiento y destino de la Ciudad Universitaria de Mexico: 1952,* pp. 5–7.

6. P. Gendrop, *Arte prehispánico en Mesoamerica,* p. 37. Gendrop described Cuicuilco as one of the oldest pre-Hispanic pyramids, faced in stone with a circular plan composed by truncated conical elements in four stepped levels, which supports the formal relationship I have established between Cuicuilco and the circular ruins of Borges's tale.

7. The statements about CU made by Pedro Ramírez Vázquez that are cited in this essay were obtained through a personal interview he granted me at his office in the Pedregal de San Angel in Mexico City on March 24,1994.

8. P. Gendrop, *Arte prehispánico en Mesoamerica,* pp. 124–125. Paul Gendrop describes Monte Alban's urban design using quotes from Holmes, Paul Westheim, and Raúl Flores Guerrero, which could appear to refer to CU's urban design if one didn't know beforehand what they were talking about. Flores Guerrero's statement about Monte Alban's "display of asymmetrical harmony" could easily be interpreted as CU's main characteristic.

9. E. Yáñez, "Enrique Yáñez" in *Arquitectura,* p. 91.

10. M. Vitruvio Polión, *Los diez libros de arquitectura,* p. 14.

11. J. O'Gorman, "El desarrollo de la arquitectura mexicana en los últimos treinta años" in *Arquitectura,* p. 51. This was a special issue that commemorated the magazine's first thirty years.

12. E. Yáñez, *Del funcionalismo al post-racionalismo,* pp. 118–119. Yáñez does not give a full description of CU's buildings; instead he establishes the main elements that are present in their design, such as the rational methodology of Villagran Garcia and the notable influence of Corbusian syntax.

13. Le Corbusier, *The City of Tomorrow,* p. 232.

14. J. O'Gorman, "El desarrollo de la arquitectura mexicana en los ultimos treinta años," p. 49.

15. L. Benevolo, *Historia de la arquitectura moderna,* p. 645.

16. F. Bullrich, *New Directions in Latin American Architecture,* p. 28. Bullrich discusses Mexican architecture and its search for a national expression that was interpreted as the integration of the arts or *gesamtkunstwerk.* According to Bullrich, Mexican architects believed this integration to be Mexican because it was also present in pre-Columbian and Mexican Baroque architecture.

17. M. Pani and E. del Moral, *La construcción de la Ciudad Universitaria del Pedregal,* pp. 96–97. Pani and del Moral include a description of all the murals at CU along with several quotes from their artists. The famous muralist Diego Rivera discusses his experience in the sculpture/painting of the Olympic Stadium as an integration between himself and the laborers, stone layers, and bricklayers—in short, all the "eighty human sensibilities" involved in the task. The theory of the *gesamtkunstwerk* appears to have been accomplished in this mural, although this phenomenon was not experienced in all the other buildings at CU, as was expected.

18. H. R. Hitchcock and P. Johnson, *The International Style,* p. 73.

19. M. Pani and E. del Moral, *La construcción de la Ciudad Universitaria del Pedregal,* pp. 102–103. José Chávez Morado, the creator of the three murals of the School of Science at CU, explains the evolution undergone by Mexican muralism, which, according to him, reached a second stage at CU. He states that social and physical changes in both formal and technical aspects were accomplished. According to him, the murals in their formal aspects were more abstract and more related to the exterior of the buildings and their architecture, while in their technical aspects, the murals on the exterior had developed more resistance against the weathering of their materials. It is interesting to see through this statement how Chávez Morado was preoccupied in establishing the mural not as an ornament but as an evolved artistic manifestation of the modern vocabulary. Unfortunately, these ideas were not as convincing in the murals themselves, which were too Mexican and Baroque, as Bruno Zevi later claimed.

20. B. Zevi, "Grottesco Messicano" in *L'Espresso,* p. 16; also published in the Italian magazine *L'Architettura-Cronache e Storia,* Rome, 1957, and republished and translated in the article "Crítica de ideas arquitectónicas" in *Arquitectura,* pp. 110–111.

21. E. Ríos González, in a response to Zevi's article; "Crítica de ideas arquitectónicas" in *Arquitectura,* pp. 113–114.

22. M. Rosen Morrison, in a response to Zevi's article; "Crítica de ideas arquitectónicas" in *Arquitectura.*

# Brasília

## Valerie Fraser

From *Building the New World:
Studies in the Modern Architec-
ture of Latin America, 1930–1960,*
2000

*This article discusses the origin and meanings of Brazil's capital, Brasília. The
city was built in an empty plain in 1960 and has been controversial ever since.
Fraser is among those who see merit in it.*

Mention Brasília, and most people—including many Brazilians—sniff dis-
missively and recite a few clichés about how it bankrupted the country, how
it is built on an inhuman scale, how it was designed with no working-
class housing, or how dated the architecture looks. All these are superficially
true, but Brasília exists—and indeed flourishes—and deserves to be revisited.
Brazil's recurrent economic problems can no longer be blamed on Brasília.
Tourists may complain that the monumental center is vast and unwelcoming,
but the center of Washington is on a similar scale, and can hardly be described
as friendly. The difference, of course, is that Washington is a world center and
buzzes with self-importance, while Brasília by comparison is quiet, and its
monumentality therefore appears vainglorious in the eyes of those predis-
posed to find Brazil full of picturesque poverty and ramshackle *favelas* [slums].
The Brazilian middle class still crack jokes about how the most popular build-
ing in Brasília is the airport, and although it is true that there are those who
still return to the bright lights of São Paulo and Rio at weekends, such stereo-
types are changing, and many who live there would not choose to live any-
where else. Like Canberra, Brasília is valued by middle-class middle-aged civil
servants with children, and, like Chandigarh, by the less well-off, for whom
it is a source of great pride. Many of the latter were the migrant laborers
who came to build the city in the 1950s and 1960s and stayed. They, with their
children and grandchildren and the many subsequent immigrants to the re-
gion, live in the thriving modern towns surrounding Brasília which have
grown up from the much-maligned original satellite shanties. Of course, like
any large city in Latin America, Brasília continues to attract rural migrants
who establish temporary settlements as and where they can: the original satel-
lites are now centers of business, industry and commerce, with their own

high-rise centers and their own shantytowns. As far as the style of the architecture is concerned, Brasília is now old enough to turn the corner into history and leave questions of fashion behind. . . . It is worth remembering that Brasília was built to be the seat of government, and in this respect it is comparable with such *fiat* [planned] cities as Byzantium, Canberra, St Petersburg, Chandigarh, and many others.

The most obvious comparison with Brasília, however, has always been Washington. In the 1940s, Brazil, with its vast landmass and a fast-developing economy, was seen by many as on course to become the South American equivalent of the USA. In 1947 the catalogue to the *Two Cities: Planning in North and South America* exhibition at the Museum of Modern Art in New York, which compared the redevelopment of part of Chicago with the new Cidade dos Motores in Rio, made several references to how the latter "will serve as a model for future Brazilian cities," and drew comparisons between US history and Brazil's future: "The great undeveloped interior and its rich natural resources are an exciting challenge to pioneers and builders today, as the unopened West of North America stimulated men of vision in the nineteenth century."[1] The comparison would have been in the mind of President Kubitschek when he began planning the new capital, and it is worth remembering that Washington, too, was met with incredulity in its early years:

> Behind Brasília may be seen an impulse akin to the irrational optimism which once prompted a group of thirteen bankrupt former British colonies to establish a capital so grandiose in its outlines as to provoke derisive comment for at least fifty years after its founding.[2]

Brasília may still provoke derisive comment, but it differs from Washington and from all other *fiat* cities of comparable scale in that it progressed from plan to official inauguration as the working capital in under four years, a breathtaking achievement by any standard.

Brasília is the embodiment of the belief that modern architecture and urbanism could produce a new kind of city that would in turn lead the way towards a new kind of nation. The impulse to design and build a city *ex nihilo,* on mythological virgin land, is a powerful one in Latin America, and one with a long tradition. In the USA, prior to Washington, few cities were laid out before they were inhabited; but in Latin America, from the earliest Spanish settlements in the Caribbean, the conquistadors had staked out the blocks of their grid-plan towns on an optimistic scale, the regularity a deliberate and explicit metaphor for the social order which the Europeans were importing and which they intended to impose on what they saw as the physical and social disorder of the subjugated Indians. First foundations in colonial Brazil were less uniform, but the motivation was the same: cities were founded in orderly fashion with the twin aims of simultaneously demonstrating and instituting

"civilization."[3] Subsequent regimes continued to embrace the same rhetoric whenever they invested in programs of urban renovation—as in Rio, where it was behind the arguments in favor of the slum clearances in the early twentieth century.[4] The impulse behind Brasília was similar, although the civilizing force of the new city was directed not at the inhabitants of the interior, whether or not they were Indian, but at the country as a whole, and at its condition of underdevelopment and cultural and economic dependency.

## The Origins of Brasília

The idea of a new capital in the Brazilian interior had first been suggested as early as 1789, when, as part of the resistance to Portuguese rule, the rebels of Minas Gerais known as the *Inconfidentes* proposed a new capital, free from associations with the colonial regime.[5] The idea surfaced periodically during the nineteenth century, again linked to Republican aspirations, until 1891, when the young Brazilian Republic (the Emperor had finally abdicated in 1889) designated a great tract of land in the central Brazilian plateau as the "future federal district," within which the new capital was to be sited. Little progress was made for fifty years, however, and then only slowly. President Getúlio Vargas recognized that a new capital would be a way of centralizing control and weakening the individual states, and in particular the rivalrous power of São Paulo and Rio, but it was his successor, Eurico Gaspar Dutra (1946–51), who—during the relatively prosperous postwar years—laid the groundwork with a series of surveys and reports. Article 4 of the 1946 Constitution stipulated the conditions for the transfer of the capital to the central highlands, and in 1948 an investigative team identified an appropriate general area within the federal district. In 1953 Vargas, who had been re-elected in 1951, set a three-year deadline on a research project that would pinpoint the exact location; and in early 1954 the US firm Donald J. Belcher and Associates was commissioned to survey and map the area with regard to its geological, geographical and climatic features.[6] Later that same year Vargas, implicated in a web of corruption and in a failed assassination attempt on a journalist, committed suicide, but despite this the project survived, and in 1955 a Brazilian team—headed by Mareschal José Pessoa, and including architects Affonso Reidy and Roberto Burle Marx—determined the precise site at the confluence of two rivers, proposing that a dam be built to create a V-shaped lake, and that the center of the city be located on the peninsula.[7] Nevertheless, this was a moment of considerable political instability, and the possibility of moving from planning to building a new capital still seemed a long way off.

Then, during the 1955 presidential election campaign, Juscelino Kubitschek made the realization of Brasília his central election promise.[8] In fact he claimed not to have given it much thought until someone asked him about it at a po-

litical rally in Goiás, and on the spur of the moment Kubitschek declared: "I will implement the Constitution." This may be part of the subsequent mythologization of Brasília but Kubitschek was as good as his word. To begin with, it did not look practicable—he was elected by a slim majority, and the army had to intervene to suppress a coup before he could be inaugurated in 1956—but Kubitschek was energetic, charismatic and very determined. He saw Brasília as a way of breaking with the politics of the past, of promoting industrialization, stimulating economic growth, and encouraging regional development. He knew that if he did not make enough progress on Brasília during his five-year term of office, the project would be abandoned by his successor. "Fifty Years' Progress in Five" was his famous slogan, and he succeeded in increasing industrial production by 80 per cent and achieving an economic growth rate of 7 per cent a year. He left Brazil with a self-sufficient motor industry, an international airline, and a brand new modern capital city.[9]

Brasília would not exist were it not for Juscelino Kubitschek, just as the Ciudad Universitaria in Caracas would not have been built without the determination of Perez Jiménez, nor the Ciudad Universitaria of Mexico City without Miguel Alemán; but as in Mexico and Venezuela, the realization of these ambitious projects also depended on the availability of architects with the experience and the vision to design and build these new worlds. Most accounts of Brasília start with the city plan, the Plano Piloto, but Kubitschek was not prepared to wait for this to be drawn up. He began his own plans even before he was elected, and no sooner had he taken office than he commissioned his old friend Oscar Niemeyer, with whom he had collaborated in Pampulha, to begin by designing a presidential palace to be called the Palace of the Dawn (Palácio da Alvorada). From the start Kubitschek used every opportunity to promote the idea of Brasília in terms of a new dawning in Brazilian history, a new beginning, as the concrete realization of a utopian dream.[10] He visited the site for the first time in October 1956 with Niemeyer, and they decided to position the new palace at the east end of the peninsula that would be formed when the rivers were dammed.[11] In other words, the presidential palace was positioned in such a way that the sun would rise behind it in a dramatic enactment of the way in which the building itself heralded the dawning of the new city and the new Brazil.

## Palácio da Alvorada: A Prototype for Brasília

The architecture of the presidential palace set the tone for the new capital. In his autobiographical account of the construction of Brasília, Kubitschek describes how he rejected Niemeyer's first proposal for the presidential palace, saying that what he wanted was something that would still be admired in a hundred years' time. Niemeyer went away, and—as is only appropriate for a

good origin myth—worked away all night on a new design. The result was just what Kubitschek wanted:

> Here was a building that was a revelation. Lightness, grandeur, lyricism and power—the most antagonistic qualities mingled together, interpenetrating, to achieve the miracle of harmony of the whole . . . with its columns in the form of inverted fans emerging from the reflections in the water, which constitute, today, the marvelous sculptural symbol of Brasília.[12]

Part of the reason for Brasília's invisibility in recent years is perhaps that just as Burle Marx's gardens now seem elegant rather than controversial, so we no longer recognize these "antagonistic qualities" in Niemeyer's architecture. Niemeyer's design for the Alvorada Palace is volumetrically simple: a long, low, rectangular glazed box, the flat roof extending out over the length of the back and front façades and supported on columns to create a protected arcade. The interior is disposed like a Renaissance palace, with services in the semi-basement, public halls and meeting rooms on the main floor, and private accommodation above. The most distinctive feature, as Kubitschek recognized, and the point at which the "antagonistic qualities" arise, is the columniated arcade. Here Niemeyer inverts the traditional arched form so that the roof is apparently supported on a series of points, the inverted arcade like a series of high-peaked waves. Indeed, at the time it was known as "Oscar's cardiogram."[13] This inverted arcade is itself supported on shallow arches, this time the right way up, and the meeting of the two arcades articulates the internal division between the semi-basement and the main floor. The lake in front reinforces the impression that the whole building floats, almost dances on the shallow lower arches, while the open arms of the upper arches reach up in an appropriately expansive and optimistic gesture.

The columniated façade lends itself to multiple readings: as an arcaded colonnade it suggests the colonial past, a link that Niemeyer valued:

> I rejoice in realizing that these forms bestowed individuality and originality upon the Palaces in their modest way and (and this I deem important) established a link with the architecture of colonial Brazil. This was not done through the use of near-at-hand elements dating from that period but by the expression of the same plastic intentions, the same fondness for curves and the rich and gracious lines that gave it its striking personality.[14]

This is not just a formal link—a taste for sweeping curves and striking effects of light and shadow—but also a more ideological link with the rejection of tradition represented by baroque forms. The inversion of the traditional ar-

cade represents a challenge to the rationalist values of classical architecture whereby buildings should be firmly grounded and stable, and columns in particular should look as if they are capable of fulfilling their intended function as supports. Baroque architecture had mounted a similar challenge in Brazil as in Europe with, for example, columns that undulate as if they were made of plasticine, and entablatures that bulge and burst instead of providing a clear horizontal reference point.

But the inverted arcade also involves a technical rupture from that past. At key points of contact—the building with the ground, the roof with the supports—the columns not only refute their traditional role as load-bearers but point literally and metaphorically to the achievements of modern technology, making the irrational rational, the impossible possible. To emphasize the anti-classical-yet-classical contrast—as in Washington and, indeed, grand palaces and seats of government throughout the world—the building is faced up in shining white marble.

## The Plano Piloto

In April 1956 Kubitschek founded a development corporation under Israel Pinheiro, the Companhia Urbanizadora da Nova Capital do Brasil, or NOVACAP, to oversee the design and construction of the rest of the city. Reidy and Burle Marx, who had worked on the preliminary survey, suggested calling in Le Corbusier to act as adviser, as in 1936, but Brazil's architectural achievements during the intervening twenty years made this hard to justify, and in any case Kubitschek was determined that Brasília should be a Brazilian project through and through.[15] So in September, at Niemeyer's insistence, NOVACAP organized a competition for the design of the city: it was open only to Brazilians, and required of entrants a plan indicating the layout of the key monuments and a written report, to be submitted by the following March. The jury included Niemeyer, and was dominated by his friends and associates, so it is hard to see as surprising the choice of his old mentor and friend Lúcio Costa as winner from the twenty-six entries. As Le Corbusier once remarked of architectural competitions, "a classic method of choosing your own favorites behind a reassuring 'anonymity,'"[16] and there was considerable bad feeling among some of the losers. The Milton brothers, who were awarded joint third prize, had invested a great deal of time and money in an extensive, thoroughly researched plan, and were outspoken in their criticism of the system.[17] Reidy and Moreira, who had complained about the composition of the jury, did not take part: they presumably guessed that it would be a stitch-up. . . .

[At the end of Costa's Report was] an extraordinarily inclusive vision of a city that will be both monumental and "efficient, welcoming and intimate,"

"spread out and compact, rural and urban," whose aims are both "lyrical and functional." He ends as he began: by referring to José Bonifácio, "the Patriarch," who in 1823 had recommended the transfer of the capital from Rio de Janeiro to the inland state of Goiás, and had suggested the name *Brasília:* "Brasília, capital of the airplane and autostrada, city and park. The century-old dream of the Patriarch."[18]

The design for Brasília, the realization of the Patriarch's dream, springs ready-formed into Costa's mind: "It was born of that initial gesture which anyone would make when pointing to a given place, or taking possession of it: the drawing of two axes crossing each other at right angles, in the sign of the Cross."[19] It is also clear from the second sketch, which included the contour of the planned peninsula, that Costa oriented the arms of his cross to approximate to the points of the compass. Brasília is therefore the primordial sign. It marks the center, the conceptual (if not the geographical) heart of Brazil, the crossroads at which the country would come together, from where the new Brazil would grow, the point at which the treasure of the future is buried. Costa's crossroads implies trade and traffic and communication. It provided a neatly symbolic starting point for Kubitschek's goal of "integration through interiorization," and accorded perfectly with the government's image of Brasília as promoted in a diagrammatic map dating from 1956 which makes it the center of a sunburst of lines that visually connect the capital to all the other major cities in Brazil, complete with distances. All roads lead to Brasília, even though there were no such roads in 1956. As Holston argues, this image, endlessly repeated in all manner of contexts from school textbooks to government reports, effectively establishes an idea of Brasília as the country's center of gravity.[20]

Costa then takes this rectilinear "sign of the Cross" and modifies it by curving the transverse arm, both to adapt it to the local topography and "to make the sign fit into the equilateral triangle which outlines the area to be urbanized,"[21] so again combining elements in a mythicized idea of unity: the four arms of the cross contained within the equilateral triangle. The origins of the plan therefore imply the geometrical purity of Le Corbusier's compelling definition of the right angle as "the essential and sufficient implement of action because it enables us to determine space with an absolute exactness,"[22] but it then evolves into something different: by curving the arms, it breaks out of the "latent tyranny of the normative orthogonal grid," to borrow a phrase from Kenneth Frampton's discussion of the more organic architects of the 1950s, particularly Alvar Aalto.[23] This allows the Brasília plan to be orthogonal in origin, like a grid-plan colonial town, while simultaneously rejecting such rigidity; it is rooted in the past, but also suggests a development, perhaps a liberation, from the limits of history.

Costa's curved north-south axis animates the design in a remarkable way, opening it up to the most diverse readings. The plan has proved to be—at a

symbolic level, at least—phenomenally successful. Some capital cities are rendered distinctive by their ancient origins; others—Buenos Aires or Paris—by their well-established reputations as centers of culture and sophistication. Closer to home, Rio de Janeiro, the capital Brasília was to replace, is associated with the hedonism of carnival and its singularly dramatic landscape features. Brasília, of course, could lay no claim to history or culture, high or popular; nor were the empty *cerrado* scrubland of the high plateau of the Federal district, or even the vast, beautiful skies, sufficient to give an identity to the city. Costa's Plano Piloto, however, does. It is most commonly described as an airplane: the Praça dos Trés Poderes the cockpit, the ministries the passenger seats, the curved north-south residential districts, of course, the wings. As a city dominated by its system of highways for cars, and shaped like an airplane, it neatly combines two key images of modernity, and points to the improved communications between the various regions of Brazil and with the rest of the world that Brasília was designed to promote.

But Costa's plan has also been described as a bird, a butterfly, or a dragonfly, more poetic metaphors for the city, suggesting natural beauty, grace and liberty. It is also—more subversively but unmistakably (at least in the sketch of the cross with curved arms within the triangle)—a bow and arrow. Even the way in which Costa has traced over the lines again, thickening and coarsening them, suggests a primitive petroglyphic character, as if to remind the ultra-modern city that there is an alternative and much more ancient history of Brazil which can never be completely eradicated.[24] This same multivalent cross-within-triangle sketch also evokes both the crucifix and Leonardo's Vitruvian man, an anthropomorphic form with its extremities touching the corners of the geometrical shape. Originally Brasília's image was that of a very masculine place, built and inhabited by gutsy frontiersmen, but more recently this has given way to a gentler, more domestic idea, reflecting the way the city has been accepted and incorporated into Brazil's sense of itself. As a mark of this domestication of Brasília it is perhaps not surprising, therefore, to find that the plan has been subjected to a new reading: that of a perfectly formed woman, reclining with arms outstretched, and "sensually bathed in the brilliance of a tropical sun."[25] Savage, modern, natural, mechanical, male, female: the imagery of Brasília's plan is all-inclusive. Costa's plan and Niemeyer's Palácio da Alvorada establish the formal language of Brasília—what Kubitschek identified as the "antagonisms" between lyricism and monumentality, but also between tradition and modernity, between continuity and rupture. In fact the distinctive column shape which Niemeyer developed, apparently overnight, is essentially a Latin cross with curved transverse arms, the same idea which Costa claims sprang into his mind unbidden as the root of the city plan. . . .

Costa placed the core functions of Brasília in a triangular plaza at the east

end of the monumental east-west axis: these were the three key government institutions—the Supreme Court, the Executive Palace and, at the apex, the Congress. As he explains in his Report: "These are three, and they are autonomous: therefore the equilateral triangle—associated with the very earliest architecture in the world—is the elementary frame best suited to express them."[26]

He does not offer examples of early architecture to authenticate his claim; he is really creating an archetype with an imaginary history.[27] He suggested that this area be called the Praça dos Três Poderes (the Place of the Three Powers), and so it came to pass. To the east of this the monumental axis is flanked by the buildings of the government ministries like a guard of honor protecting the route to the triangular apex. The rest of Brasília is strictly zoned in CIAM fashion [typical of city plans developed under the influence of the Modernism of Le Corbusier]. Around the central crossing point of the two arms of the plan are grouped the cultural and entertainment zones, with hotels to the west, and banking and commercial zones to the north and south. The residential districts are contained within the great curving wings of the north-south axis. These were organized into *superquadras,* high-density housing complexes similar to those we have seen elsewhere in Latin America, but of course in Brasília *superquadras* were the rule, instead of being isolated examples of modern high-rise developments in the midst of an otherwise heterogeneous and disorderly urban sprawl.

Costa's submission for the competition was adopted in its entirety, and although as the city has grown there have been some modifications in detail, the overall plan, with its through-routes, its zones and monumental buildings, remains more or less exactly as laid out in the Plano Piloto. . . . Costa's view that the creation of Brasília would be instrumental in the future development of the region, and of Brazil, is absolutely in line with the ethos of the European conquerors of the sixteenth century, and Costa himself is conscious of this historical precedent, "for this is a deliberate act of possession, the gesture of pioneers acting in the spirit of their colonial traditions."[28] This also attracted Holford, who caught the spirit of the enterprise in his report to the *Architectural Review* (1957):

> [Brasília was needed because] enormous potential wealth, in agriculture, stock, minerals, water-power and other natural resources, remains untapped for lack of centers of communication, marketing and culture, in the partly unexplored hinterland of Brazil.[29]

With the idea of Brasília, the rhetoric of the sixteenth-century conquerors and that of the twentieth-century modernists converge. What was needed next was an architecture to match such aspirations.

## Niemeyer's architecture

Niemeyer was architect-in-charge of NOVACAP and personally responsible for designing almost all the major buildings for the monumental center, giving Brasília a homogeneity comparable to that of Villanueva's university city in Caracas. For the Praça dos Três Poderes he designed two long low palaces facing each other: the Planalto Palace for the Executive, to the north, and the Palace of the Supreme Court, to the south. The core of both is a glazed International Style box, but as in the Alvorada Palace each is suspended within a form of inverted colonnade. Again the architecture embodies fundamental contradictions, as Niemeyer recognized:

> I did not feel inclined to adopt the usual sections—cylindrical or rectangular columns which would have been far more economical and easier; on the contrary I looked for other forms such as, even if clashing with some requirements of a functional nature, would characterize the buildings, impart greater lightness to them by making them appear almost to float or at least to touch the ground only slightly.[30]

The architecture can been seen as a metaphor for the way in which Brasília would enable Brazil to take flight, to lift off into the future. On several occasions Niemeyer reiterates that he wants architecture to challenge the imagination—that far from being coldly functional and rational it should be inspiring, surprising, astonishing in its beauty and apparent *irrationality:*

> [The architecture] should not seem, as I saw it, cold and technical, ruled by the classical, hard and already obvious purity of straight lines. On the contrary, I visualized it with a richness of forms, dreams and poetry, like the mysterious paintings by Carzou, new forms, startling visitors by their lightness and creative liberty; forms that would seem not to rest heavily on the ground as required by technical reasons but make the Palaces look airy, floating light and white in the endless nights of the Brazilian highland; surprising and breathtaking forms that would lift the visitor, if only for a little while, above the hard and sometimes insuperable problems which life puts in everyone's path.[31]

This is not the modernism of maximum-efficiency-at-minimum-cost functionalism This is a much more utopian vision of the role of architecture in society, closer to the aims of the Russian Constructivists. It could almost be an adaptation of an early description of Tatlin's *Monument to the Third International* (1920):

[W]hile the dynamic line of bourgeois society, aiming at possession of the land and the soil, was the horizontal, the spiral, which, rising from the earth, detaches itself from all animal, earthly and oppressing interests, forms the purest expression of humanity set free by the Revolution.[32]

In these palaces Niemeyer creates an architecture which "rises from the earth," but the Congress buildings at the apex of the triangle provide a strong contrast: twin administrative towers, twenty-eight stories high, and a broad, low block housing both the Senate and the Chamber of Deputies. These last are represented above the roof line by the twin cupolas of their respective assembly halls: one convex for the Senate, the other concave for the Deputies. The twin towers dominate the vista down the Monumental Axis, and are thus reminiscent of the twin towers at the head of the monumental Avenida Bolívar in Caracas. In Brasília, however, instead of suggesting a gateway, the towers are closely paired, and hold hands, as it were, via a linking bridge between the thirteenth and sixteenth floors. Costa's Report had recommended that the site be landscaped with raised platforms in what he called the "ancient oriental technique," in order to provide "an unexpected monumental emphasis."[33] Here too, however, Niemeyer adds an impression of weightlessness to monumentality—the twin towers float above a pool of water, while the flat roof of the assembly building appears to be suspended between the two lanes of the monumental highway, like a launching pad for the flying-saucer cupolas.

The various Ministry buildings are aligned on either side of the monumental axis in a very similar arrangement to the one sketched in Costa's Plano Piloto. The Ministry of Justice and the Ministry of Foreign Affairs, the Palácio Itamaraty, are given pride of place at the end of the esplanade nearest the Congress, as stipulated in the text. These two ministries are again "palaces," like the Planalto and Supreme Court beyond. Each is enclosed within a modern version of a classical peristyle, this time with the colonnades the right way up, but having set up a more traditional type, Niemeyer then backs off again: the structures are not faced in classical marble but left as explicitly modern coarse-textured concrete. Both make use of water to enhance their impact: the Itamaraty colonnades grow out of a still pool, while on the Ministry of Justice water pours from outsized spouts along the façade, like a version of a motif used by Le Corbusier in Chandigarh. Niemeyer was at pains to make the most of Brasília's greatest natural asset—its vast skies—and the use of water and walls of glass animate the architecture by reflecting the endlessly changing cloud-patterns, another means of incorporating an idea of flight and weightlessness. As if by contrast, however, the other ministries are plain slabs with no columns, water or any form of screening to protect their glass façades from the sun's glare.

Brasília Cathedral is another of Niemeyer's highly original designs. It is set

back from the line of the ministries for the reasons listed in Costa's plan: so that it has its own monumentality, so that it does not impinge on the view down to Congress and the Three Powers Plaza from the crossing point of the two axes, and to ensure that the functions of Church and state are visibly distinct.[34] Circular in plan, the structure is essentially sixteen gigantic ribs which curve together and then fan out to form what has been variously described as a crown, praying hands or an opening flower. Niemeyer's ideas, here and elsewhere, were realized by Joachim Cardoso, a brilliant structural engineer whose importance often tends to be overlooked. From the outside it is these structural features which predominate; from inside it is the brilliance of the stained glass, which appears all the more spectacular because the entrance is by means of a dark underground corridor. A further dramatic effect is created by the angels suspended by wires above the nave, which turn in constant slow motion.

The theatricality of the cathedral is akin to that of the baroque churches of Brazil, where the exteriors are relatively plain, with the emphasis on the architectural and the volumetric, while the interiors are a breathtaking riot of carved and gilded woodwork, painted ceilings and gesticulating angels. In another more explicit reference to Brazilian baroque art, along the route leading to the subterranean entrance over-lifesize sculptures of the apostles by Alfredo Ceschiatti form a severe guard of honor in a reworking of Aleijadinho's famous Old Testament prophets on the monumental stairway up to the church of Bom Jesus do Matozinho in Congonhas do Campo, Minas Gerais.

David Underwood sees Niemeyer's "free-form modernism" as "rooted in a fundamentally Surrealist project: the attempt to call into question the objects and conventions of the everyday and the commonplace through the deliberate juxtaposition with the extraordinary and the marvelous."[35] Niemeyer and Cardoso between them certainly achieved visual effects which were deliberately startling in a way that seems to have more to do with either surrealist or baroque art than with much of mainstream modernist architecture. Niemeyer believed that architecture should aspire to the level of a work of art, and in pursuit of this he favored "an almost unlimited liberty of forms," regardless of functional constraints:

> It is the timid, those who feel safer and more at ease when limited by rules and regulations which leave no room for fantasy, for deviation, for contradiction of the functional principles they adopt and which lead them to accept passively solutions that, repeated again and again, become almost vulgar.[36]

This is a long way from the "form follows function" formula that was so popular with the earlier generation of modernists—Warchavchik in Brazil and O'Gorman and Legorreta in Mexico. It is a long way from the parsimonious-

ness that necessarily underlies the large social projects—schools and housing—in Mexico, Venezuela and Rio; it is far removed from the modernist variant of classical architecture whereby the interior and the exterior of a building should correspond, where honesty in the form of structural and technical clarity (exposed steel frame, supporting members visibly *supporting*, exposed concrete, exposed electric wiring and service elements) is seen as a requirement. . . .

But despite—or perhaps because of—this, what Costa and Niemeyer did achieve was a city with a sort of ready-made identity that has helped people to identify with it, and to feel at home. This they did by establishing from very early on an easily recognizable set of symbols. The plan itself, as we have seen, lends itself readily to a variety of interpretations: aeroplane, bird, butterfly, woman. The plan was prefigured—and, in a sense, legitimized—by the Alvorada Palace columns, whose distinctive, four-pointed star shape, faceted like the head of a lance or a crystal, quickly came to be seen as the symbol of Brasília, and was adopted as the format for the city's coat of arms in 1960.[37] Niemeyer's monumental architecture encourages symbolic or metaphorical readings of a relatively simple kind. I found that the ordinary people of Brasília were very anxious to explain to me that, for example, the twin towers of Congress, with the linking bridge between them to form an H, represents Humanity; or that the military museum was shaped like an M. The arching shape of the military Acoustic Shell was described to me as cleverly designed by Niemeyer so that it could be interpreted as a sword hilt, an image the military would accept, or an all-seeing owl, in which guise it represents the people. Like the owl, the people are always alert, and see everything; the military, on the other hand, can see only what is straight in front of them. Whether or not Niemeyer designed these buildings with such "popular" readings in mind is not important. What is important is that he created architectural forms which lend themselves to such interpretations. Perhaps it is because they are so "startling," so new, and therefore carry no ready-made historical interpretations with them. To create monumental architecture which does not speak in an alien, elite language, but is something in which everyone can participate, seems to me an important form of empowerment. It encourages a sense of ownership and pride.

Brasília, for all its problems and contradictions—or perhaps, again, *because* of them—continues to grow and flourish in a way that confounds the critics.

## Notes

1. Museum of Modern Art, *Two Cities: City Planning in North and South America*, Museum of Modern Art, New York 1947, p. 4.

2. Norma Evenson, "Brasília: 'Yesterday's City of Tomorrow,'" in H. Wentworth Eldridge (ed.), *World Capitals: Toward Guided Urbanization*, New York 1975, p. 503.

3. Valerie Fraser, *The Architecture of Conquest: Building in the Viceroyalty of Peru 1535–1635,* Cambridge 1990, pp. 49–50; James Holston, *The Modernist City: An Anthropological Critique of Brasília,* Chicago 1989, pp. 201–2.

4. Teresa Meade, *"Civilizing" Rio: Reform and Resistance in a Brazilian City 1889–1930,* Pennsylvania 1997.

5. Evenson, "Brasília: 'Yesterday's City of Tomorrow,'" pp. 472–3.

6. Willy Staübli, *Brasília,* London 1966, p. 10.

7. Yves Bruand, *Arquitetura contemporanea no Brasil,* São Paulo 1981, p. 354.

8. Evenson, "Brasília: 'Yesterday's City of Tomorrow,'" pp. 474–5.

9. Simon Collier, Harold Blackmore and Thomas Skidmore (eds.), *The Cambridge Encyclopedia of Latin America and the Caribbean,* Cambridge 1985, p. 272.

10. The dawn image is ubiquitous. For example, the official hymn to Brasília, sanctioned by decree in 1961, and the popular song "Brasília, Capital da Esperança / Brazil, Capital of Hope," both refer to the city as marking the dawn of a new era: *Brasília Tourist Guide,* Brasília 1995, p. 12.

11. Staübli, *Brasília,* p. 131.

12. Juscelino Kubitschek, *Por que construi Brasília,* Rio de Janeiro 1975, p. 60.

13. William Holford, "Brasília: A New Capital for Brazil," *Architectural Review* 122, December 1957, p. 396.

14. Staübli, *Brasília,* pp. 22–3.

15. Bruand, *Arquitetura contemporanea no Brasil,* p. 354.

16. Le Corbusier, *When the Cathedrals Were White,* London 1947, p. 21.

17. Bruand, *Arquitetura contemporanea no Brasil,* p. 355, n. 24.

18. Holford, "Brasília," p. 402.

19. Plano Piloto in ibid., p. 399.

20. Holston, *The Modernist City,* p. 19.

21. Plano Piloto in Holford, "Brasília," p. 399.

22. Le Corbusier, *The City of Tomorrow and Its Planning,* London [1924] 1987, p. 13, a text with which Costa was very familiar.

23. Kenneth Frampton, *Modern Architecture: A Critical History,* London 1985, p. 202.

24. In the popular imagination of the 1950s there were those who viewed Brasília as fit only for Indians. Holston quotes from a samba of 1958: "I'm not going to Brasília . . . I'm not an Indian or anything; I don't have a pierced ear," Holston, *The Modernist City,* p. 321 n. 12.

25. *Brasília Tourist Guide,* p. 4.

26. Plano Piloto in Holford, "Brasília," p. 400.

27. No one seems to have commented on one of the accompanying sketches: a triangular plaza with buildings that correspond closely to those later designed by Niemeyer. The sketch is labelled "Forum de palmeiras imperiaes proposto em 1936 por Le Corbusier / Forum of imperial palms proposed in 1936 by Le Corbusier." The Praça dos Tres Poderes would therefore seem to be lifted directly from something Le Corbusier suggested while he was in Rio in 1936, which would support the story told to Geoffrey Broadbent.

28. Plano Piloto in Holford, "Brasília," p. 399

29. Holford, "Brasília," p. 396.

30. Staübli, *Brasília,* p. 22.

31. Ibid., p. 23.

32. Quoted in *Art in Revolution: Soviet Art and Design since 1917,* Hayward Gallery, London 1971, p. 22.

33. NOVACAP, *Relatório do Plano Piloto de Brasília,* Brasília 1991, p. 22.

34. Plano Piloto in Holford, "Brasília," p. 400.

35. David Underwood, *Oscar Niemeyer and Brazilian Free-Form Modernism,* New York 1994, p. 79.

36. Staübli, *Brasília,* p. 21.

37. *Brasília Tourist Guide,* p. 11.

# 5. Non-Objective and Informalist Modes of Abstraction

# The New Art of America

**Joaquín Torres-García**

From *Apex,* July 1942

Translated by Anne Twitty

*A*lways a persistent polemicist, Uruguayan painter Joaquín Torres-García *called even more urgently for an autochthonous art form in the 1940s. His Americanism was founded on a primitivist appreciation of certain pre-conquest art forms, expressed in an abstract language that he regarded as universal. This combination was his own creation, yet it had great influence across the continent.*

The artist of today has understood that art cannot be separated from the human problem. Therefore, he should select what each epoch requires, but, in my opinion, only what it requires in a universal sense, meaning that which can unite men rather than separate them. And in this sense, art can not only preserve its purely plastic and non-descriptive aspect (since the plastic act belongs to the universal order, being based on universal laws); but then too, in this way, there is no longer any disparity between the form and what is expressed, for everything joins in perfect unity. Perhaps the artist has usually misunderstood something in trying to approach human life, because he has believed that the human was only to be found in the anecdotal, but we don't believe that; we have resolved the problem in another way. And by resolving it in this way, we see that we enter fully into the great universal tradition that demands, just as we do, that both the life and the aspirations of man, like those of art, be founded on the pure laws of thought, thereby establishing an objective law that would raise man above the level of his individuality; for it is this individuality that separates men, while the universal law is what unites them.

So thought, geometric thought, should dominate our art and our life.

Well then, on our continent, many centuries ago, there was a perfect and astounding culture, founded on those principles. And that is why we should not search far afield for something we already have close at hand, and in a form that is, understandably, more appropriate to our world. Vestiges of those generations still remain, arts and people who are keeping the faith in that principle alive and struggling to reestablish it, by casting off the avalanche of conquerors who tried to annihilate it. That is, there exists the idea of a peo-

ple founded on the universal and cosmic concept of man, an idea that today arises anew from those vestiges of ancient and noble races who are surrounded by the motley horde of sometimes crude and ignorant invaders impelled only by corrupt ambition. And we, who lack coats of arms, but who interpret the ancient and honored law in the same way, should we be indifferent to such noble emotions?

A great desire for unification is arising in all the Americas today. And although some interpret it in the narrowly political sense, we ought to contribute to this movement, without losing sight of the primordial, and while distancing ourselves from the narrowly political. We must explore the depths, disregarding the purely material aspect.

Faced, then, with problems of other countries, which interest us because they concern human nature (on the universal order, always), without being selfish, we should be even more interested in our own problems. Here we have been given ground to cultivate and we should fulfill our duty. Therefore, even before this, we turned the map around, indicating that our North was the South, and so, in a way, cutting our ties to the spiritual tyranny of Europe. Let us reintegrate ourselves, then, into the great Indo-American family.

What we are proposing is not pan-Americanism, but a spiritual union based on a profound relationship that goes beyond the concept of States. We needed an objective toward which to orient our production, and also one to serve as a base for us; and not only to define us, in that sense, for ourselves, but also for others. So that under the sign of Indo-America, we can march in perfect unison, basing ourselves on something real, since the artist too must take from the earth. We must be, then, artists of the Americas.

Here we were born, here we first saw the light, and this is far from Europe, not only in a material sense, but in habits and customs, mentality, character, and temperament. So much attention has been paid to Europe, and why? Isn't this the World too? Let us live according to the realities of this place without thinking about those over there, not even of those old cultures as such. Because here we have to build again, to form ourselves. And we shouldn't do it by imitation. Certainly, we all have European blood; we are *criollos;* and therefore we can't say that we are Indo-Americans. But we were born in America! And are we going to try to compete with the Spanish or Italian grandfather, born in Europe . . . trying to pretend we are from there? We never will be. This land has already placed an indelible and permanent seal on us. And therefore, although we are not completely native, we are from here. Our generation should be a new one, which attempts to relate to this land by penetrating into its depths. Therefore, disregarding or repudiating the superficial, which, as it has no roots, does not survive here; and this means everything foreign. Also rejecting the family of colonialism, the invader, and the pseudo-culture it created: a bitter drink brewed from the worse kinds of alcohol. To be precise, if we want to find stature, nobility, measure, order—

that is, what should be called culture—we can find it in the archaic culture of the continent; everything that could elevate, regenerate, purify us. . . . Purify us of vulgarity and crudity (our gaucho ways), and of the heritage of intrigue and the underhanded procedures of shyster lawyers, of the invaders, which presently form the basis of the customs, sentiments, and character of the criollo we now are but should not continue to be. In other lands of this southern part of the Americas, all of this is now being shaken up and the native is being vindicated; because the living rock of the race continues to appear from under the avalanche, and it is no longer a compound substance, but in its pure, native state. Whatever we are, pure or mixed, of native blood or not, by the mere fact of being born here, our password should be—whether we are from Chile or Mexico, the Rio de la Plata region or Brazil—to search for America; to delve into the living bowels of the earth; to take root in it forever; to grow, to exist for this soil, and to leave behind the fluctuating whims of Europe. To build. To form ourselves. To create. A true culture must replace what is referred to here as culture. Not, then, an amalgam of diverse kinds of knowledge and principles, incoherent and random, but something mature, unified: a structure. Something integral, based on an idea that serves as a matrix, in harmonious conjunction.

Well then, we have executed an initial task during these last few years. The idea of structure, of construction, has been launched, and plastic works have been created in accordance with it. The geometric principle has appeared, and this is already a reintegration into the archaic culture. Also the idea of the cosmos, of universality. And, since these ideas did not previously exist among us, we can say that the return to the tradition of the continent begins now—and not through archaeological studies, as in other parts of America—but through the essence of that tradition; and therefore, not imitating it, but wanting only to perpetuate it, in accord with that motivation, and yet now with another form and expression—which means—adapting it to our present spiritual needs. Yes, our works of art, in which we believe we can still find traces of European culture (for we had to start from there), already contain all of the qualitative essence of their own tone and structure, and as a greater affirmation, they are sustained by an analogous concept of the universe. A very humble beginning, but at any rate, a beginning.

The fact that we want to give our art a very concrete path in that sense does not mean that we have to put it into a mold; that we have to elaborate it by thinking; in sum, to fabricate it, as they say. Not at all. To think, yes, and a great deal; to meditate on this; to bring our behavior into harmony with it; to live in that great thought of the Americas, that, yes. But then, when we begin to work on our art, to forget everything! To try, as always, to make a structure, only a structure, guided by our feeling. And then that tone of the Americas will demonstrate itself: in one, through color, in another, by an arabesque or a type of composition, in another, through symbols, according to each par-

ticular temperament. And everything will belong to that tone of America. A tone that we can barely perceive (precisely because it is ours, and natural to us), but which will become perceptible, as it was already in Paris, in the works in our exhibition—for according to a critic from the journal *Beaux Arts,* these works had an "Indo-American character." And I repeat, we will achieve this in the measure in which we are able to stop thinking about it. Because, in thinking about it, something extremely dangerous can happen: falling into the archaeological, making South American pastiches. And that has at all costs to be avoided. That is what everyone who has tried to make an indigenous art has fallen into: Chileans, Mexicans, Peruvians, etc., not excluding figures like Diego Rivera: and if not that, into another stumbling block just as dangerous: the folkloric. For now we have freed ourselves from such a fall, and I am sure that we will remain free of it. So we are untouched by the values and qualities of European art (which we studied so devotedly). Let Cézanne and Picasso, Matisse and Renoir, remain over there. And even the masters of all schools. And why not Egypt and Greece, and Byzantium . . . since we have here an art as strong and as profound as theirs? It is better for us to study our own, in order to penetrate into its essence.

Our attitude will have to be better interpreted for the public; perhaps then they will see where we come from and where we are going. . . . Perhaps the reason for this schematic art, its symbolism, which has remained incomprehensible for so many, and the logic behind such an orientation, will be understood. But we will have to make an effort to make it clear that we are not in this tradition in order to plagiarize it, but because we have realized that it forms part of the great universal tradition of the centuries: the tradition of Abstract Man.

Perhaps we have occasionally enclosed ourselves within the limits of total abstraction, that is, we have rejected any relationship with the world of forms; or rather, we have stopped paying attention to the forms of the real physical world. The images of things and their groupings have sometimes been excluded from our works. As a discipline, I feel that this has been beneficial; and I even believe that its continuance would not be prejudicial to our art. But not all temperaments are alike, and there may be someone among us who feels the need to introduce elements of the real world into his work. I would say, so much the better! Because this never signifies abandoning the rule. For the visual quality of a form is not determined by the fact that it is related to an invented rather than a real form, but by the fact that it is within the geometric plane and can therefore function with other forms within this plane; by the fact that it is not an imitative form. And for this reason we reject imitation, not figuration.

I would now like to call upon another reason for suggesting a partial turn toward a certain mode of figuration, whether taken from reality, as a synthesis, or as a symbol of certain ideas. We all know how it is possible to vary the

expression and aspect of works of art, even within the terrain of total abstraction; and we could almost say that, in this sense, the possibilities are endless. But even though this is possible, in practice it may happen that, in the absence of outside elements (of whatever kind), the artist may either exhaust his themes or repeat them monotonously. So contact with the real may generate new ideas. And that is what I now suggest, as long as the motifs are selected according to their suitability for transformation into something universal.

Having said that, I would like to warn you that I am not contradicting myself, for it might seem that I am contradicting what I have so often recommended, to approach the work without any proposition in mind except that of creating a structure. To consider real objects, or groupings of objects, etc., does not contradict such a proposal, since I am not suggesting giving any particular literary expression to a grouping, dramatizing it, writing a thought graphically so that it can later be deciphered; no, I am only suggesting the adoption of certain forms, just as if they were abstract and geometrical forms. Since above all we want each artist to produce something previously unrealized that may be contained in his soul (in his subconscious), we know that will not be achieved by deliberately trying to express particular ideas, emotions, or feelings. So approach the work cleanly, without all of that, without any intention at all; but there is no reason not to think of real objects, or universal ideas, if these are seen through the imagination with total objectivity. Therefore, next to the idea of good or bad, symbolized by any real form, they can place a hammer or a clock, since for the plastic artist they will or should have value only as forms. And in such a grouping, and independently of those schematic representations, something imponderable, from his innermost nature, will be expressed, and that will be the best: the soul of the work, its music, its perfume: some of that mystery known as personality. And in our case, South American personality.

Representation and figuration, then, in the sense of giving greater vitality and juiciness to the work, are beneficial, but, I repeat, not indispensable.

It is undeniable that we can come even closer to our tradition through figuration; but that is just what we should avoid. In the first place, because none, or very few, of those representations can suit us; but above all because that will bring us nearer to plagiarism or imitation of that art and its particular stylization. Let us be content to be within the geometric style, which is what links us to that remote art, and to be from these American lands, like them, and therefore to give color and genuine expression that will establish a kinship. For since the primitive peoples of this continent made use of whatever they saw around them and whatever stirred in their souls, we should do the same. That the Sun (Inti) be the father of all, as it was to them, is no contradiction, since our present knowledge does not conflict with this idea; for, in effect, the Sun gives us life. But if we men of the cities see neither snakes nor wild beasts, and cannot believe in supernatural beings, why should we pre-

tend? On the contrary, let us be very precise; let us look at present reality with the naked eye; let us consider the century we are in and not falsify us as artists have too often done (and as many of them are still doing), by trying to feel like a primitive (an inhabitant of Nigeria or Australia); for it is one thing to recognize the plastic values of the art produced by these primitives (and even to interpret it as a standard to follow), and another to imitate it—whether in its deformations, subjects, stylizations, etc. On the contrary, since we have to introduce forms taken from reality into our art, let us do it by interpreting those of today, contemporary with us, what we observe daily. And I am sure that the most recent work, as long as its representation is geometric and schematic, observing rhythm, order, and measure, can—because of that representation and because we are native to these lands—be as genuine as any Inca or Aztec work. Because what characterizes the art of a country is a hue of the color, an atmosphere of the work, a particular form of stylization, and not what is represented. And have faith in what I say, and act accordingly, for this is absolutely certain. For this reason too, imitating or copying the typically folkloric is a mistake, because it is not there that we find the soul of things, but rather in the qualities and structures of their plastic organization, in the tones and ways of opposing and discriminating between them, in something non-descriptive: rhythms, tonalities, arabesques, proportions, something that will emerge from the soul without our being aware of it.

Much is expected of the Americas, but how do we live and how do we think?

We live day by day, according to the circumstances, resolving small material problems; that's all. And as far as art is concerned, trusting in pure instinct and not in plagiarism.

Now let us start from this: that we here are not in Western Europe. This is a reality. And although this land was colonized by Europeans, that means nothing; we are in South America.

Their European problem, then, does not have to be our problem. Our culture must have a different origin. This continent is younger; its chronology is not that of the Old World; our prehistory is considerably behind European prehistory. So the origin of culture here is more recent. Besides, at a certain moment its normal evolution was interrupted by the invaders. Which is to say, that it was buried for almost four centuries.

Well then, I believe that if the autochthonous culture is to continue, it has to be taken up where it was left off, ignoring a false culture that was formed later: false in the sense that it could never be more than a transplant. And that hybrid thing (for it has mixed and become deformed) is what we call our culture. Poets, philosophers, artists, musicians, statesmen, legislators, educators, everyone, for the moment, has that illusion—meaning, is in that false position.

We here are in need of a true renaissance. Surely, we will contribute to it, but so will archaeologists and historians, artists and poets, by exhuming, with

true enthusiasm, that buried America. And we are already able to outline a strong, complete civilization, complete in every order of things.

Now then, delving into its essence, what do we discover? That Truth which is always the same, which we will find wherever man has penetrated deeply. Does that mean that it is no different from any other culture? Yes and no. It is not different (nor could it in essence be different, for then it would not be true and certain). But yes, in its appearance, in its modality, in its form. It has its own structure, its mythology, its maps and details according to a corresponding medium. And it is perfect, complete. Here is a fundamental reason for cutting our ties with Europe, both as an attempt to perpetuate the native culture and also to repudiate that bastard culture that has taken shape on our continent. We must go deeper. And that does not mean (as some would like to pretend) that we reject the knowledge of the world. Well, I will not say any more about that. The lack of character of these South American peoples is only apparent, for underneath the slight European veneer lies the true autochthonous character. Now what happens is that, due to the European, the true character does not thrive. But with a different consciousness of the situation, it can grow and develop, and this is what should happen. This true character is also threatened by the bastard culture to which I have referred, a sort of scab that leaves no outlet for the genuine. One lives in that shadow and ignores a reality whose hour has come. It is time for it to manifest. Above all, that exaltation of the invader and its grotesque manifestations should cease. Because the Indian was a geometer. And that means culture. Because that is a manifestation of Universal Man. With the Indian (and one can hardly speak of the contemporary Indian), we can have a dialogue. His monuments, his cosmic concept of the world—which determined his social system, his calendar, his mythology, and his art—speak to us eloquently. But such fundamentals, similar to those of other countries, here are stamped with their own particular structure and qualities. Therefore, we must follow the great Tradition of Man, but within this Indo-American modality.

# Inventionist Manifesto

From an exhibition brochure,
Salon Peuser, Buenos Aires,
March 1946

Translated by the editor

*Buenos Aires witnessed an important flowering of abstract art in the late 1940s, as artists took steps that anticipated developments in Europe and the United States. These innovations were accompanied by much pamphleteering, as artists split into groups and subgroups. This manifesto was written by the members of the Concrete-Invention group before the Madí movement split away from it. The polemic here is against illusionistic art of any sort, including such modern movements as Cubism, which are also based on reality.*

The artistic age of representational fictions has reached its end. People everywhere are becoming less and less sensitive to illusory images. That is to say, they have progressed in their sense of integration into the world. The old phantasmagoria no longer satisfy the aesthetic appetites of the new person, who is formed in a reality that demands total participation, without reservation.

Thus the curtain comes down on the prehistory of the human spirit.

Scientific aesthetics will replace speculative, idealist, and millenarian aesthetics. Considerations based on the nature of beauty have lost their reason for being. The metaphysics of beauty have died of exhaustion, to be replaced by the physics of beauty.

There is nothing esoteric about art; those who style themselves among the "initiated" are only liars.

Representational art shows abstractly framed static "realities," when in fact all representative art is an abstraction. In truth, these experiences, whether we realize it or not, have taken us in the opposite direction from abstraction; the results, which have included an exaltation of the values of pure painting, prove it irrefutably. The battle opened by so-called abstract art is fundamentally the battle for concrete invention.

Representational art tends to sap the cognitive strength of viewers, rendering them unaware of their true powers.

The raw material of representative art has always been illusion: Illusion of

space. Illusion of expression. Illusion of reality. Illusion of movement. A formidable play of mirrors which leaves people cheated and debilitated.

In contrast, Concrete art exalts Being, because it practices it. Art of the act generates the will to act.

Let a poem or a painting not serve merely to justify a renunciation of action, but rather let it contribute to the viewer's sense of the world. We Concrete artists are not above any controversy. We are on the front lines of all controversies.

Down with art which reinforces our differences. We favor an art which serves, from its own sphere, the new union which is arising in the world.

We practice the technique of joy. Only exhausted techniques feed off melancholy, resentment, and conspiracy.

We favor creative delight. Down with the disastrous pestilences of Existentialism and Romanticism. Down with the minor poets with their minor wounds and insignificant introspective dramas. Down with all elite art. We favor a collective art.

The Surrealists have said, "Kill Optics." They are the Last Mohicans of representation. We say, "Exalt Optics."

This is fundamental: to surround people with real things and not phantasms. A particular aesthetic demands a particular technique. The aesthetic function opposes "good taste." The pure function. LET US NEITHER SEEK NOR FIND. LET US INVENT.

# The Founding of Madí

**Gyula Kosice**

From Osiris Chierico, *Reportaje
a una Anticipación,* 1979

Translated by the editor

*One of the founders of the Madí group here discusses the reasons for the split with
the Concrete-Inventionists. The Madí artists favored kinetic art and explo-
rations of different media; hence they regarded their enterprise as more "inventive"
than Concrete-Invention.*

You could say that we had no history, no ancestor on which to rely, in the
entire country. Not one of the European movements after Cubism had flow-
ered here, not even as an echo. Nor could we consider Pettoruti as a truly
valid example, since we regarded him as a painter of Cubism by machine. He
had remained definitively behind, unable to take advantage of the possibilities
in new openings. It should be understood that between 1924, when he
brought his Cubo-Futurism to Buenos Aires, and our present time, he had re-
mained dormant, on the sidelines of many important events. The Bauhaus
was one of these, which few people in Buenos Aires knew of in those years.
Luckily Grete Stern, who played such an important role in the development
of the Argentine avant-garde, had a very large archive of this movement and
others, which allowed us direct contact with them. It was a revelation. Male-
vich, Moholy-Nagy, Gropius, Pevsner, and Gabo all provided us with valu-
able conceptual tools. And after urgently analyzing them, we began working
almost clandestinely to construct our own ideas. For example, we noticed that
the postulates of the Concrete Manifesto of Van Doesburg, which was the
point of departure for the great period of nonfigurative art, had been taken
over by Max Bill, but he opened the door only a crack. In his work and in that
of Vantongerloo there remained traditional elements and outmoded points of
view, such as the immovable art object, whose animation they had never even
proposed. We surpassed these examples, and if we were to recognize ances-
tors, they would be Duchamp and Calder; they were the only ones who up to
that time truly dealt with the kinetic enterprise, with movement as an objec-
tive and fundamental concept of the work. But, isolated as we were, we had to
do everything on the run and by ourselves.

## On the Split between the Madí
## and Concrete-Invention Groups

It was not a breakup of a conceptual character. Maldonado, Lidy Prati, Edgar Bayley together with his wife and his brother all just moved away from the original core of the group. Meanwhile, Rothfuss, Arden Quin, and I began to work out the building of what would later be called Madí. It is important to point out our reasons for our not keeping the same name after the split. We thought that to do so would be a flagrant contradiction in terms. If we were going to work under the rubric of "Invention," then we could not say that we were also devoted to "Concrete Art" since the former by nature excludes the latter. We were not involved in Concrete Art, but rather in the Invention of totally new objects. Thus I invented the term "Madí," a word that could have any meaning whatever. In fact, it was not that way, because the word was itself a complete invention in accord with the premises of the group. From the beginning there were those who believed, and still believe, that the word meant "Movimiento de Arte de Invención," but this was not the case. Some even saw an echo of a slogan of the Republican side in the Spanish Civil War, still reverberating in our unconscious: "Madrid, Madrid, Madrid!" But in the final analysis it was just a new word, the product of a pure act of invention.

We were a group of people who could be broadly defined as leftists, but only ideologically and not in the sense of being militants. We had all embraced Marx with enthusiasm and without preconditions, but we were not Marxists in the normal sense of the term. Rather we were idealists who were at that moment searching for a theory. We believed in totally free expression in the political and social realm, in a world where all forms of exploitation of man by man had been eliminated. Naturally, this position gave us a somewhat tendentious character which I cannot completely deny, but it never really went beyond that.

# Madí Manifesto

**Gyula Kosice**

Translation reprinted from
Dawn Ades, *Art in Latin
America,* 1989

*This manifesto was penned in 1946 by the leader of the Madí movement. It
reflects the group's tendency toward kinetic and multimedia forms, as it sepa-
rated from Concrete-Invention.*

Madí art can be identified by the organization of elements peculiar to each
art in its continuum. It contains presence, movable dynamic arrangement, de-
velopment of the theme itself: lucidity and plurality as absolute values, and is,
therefore, free from interference by the phenomena of expression, representa-
tion and meaning.

Madí *drawing* is an arrangement of dots and lines on a surface. Madí *paint-
ing,* color and two-dimensionality. Uneven and irregular frame, flat surface,
and curved or concave surface. Articulated surfaces with lineal, rotating and
changing movement. Madí *sculpture* three-dimensional, no color. Total form
and solid shapes with contour, articulated, rotating, changing movement, etc.
Madí *architecture,* environment and mobile movable forms. Madí *music,* re-
cording of sounds in the golden section. Madí *poetry,* invented proposition,
concepts and images which are untranslatable by means other than language.
Pure conceptual happening. Madí *theater,* movable scenery, invented dia-
logue. Madí novel and short story, characters and events outside specific time
and space, or in totally invented time and space. Madí *dance,* body and move-
ments circumscribed within a restricted space, without music.

In highly industrialized countries, the old bourgeois realism has almost
completely disappeared, naturalism is being defended very half-heartedly and
is beating a retreat.

It is at this point that abstraction, essentially expressive and romantic, takes
its place. Figurative schools of art, from Cubism to Surrealism, are caught up
in this order. Those schools responded to the ideological needs of the time
and their achievements are invaluable contributions to the solution of prob-
lems of contemporary culture. Nevertheless, their historic moment is past.
Their insistence on "exterior" themes is a return to naturalism, rather than to
the true Constructivist spirit which has spread through all countries and cul-

tures, and is seen for example in Expressionism, Surrealism, Constructivism, etc.

With Concrete art—which in fact is a younger branch of that same abstract spirit—began the great period of non-figurative art, in which the artist, using the element and its respective continuum, creates the work in all its purity, without hybridization and objects without essence. But Concrete art lacked universality and organization. It developed deep irreconcilable contradictions. The great voids and taboos of "old" art were preserved, in painting, sculpture, poetry respectively, superimposition, rectangular frame, lack of visual theme, the static interaction between volume and environment, nosological and graphically translatable propositions and images. The result was that, with an organic theory and disciplinarian practice, Concrete art could not seriously combat the intuitive movements, like Surrealism, which have won over the universe. And so, despite adverse conditions, came the triumph of instinctive impulses over reflection, intuition over consciousness; the revelation of the unconscious over cold analysis, the artist's thorough and rigorous study vis-à-vis the laws of the object to be constructed; the symbolic, the hermetic, and the magic over reality; the metaphysical over experience.

Evident in the theory and knowledge of art is subjective, idealist, and reactionary description.

To sum up, pre-Madí art was:

A scholastic, idealist historicism
An irrational concept
An academic technique
A false, static and unilateral composition
A work lacking in essential utility
A consciousness paralyzed by insoluble contradictions impervious to the permanent renovation in technique and style

Madí stands against all this. It confirms man's constant all-absorbing desire to invent and construct objects within absolute eternal human values, in his struggle to construct a new classless society, which liberates energy, masters time and space in all senses, and dominates matter to the limit. Without basic descriptions of its total organization, it is impossible to construct the object or bring it into the continuity of creation. So the concept of invention is defined in the field of technique and the concept creation as a totally defined essence.

For Madí-ism, invention is an internal, superable "method," and creation is an unchangeable totality. Madí, therefore, INVENTS AND CREATES.

# An Interview with Fernando de Szyszlo

**Álvaro Medina**

*Art Nexus,* January 1994

*F*ernando de Szyszlo of Peru is one of Latin America's best-known abstract
artists. Important subjects taken up here include the issue of cosmopolitanism
versus nativism in Latin American art and an explanation of how Szyszlo arrives
at the titles of his works.

AM:   *Your artistic training was a classical one common to all our artists: first,
fine arts studies in your own country, Peru; followed almost immediately
by a journey to Europe. Let us begin with your European experience.*

FS:   I arrived in Paris in 1949, at the age of 24. I immediately became
aware of two things: that I did not know how to paint, and that
I was Latin American. I wanted to achieve a dense kind of work,
something which was not direct, but somehow I was working like
an Impressionist because the color which I put on the canvas was
the same as that which was on the palette, that is, I did not mix it
or shade it afterwards. I longed for a painting of transparency, a
problem which I solved by going to Florence, where I began to
copy Titian and Tintoretto in order to learn. The other point which
I became conscious of in Paris was much more important because
it had to do with myself as a human being. We Latin Americans
were part of Western civilization, though we were only its poor
cousins, essentially marginalized. Although Baudelaire was as
familiar to me as César Vallejo, in art things were very different.

AM:   *Why was this?*

FS:   Because in literature, in the Americas, the other non-Western tradi-
tion had almost disappeared, a disappearance which began with the
problem of a language which had no written form and had survived
only orally. Even so, some of the examples which have come down
to us are really amazing. In the sphere of the plastic arts, however,
the legacy is not only amazing but inexhaustible.

AM:   *Did the fact that things were different awaken in you an interest in pre-
Colombian art?*

FS: I had already done some painting inspired in pre-Colombian textiles. I never copied nor took pre-Colombian elements in any direct way, because as Rilke said, "You have to have lived," which means that we have to learn to use our own experience. Since then I have tried to use all my cultural heritage, which includes not only Vermeer and Rembrandt but the anonymous artists who wove textiles in ancient Peru. I have always been interested in primitive things because technique never overwhelms the content. Perhaps the opposite occurred during the Renaissance, where we have to look behind the elegance of Botticelli to appreciate the content. In primitive art, the form is a very fine skin which barely covers the content. To put things in another way, we could say that artists, although they have a name, are in the end always anonymous, because they express only the greatness and misery of our human groups.

AM: *This is not exactly the case with other Latin American artists.*

FS: We have to distinguish between two poles of attraction: Mexico City and Buenos Aires. Mexico exalts its own tradition, whereas Buenos Aires has wanted to become one with Europe. Pettoruti is a painter whose work is admirable, but his defect is that he has no roots. They have always been up to date in Buenos Aires, but they have had to pay the price of renouncing the search of their own identity to do so. They have done some first class work, but without any soul. Mexico has rejected outside influences and has exploited their circumstances: revolution, politics and so on. . . . It is here that the confusion arises. In the rest of Latin America, those who followed confused the local theme with the Mexican theme, as though the character lay in the theme. This was fatal, because in the other countries politics were eliminated and what remained was the picturesque, in the belief that you could do Latin American painting by depicting Indians. Then Tamayo came along, and this was his greatness. Stimulated by the experience of his work in the Museum of Archeology, Tamayo discovered the essence and was able to recapture it in the 1930s, showing the path towards our own image.

AM: *When and where did you meet Tamayo?*

FS: I met him in Paris, thanks to Octavio Paz. This search for our own image was something which concerned a lot of us. On other occasions I have said that Octavio Paz wanted to publish in the Paris of the 1950s a Latin American magazine to express the frustrations of Latin Americans. He wanted to call it *El Pobrecito Hablador,* like the figure from Larra. We used to meet in the Café Flore and in the Café de l'Hôtel des Etais-Unis. Julio Cortázar, Serrano Palza and the Nicaraguan Carlos Martínez Riva came along to these meetings. Paz then wrote his article on Tamayo and Mexican painting. My friend-

ship with Obregón, Zañartu, Soto, Otero and Vigas dates from that period.

AM: *Did you converse with Latin American painters?*

FS: I have had more contact with writers. I did not discuss these matters with painters. The person who really promoted the idea of Latin American art was Pepe Gómez Sicre. Before him, there was Argentinian painting, Colombian painting, Venezuelan or Mexican painting. It was Gómez Sicre who was the first to speak of Latin American painting and to see the link between Lam and Tamayo. He proposed the idea and found an ally in Marta Traba, who was one of the initial promoters of the idea. Together, they worked towards making Latin American art something more than a mere appendix to other art.

AM: *Were they really successful?*

FS: To the extent of what had already been achieved by the painters in their studios. I myself have always followed Ortega's philosophy: "I am myself and my circumstances." If I live in Lima, I cannot paint like a New York painter. We in Peru are not overwhelmed by advertising but by poverty and underdevelopment. I cannot do conceptual art like an artist in SoHo in New York.

AM: *Who agreed with you in this?*

FS: I feel closest in this respect to Francisco Toledo, because he has the same interest in erotic, ritual and sacred elements that I have. Mine is more clandestine, of course. . . . I also feel close to the early Obregón, from the 1940s, 1950s and 1960s, with the first period of Armando Morales not with his current figurative work, which is very handsome, but with his work from the 1950s. I organized the first exhibition by Morales in Lima, in 1959: pictures of dead guerrillas which were almost abstract. I admire Edgar Negret and Eduardo Ramírez Villamizar, who are great artists in my opinion.

AM: *The roots of your work lie deep in various expressions of pre-Colombian art. Could you tell us what these sources are?*

FS: I am very interested in the art of Chantay, particularly the painted fabrics, where there is an almost gestural kind of expression. They seem to me to be very free, naive and innocent. The artists who did these textiles were, I believe, like Miró or Klee. Later I became interested in the textiles of Paracas. I take a knife or teeth from a Chavin fabric. . . . I do it unconsciously and this is perfectly natural. Then we have *The God of Chavin*. There is thus a vocabulary which has gradually been established on the basis of forms of aggression, such as that of the *tumi* or sacrificial knife, forms which I connect to a table or an altar. The deep contact which I have had not only with pre-Colombian art but with the so-called primitive art of Africa or

Oceania, has inspired me to seek out inhabited forms, forms which are a cloak for a living content.

AM: *These forms of aggression of which you spoke were also used by Orozco, Tamayo and Lam. Obregón too used them at the same time as you did. How can we explain this kind of morphological obsession?*

FS: I believe that the strength and possibilities of Latin American art lie precisely here. In our societies there is still much to narrate, to name and to attest. For me this is why Latin American literature has proved so fascinating. Where else could Vallejo or Neruda have been born, but in these harsh, frustrating and suffocating regions, which are at the same time full of marvelous things?

AM: *You mentioned earlier the existence of two conflicting poles: Buenos Aires, with its tendency towards cosmopolitanism, and Mexico, with is national-ism. Which is the correct path in your view?*

FS: There is no doubt that the Mexican path is the surest. The only way to do good art is to establish a relationship with the place. Fashion has fallen to the wayside. Dalí used to say that "fashion is what goes out of fashion." Cosmopolitanism is the contrary of universalism. To be cosmopolitan is to be provincial and therefore local. Art has never been a search for the superficial. It is true that there was a time when what was successful was what was in fashion, but time has passed and proves the contrary.

AM: *But Marta Traba criticized Mexico and the Andean countries for being too closed, unwilling to adopt the open attitude flourishing in Buenos Aires.*

FS: Both forms were, I believe, essentially provincial ones, present both in those who admire everything which comes from outside simply because it comes from outside and in those who refuse to see only what is strictly at hand. The provincial and the cosmopolitan join hands in their respective worlds where there is neither wind nor oxygen.

AM: *Since 1959 your work has been organized around a thematic series with very suggestive titles. How did you choose these titles?*

FS: In each case the title has come afterwards. I do not try to find forms which explain a title but rather forms which in turn suggest their own title. In general they are a set of aggressive forms which are like daggers or the beaks of birds. This violence is consonant with a general pattern with which I have been working for a long time, in which there are both birds and angels. At the moment I am working with winged figures. I have always been very impressed by a verse of Rilke, who said "all angels are terrible ( . . . ) because they are disdainful of our destruction." I have always remembered this. I had the same impression when I visited the Cathedral of Chartres

in 1949 and read that "this place is terrible, God inhabits it." This fusion of what is beautiful and terrible has always moved me. That is why I like writers such as Georges Bataille and Samuel Becket and am interested in anything dealing with the idea of sacrifice. Breton spoke of the laicist-sacred art as a way of achieving this, something to which only religion previously gave us access.

AM: *Let us turn to some of the implications of the titles, and begin with Cajamarca, one of your first series.*

FS: With the death of Atahualpa, in Cajamarca, there was a sacrifice. I must point out that my interest in pre-Columbian culture is not limited to its visual dimension. When I paint Atahualpa, I am evoking an event which is part of my cultural heritage. It is my political and social commitment which is brought into play, the way in which I establish a relationship between myself and one of the components of Latin American art. Of course, my position goes beyond just art and encompasses man and all that he is. Art that is only art is but a fragment. If it is merely visual, then it is mere entertainment.

AM: *Could you say something about two series with titles which are apparently clear, but in the end very secret: Path to Mendieta and Sea of Lurin?*

PS: Mendieta is a beach in Paracas, to the south of Lima. On the one side there is the desert and on the other the sea. On this sand-strewn place, a thousand years ago there emerged a culture which produced some of the most handsome and elaborate textiles ever created. Why were these textiles so elaborated, when these people lived in cane huts? The most curious thing about the textiles is that they were woven not for the living but for the dead. The old inhabitants of Mendieta lived alongside the graves and spent their time visiting the dead. Lurin is a desolate and mysterious desert. I have had a small house and workshop there for three years. José Maria Argüedas used to say that all the places settled by the pre-Colombian peoples are of immense beauty. This is the case, for example, with Machu Picchu and Chavin. This beauty continues to shine and it helps me find the past.

AM: *You seem to have a great nostalgia for ancient Peru prior to the arrival of the Spaniards. Does this explain why the titles of so many of your works are in Quechua?*

FS: I use Quechua because it is a way of seeing Peru which is not exclusively Western. I am not trying to present an alternative but rejecting the notion that we are purely Western. Fashion makes us look outwards, rather than inwards. The kind of painter which I am has only one kind of painting. Each picture is a failure to capture that picture, or if you like, the gap between what I want to do and what I can do. I am not interested in the past just because it is the past. I

am above all interested in the poetry, which is fundamental in my work. I have worked from César Vallejo, Saint-Jean Perse, Samuel Becket, Rilke and Octavio Paz, among many others. In one of his poems, Saint-Jean Perse describes a journey through a desert which seems to me so like that of Peru. . . . For me, the titles in Quechua possess this poetic connotation. Inkarri is the name of a quechuan myth whereby Tupac Amaru, the Inca chief who was cut up, is recovering underground and preparing to recapture his land. Uku Pacha means the underworld; a world full of evil and good, but on a different scale from that in which we live in. Apu Inka means Lord Inca. The series entitled Apu Inca Atawallpaman is an elegy for the death of the Inca Atahualpa. It means, literally, Lord Inca Atahualpa. Runa Macii means my fellow-creature, my neighbor. Puriq Runa means traveler, walker. Puka Wamani is a red falcon, and Waman Wasi is the home of the falcon. Illa is a magical stone. Moon, for example, is killa.

AM: *I was surprised by your move from painting to sculpture.*

FS: The sculpture which I recently did took years to incubate. For a long time I had been curious to see how these images would look in three dimensions. This urge has now been satisfied.

AM: *It was thus an isolated experiment?*

FS: Sculpture requires concentration on things which do not really interest me. The plaster, the smelting. . . . I am 66 years old and all I want to do is to paint.

# Alejandro Obregón

**Marta Traba**

From *Revista Mito,* Bogotá,
1960

Translated by the editor

*M**arta Traba's art prose sometimes hurtles forth with the intensity of the poetry that she also wrote. Here she defends one of her favorite artists, Colombian painter Alejandro Obregón, seeing in his work deep allegories of Latin America.*

The first great theme that Obregón took up in his painting in the new expressive style was the condor. The period of the condors is unforgettable in his work because it is the period in which he searches for great meanings, entering decisively into ambitious enterprises.

Obregón deployed enormous condors posed over imaginary Andes, and like the real colonizers, he founded tiny cities of fragments painted with implacable fervor, around which he set forth luminous battles among vast plains, inexplicable lacunae with deep and convoluted shadows. These condors form, from a strictly pictorial point of view and without considering his weighty ambition, the line of greatest effort and risk for any artist because the condors force the painting, formed up to now with strong backbones, to continuously decompose. But Obregón shows here that he knows, as few do, how to shore up at the precise time and place a structure that is crashing down. The tension in the work is tremendous; tremendous also is the dramatic expectation that these adventurous compositions cause in the viewer, where the eye supports itself even as it begins to fall irrevocably, or as the eye stops after it has launched off like an arrow upward through the lightness of the washes, or how it halts when a fiery part threatens to spread an uncontrolled blaze across the entire work, or when it restarts and reanimates itself when a grave and somber gray envelops some other vast zone of the work.

The Manichaean philosophy is one of the most moving examples of human thought, because it is the history of an endless combat; I do not know if Obregón is aware of how easily these canvases ally themselves with the search for meaning inherent in that movement, nor does it matter if the artist has the philosophical awareness to comprehend the aesthetic reach of his art. He should only create; someone else should investigate, so that the greatest num-

ber of people can understand and feel. Thus is established the logical order of creation, the critical and receptive faculties in which the art work rests in order to form itself.

When I speak of the Manichaean meaning of Obregón's recent works, I want to say in some just and exalted way exactly what deep feeling these formal and illusionistic works reach, but I also wish to underline also that these meanings could not have leapt abruptly to light without first undergoing a slow gestation, a deliberate hidden elaboration, requiring years of skill and intricate fencing which at the end drop off as the artist masterfully manipulates the urgent need to build and compose.

In the condors of 1959 and in the later works in this meaningful line, Obregón does not break away, however, from the Baroque spirit toward which his style has always tended.

I think it is difficult to find a country other than Colombia in which so many "epochs" can flourish at the same time: the Baroque epoch, the Classical epoch. Because we are dealing with a country with great extremes of climate, a landscape shocking in its sudden and unmediated shifts from cold to hot, and of extremes in its intellectual life such as might correspond to a new country, virgin in culture, where the citizen fluctuates from pole to pole without the weight of tradition which would lend some stability. In essence, and in accord with the aesthetic generalizations that are common currency in this day and age, Colombian artists should be unstable, since they lack all the counterweights that might fix and stabilize them. They wander through a cultural desert which they try to populate in vain, a land whose cultural frauds, irrelevance, and falseness demoralize them unceasingly. They are very far from possessing that security in awareness and reason that might exist in an environment that meets their needs, in their image and likeness, which are necessary if humanity is to have classic equilibrium. If we accept that Classicism is born of the harmony of a person with his circumstance, nothing can be more radically anti-classical than we Latin Americans, who live in perpetual nonsense, tyrannized by extreme passions, confronted with legal, political, and social facts that are utterly inexplicable, held up in a volcanic world which twists all relations between persons and between a citizen and the society.

The specifically Baroque character of contemporary Latin America cannot, however, live within any past category of the Baroque. Let us say that we are dealing with a congenital disposition toward chaos, in the same way that Jorge Romero Brest defines Expressionism as an emphasis applied to known forms. The emphasis both underlines and deforms them: this disposition toward chaos shakes them and alters them. The insistently Baroque character of today's Latin American painters signifies an irruption into each work of a confused, burdened, and disorderly world; but it is no more than the loyal confession of principles of those who live in the chaos. They are sensitive witnesses to the chaos, and since they are not legislators but painters, they let the

anarchy flow through their hands, they work with it, they let it create the environment, they populate it with toys, visions, phantoms, and monsters. If there is something authentic in contemporary Latin American painting, I firmly believe that it is this "Baroque perversity," mixed at times with endemic inertia unable to put order to the chaos; perversity or amalgamation that can give very diverse results, surprisingly poetic in the work of Fernando de Szyszlo of Peru, movingly mythological in the work of Rufino Tamayo, shrill and spectacular in Osvaldo Guayasamín.

Returning to the Baroque style of Obregón: what is original in him—now more than ever—is that his art implies an arduous combination of Baroque and Rococo: that is, a mixture of force and highly refined feebleness; of the strong and hard will of the Baroque with the gratuitous act which marks the Rococo in painting; of the ample understanding of wide surfaces and great dynamic compositions alternating with paradoxical care over the most minute detail, according to Herbert Read's splendidly disrespectful definition of Rococo, "an out-of-place ingenuity." Only thus can we explain his slicing a dark night, a field of battle among dramatic grays, with the exasperated arabesque of a red line; or that he crumbles the cold heart of a fish until it becomes a glowing plume of radiant tones within a violent storm of blue that scrapes and electrifies the canvas.

His style begins with a clear formal development, and later with equal honesty and ardor, he embarks on an impetuous search for meanings, allying himself with the best art of our times. Thanks to these strengths it loses its local flavor, and it is not a simple vanity to believe his art to rank in aesthetic categories of worldwide validity. It is certain that his work situates itself admirably at its birthplace, and it develops according to the temperature and climate of his native city, just as it obviously embodies the character of a country with its constants (even the weak, negative, and hesitant ones) that one can take from this continent. But it is just as certain that his lively and epic painting could in its essence be born very comfortably in the Mediterranean region, even though condors fly only over the Andes, where they originated, and volcanoes erupt only in our jungle regions, ultimate testimonies to anarchy.

Should we keep this great painter only for Colombia and hold him within an arbitrary and accidental geographic perimeter, or should we enroll him among the great figures of all contemporary art? However much one studies, analyzes and admires the work of Obregón, it is possible to locate him most precisely in this particular ambiance, that of the chaotic spirit of the Americas, vulnerable and ambitious, potentially capable of the most sudden gushes of feeling. We could add he embodies this spirit, which in certain measure conditions him and which he expresses, much better than his predecessors and contemporaries, as he clearly repudiates in a natural and instinctive way any base form of nationalism, and any servile tracing of folkloric or picturesque themes, which have been widely held to represent America.

Obregón is not *definitively* ours (because there can be no definitive definitions in chaos except as the raw material from which they spring); but he is an important element for our future definitions. And the text of these possible definitions will come from painting, much more than from other artistic expressions of the Americas. Obregón is not painting just to write this text, but it does seem to flow from his work, and his work gathers certain tendencies that in the future will go to form our own face, hands, and body. Deep, unconscious voices find their sound box in his art. We feel there, for example, the devotion with which our new nations seek their destiny, even as they fail to notice the futility of such quests; the innocence with which they discover and claim things; the incessant counterpoints of strength and weakness; the speed with which they accustom themselves to the struggle, enjoy it, and from it derive unexpectedly deep-rooted powers; the delirium of constant invention; the sensuousness of creation and destruction, of errors, deviations, and progress; the constant flux, in the end, of a continent which is still in development, has not yet solidified completely, and turns all minds into nomadic and questing ones.

Alejandro Obregón was born in 1920. At age forty, we can already see clearly what he has accomplished, and we can judge his great qualities as an indisputable part of Colombian art. We cannot predict what he will do in the future. His work seems still rather splendidly inconclusive, even though it has left behind the difficult stages of apprenticeship and development of a style. He worked for many years building dreams and hallucinated landscapes on his skewed tables, until he found himself able to throw off all that was inessential. Now he paints condors and volcanoes from his position on the slope of a mountain, catching glimpses of torrid beaches by the shores of chaos. His outstanding paintings have become grave, desperate, and powerful.

# 6. Constructivist
# and Neo-Concrete Art

# GRAV Manifesto

## Transforming the Current Situation in Plastic Art

---

Published for an exhibition
at Maison des Beaux-Arts,
Paris, 1962

Translated by Davida Fineman

*A*rgentine artist Julio LeParc was one of the founders of the Visual Arts Re-
search Group (GRAV). This manifesto sets forth the group's approach to re-
examining the most basic aspects of the social function of art and the relationship be-
tween viewers and works.

The Groupe de Recherche d'Art Visuel invites you to demystify the artistic
phenomenon, to pool your activities so as to clarify the situation, and to set
up new ground rules for appraisal. The Groupe de Recherche d'Art Visuel is
made up of painters who are committing their activities to ongoing research
and the visual production of primary basic data aimed at freeing plastic art
from tradition. The Groupe de Recherche d'Art Visuel thinks it is helpful to
offer its viewpoint, even though this viewpoint is not definitive and calls for
subsequent analysis and other comparisons.

### General Propositions of the Visual Arts Research Group (1961)

*Relationship of the artist with society*

This relationship is presently based upon:

> The unique and isolated artist
> The cult of the personality
> The myth of creation
> The overestimation of aesthetic and anti-aesthetic conceptions
> Creation for the elite
> The production of unique works of art
> The dependence of art on the marketplace

## Propositions to transform this relationship

> To strip the conception and the realization of works of art of all
>   mystification and to reduce them to simple human activity
> To seek new means of public contact with the works produced
> To eliminate the category "Work of Art" and its myths
> To develop new appreciations
> To create reproducible works
> To seek new categories of realization beyond painting and sculpture
> To liberate the public from the inhibitions and warping of apprecia-
>   tion produced by traditional aestheticism, by creating a new
>   social-artistic situation

## Relationship of the work to the eye

This relationship is presently based upon:

> The eye considered as an intermediary
> Extra-visual attractions (subjective or rational)
> The dependence of the eye on a cultural and aesthetic level

## Propositions to transform this relationship

To totally eliminate the intrinsic values of the stable and recognizable form, be it:

> Form idealizing nature (classic art)
> Form representing nature (naturalistic art)
> Form synthesizing nature (cubist art)
> Geometrizing form (constructivist art)
> Rationalized form (concrete art)
> Free form (informalism, tachism, etc.)
> To eliminate the arbitrary relationships between forms (relationships
>   of dimension, placement, color, meanings, depths, etc.)
> To displace the habitual function of the eye (taking cognizance
>   through form and its relationships) toward a new visual situation
>   based on peripheral vision and instability
> To create an appreciation-time based on the relation of the eye and
>   the work transforming the usual quality of time

## Traditional plastic values

These values are presently based on the work which is:

> unique
> stable

definitive

subjective

obedient to aesthetic or anti-aesthetic laws

*Propositions to transform these values*

To limit the work to a strictly visual situation

To establish a more precise relationship between the work and the
human eye

Anonymity and homogeneity of form and relationships between
forms

To stress visual instability and perception time

To search for a non-definitive work which at the same time is exact,
precise, and desired

To direct interest toward new variable visual situations based on
constant results of the eye-art rapport

To state the existence of indeterminate phenomena in the structure
and visual reality of the work, and from there to conceive of new
possibilities which will open up a new field of investigation

# Color and the History of Painting

**Carlos Cruz-Diez**

From *Carlos Cruz-Diez*
by Alfredo Boulton, 1975

Translated by Francis M.
López-Morillas

*H*ere the Venezuelan artist Carlos Cruz-Diez gives a historical rationale for his
explorations in color.

The history of painting has been the history of a long journey toward real-
ity, but an apparent, a representative reality. That is, painting is a transposi-
tion: the man, tree, or house that we see has been represented by the painter
on a two-dimensional surface, thanks to a set of symbols, or a visual formula,
that has not ceased to evolve from the first fumbling attempts in caves to the
realism of [Jacques-Louis] David. Fundamentally, to improve this visual sym-
bolism was to attempt to draw closer to reality itself.

Hence, in the nineteenth century, when man discovers or invents im-
proved methods of visualization, he discovers that painting is expression and
has always been, like any other human activity.

Now painting is turning toward the metaphysical, the purely expressive;
that is, and fundamentally, toward the search for a different, invisible reality.
But this invisible reality cannot be captured through visible elements, for then
its own dynamic will die. Hence it is an internal reality.

But this art has spoken of reality in terms of figuration, of representation;
and this, in my judgment, creates an error in the natural evolution of ideas
and in man's progress in search of his truths.

Thus, today's art is an art of "realities." It could almost be said that it is a
sort of "autonomous reality." When David painted *The Coronation of Napoleon*,
painting achieved one of its greatest aspirations: reality. But this reality is pre-
cisely a negation of itself. In fact, time is stopped and space is fictitious, un-
real: it is a question of an interpreted space, and the spectator has needed long
training to decipher it.

Obviously this preoccupation with real space that was foreshadowed [by

Diego Velázquez] in *Las Meninas* is all the difference between represented space and real space, and hence all the difference between the previous two-dimensional art and the art of today. This means that when I decide to confront the problem of color, I do it with full consciousness and full knowledge of reality, and I do not represent the coloring of a form, but the power of continuous transformation of this color in time and space, exactly as in reality itself.

The impressionists understood this phenomenon, this revelation: things are transformed in space-time. And they felt the need of demonstrating this phenomenon and representing it with infinite situations of landscape, that is, of reality. But they also understood this instantaneous evolution of light: it explains why they repeated the same landscape and the same motif as rapidly as possible, in order to capture that light which eluded them. With the *Physichromies*, on the other hand, I propose to demonstrate this continuous transformation of light.

The phenomenon of light and its results are very well understood, and have been understood since the beginning of time; but when we use light today in a work of art, it is not to repeat the known phenomenon.

# Reflections on Color

## Carlos Cruz-Diez

From *Reflections on Color,* 1989

*This excerpt contains a key insight that the Venezuelan Constructivists reached: If color is separated from its traditional descriptive function, it can interact with itself and with the viewer in a way that is conducive to aesthetic appreciation.*

After graduating from the School of Fine Arts in Caracas, I thought that the work of an artist was essentially to express himself in order to make a sort of great chronicle of that unknown and magical world called Latin America. This was also an affirmation to confront cultural dependence. This resulted in painting that was aesthetically conventional, and an ambiguity between political events and the timelessness of art.

In 1954 I started having the same thoughts that, in principle, all artists have at one point in their lives when they begin to doubt the validity and transcendence of their own painting. At that time I structured a conceptual platform which so far has allowed me to do my work based on a nontraditional perspective of color.

Study and constant experimentation revealed that, conceptually, the element of color in painting had not changed throughout time, as had happened with drawing, chiaroscuro, perspective and composition. The same concept has prevailed since ancient times: first you draw a form and then you color it, as if color were something added to form. Only the impressionists, the pointillists, the fauvists and the expressionists assumed different attitudes toward the chromatic phenomenon, while some Constructivist and abstract artists insisted once again on the "form-color" relationship.

Based on this analysis I started to research methodically what artists had done and written about color throughout time. I also made contact with the world of physics, chemistry, the physiology of vision, and optics. I searched for what philosophers and humanists had thought about the phenomenon of color perception. I did all this aided by my knowledge of image multiplication, color photography, photomechanics and the different systems for printing on paper. I concluded that the perception of the chromatic phenomenon is unstable, that it is constantly evolving, that it is subject to many circumstances and that this characteristic had never been put to use by artists.

For example, the impressionists were never able to overcome the contra-

dictions underlying their experiences. They wanted to be more genuine than the academicians by reconstructing the ephemeral quality of light on the static support of the canvas; but in the time it took to observe the model, prepare the color mixture on the palette, and return to the canvas, the situation and the color relationships had changed. This is why their attitude towards the model was the same as the academicians', that is, an artificial and static reconstruction of a changing reality.

This evidence and all my previous experiences with color helped me create a support structure that would allow me to materialize and demonstrate the changing condition of the chromatic experience. The solution I found to the eternal **binomial form-color** was to divide the form, transforming the colored plane into a succession of color parallels placed vertically, which I called **chromatic event modules.** This structure allowed me to prove that *color is constantly in the making,* that it happens in time.

# Artist's Statement

**Alejandro Otero**

From *Alejandro Otero*
by José Balza, 1997

*This statement refers to the series of works by this Venezuelan artist called* Colorrhythms.

The colorrhythms were simply large elongated panels, crossed from side to side by white and dark parallels between which the space was filled with forms of pure and brilliant colors. The purpose of these lines was to insure a totally dynamic surface, establishing an open directional rhythm as regarded both the sides and the extremities of the panels. The colors played between the lines creating dimensional and spatial counterpoint, whose departure was the vibration of the parallels and the colors.

From 1955 to 1960—the period in which this phase of my work lasted—the colorrhythms changed. At first what appeared between the lines were quite clearly geometric forms. Then these forms became small accents drawn out by more subtle sonorities. Later, however, these forms grouped together into large patterns in which the parallels almost disappeared until, at last, color and white and dark lines were one sonorous block—sometimes a very strong one, sometimes extremely subtle. The colorrhythms changed not only as an expressive climate but as color, form, vibration as well. The only constant element was the presence of the parallels and the material being used, which improved in subtlety and quality.

This series of paintings might be defined as a body of experience—in the sense of an adventure in expression—whose chief interest lies in rhythm and color, in the strength of the form-color linked to the visual dynamic of the rhythm. . . . Contrary to what one might think in looking superficially at these compositions, they are not the result of plan, nor the application of preexisting theory. . . . As I composed the trial sketches which preceded each of these panels, rhythms and tensions, forms and colors followed the free movement of my intuition. No judgment or criteria intruded upon the unity of the creative act from outside. In each sketch the work sought out, almost of its own volition, its own unity, its own beginning and end.

This does not mean that the painter did nothing but follow the inspiration of the creative moment and then transfer these intuitions, noted down in the

sketches, into more docile and more beautiful materials. . . . Developing a sketch or carrying it forward to its dimensions as a more complete or mature work does not mean breaking with the creative act; on the contrary, it means carrying this act to its ultimate possible consequences. There is no doubt that this task, which brings the work to a new stage, implies the risk of the artist's losing the eloquence of the original intuitions, but it may also open out possibilities for further enrichment or new development.

# Serialization

**Jesús Rafael Soto**

From *Conversaciones con Jesús
Soto,* edited by Ariel Jiménez,
2002

Translated by Ariel Jiménez

*Here the Venezuelan constructivist Jesús Rafael Soto discusses a parallel between his constructed sculpture and the serial movement in contemporary classical music.*

All I know about the new musical structures, the dodecaphonic system and serial experiments, I discovered in a book by René Leibowitz, a disciple of Webern. I studied in depth his discussion of the dodecaphonic system, trying to understand the new musical system in order to figure out a way to apply it to the visual arts. When I understood the concept behind serial music, I found a fabulous world in which the value of each note was codified in advance so sound was not used according to taste or any other consideration. In serial music every note was like a number; using nontraditional measurements it was therefore possible to produce a completely different music. I decided to follow this example and codify the elements of painting by using only eight colors. I wanted to eliminate any trace of subjectivity linked to personal taste, including my own. I limited myself to perfectly defined colors. No olive greens with reddish tints or dark pinks: these are colors that can lead to confusion. I chose the three primary colors, the three secondary colors, and black and white. Later on I introduced ultraviolet, considered the sublime color. After codifying them I decided to carry out permutations as is done with the notes in serial music. I was greatly surprised when I realized that by limiting myself to these basic elements and by observing the established permutations I was able to create a group of paintings that worked from the point of view of visual art.

# Artist's Statement

## Jesús Rafael Soto

From "Statements by Kinetic Artists," *Studio International*, February 1967

My works are classical, without confusion or mystification. I work with very simple elements. These elements in themselves are unimportant. A piece of wire, a few lines—what are they? What are important are the relationships which they bring into being.

A piece of wire against a *moiré* background of narrow parallel lines becomes broken up. Its form is "dematerialized." It undergoes a transformation, a metamorphosis. You cannot say which is wire and which is ground. I hang yellow rods in front of the same background, and black spots appear on the yellow. Where has the color come from?

This has to do with reality, with perception. We are forced to question our perceptions, which seem so reliable. When Duchamp set a two-dimensional disc spinning and it looked solid, he was doing the same thing. He made us question our perceptions.

The Impressionists, Cézanne, the Cubists and Mondrian broke up form into light and color. They liberated these elements.

I am not interested in connections between things, but only with their relationships *(relations)*. I am not interested in the connection of one color with another or one line with another. Relationships are more than connections.

There need be no logical connection between the elements in my work. Two themes in a Bach fugue have no logical connection. The work is essentially a relationship. Not between two elements in the picture but between the principle which governs the picture—for example, the dematerialization—and a general law of the universe which conditions everything. You may call these relationships chance relationships: they cannot be foreseen. They happen by chance, by the laws of chance. It may seem strange to talk of laws of chance, but chance occurrences do not come about independently of laws. It is just that the laws are very hard to discover. That is why we call them laws of chance. It is my aim to discover these laws.

# Neo-Concrete Manifesto

## Ferreira Gullar

From *Jornal do Brasil*,
22 March 1959

Translation reprinted from
Dawn Ades, *Art in Latin
America*, 1989

*H*ere an important art critic sets forth the basic principles of Neo-Concrete
art. What crucially separates this new movement from the Concrete art that
preceded it is a new conception of the spectator's body as a means of perception, stress-
ing the physical presence of the work and its impact on the viewer.

We use the term "neo-concrete" to differentiate ourselves from those com-
mitted to non-figurative "geometric" art (neo-plasticism, constructivism,
suprematism, the school of Ulm) and particularly the kind of concrete art that
is influenced by a dangerously acute rationalism. In the light of their artistic
experience, the painters, sculptors, engravers and writers participating in this
first Neo-Concrete Exhibition came to the conclusion that it was necessary to
evaluate the theoretical principles on which concrete art has been founded,
none of which offers a rationale for the expressive potential they feel their art
contains.

Born as Cubism, in a reaction to the pictorial language of the Impression-
ists, it was natural that geometric art should adopt theoretical positions dia-
metrically opposed to the technical and allusive features of the painting of the
time. Advances in physics and mechanics widened the horizons of objective
thought and led those responsible for deepening this artistic revolution to an
ever-increasing rationalization of the processes and purposes of painting. Me-
chanical notions of constructing works of art invaded the language of painters
and sculptors, generating, in turn, equally extremist reactions of a reactionary
nature such as the magical, irrational realism of Dada and Surrealism.

However, there is no doubt that, despite the consecration of the objectivity
of science and the precision of mechanics, true artists—like, for example,
Mondrian and Pevsner—overcame the limits imposed by theory in the daily
struggle to express themselves artistically. But the work of these artists has al-
ways been interpreted with reference to theoretic principles which their work,

in fact, denied. We propose that neo-plasticism, constructivism and the other similar movements should be reevaluated with reference to their *power of expression* rather than to the *theories* on which they based their art.

If we want to understand Mondrian's art by examining his theories, we would have to conclude one of two things. Either we believe that it is possible for art to be part and parcel of everyday life—and Mondrian's work takes the first steps in this direction—or we conclude that such a thing is impossible, in which case his work fails in its aims. Either the vertical and the horizontal planes really are the fundamental rhythms of the universe and the work of Mondrian is the application of that universal principle, or the principle is flawed and his work is founded on an illusion. Nevertheless, the work of Mondrian exists, alive and fertile, in spite of such theoretical contradictions. There would be no point in seeing Mondrian as the destroyer of surface, the plane and line, if we do not perceive the new space which his art creates.

The same can be said of Vantongerloo and Pevsner. It does not matter what mathematical equations are at the root of a piece of sculpture or of a painting by Vantongerloo. It is only when someone sees the work of art, that its rhythms and colors have meaning. The fact that Pevsner used figures of descriptive geometry as his starting-points is without interest alongside the new space that his sculptures gave birth to and the cosmic-organic expression which his works reveal. To establish the relationships between artistic objects and scientific instruments and between the intuition of the artist and the objective thought of the physicist and the engineer might have a specific cultural interest. But, from the aesthetic point of view, the interesting thing about art is that it transcends such considerations and creates and reveals a universe of existential significance.

Malevich, because he recognized the primacy of "pure sensibility in art," spared his theoretical definitions the limitations of rationalism and mechanicism, and gave his painting a transcendental dimension that makes him very relevant today. But Malevich paid dearly for the courage he showed in simultaneously opposing figurativism and mechanicist abstraction. To this day, certain rationalist theoreticians have considered him to be an ingenuous person who never understood properly the true meaning of the new plasticism. . .

In fact, Malevich's "geometric" painting already expresses a lack of satisfaction, a will to transcend the rational and the sensory, that today manifests itself irrepressibly.

Neo-concrete art, born out of the need to express the complex reality of modern humanity inside the structural language of a new plasticity, denies the validity of scientific and positivist attitudes in art and raises the question of expression, incorporating the new "verbal" dimensions created by constructivist neo-figurative art. Rationalism robs art of its autonomy and substitutes the unique qualities of art for notions of scientific objectivity: thus the concepts of form, space, time and structure—which in the language of the arts have an

existential, emotional and affective significance—are confused with the theoretical approach of those who want to make a science of art.

In the name of prejudices that philosophers today denounce (M. Merleau-Ponty, E. Cassirer, S. Langer)—and that are no longer upheld in any intellectual field beginning with modern biology, which now has gone beyond Pavlovian mechanicism—the concrete rationalists still think of human beings as machines and seek to limit art to the expression of this theoretical reality.

We do not conceive of a work of art as a "machine" or as an "object," but as a "quasi-corpus" (quasi-body), that is to say, something which amounts to more than the sum of its constituent elements; something which analysis may break down into various elements but which can only be understood phenomenologically. We believe that a work of art represents more than the material from which it is made and not because of any extra-terrestrial quality it might have: it represents more because it transcends mechanical relationships (sought for by the Gestalt) to become something tacitly significant, something new and unique. If we needed a simile for a work of art, we would not find one, therefore, either in the machine or in any objectively perceived object, but in living beings, as Langer and V. Weidlé have said. However, such a comparison would still not be able adequately to express the specific reality of the aesthetic organism.

That is because a work of art does not just occupy a particular place in objective space, but transcends it to become something new that the objective notions of time, space, form, structure, color, etc. are not sufficient in themselves to explain. The difficulty of using precise terminology to express a world that is not so easily described by such notions did not stop art critics from indiscriminately using words which betray the complexity of works of art. Science and technology had a big influence here, to the extent that today roles are inverted and certain artists, confused by this terminology, try to use objective notions as a creative method in their art.

Inevitably, artists such as these only get as far as illustrating ideas *a priori,* because their starting-point already closely dictates the result. The concrete rationalist artist denies the creativity of intuition and thinks of himself as an objective body in objective space. Artist and spectator are only required to be stimulated or to react; the artist speaks to the eye as an instrument and not to the eye as a human organ capable of interaction with the world; the artist speaks to the eye-machine and not to the eye-body.

It is because a work of art transcends mechanical space that, in it, the notions of cause and effect lose any validity. The notions of time, space, form, color are so integrated—by the very fact that they did not exist beforehand, as notions, as art—that it is impossible to say art could be broken down into its constituent parts. Neo-concrete art affirms the absolute integration of those elements, believes that the "geometric" vocabulary that it uses can express complex human realities as proved by many of the works of Mondrian, Malevich,

Pevsner, Gabo, Sofie Tauber-Arp, *et al*. Even though these artists at times confused the concept of form-mechanics with that of form-expression, we must make clear that, in the language of art, the so-called geometric forms lose the objective character of geometry and turn into vehicles for the imagination. The Gestalt, given that it is a causal psychology, is also insufficient to allow us to understand a phenomenon which dissolves space and form as causally determined realities and creates a new time and *spatialization of the artistic creation*. By spatialization, we mean that the work of art *continuously makes itself present*, in a dynamic reaction with the impulse that generated it and of which *it is already the origin*. And if such a reaction leads us back to the starting-point, it is because neo-concrete art aims to rekindle the creativity of that beginning. Neo-concrete art lays the foundations for a new expressive space.

This position is equally valid for neo-concrete poetry, which denounces the same mechanical objectivism of painting. The rationalist neo-concrete poets also had as their ideal the imitation of machines. For them also, space and time are nothing more than exterior relationships between word-objects. Well, if this were so, the page becomes graphic space and the word one element contained in this space. As in painting, the visual is reduced to the optical and the poem goes no further than its graphic dimensions. Neo-concrete poetry rejects such spurious ideas and, faithful to the nature of language itself, affirms the poem as a temporal being. The complex nature and significance of words becomes apparent in time and not in space. A page of a neo-concrete poem is the spatialization of verbal time: it is a pause, a silence, time. Obviously, it is not a question of harking back to the concept of time held by those writing discursive poetry. In the latter, language flows in one continuum while, in neo-concrete poetry, language *extends* itself in time. So, contrary to rationalist concretism, which takes the word as an object and transforms it into a mere optical signal, neo-concrete poetry gives it back its power of "expression," that is to say, it presents reality in a human way. In neo-concrete poetry, language does not trickle away; it is enduring.

Meanwhile, neo-concrete prose opens a new field of expression, recovers the flowing qualities of language, overcomes its syntactical uncertainties and gives a new amplified meaning to certain solutions wrongly understood to be poetry. This is how, in painting as in poetry, in prose as in sculpture and engraving, neo-concrete art reaffirms the independence of artistic creativity in the face of objective knowledge (science) and practical knowledge (ethics, politics, industry etc.).

The participants in this first Neo-concrete Exhibition are not part of a "group." They are not linked to each other by dogmatic principles. The evident affinity of the research they have been involved in in various fields brought them together and to this exhibition. Their commitment is firstly to their own particular experience and they will be together for as long as the deep affinity that brought them together exists.

# Beasts [Bichos] 1960

**Lygia Clark**

From *Signals*, April 1965

Translated by Madalena Nicol

*Brazilian sculptor Clark made a series of works called* Bichos *in 1960, consisting of asymmetrical metal plates joined by hinges that the spectator could move at will. The translator calls them "beasts" because the word* bicho *is not easily translated.*

My latest works have been called "beasts" because of their essentially organic aspect. And besides, having used a hinge to join the plates, it suddenly reminded me of a backbone.

The arrangement of the metal plates determines the positions of the beast, which at first sight appear to be limitless. When asked what are these possibilities of movement, I usually answer: "I don't know, neither do you, but he does."

The beasts have no wrong side.

Each beast is an organic entity completely revealed inside his inner time of expression.

He is alive, and an essentially active work. A total, existential interaction can be established between you and him. And in this relationship there is no passivity, neither on your part nor on his.

There is in fact a dialogue in which the beast gives, to the spectator's prompting, well-defined answers.

This relationship, up to now abstract, between man and the beast becomes real.

The beast has his own and well-defined cluster of movements which react to the promptings of the spectator. He is not made of isolated static forms which can be manipulated at random, as in a game; no, his parts are functionally related to each other, as if he were a living organism; and the movements of these parts are interlinked.

The first movement (yours) does not belong to the beast. The inter-linking of the spectator's action and the beast's immediate answer is what forms this new relationship, made possible precisely because the beast moves—i.e., has a life of its own.

# Tropicália: *March 4, 1968*

**Hélio Oiticica**

From *Folha de São Paulo,*
Folhetim, São Paulo,
8 January 1984

Translated by Guy Brett

*T*his is the artist's explanation of his installation called Tropicália. Here he
articulates a central goal: the creation of a Brazilian type of contemporary art,
based in part on the earlier formulation of Anthropofagia, or cannibalism.

*Tropicália* was born from the idea and conception of "New Objectivity,"
which I initiated in 1966. Completed in the beginning of '67, it was exhibited
(as an environmental project) in April of '67. With the "Theory of New Objec-
tivity," I wanted to institute and characterize a state of Brazilian avant-garde
art, confronting it with the major movements of world art (Op and Pop), and
aiming at a Brazilian state of art, or of manifestations related to this. The con-
cept of *Tropicália,* presented at the exhibition "Brazilian New Objectivity"
(Museum of Modern Art, Rio de Janeiro) in April, 1967, came directly from
this fundamental need to characterize a Brazilian condition.

Actually, in the beginning of the text about "New Objectivity," I invoked
Oswald de Andrade and the meaning of "Anthropophagy" as an important
element in this attempt at a national characterization. *Tropicália* is the very
first conscious, objective attempt to impose an obviously Brazilian image
upon the current context of the avant-garde and national art manifestations in
general. Everything began with the formulation of the *Parangolé* in 1964,
with all my experience with the samba, with the discovery of the Morros [a
large poor district], of the organic architecture of Rio's favelas [slums] (and
consequently of others, such as the palafitas [riverside shacks on stilts] of the
state of Amazonas), and principally of the spontaneous, anonymous con-
structions in the great urban centers—the art of the streets, of unfinished
things, of vacant lots, etc.

*Parangolé* was the beginning, the seed, although still on a universalist plane
of ideas (return to the myth, sensory incorporation, etc.), of the conceptions
of "New Objectivity" and *Tropicália.* In reality, in order to arrive at an under-
standing of what I want with "New Objectivity" and *Tropicália,* it is indispen-

sable to know and understand the meaning of *Parangolé* (something actually much more quickly understood by London critic Guy Brett when he wrote in *The Times of London* that the *Parangolé* is "something never seen before," which may "strongly influence European and American art," etc.). Yet *Tropicália* is where, from my point of view, the idea becomes completely objectified. The main *Penetrable* which comprises this environmental project was my supreme experience with images, a sort of experimental image field. For this I created a tropical scenario, as it were, with plants, parrots, sand, pebbles (in an interview with Mario Barata of *Jornal do Comércio*, May 21, 1967, I describe a experience which I consider important: it seemed to me, while walking about the environs and set of *Tropicália*, that I was going through the gullies and over the curves of the Morro, which were organic, like the fantastic architecture of the slums; another life-experience: I had the sensation of "treading the earth" once again). Entering the main *Penetrable*, undergoing several tactile-sensorial experiences addressed to the participant who, through them, creates their imagistic meaning there, one arrives at the end of the labyrinth, in the dark, where a TV set is permanently switched on: it is the image which then devours the participant, because it is more active than his sensory creating. Actually, this *Penetrable* gave me the powerful sensation of being devoured (I described this in a personal letter to Guy Brett in July of 1967—it is, in my opinion, the most anthropophagist work in Brazilian art). The problem of the image is posed here objectively—but, since it is universal, I also propose this problem in a context which is typically national, tropical and Brazilian. Ever since I invented the term *Tropicália* (a designation I made myself, long before others took it up and made it fashionable), I wanted to accentuate this new language with Brazilian elements, down to its smallest details, in an extremely ambitious attempt to create a language that would be ours, characteristic of us, that would stand up to the images of international Pop and Op, in which a good many of our artists were submerged. Even in the "New Objectivity" exhibition one could notice this. I asked myself: why use "stars and stripes," elements of Pop Art, or dots and images from Lichtenstein and Warhol (serial repetition of figures, etc.)—or, like the orthodox Paulistas [from São Paulo], "Op" illusionism (which, as a matter of fact, could have roots here, much more so than Pop Art, whose imagery is completely inadmissible to us). In reality, the exhibition "New Objectivity" was almost entirely immersed in this "Pop" language, hybrid for us, in spite of the talent and strength of the artists involved. For this reason, I believe that *Tropicália*, which encompasses this entire series of propositions, came to contribute strongly to this objectification of a total "Brazilian" image, to the downfall of the universalist myth of Brazilian culture, entirely based on Europe and North America, and on an Aryanism which is inadmissible here. In reality, with *Tropicália* I wanted to create the "myth" of miscegenation—we are Blacks, Indians, Whites, everything at the same time—our culture has nothing to do with the European, despite being, to this day,

subjugated to it: only the Black and the Indian did not capitulate to it. Whoever is not aware of this can leave. For the creation of a true Brazilian culture, characteristic and strong, expressive at least, this accursed European and American influence will have to be absorbed, anthropophagically, by the Black and Indian of our land, who are, in reality, the only significant ones, since most products of Brazilian art are hybrids, intellectualized to the extreme, empty of any meaning of their own. And now, what do we see? Bourgeois, sub-intellectuals, cretins of every kind, preaching "Tropicalism," *Tropicália* (it's become fashionable!)—in short, transforming into an object of consumption something which they cannot quite identify. It is completely clear! Those who made "stars and stripes" are now making their parrots, banana trees, etc., or are interested in slums, samba schools, outlaw anti-heroes, etc.

Very well, but do not forget that there are elements here that this bourgeois voracity will never be able to consume: the direct life-experience element, which goes beyond the problem of the image. Those who speak of "tropicalism" just pick up the image for consumption, ultra superficially, but the existential life-experience escapes them, because they do not have it. Their culture is still universalist, desperately in search of folklore, or, most of the time, not even that. I then came to the idea which for me is the main and fundamental consequence of my experiences with my previous formulations of *Parangolé,* "New Objectivity" and *Tropicália:* this is the Supra-sensorial, which I presented at the Brasilia symposium promoted by Frederico Morais in August of 1967. This formulation objectifies certain elements which are extremely difficult to absorb, almost impossible to consume, which, I hope, will set the record straight: it is the definitive overthrow of universalist culture among us, of that intellectuality which predominates over creativity—it is the proposition of maximum individual liberty as the only way to defeat this structure of alienated domination and cultural consumption. In a long article which I am preparing, "In search of the Supra-sensorial," all these problems are posed and proposed: the old problem of the "return to myth," the problem of national culture, of the definitive suppression of the "work of art" (transformed into consumption in the capitalist structure), of creativity on the collective level, in opposition to the reigning conformity, of the use of hallucinogenic drugs on the collective plane (also showing a considerable difference between this proposition here and that of Timothy Leary and his followers in the U.S.), of the expansion of individual consciousness onto the creative plane, of the incomparable difference in the expressiveness, intellectually, of Blacks in relation to Whites, and of the creation of the Brazilian myth of "miscegenation." As can be seen, the myth of "tropicality" is much more than parrots and banana trees: it is the consciousness of not being conditioned by established structures, hence highly revolutionary in its entirety. Any conformity, be it intellectual, social, or existential, is contrary to its principal idea.

# "Tropicália"

### Caetano Veloso (1967)

Translated by the editor

*Caetano Veloso is one of Brazil's most highly regarded popular singers. His manager during the late 1960s was a friend of Neo-Concrete artist Hélio Oiticica. When the manager noticed a thematic connection between Oiticica's installation* Tropicália *and this song, he suggested that Veloso give it the same title. Thus the installation gave its name not only to this song but to an important movement of rebellion in popular music. Veloso said that the song recaptures the spirit of Antropofagia, the cannibalistic modern art movement first elaborated by Oswald de Andrade; the lyrics bear out his claim.*

Over my head, the airplanes,
Under my feet, the trucks;
With my nose pointing out at the prairies,
I organize the Movement.
I guide the Mardi Gras
I inaugurate the Monument
In the country's central plateau.

Hooray for the Bossa Nova
Hooray for the Shanty
The Monument is made of crepe paper and silver
The mulata's green eyes
Her long hair hides behind the green forest

The monument has no door
The entrance is an old, narrow, winding street
And on one knee a smiling child, ugly and dead,
Holds out his hand
Hooray for the Rainforest
Hooray for the Mulato

In the courtyard there's a swimming pool
With blue water from Amaralina
Coconut-tree, breeze, and Northeastern slang
And lighthouses

In her right hand she holds a rose tree
Proving eternal spring.
And in the gardens, the black vultures stroll all afternoon
Among the sunflowers.
Hooray for the Virgin Maria
Hooray for Bahia

In the left wrist, bang bang,
In his veins there's too little blood.
But his heart beats to a tambourine samba
Emitting dissonant chords
From five thousand speakers:
"Ladies and Gentlemen," he lays his big eyes on me,
Hooray for Iracema
Hooray for Ipanema

Sunday is the elegance of Bossa Nova
Monday he has the Blues
Tuesday he goes to the country
However
The Monument is very modern
It says nothing about the cut of my suit
That everything else goes to hell
My dear
Hooray for the Banda
Hooray for Carmen Miranda

# Afro-Brazilian Symbolism in the Art of Rubem Valentim

**Henry John Drewal**

From "Signifyin' Saints: Sign, Substance, and Subversion in Afro-Brazilian Art," in Arturo Lindsay, ed., *Santería Aesthetics in Contemporary Latin American Art,* 1996

*The sensuously curving forms of Brazilian sculptor Rubem Valentim may mark him as a successor of the Neo-Concrete artists, but his combination of modern style with Afro-Brazilian content take him into new territory.*

Like the man himself was, the art of the late Rubem Valentim is precise, meticulous, strong, and straightforward. He worked "with geometry": paintings, relief, and three-dimensional sculptures filled with an endless recombination of geometric, hard-edged shapes: triangles, spheres, arcs, stars, parallelograms, arrows. Most are strictly symmetrical, supremely balanced arrangements. They are rendered with extreme care, giving the sense of having been mathematically, scientifically created. The colors he used reinforce this impression. They are bold and flat, essentially primary and secondary hues juxtaposed with their complements to produce dramatic optical effects—again, science at work.

Yet, despite the impression of coldly objective forms presented for their optical effects, Valentim's works express spiritual matters. As he explained (1988): "Today physics approaches both religion and aesthetics . . . I am creating a new metaphysics." He achieved a true synthesis of the physical and the spiritual, for all these seemingly "meaningless" forms are in fact signs and symbols of spiritual forces at the heart of Afro-Brazilian Candomblé that was part of his childhood in Bahia, a region he described as "very strong in mysticism, religiosity." Even his working process was a synthesis of science and spirit. Every day, he began by making a large series of small studies or models in a very systematic and disciplined way which he described as both "laboratory experiments" and "devotions"—daily efforts to evoke and invoke spiritual forces that inhabited his thoughts, his world, and his work.

When one is aware of this metaphysical synthesis in Valentim's work, it takes on many unsuspected aspects. Forms become meaningful. The persistence of tripled motifs is not simply a matter of composition but a sacred number that invokes sacred forces. Blood-red color and hard-edged forms in some of his works signal the ax of Xango. Such boldness strikes the viewer.

Other geometric motifs and colors reveal other Yoruba or African spiritual presences. Works bathed in whiteness signal the presence of Oxalá, lord of creation. Multi-tiered shafts evoke Oxalá's staff of authority, the *opaxoro*. Oxalá is a most appropriate subject for he is the divine artist who shapes all existence. Strong, stable forms and a cool color capture visibly and symbolically the essence of Oxalá.

While deeply rooted in African sacred signs and cosmological concepts, elements of Valentim's compositions visualize cosmic shapes and forces that come from other, universalizing intentions. He explained that he wanted to "popularize," that is, reach beyond specific symbolic, meaning-full systems to "signs" that were "pure" forms expressing "feelings and rhythms" universally. His work is often described as being full of Jungian archetypes, things stored in the human subconscious. Thus he was an artist who combined many seemingly contradictory attributes to create powerful images; science/religion/aesthetics to create a new metaphysics; a new visual language based on semiotics; and signs and symbols rooted in Africa and his early life as a Brazilian of color in order to create a universal imagery that could touch people everywhere.

# 7. Postwar Figural Art

# The Cactus Curtain

## José Luis Cuevas

From *Evergreen Review,* 1959

*This article amounts to a manifesto against the dominance of mural painting among Mexican artists of the generation that came of age in the 1950s and 1960s. José Luis Cuevas resented this dominance, and tells us why here.*

I do not pretend to be a leader of the young, and I am not trying to recruit an army of rebels to storm the Palace of Fine Arts. I will limit myself to stating what I firmly believe to be the convictions of other members of my generation both in the fine arts and in other intellectual fields. If what I have to say is of any use to young artists, either now or later, I will feel that I have paid a debt. But even if what I suggest is not followed in the future, even if most of my generation chooses to conform and to stick in the same rut, I will still feel that my own conscience is clear, for I will know that I have stated publicly my refusal to conform with the harmful situation that exists in our cultural life.

I am not equipped to deal with other fields. Permit me to restrict myself to my own, but this time I propose to use the narrative form, in order to express my ideas more coherently.

Juan was fifteen years old. His father was a plumber, or a cobbler, or perhaps a minor official, one of those who, for a ten peso bribe, will settle within the legal period what would otherwise take months. Juan was born with a talent that occurs very often among the population of the Republic of Mexico. This talent, this rich and ancient legacy, was not that of taking bribes, an infection poisoning the blood of the whole country, but of creating another, unknown world, the world of art.

Juan stood out in grade school because of his excellent drawings. A school inspector saw them and told his teacher to encourage him. This continued until, one day, Juan was given a prize and entered art school. Let us pretend it was La Esmeralda, to make the fable more realistic. Juan completed all of his classes with the same competence he had shown in grade school. His professors praised him, his fellow students looked up to him, and he graduated from the school with diploma in hand. Thus far all had gone well. Mexico is a great nation, with opportunities for everyone. Even the sons of bribe-takers, or of plumbers or cobblers, have the chance and the right to study art. We live

in a grand democratic country. *¡Viva México!* There is only one insignificant shadow across the happy progress of our narrative, and that is the fact that Juan's father, as a plumber or bribe taker, felt cheated: he considered his son a good-for-nothing, and he was sure those drawings of naked women were the result of unspeakable secret vices. Juan's father was of the people, and it is for him and those like him that walls have been painted in Mexico for thirty years, in fresco or in other more rapid techniques. But all of the techniques have been useless. Juan's father and his next-door neighbor and his brother and everyone else of his class have never seen a single mural. Or if they have, they have agreed with the janitor of the building that it is terrible. Others of the same class have gone even further in their appreciation, scratching the murals with knives, writing dirty words on them, smearing them with tar, etc.

Juan blamed his father for not understanding in all those thirty years that an artist's duty is to paint for the people. At least, so says an all-powerful majority in the country. Juan had no idea what to do with his diploma or the pictures he painted in school. He could not hang them at home because his mother had decorated the living-room with portraits of Jorge Negrete and Pedro Infante [popular actors in Mexican cowboy movies], both of them set off with black crepe and artificial flowers. As for Juan's father, he had adorned his wardrobe with refreshing pictures of La Peluffo [Mexican movie actress], and on his share of the wall there was a lovely blonde advertising Coca-Cola (which also, of course, refreshes) and a portrait of Ratón Macías, whom he, as a good Mexican, considered the greatest boxer in the world. There was no place in that house of the people for Juan to hang his works. One day, feeling an urgent desire to smoke, he went to the corner store and offered a drawing to the storekeeper, a man of the people, in exchange for a pack of cigarettes. The man laughed, naturally, and refused. At home there was never any mention of the artists who are supposed to be the apostles of the people. The talk was about the latest amorous adventures of Maria Félix and the latest sensational crime. There was never any reference whatsoever to the art that is supposed to be of and for the people.

They had taught Juan at La Esmeralda to draw simplified figures—smooth, undulant, curvilinear, with large hands and feet—and to use special effects such as foreshortening, so that certain intellectuals would say that he produced "strong" works, of profound popular origin. They were not two-dimensional works. They tried to achieve three-dimensionality by an almost automatic method of drawing, a strict, uniform intensity of line. With such a formula, all is solved: it works equally well for portraying a man with a bandanna, an Indian woman selling flowers in the market, a worker in the oil fields, or one of those proletarian mother-and-child scenes which have been turned out for over thirty years without there having intervened, for the good of Mexican art, a single Malthusian or neo-Malthusian to hinder such an empty repetition of maternity.

Juan had not had access to books on the art of other countries either in school or in the public library, much less in the Palace of Fine Arts. Nor were there any museums in which he could see foreign art of the present or the past. When there was an exhibit of some artist who was not Mexican or who refused to follow the style he had been taught to believe was the only one, Juan's friends told him it was not worth seeing, because it pertained to an exhausted, degenerate culture, to inferior races that have nothing like the grandeur and purity of the Mexican race, which is the only one in the world that has complete command of the truth. On one occasion a friend told him about a certain Hitler, who pronounced the same things about a blond race that talked from the esophagus. But Hitler was wrong: if he had known the Mexican race with its dark skin, straight blue-black hair, almond eyes and labial speech, he would have changed his doctrine. The superior race was in Tenochtitlan [Mexico City] and environs, and it was the indisputable possessor of absolute truth.

But one day in a bookstore on the Alameda, Juan saw an art magazine containing things very different from his own work. Some of them were unintelligible to him, and others struck him as absurd, but all of them fascinated him. "So there are artists in other countries too," he said to himself, "not just here in Mexico." He went back to the bookstore several times, and began to see meaning in what had at first been mere puzzles. The absurdities revealed a logic of their own, everything took on order and shape in his mind. After a number of these visits he no longer felt any desire to continue working in the style he had been taught. The new ideas had begun to intrude among the local themes he was treating, and his work was being dominated, and vitalized, by other concepts.

Juan needed support for his new work, because he had lived till then on what his proletarian father brought home after taking bribes at the office. One friend suggested the salon of the Plástica Nacional as a solution, another advised him to join a national association; both solutions offered him a certain breathing-space. He decided on the former, and to carry it out he had to see an abbot-like functionary in the Palace of Fine Arts. We shall call him Victor for convenience, although his last name may or may not have been Reyes. His friend took him to see this amiable clerk, but first he warned him not to bring any of the capitalist bourgeois works he had recently turned out under the influence of decadent foreign magazines. Juan insisted, but his friend was so upset that he finally compromised and brought both his earlier and later things.

Victor "Reyes" gave him a questionnaire asking whether the artist belonged to the Mexican school, and then asked to see his portfolio. Juan began to show him his drawings and sketches in chronological order. When he arrived at the new things, Victor asked dryly, "Will you please explain these monstrosities that look as though they had been taken from the waiting-room

of a Wall Street bank?" Juan was distressed. The clerk, with his abbot-like na-
ture, had to follow the dictates of the clerical tribunal to which he belonged,
there in that dazzling palace whose glass curtain was made by Tiffany. Juan
knew he would lose everything if his application were rejected, because his fa-
ther would make him become an apprentice bribe-taker. "My friend," Juan
stammered, "these things are here by sheer mistake. They belong to a foreign
acquaintance of mine, a would-be painter who asked me to keep them for
him. Excuse me, Victor my friend . . . "

This was the proper treatment, and Juan entered the salon of the Plástica
Nacional. Later, following the advice of another friend, he joined a national
association, where both his errors and good judgment would be protected as
long as he followed the line traced previously by who knows what comrade.
There were conquests to be realized both in the salon and the association, and
new demands to be made: "Give us more walls to decorate for the people!"
Juan's two friends told him that this was the newest and clearest demand of
the courageous young men who paint in Mexico, but he had read in a history
of Mexican painting that it had been the hue and cry for almost forty years.
However, it was convenient for him to follow the majority. Perhaps he would
receive a fat commission. When the others shook their clenched fists, he did
too.

Now that he was protected by official and semiofficial institutions, Juan
began to make progress; he had genuine talent, even though he could not use
it as he wished. He began to sell his drawings and paintings to tourists in
search of souvenirs of their trip. He knew they were stale and lifeless, but the
tourists did not care about their execution as long as they had local color, as
long as their themes were Mexican. In this matter, his artist friends and his
foreign customers were in complete agreement.

Juan sold his work so regularly that he could afford to marry. He observed
that when he dressed his wife in a Tehuantepec costume or one of those other
colorful folk-costumes that Columba Domínguez wears in her pictures, his
clients paid better prices. After a while she hardly took off her disguises even
to sleep, because a buyer might wake them up in the early morning after a
night on the town.

Juan accepted all types of commissions in order to maintain his success. He
always wore overalls, like a working-man, and huaraches [sandals], and a big
mustache like Zapata's. His style featured massive, corpulent figures, but if a
commission for a mural specified lean, cadaverous figures, he painted them,
knowing that the compromise meant a few more pesos in his bank account
and increased prestige among his friends in the association.

He was quite willing to let his career be furthered by the dithyrambic criti-
cism of the champions of nationalism in Mexican art. He knew that Van
Gogh was a Post-Impressionist, and that Giacometti was an elderly Swiss
sculptor (almost 70) of the School of Paris, who occasionally painted. But

when a critic named J. C., the dean or president or who-knows-what of Mexican critics, said that "Van Gogh was a fauve," or announced with angelic innocence that Giacometti was "a young French painter," Juan kept still. If he had protested, he would have been condemned to silence and neglect. If he had corrected one of those baroque art critics—for instance, J.C., whose Gongorism is one of the puzzles of our cultural life—he would have been ostracized forever by the frustrated painters who cannot finish a canvas themselves and therefore obtain a weekly column in the press, in order to babble about an art of the people, i.e., the father and mother of Juan the contented conqueror.

He also had to give evidence of his nationalism during café conversations, and agree with his friends' opinions. Therefore he had to maintain that the acting of that witty illiterate, Cantinflas, was equal to or even superior to Chaplin's pure, intellectual genius. He had to assert that a monument to vulgarity like Agustin Lara should be included in supposedly serious anthologies of Mexican poetry. He had to maintain to the point of nausea that Rufino Tamayo was a traitor, rejecting both his good work and his bad with the very same arguments, and dismissing him without further analysis as corrupted by Paris. If that merchant of housemaids' tears named Fernando Soler [Mexican actor] said that his neo-realistic films were better than the Italians', Juan agreed. He even agreed that the schoolboy pornography of *Poesía en Voz Alta* [amateur theatrical group] was a praiseworthy effort. He repeated formulas, watch-words, and dogmas, and felt strong. Tequila is the best drink in the whole world. "There is no other country like Mexico." (*"Como México no hay dos."*) The rest of the universe ought to eat enchiladas. He felt strong and secure, and he lost his desire to progress, to change, to grow. He followed the "only possible" direction for the arts. He retreated once and for all behind the cactus curtain. *¡Viva México!* End of story.

Juan is a fictional character, but he is based on the actual people who swarm around our national culture. They stifle and terrify it, while those who ought to fight back are too apathetic or too frightened to speak up. I must admit, of course, that Juan's story has a happy ending, exactly like those in Hollywood's blissful dream-world. But it is also the happy ending of modern Mexican art, and although it is definitely happy, it is just as definitely an ending. I reject the idea that a culture should achieve a certain end and then halt there, and that is why I have rebelled.

My mistake—if I may speak of myself—has been to oppose the set pattern I have outlined in this story. When Victor Reyes gave me a questionnaire that asked if I belonged to the Mexican School, I answered with a sacrilegious question. When I was requested to paint a series of murals in which I would have to subordinate (that is, falsify) my pessimistic view of life in favor of an optimistic vision, I turned the job down, even though it was in other ways a tempting offer. I have not wanted to become a Juan; on the contrary, I have

fought against the Juans all my life. Against vulgarity and mediocrity. Against superficiality and conformity. Against the standardized opinions that are parroted over and over again, without interruption, from the opening of an exhibit to the discussion afterwards at the café. I protest against this crude, limited, provincial, nationalistic Mexico of the Juans, but thus far I have been answered only with personal attacks, even though my own attacks have always been aimed at works of art and the theories behind them, never at personalities.

I want to repeat that I do not consider myself to be either a pioneer or a reformer. I have tried to work within an accepted artistic tradition, and to bring to it something of my own, something that would carry it forward, however little that something might be. If what I am trying to do is not appreciated in my own country, if I am to receive personal insults instead of serious criticism, perhaps I should look for a different way of explaining my efforts. Perhaps I should consider the cactus curtain an impregnable fortress. But I believe we can progress only by refusing to conform, and I believe I have the right as a citizen and an artist, to rebel against conformity. That is my unpardonable sin.

I should also admit that the Mexico I have attacked is not the only one. There is another Mexico, one that I deeply respect and admire: the Mexico of Orozco, Alfonso Reyes, Silvestre Revueltas, Antonio Caso, Carlos Chávez, Francisco Goitia, Tamayo, Octavio Paz, Octavio Barreda, Carlos Pellicer, Manuel Bravo, Nacho López. I am proud there is a publishing project in Mexico like the Fondo de Cultura Económica, and a rostrum like *México en la Cultura* [a magazine of culture] for the expression of nonconformist opinions. I am delighted when I hear praise for *Los Olvidados* and *Raíces* [films made in Mexico] in other countries, although both films were box-office failures at home. It is this other Mexico that encourages me to protest because it is the true, universal Mexico, open to the whole world without losing its own essential characteristics.

There is a younger generation in Mexico with ideals similar to those I have been discussing. I wish to associate myself with it. I am not setting myself up as an arbiter, and I am not seeking disciples. I approve of many different tendencies and directions, of many roads in art . . . but only when they are free and meaningful extensions of life itself. What I want in my country's art are broad highways leading out to the rest of the world, rather than narrow trails connecting one adobe village with another.

By way of conclusion, I would like to offer two brief parables. The first concerns a Tibetan mission that asked for American economic aid some twenty years ago. In the name of the Dalai Lama it requested only the most essential foods and materials, because nothing that represented modern progress could enter the sacred gates of Lhasa. No wheels, no electricity, no machinery of any kind.

Nothing that would threaten the control of the theocracy over its ignorant subjects. The second derives from the same country. Around the middle of the last century a very respectable gentleman suggested to the government of the United States that it should close down its Patent Office. Why? Because everything that was necessary had already been invented.

# Chaos as a Structure

**Luis Felipe Noé**

From *Antiestética*, 1965

Translated by the editor

*This artist was a member of the New Figuration movement in Argentina in the early 1960s. The group articulated a vision of disorder in their art that paralleled the lack of order they sensed in Argentine life at that time. Their attitude toward this chaos differs markedly from that of their contemporary in the United States, Robert Rauschenberg.*

I have spoken at length about chaos, about the breakdown of unity, the rupture of vision and other concepts without defining them very carefully. The moment has come to do so; up to now I was only approaching them.

Let us speak first of the way things are, so that later we can consider how they might be.

Unity. Here we have a myth and a taboo. Nobody doubts the need for unity in a work. Even more, it is a supreme value. Prudent persons no longer speak of beauty in the work, but they retain the idea of order and beauty as ideal prototypes of order: unity. Thus, to speak of the breakdown of unity seems a crazy thing to do. Has not Kahler said most emphatically in his *Historia Universal del Hombre* [Erich Kahler, *Man the Measure,* New York: Pantheon, 1943] that "the principle of harmony, of intrinsic conformity, of perfect coherence, presents itself invariably in all the artistic manifestations in all the ages of the human species"? Why do we thus wish to destroy such a fundamental concept?

I have shown that in tribal and non-Western societies there is a vision of the world which integrates ethics, morals, and aesthetics. I have said that Western civilization has been centered on an ideal, the principle of harmony. In the Middle Ages this was called God; later it was called Humanity, and now, the Individual. The later development of individualism shattered the ideal as a point of meeting of the world-view of society. Each individual has become an order in itself. All the system of structures created by Western civilization in its state of evolution were analyzed and shattered under individualism. Then comes the crisis; order does not exist anymore, at least not a closed order. We have arrived at the first type of society with an open order. . . .

In these times, the projection of a rational order in an art work is not natural; it is not natural for the simple reason that this order no longer exists. Despite this, the myths of unity and order persist. People today conceive of disorder only through a vision of order. To demand order in the art of a society that lacks it!? Even so, unity is an unquestioned concept . . . But why?

What does this mythic, enormous taboo consist of? Why is no one content with the unity of a work that comes from the work itself, with a unity that ensures that there is just one work and not two? What is this unity that is more essential than the simple fact that one thing is one thing? In asking that a work of art show unity, what are we asking for?

Is the problem that unity is breakable if it is intrinsic to just one work? Should we not rather destroy unity itself, but since that is impossible, rather the idea of unity? Or, better yet, the positive regard that unity enjoys?

It's curious. At the moment that Modern art arrived at the limit of the idea of unity in a work of art, a tremendous wave of nostalgia arose for balance and harmony. Thus, just as the Cubism of Braque broached the limits of chaos as a possibility, the post-Cubism of André Lhote held on to the old skeletons, devoid of any potential for life. And thus we stopped teaching students to approximate the look of things, as in the old academy, but above all we taught the existence of a compositional skeleton within the work itself. Students began assembling Cubist facets without exactly understanding why. Historians formed under this vision took apart the canvases of Rubens, for example, until they found in them secret structures, thereby turning his chubby and rosy-cheeked women into surplus material. As if Rubens would have done these works with those elements only because he had not arrived at the sublimity of abstraction! What have we gained by trading the skeleton for life, for the free impulse?

The concept of unity refers not only to the organization of a composition. Each society, each epoch has lived this out in its own way. But it is evident that as the world-view of Western societies began opening up, the concept of unity, of coherent harmony among parts, could be maintained only with ever-greater difficulty. This evolution has continued. Unity as a basic precondition is now so remote that it's unnecessary. . . .

We are confronted with a society that lacks order even as it pines for it. Moreover, order is spoken of as if it were an organic whole. Order and organism are not equivalent terms, as they were in the past. Today's society is a social organism that lacks order, at least according to our old idea of order. The only reality it has is chaos. Here I am in agreement with Fernando Maza as he told me one day, "Chaos does not exist; what is happening is that we are attaching the label chaos to something that we lack the ability to understand." That is, that chaos, or disorder, is in reality a type of order that we don't understand. It is an order in the making, or it is an open order. This is what I mean by the assumption of chaos. It means to understand an idea of unity and

an idea of order which is not the idea of unity nor of order that we presently have.

My oft-cited Kahler, on speaking of the Renaissance (that society whose center of gravity was not the divine but the individual) said that "the work of art must choose and put forth essential unity over the base of a multifaceted reality."

Well, our reality today is also multifaceted, and much more, it is chaotic. Yet, in spite of this, we hold fast to the same concept of unity that was maintained in the Renaissance, that of unity through harmony.

Is this possible? No, it's an abstraction. Our society lacks any sense of order as equilibrium or as static fact. Our society's only truth is lack of balance. This lack of balance constitutes a variegated fact, a polemic multiplicity. It could be a totality: a totality with elements that are related among themselves in a chaotic relationship, but a relationship nonetheless. These relationships constitute a structure, the structure of chaos.

Chaos has been traditionally alleged to be opposed to any structure, being a junction of relations among discrete things. Isn't this a structure? I basically understand "chaos as a structure" as the structure that emanates from these chaotic relationships, that is, a distinct type of order. This order is called chaos. But why put the name order on this chaos, as the aesthetes want? Wouldn't that be putting an order over something, without taking advantage of the potential of chaos as an order?

What is certain is that we can only access this possible order, this chaotic structure, if we forget the idea of any previous structure or any previous order. We have only the elements of a reality that we find in collision with one another. Let us assume, then, that chaos is an organic order.

What does it mean to assume? It means "to take charge of" or make one's own. What is chaos? Chaos is disorder, or better yet, absence of order as heretofore understood. What does it mean to assume the chaos? It means to take on disorder as one's own. To understand it in all its possibilities. To find new modes of understanding.

Henry Miller pointed out very wisely that things outside of context lose their meaning; each thing reverts to its original meaning. It tries to take on chaos globally, as a multifaceted whole. One element of an order represents all of that order, but one element of chaos does not represent chaos. Rather it represents an earlier order of some sort from which it descended.

It's true today that no formalist vision makes any sense. How absurd those pronouncements seem, about a kind of painting with an optical center and tonal balance! For what does one need an optical center, to communicate with the viewer more easily? And why this slavery to the viewer? No: The optical center was indeed something when it had meaning. It was the focal point of a compositional order. But if order does not exist today, then why maintain it? Because the viewer today must participate in the breakdown, in the chaos.

Abstract art has an essential deformity, that it is based on anachronistic pre-suppositions. If it was interesting, this was because it surpassed the limits of art as representation. But to remain within the limits of formalism is not an advance. Life itself, with its potential for chaos and meanings, surpasses the limits of formalism. What value can there be today in speaking of escaping the limits of the picture frame? Let's escape them! What we should not escape is our consciousness. Why then do we not take on what is all around us?

Chaos could be defined as the imprecision that we feel before a decision is made. It could also be the collision of distinct and antagonistic elements. I have spoken a fair amount with Ernesto Deira about this. He prefers the first definition; I prefer the second. I pointed out to him that his definition was somewhat faulty because it did not include enough danger. He took my point, but he replied that he was not interested in analyzing the imprecision, but rather in refusing to define what is imprecise, the better to respect its spirit. He is interested in alluding to a permanent dynamic. He also told me that my position is also faulty, since it tends to institutionalize chaos, some-thing that is basically dynamic. I admitted this danger. Then I clarified to him that I can only allude to the possibility of chaos, and that I would never con-sider a work of mine to be definitively finished. I could always add a thousand more elements, or take them away, or move them about.

In the end we concluded that there could be as many versions of chaos as there are people in the world. Beyond that, we noticed another important thing. What we call "movement" (what I consider to be "permanent change") is a key element in contemporary art. We noticed that we are heading toward a new solution to an evident modern problem. Just as revolutionizing space and seeing it as the field of many possible deployments was the great achieve-ment of painting in the first half of this century, movement is the most impor-tant preoccupation today. Futurism was a precursor to this. Those artists searched for movement, for the actions of machines, for optical vibration, for a way to create the representation of motion. I think that the utilization of all these elements in conjunction would come close to showing the chaotic real-ity of today, but it would not be sufficient. I think the concept of "continuous transformation," or the idea that something never "is" unless we think that what "is" could also exist in another way, opens new possibilities. It is some-thing more than a movement; it is the future. Painting could thus cease being an essentially static art.

The two of us also agreed that chaos should be taken on as it is, as some-thing much greater than ourselves. The individual work can only witness to one individual's relationship to chaos. Therefore a work will reflect a certain coherence because its diverse elements will relate to one living person, to just one person's mind as it confronts chaos. This is the opposition of distinct wills. Thus chaos as a structure can be proposed in individual works, but it would take more organic form through the creation of a group product.

The myth of individuality in the work has tended to disappear, but not the myth of the individual work. The latter will be with us as long as people want to unburden themselves about their relationship to the world. I do not wish to commit the error of the theoreticians; I will not assert that the individual work will disappear. But I do believe that the myth of the individual work will disappear. It is obvious that artistic creativity, even of the Expressionist type, tends toward objectivity from the moment that the subject of a work is made into an object and set forth as a point of encounter with viewers. It's also evident that the subjectivist and the objectivist will both exist in contemporary art—the obverse and reverse of the same will. It's evident that any organic art form gathers the subjectivities of viewers into a joint labor of individuals. It is a collective art.

Thus I believe that we are tending toward a global vision of incoherence, an organic vision, as definitely organic as existed in societies with a closed order. Moreover, I believe that we are tending toward this through a joint action like that of closed-order societies that are not individualistic. But in this case it will be the clash of individualities that will be the important element.

Therefore, if this new group art will be arrived at through certain orchestrated experiences, I think that later, the orchestration of chaos will be surpassed as well. An orchestrated chaos is an impossibility.

I think, as I have said, that the time has arrived when we should speak not of the chaos of contemporary art, but rather of a contemporary art of chaos.

Very well, I can't say anything more, anything else would be merely obvious. After we have reflected on this, the search can be made with the tools we have at hand. I cannot say any more about what I understand to be the shattered vision or the structure of chaos. To do so would limit its possibilities. Clarity has nothing to do with mental schemes. This is about breaking open; chaos here and now. Chaos is within our grasp if only we reach out.

I think that here and now we will open an important possibility in artistic creation as soon as we can wipe away the traces of our frustrating provincialism.

Here and now, because, as the cabinet ministers say when they take the oath, "God and country demand it." Even though in reality, when dealing with chaos, will we be serving God? I have no idea. But at least let's serve something.

# A Latin Answer to Pop

**Jacqueline Barnitz**

*Arts Magazine,* June 1966

*There was a vigorous vanguard scene in Buenos Aires in the early and middle 1960s. This article, written at that time by one of the pioneer scholars in the field, considers one of the most important artists from this fertile period.*

Early this spring, a twenty-five-year-old blonde from Buenos Aires created a sensation at the Bianchini Gallery with a semi-Pop, semi-Happening environmental construction. The young lady was Marta Minujín, leader of Argentina's avant-garde. The environment was *El Batacazo* (The Long Shot), for which she won the Torcuato di Tella prize last year in her native city. *El Batacazo* filled the Bianchini Gallery almost wall to wall. Penny-arcade music played, and a battery of neon lights covering the work's exterior blinked at arriving visitors. A recording invited them to take off their shoes and enter. *El Batacazo's* guests first climbed up steep, soft vinyl stairs to find themselves facing a colony of caged live rabbits (from a Greenwich Village backyard). Then they proceeded to a melee of man-sized stuffed rugby players enlivened by sounds of cheering crowds. From there they tobogganed down a chute to land on the face of a seventeen-foot recumbent effigy of Virna Lisi whose charms were more akin to those of a Raggedy Ann doll than to a movie queen's. She moaned and groaned erotically as her guests scrambled over the length of her vinyl body, sinking ankle-deep into its soft mass. They plowed through a narrow tunnel lined with a plastic encasement filled with live flies (from an insecticide factory), then on to a pair of astronaut dummies, one dangling aloft, the other seated and motorized into sporadic jerks.

Miss Minujín was only fifteen when she first broke away from traditional art forms. Four years later she was already well known in progressive art circles for her exuberant cardboard constructions, and shortly after that for the gaily colored mattresses that become her staple. In 1962 she began to incorporate found objects into her large assemblages. The purpose of her work, far from being that of accentuating the objects themselves (as in USA Pop), was largely symbolic. Objects served only as the means to an idea. Sometimes her compositions had an immediate message. For instance, *Cemetery for the Military,* shown in Buenos Aires in 1962, consisted of rows of cartridges, a cluster of guns, military caps, boots and old sacks accompanied by the sound of a

recorded military march. This was her way of criticizing the revolutions that had taken place in her country that year. But Marta Minujin soon abandoned such direct references and began to treat broader themes. Her work took on a wider range of symbolism in the manner of much European art, and very much in the manner of most Latin American art regardless of personal style. It is no accident that the Latin Americans refer to their new realism as the "art of things" (like the French *art des objects)* rather than Pop art. While popular images are used, their implication is very different. Pop art speaks of "things," the things that surround us, whereas the "art of things" paradoxically speaks of people. It employs objects in order to create an image of man. In this sense, it is not very different from Goya's commentary on war and reason, or from the Mexican muralists' social criticism. But in keeping with an age of industry and mass production, contemporary artists have recourse to more strident means in order to be heard. Marta Minujin's art demands the active participation of the people who come as spectators. People in Buenos Aires accepted her work at first with reservations, then with an almost proprietary sense.

In 1964, Jorge Romero Brest, Argentina's foremost critic and the director of the Instituto Torcuato di Tella, backed her in her first large-scale project, a structure a half-block long, *La Menesunda* (The Challenge), which drew an eight-hour waiting line and a crowd of thirty thousand. "It was like Coneezland," says Miss Minujin, who had never seen Coney Island before her recent visit to the United States. Far more complex than *El Batacazo, La Menesunda* offered a complete repertoire of sensory experiences—smells, sounds, sights, and the inevitable tactile sensations of soft plastic forms which Miss Minujin liked to incorporate even before she became acquainted with Claes Oldenburg's soft objects. *La Menesunda* was a womb-like circus, a sensory distortion of reality, with touches of the freakish as well as the comic. The visitor entered *La Menesunda* through a veil of transparent plastic to find himself immediately assaulted by the sound of ten television sets, each tuned to a different channel. After ascending the soft stairs, going through a white vinyl bedroom in which a couple lay in bed, then through a tunnel smelling of fried foods, the guest found himself disconcertingly back in the television room. But this time he faced a passageway he had not seen before. The narrow opening led into an oppressive little compartment filled with bloody, oversized intestines of plastic. If the visitor found this too stifling, he could look through a window on the side and enjoy slides of cool Andean lake and mountain views. All through *La Menesunda,* his consciousness was battered from revulsion to relief, anguish to pleasure. There was nothing he could do to escape awareness of what he felt, smelled, heard and saw. He sank insecurely up to his knees in tunnels with soft walls and floors, and he went through compartments where he could find the solace of human company in a garish ambiance. Fancifully attired women, in one small compartment, spent eight hours a day applying cosmetics to one another. Marta Minujin used human "inhabitants" in *La*

*Menesunda* much as she did animals in *El Batacazo*. Living things are essential to the purpose of her work. They are a plastic extension of inanimate soft objects, and they increase the intensity of the experience. "My work means nothing as mere structure," she says. "It is complete only from the moment the spectator walks inside and participates."

In her art, Marta Minujin is very much a product of this century. She is both victim of the century and victor over it. As victim, she is condemned to perpetual changes, movement; as victor, she dominates this state by choosing her terms as she moves with the changes. "Easel painting is dead," she states flatly; "today man can no longer be satisfied with a static painting hanging on a wall. Life is too dynamic. It moves with the intensity and speed of a jet, and a painting cannot possibly transmit or register the changes that take place minute by minute." Marta Minujin's generation feels that Goya's commentary can no longer be heard. The only way open is to scream in people's ears, involve them physically in order to insure their attention. Once she gets that attention, she challenges tradition and accepted mores, but not without humor. She tries to liberate people from what they are not by steering them into experiences that free them to be what they really are. She does this by laying traps and dangling baits. Her ability to draw a crowd and hold it as long as she wants is an asset for her Happenings.

One of her Happenings took place in Montevideo, Uruguay. At noon one day she circulated rumors that an unusual theatrical performance was to take place at the stadium that afternoon. Within minutes she had rounded up props and gathered participants right off the streets. Some resisted the idea of performing in this strange event, but Miss Minujin managed to persuade enough of them to justify the use of an arena. As preparations were taking place, a crowd gathered outside the stadium to buy tickets. Suddenly a swarm of howling fire engines followed by twenty motorcyclists forced the startled people into the arena. From that point on, event followed event at a disconcerting pace. Fifteen athletes and fifteen young ladies emerged from the crowd and tried to wrap one another up in yards of tape. Fifteen more women smeared with wet paint rubbed against the athletes, and the firemen prepared their hoses for action. This grotesque bacchanal was interrupted by a low-flying helicopter from which Miss Minujin rained down live hens, lettuce and flour. People ran in all directions trying to catch the hens—like bridesmaids competing to catch the bouquet. Many succeeded in leaving with their door prize. They had forgotten that the joke was on them as well as on all men. They had unwittingly dropped their assumed daily roles and joined in the event with un-self-conscious abandon.

Miss Minujin first became aware of her ability to lead a mob into action during a Happening she staged in Paris in 1963. In the two years she had spent there (partially on a French Embassy scholarship), she had accumulated a studio full of vividly painted mattresses. Just before returning to Buenos Aires,

she decided to destroy all her work rather than leave any of it to the "commercialism of Paris galleries and dealers." But she wanted this destruction to take place in a grand display of creativity. She invited her friends to participate in the event (on a lot near her studio), each according to his own particular bent. The Portuguese artist Lourdes Castro covered a mattress with silver paint; the Expressionist Mariano Hernandez executed an action painting on another; and Christo, whose Wrapped Packages were in the Sidney Janis "New Realists" show in 1962, packed a third up in paper and cord. The French Surrealist poet Élie Charles Flamand performed a delicate surgical operation on a mattress, somewhat in the spirit of Salvador Dalí. An "executioner" then took over, slicing each work measuredly with an ax. The participants assembled the debris and set it afire, while Marta Minujin released a few rabbits and a flock of birds; other participants attacked one another with shaving cream. During this finale, crowds of strangers who had been curiously watching on the sidelines rushed into the scene and joined in the activities. Miss Minujin suddenly saw an unlimited potential in inviting outsiders to join in activities that would ordinarily never occur to them.

Marta Minujin's environments and Happenings have a very real and basic purpose. They present the participant with a mirror of himself. But they also speak of the transitoriness of "things" in people's lives. Her constructions, like her Happenings, logically are one-time experiences. A form of destruction must take place each time (with or without ritual). But for Miss Minujin, destruction is as much an affirmation of life as of death. She destroys in order to rebuild. She destroys because she believes in life, not because she wants to kill it. She destroys because "nothing is static, life is constant change." She destroys so that nothing can become stagnant, or become another formula. Life is constant rebirth.

Marta Minujin's work has so far been shown mainly in galleries. But she cherishes the wish to put it right out on the street and charge admission. "I would love to put up a huge construction in the middle of Times Square and have all the people in the street come in, and even live there for several days. They could even go to sleep in one environment and wake up in another." She is planning a new structure even larger than *La Menesunda*. "Next time I would like to use live cows. They are so wonderful and plastic."

# The Perils of Popularity

## An Interview with Fernando Botero

**Cristina Carrillo de Albornoz**

From *The Art Newspaper*, December 2001

Translated by Alex Campbell

*F*ernando Botero has given many interviews over the years, but this one is among the few that cover his entire career, including his later success.

TAN: You were born in a small town 69 years ago. Was there any cultural life there?

Fernando Botero: I was born in Medellín, in Colombia, in 1932. It was a small provincial town with little in the way of culture or art at the time. My father died when I was four so I grew up in very straitened financial circumstances. The career of painter had only negative connotations;

"It's the profession you do if you wish to die of hunger," people used to tell me. Yet I was so strongly impelled to take it up that I never thought about the consequences.

TAN: How did you start to paint?

FB: As I was saying, my father, of very humble birth, was a travelling salesman. An uncultivated man, he nevertheless had a fascinating book on the French Revolution. As a small child I would spend the day looking at illustrations of Louis XVI and Madame Pompadour which I then painted. Until the age of 19, I did not see a real picture. My first job was as a bullfighter. Even now, apart from reading the *New York Times* and art books, my great source of pleasure, almost as intense as painting, is to watch a bullfight every day—on video if need be. Bullfighting, in an increasingly gray world, is one of the few fields that still has color. That first career collapsed in front of the first brave bull, weighing *350* kilos. I remember my legs trembling. I crossed to the other side of the fence and started to paint pictures of bulls, dedicating myself for good to painting.

TAN: You then went to study in Spain and Italy. How did you manage this in such impoverished circumstances?

FB: Fifty years ago, in 1951, I held my first individual exhibition in Bogotá, the capital, with great success; the following year I won the national painting prize, competing against all the other artists of my country. The prize was something in the region of $8000, a considerable sum at that time, particularly in Europe where I went to study that same year. I was very happy as a student. In Spain and Italy, the museums were my teachers. The first picture I saw in my life was in Barcelona, in the Museo Montjuic. It made a huge impression. I had seen engravings but never a painting by a great master. After that I was treated to an orgy of pictures, as I lived for a year opposite the Prado, where I was a copyist. Paris and Italy came next. I hired a motorcycle and for months traveled all over Italy seeing all the frescoes. Italy is the country of refinement, of aesthetic perfection—just what I am looking for. Fresco painting is my passion.

TAN: In what sense are you self-taught?

FB: I learnt what I know painting, looking and copying in museums as well as reading the letters and writings of the great artists of the past. Although I went to the Academy of San Fernando in Madrid and the School of Fine Arts in Florence, this was more to have a studio with painting materials and heating than to get guidance from the teachers. In any case the teachers were not on hand and every pupil did as he wished. It was better like this as I did not have to spend years trying to forget the bad advice of the school. It is because of all this that I've always felt self-taught.

TAN: After Europe came Mexico . . .

FB: I spent the year 1956 in Mexico, a country that awakened my interest in pre-Colombian art, Mexico's popular art and the illustrative skill of the mural painters who had made Mexico the subject of their works.

TAN: It was in fact in Mexico that you found your style, the "boteriano" language.

FB: From my student years in Florence I had developed a great interest in volume, the central, fundamental element of Florentine painting. In Mexico I found my own way of expressing that volume while also maintaining the quality of color, as the Italian masters of the Quattrocento had done. This happened in 1956, an intense year: I painted non-stop in Mexico, preparing an exhibition in Washington. The last picture I did was called *La Mandolina*. Executing it with broad strokes, I unconsciously made the hole very small and the mandolin acquired fantastic proportions. I realized something ex-

traordinary had happened. Thus, my universe of large forms was born. A painter has no *raison d'être* if he does not create his own world.

TAN: You always insist that your taste in art stopped at the figurative. In what sense do you consider yourself contemporary?

FB: My painting is contemporary because no one can escape their century, and whatever admiration one may have for artists of the past does not situate one in another age. Goya, for example, admitted that his masters were Velázquez and Rembrandt, yet Goya is clearly of the 18th century and not the 17th like his masters.

TAN: Do you consider yourself a classical artist?

FB: In no sense. A great matador such as Juan Belmonte defined the classical in bullfighting as "what cannot be done better" and I think that this definition can be applied also in art. The classics are the Greeks, the artists of the Renaissance, Velázquez, Vermeer.

TAN: In the Fifties you decided to go to New York. Why?

FB: New York was the center of artistic creation in the Fifties and Sixties. So I decided to establish myself there in 1960.

TAN: Who helped you?

FB: I arrived with very little money and without any English. At first it was very difficult to find anyone to take an interest in my work. I had various Colombian friends who knew many gallery directors and they showed me around the city. I visited as many galleries as I could and showed my drawings and said I had oils too. I sold my works for next to nothing and the drawings for $10.

TAN: Your great triumph was that MOMA bought one of your paintings. How did you achieve this?

FB: In 1961 Dorothy Miller, the assistant of Alfred Barr, founder of the Museum of Modern Art, came to my studio. She was in the habit of visiting young artists in the Village and some of them mentioned my name to her. As soon as she saw my picture, "Mona Lisa aged twelve," she decided to buy it for the Museum, where it was prominently hung for a couple of years. The picture appears in a book of 100 works from the collection selected by Barr himself; it included artists such as Picasso and Braque. This acquisition helped matters greatly and some important collectors started to buy my works.

TAN: After that museums all around the world wanted your work.

FB: I was invited to take part in the Carnegie International in Pittsburgh. I think it was in 1966. Out of that came an exhibition of my work which toured to five German museums in 1970. After that some of the most prestigious galleries invited me to exhibit: first the Hanover gallery in London directed by Erika Nrausen, then Claude Bernard in Paris, the Brüberg in Berlin, Verenemann in Belgium and

the Marlborough in New York. Frank Lloyd, founder of the Marl-
borough, came to my studio in 1970 and invited me to join the
gallery, and I exhibited there for the first time in 1972.

TAN: What do you say to those who describe your success as a marketing
operation?

FB: I reply that my success is simply a great operation of work and inde-
pendence. Everything I own, I have made myself. I owe my success,
at the end of the day, to museums and books. I am the living artist
who has had the most exhibitions in museums—over 50. Each year
new books are published on my work. The public buys more each
time.

TAN: How important for you is the quality of a work?

FB: Quality is everything in a work. I take quality to mean originality
and coherence of language or style—in addition to technique which
should correspond to the style of each individual . . . Because of the
enormous pleasure I feel doing my work, I am always working and
my oeuvre is very extensive. My timetable runs from morning till
night—over 1000 pictures and sculptures.

TAN: Is there any truth in references to "the Botero industry"?

FB: Absolutely none. This is something that always amazes me. It is
meaningless to speak of the "Botero industry." My work is done en-
tirely by my own hands, without assistants. The real "Botero indus-
try" is the vulgar copies of the same dimensions and in oil that are
widely produced in workshops in Vietnam, India, Thailand, Florida
and Latin America, and that to my great sadness and fury I see all
over the place. I have equally been accused of working for money.
I don't think that this profession is pursued for money. People are
judged by the money they earn. This is ridiculous. But what most
pains me is that they call me "the painter of fat people."

TAN: Your work is exultant and joyous. Do you think this is a quality that
has not been understood?

FB: It definitely does not correspond to the cliché of the sad, wretched,
consumptive artist. The greatest artists of the past such as Titian,
Velázquez, Rubens, Goya, were men with a positive vision of life
and I believe this is how it should be. In their pictures I see exulta-
tion of life, work done to ennoble and not to diminish man. By na-
ture I am optimistic and positive and my work is a reflection of
my way of being and living.

TAN: You were saying that the criticism which most pains you is that they
think you "the painter of fat people."

FB: It is just a gross simplification, a vulgarity. Like describing Picasso
[as] the painter of someone with two eyes in the same place. I do
not paint the fatness but I am interested in the volume, something

very much forgotten in our century, like sensuality and tenderness. I think there are two types of beauty. The real one—objective and everyday—and that of art, which is subjective. Nothing is more banal in art than a sunset, but in life it can be very beautiful. A perfect woman in art can prove banal in reality, like a photograph in Playboy; the most beautiful women in art, like Mona Lisa herself, were ugly in real life. There are those who see the monstrous in my work, but my work is what it is.

TAN: How many museums hold works of yours today? And private collectors?

FB: To my knowledge, 45 museums and public collections have works of mine. In America, MOMA, the Metropolitan, the Guggenheim, the Hirshhorn Museum, the Baltimore Museum, among others . . . And then in [the rest of] the world from the Hermitage in St. Petersburg to the Vatican. I cannot say in the case of private collectors, who are numerous, as it is the galleries that sell my works. However, I know that New York, the shrine of contemporary art, is where my work is now most bought, where I have most friends. But the global market for my works is half American, half European.

TAN: How important to you is success?

FB: Success is after all a stimulus and a fount of enthusiasm and energy. However, the real reward for an artist is not fame or money but the pleasure of painting every day.

TAN: Are you saddened by the fact that art today is so bound up with commerce, with business?

FB: Art has been commercial throughout history. I always say that the art of today is less commercial than ever. Before, it was the painter himself who made copies of his work. El Greco, for example, if he liked a picture, did five. The painter was indebted to his protector or patron who dictated the subject, the title, even the size of the work. All the great frescoes were done to order. The artist was a slave to the nobility, to the great patrons. In our age, the painter is king. The artist is more highly valued than ever. The fact that there are galleries changes nothing.

TAN: Although you have five studios, you produce your sculpture only in Pietrasanta.

FB: Yes, I spend the summers in Pietrasanta, a small town in Tuscany where Henry Moore went and even Michelangelo made his sculptures. Centuries of art are breathing there, and foundries are far more numerous than in Paris. It provides the ideal conditions for sculpting . . . My sculpture is a natural extension of my painting. For me, sculpture is painting without borders.

TAN: What has been most essential in your life?

FB: The important thing is to achieve a magic coherence that surprises, not fidelity to reality. I have been lucky enough to withstand all kinds of storms and manage to live on my work from the beginning. I am lucky, very lucky, to be an artist. Painting—art in general—is an oasis created for man to take refuge from harsh reality; it is an alternative. To live in music, in literature, in poetry, in painting, is to live in a world of perfections. Unhappily many do not see it in this way. Matisse was much criticized for defining art as "a good armchair in which to rest and escape." His painting was of beauty, pleasure, luxury, sensuality. A great painter.

# The Death of a
# Mural Movement

**Eva Cockcroft**

From *Art in America,*
January 1974

*This article deals with the most famous mural-painting group in Chile, the
Ramona Parra Brigade. This group was founded in the late 1960s and contin-
ued its activities even after the 1973 military coup that caused the fall of the demo-
cratically elected government.*

Painting slogans on walls is a traditional mode of political communication
in Latin America, since the formal media are normally dominated by US in-
terests and the political party in power. During the Allende campaign of
1969–70, painted walls emerged as an essential communication link between
the Left and the masses. Rival painting brigades were formed as part of the
youth organizations of several parties in Allende's Popular Unity coalition.
When the Ramona Parra Brigades of the Communist Party began to draw po-
litical symbols to complement the verbal messages, a new mural style began
to evolve, and when Allende was elected, this new style flourished on every
available surface throughout the country Named after a twenty-year-old
worker-heroine shot down during a nitrate strike in 1946, each Ramona Parra
Brigade (before the coup there were 50 in Santiago and 150 in all of Chile)
consisted of twelve to fifteen members with an average age of seventeen,
though some were as young as twelve. They worked cooperatively, creating
some projects directly on the wall, while more complex designs were worked
out beforehand and passed from group to group, though freely altered during
the painting process.

A common imagery and a vocabulary derived from Cubism developed
into a complex, organically evolved metaphor. Whole walls were transformed
into a series of intertwined symbols much in the way that words are joined
into sentences and sentences into paragraphs. A fist became a flag became
a dove became hair became a face, and so on. Speed, a necessity for clandes-
tine, illegal painting, determined the high degree of simplification and the
use of flat, bright colors applied with more regard for visual clarity than for
naturalistic effects. Thus elements of "modernity" developed naturally, with-

out a conscious search for style. And within the limits of effectiveness, the styles were varied. Permanence was not a factor. As issues changed, some walls were painted over and the cheap tempera paint was quickly faded by rain and sun.

The primary function of the murals was mass political education. During the Allende campaign, travelling brigades were formed to go into isolated communities and paint walls, give puppet shows and political speeches. Once Allende was president, the brigades worked with the people in communities, housing developments, and factories, as well as on the streets and in parks, consciously attempting to revise and redirect the taste of the masses. In the case of Fabrilana, a textile factory nationalized in 1970, the young artists studied its processes and were impressed by the movement of huge skeins of colored yarn. In the resulting mural the great looms become rectangular forms and the colors of the wool flow throughout, becoming hands, smoke, hair, flags. Initially the workers' preference for strict naturalism (resulting, the brigades were convinced, from cultural deprivation rather than any innate sensibility) led them to question the abstraction. But when the mural was completed, they felt it to be a more convincing reflection of their experience than the conventional group of heroic figures would have been.

The *Rio Mapocho Mural* was the most ambitious of all the BRP projects. Painted along a stone wall by the river beside a large and popular Santiago park, it ran for more than a quarter of a mile, between two bridges. About fifty Brigadistas worked for more than a week to complete it. The mural began with a quotation from Pablo Neruda: "Me has dado la patria como un nacimiento" ("You have given me the fatherland as a new birth"). Its five sections showed the nation mobilized for a new birth, marchers with their flags, the people reborn, the flag-face symbol of the *compañera;* a poem on the labor union struggle, workers, a mining village, and the martyrs of that struggle; the giant words NO TO FASCISM, prisoners, fists, flag and gun; a paean to Copper and Industry; a fanciful celebration of the fiftieth anniversary of the Chilean Communist Party. The brilliant colors took on subtlety from the uneven surface of the stone.

The figure of a massive laborer in the *Rio Mapocho Mural* is a rare echo of Siqueiros. Although not unaware of the work of the Mexicans, individual BRP members stated that they did not consider Siqueiros an important influence: "The style of Siqueiros and the Mexican mural movement is no longer relevant even for Mexico, since it serves as the symbol of a prostituted revolution. Siqueiros is now a painter of the Mexican Establishment, an establishment which needs to be overthrown by a new and legitimate revolution which will bring with it a new style." The debt to Cubism and artists such as Leger is also acknowledged, but the Brigadistas pointed out that it was ideologically important to see that while Leger went from the sophisticated to the primitive, they were moving in the opposite direction, seeking an indige-

nous style, an art truly of the people which would foster a higher class con-sciousness. To what degree they succeeded before they were so rudely halted is difficult to determine. Certainly they were putting into practice the collec-tive ethos, a genuine participation of the people in its own art. In doing so they had to combat historically imposed colonialist deformations of taste by the Capitalist mass media, and the prejudice of the international artistic elite against propagandist art.

The collective execution of these murals is perhaps the most important ele-ment for art in general, a significant departure from the concept of individual "genius" as a prerequisite for the creation of "art." Cooperative creation and collective responsibility help to diminish the ego conflict and insecurities so common in competitive societies. There was in the brigades a strong group solidarity. Individual style was not encouraged, although experimentation and innovation were prized. In their attempt to forge a bridge of communication including modernistic simplifications and distortions but retaining a human-istic element, they experimented with several different styles, from fantasy and comic strip to an epic symbolism. As their reputation grew they began to re-ceive some recognition and exert some influence on the established art com-munity. Occasionally students from the School of Fine Arts would paint with them, and on the wall at the Piscina La Granja, outside of Santiago, Surrealist Roberto Matta Echaurren worked with the BRP. The gap between art and life, between art and people, was being closed.

That process has stopped now. The junta has begun an "ideological strug-gle to try to wipe out the effects of three years of left-wing government on the consciousness of the working class and the very poor." The nine-foot statue of Che Guevara in Santiago was pulled down by a group of soldiers and driven off in a truck to be melted down. On October 2 the Junta announced that as part of its "clean-up campaign" it intended to "put an end to the black night of Marxist cinema" by importing American films which will necessitate a ten-fold increase in the price of admission to movie theatres, effectively eliminat-ing movies as a recreation for workers. News as to the fate of hundreds of left-wing Chilean artists and intellectuals is still not known. There is, however, enough information to establish a general picture of the situation. Victor Jarra, the singer and innovator in the new folk music, was killed. In one of many mass executions, an entire left-wing ballet troupe was killed. When Pablo Neruda, Nobel prize-winning poet, died of cancer and heart disease a few days after the coup, his house and library were sacked and his books burned. A young American filmmaker visiting Chile was arrested and killed. The reign of terror continues, and with it a determination to eliminate all forms of freedom of expression.

# An Interview with
# Luis Cruz Azaceta

**Friedhelm Mennekes**

From *Luis Cruz Azaceta,* 1988

*T*he expressionist style of Cuban-born Luis Cruz Azaceta grew out of his sense
*of frustration with minimal and conceptual art. As this interview shows, his
experience as an exiled Latin American was another powerful influence.*

FRIEDHELM MENNEKES: Luis, you were born in Havana, Cuba, and
grew up during a very turbulent period. You were only 17 when
Fidel Castro overthrew Batista and set himself up as Dictator; and
then you came alone to the United States when you where just
barely 18.

LUIS CRUZ AZACETA: Yes, that's right. I came to the United States in
1960, almost two years after the Revolution. I wasn't completely
alone though; I had two aunts and an uncle living in New Jersey.
I lived with them for about three years while I worked in a local
factory.

FM: And very soon afterwards you decided to study art?

LCA: No, I always wanted to study art, even while I was in Cuba. But it's
difficult in Latin countries. Art is for the rich, and artists are consid-
ered lazy and feminine. Even here in the United States it's difficult
for Latino artists to break from this stereotype. Three years after I
got here, I was fired from the factory where I was working. I spent
an entire month during the winter looking for a new job. And, out
of boredom, I began to draw. I went to an arts supply shop and
bought some crayons and paper and began drawing still-lifes. That
was back in 1963. I'll never forget that day; I was in the store buying
supplies when I heard that President Kennedy had been assassi-
nated. My interest in art grew and I started to buy books on art his-
tory, mostly the classic modern. Ever since then, it's become a fever.

FM: And you ended up at the School of Visual Arts in New York. You
were there from 1966 to 1969; that was a very interesting period.
There were student revolutions . . .

*LCA:* . . . the sexual revolution, racial riots, the drug revolution. Everyone was dealing with drugs. I was several years older than most of the other students and, coming from another culture with different values, I didn't get involved in all this madness. I was always afraid of drugs. I noticed that some of the students were more into drugs than their own art. They went to school just to get drugs. I have friends, really talented artists, who got completely burned out from drugs. Crazy!

*FM:* It was at this time that a great new art broke out in the United States—an art of feeling, living and new beliefs.

*LCA:* No, not really; not yet. No one was dealing with political issues for example. That's what's so funny. Here you had the Vietnam War, racial riots, a sexual revolution, and art was concerned primarily with aesthetics. Everyone was doing geometric abstractions like Frank Stella. There were those who dealt with politics or who painted figuratively, like Leon Golub for example. He was one of my instructors. But these artists were totally ignored. Sure the Pop artists brought a few social issues to the scene, but they weren't very serious.

*FM:* How did all this influence your work at the time?

*LCA:* While I was at the School of Visual Arts I was painting geometric abstractions like Victor Vasarely, Frank Stella, and the rest of New York for that matter. It wasn't until I graduated in 1969 and went to Europe that I realized that what I was doing was all wrong. I wasn't saying anything with my art. So, when I got back from Europe I began to paint from memory. I had an automobile crash in 1966, so I did an entire series based on this experience. I also did a series on the Vietnam War. It was at this point that I began to paint expressionistically.

*FM:* Was this a result of a confrontation with other painters in Europe?

*LCA:* It was a confrontation with paintings in museums. I was a tourist and didn't know anyone in Europe, so I didn't meet any artists the entire time I was there. I was looking at works in the large museums, especially the Prado in Madrid. Francisco Goya definitely made a huge impact on me; there's no question about it. And Hieronymous Bosch as well. Seeing these masterpieces changed my whole attitude, my entire perception of art and what I should be doing as an artist.

*FM:* So you returned to the United States and you began to paint in a new way?

*LCA:* Yes, I was inspired by the paintings I had seen in Europe. I began dealing with social and political issues in my art.

*FM:* New York City began to play a large role in your paintings. Personal experiences from your past became important as well. There are very

aggressive feelings in your paintings from this period. Tell me about what was going on inside you at the time.

LCA: New York is a very aggressive city. The thing that struck me most when I came to the United States was the subway—the behavior of people in the subway. In Cuba most people talk to one another while using public transportation. Here nobody talks to anyone. Everyone is so quiet; they just stare or they read their newspaper. Someone could be killed in front of hundreds of eyewitnesses and nobody would even lift a finger. That really struck me. It's unreal. I mean, that's not reality, is it? There's always a type of psychological paranoia in the city. Every time you turn a corner you experience a certain fear. To be alone in a park in New York City is a fearful experience. I become aware of my mortality in New York. It's funny in a way, because you don't necessarily see it, but you sure do feel it. It's all very strange, very unreal. All this began to come out in my work.

FM: That's what really impressed me most about your paintings. They're unlike other paintings one sees in museums. Normally you have to experience life in a big city for yourself to really understand this sense of fear; you can't do that in museums. But when I see your paintings I experience the fear as though I was there, in New York.

Are there particular conflicts or special personal experiences that have influenced your work?

LCA: Well, the biggest barrier or problem that I had as an immigrant was, of course, the language. I didn't know much English when I first arrived. It was very difficult for me then. I felt alienated from the rest of society. Most of my friends were from a similar background so it was hard for me to integrate myself. I think immigrants always feel a little territorial. This is wrong; it only leads to isolation. We should all learn the language and thoroughly integrate ourselves. For some reason that's difficult for Hispanics.

FM: Tell me about the tensions one experiences in a city like New York. There are signs of conflicts and pressures in your work. One senses a certain feeling of oppression. But that's only one side of the coin. That's the outside. What's on the inside?

LCA: It's all a matter of feelings and emotions. When I was very young I was quite sensitive. I was a child of feelings. I guess that's why I'm an artist. And here in New York I'm always an eyewitness. I work with what's around me—the city and people's behavior in the city. When I look around me I see a lot of things. The central theme of my work is man's inhumanity to man. Man is totally victimized either by political pressure or by the wealthy, or whatever. And although we try to manicure reality, to make it like Hollywood, it's actually very brutal. People behave more like animals than humans.

*FM:* So what are the political implications in this kind of thinking, this kind of art?

*LCA:* I think of my art as having more concerns with social implications than political ones. Of course, social issues mix with political issues. But my work isn't political per se. My concern is with humanity. I want to confront the viewer with life and what we are doing to each other. I hope to awaken in the viewer a sense of compassion. I never measure a person by his wealth, intelligence, beauty or power. I'm concerned with how compassionate a person is. Without compassion there is nothing.

*FM:* In your most recent work, you've reduced the composition down to one isolated figure. Is this a result of loneliness or a sense of isolation? Or what's going on here?

*LCA:* Perhaps in my newer work, yes. Earlier I jammed the canvas full of imagery. The works were more anecdotal then. Now the work is condensed to the minimal—a centralized, confrontational figure acting out a role. I try to make the figure somehow more general, to give it a universal language that anyone can identify with. My work no longer deals with specifics.

*FM:* Max Beckmann is obviously important for you. He too had a certain iconography which he discovered through mythology and political spheres. What's your relationship to Beckmann?

*LCA:* Max Beckmann understood myth. What I find interesting in his work, however, is not his iconography per se, but the way he congested the space of his paintings with this iconography. Although the paintings are jammed full with imagery, you can read everything clearly. They're never confusing. Beckmann was very important for my earlier works. But I'm moving away from all that now. And I'm not trying to create a myth—or at least I'm not aware of it. I work through intuition more than intellect. Often, I don't have a preconceived idea when I begin a painting. I come every morning to my studio and look at the canvas. At that moment I have an insight; I see images and I try to put them down onto the canvas. My work is immediate. I usually do a painting within a week's time, otherwise the impact is lost.

*FM:* The Hispanic population in New York is very prominent. One could almost say that New York is bilingual. The way you use colors and your choice of iconography has something to do with Latino aesthetics, no?

*LCA:* Yes, absolutely. For example, Christian iconography is very important in Latino art. When I talk about Latin-America I'm concerned with the political and social conditions of the people as a whole; I don't focus on Cuba for example. Of course I deal with my experi-

ences in Cuba, but I apply them in a more general way. I just finished a painting called "The Dictator." Blood comes out of his hands and his face is similar to that of a pig. It's a universal image of a Latin dictator as opposed to one particular ruler. He is not Fidel Castro. As a Cuban, I could have easily presented an image of Castro, but I chose not to. I represented the symbol of the Latin dictator. He could be anyone. Many of my sources come from my childhood, often unconsciously. What I remember most about my childhood in Cuba is fear—a child's fear, which is different from the fear an adult experiences. It's more surreal. In Cuba we had huge Carnivals. People used to wear large paper maché animal heads. As a child, this scared me tremendously. I would run home as though terrorized. It was all totally surreal. All this comes out in my work. I use a lot of large severed heads in my paintings for example. But this is all more or less subconscious. I deal with fears, phobias and taboos; also black magic in a way.

FM: Another major theme in your work is death. What does death mean to you? Do you hold existential attitudes?

LCA: Yes, existential is the right word. It has to do with the fact that I lived through a revolution in Cuba. The dead were everywhere. Bombs exploded in cinemas and even in supermarkets. These terrorist acts went on both before and after the Revolution. I experienced all of this as a young man, a teenager. It's something I can never forget. It will be with me my entire life. And this all has to do with fear. It definitely comes out in my paintings. I use self-portraiture as a vehicle to convey these conditions. In my work, the heads are always screaming. This has to do with absolute fear and terror. Fear motivates my work.

FM: I've done a lot of work with Francis Bacon. Fear, violence and screaming are all very important for his work as well. Is there some relationship to Bacon in your work?

LCA: Yes, there's a similar expression. You could almost say that Francis Bacon is one of my fathers. I identify completely with his art. I feel a spiritual connection to Bacon, and also to James Ensor, Francisco Goya and Pablo Picasso. Max Beckmann and Otto Dix are also very important for me. And from Latin America I identify with José Clemente Orozco and Frida Kahlo. These artists truly moved me. Frida Kahlo died in 1944. She was the wife of Diego Rivera. She too dealt with self-portraiture and focused on suffering and victimization. She had an accident when she was very young which left her in a wheel chair with a broken spine. She led a very tragic life. All this comes out in her work. She was truly a great painter and had an enormous influence on my painting.

*FM:*  This idea of self-portraiture as a vehicle of expressing universal themes is very interesting. But this comes out only very recently in your work. Why the sudden change?

*LCA:*  I use self-portraits as metaphors. I've always used self-portraits to some extent. Recently my work has gone through a metamorphosis as a result of a new self-examination. I'm dealing with my own personal feelings and emotions. But they're all universal in some way, no? I mean, fear is something we all experience.

*FM:*  Luis, you are a very successful New York painter. You're represented by a highly respected gallery. At the same time you have a continuing relationship with the Museum of Contemporary Hispanic Art in Soho where you have your studio. As a Hispanic artist working in New York, do you feel accepted by the art community?

*LCA:*  Only now. I was neglected for many years. But I don't think it was because I was a Latino artist. The art critics didn't know how to deal with my paintings. Now that Neo-Expressionism is in, they have a language to fall back on. Besides, I don't consider myself a Latino artist per se. First and foremost I'm a New York artist. I've been in New York for 28 years now, and I'm an American citizen. I'm a part of New York and New York is a part of me. New York is in my blood.

# In the Studio
## Miguel Von Dangel

### Ricardo Pau-Llosa

*Sculpture Magazine,*
October 1996

*T*his brief account deals with one of Venezuela's most important artists of the
generation that came of age in the 1980s. His work shares important character-
istics with the international movement known as Neo-Expressionism, but he was in
no way a follower. Rather, he arrived at the style before the trend became dominant,
and his art uses different sources, reflecting his heritage.

Not since the kinetic art boom in the '70s has an artist so dominated the
visual arts scene in Venezuela as has Miguel Von Dangel. His fusion of mysti-
cal references, rooted in Christian, Amazonian, and Afro-Cuban religions, is
in sync with his eclectic attitude toward media. His sculptures, as well as his
object-rich "paintings" (more like wall-hanging sculptures), are home to frag-
ments of pre-Columbian pottery; feather arts of the jungle tribes; fragments
of maps, bones, and other animal body parts (sometimes the entire dog,
horse, or reptile); and countless elements gleaned from the detritus of indus-
trial life. Von Dangel uses myriad pigments, polyester resin, industrial paint,
and glitter to charge the surfaces and volumes of his works with a rapturous
energy.

Von Dangel represented Venezuela at the 1993 Venice Biennial with an 11-
panel installation, *The Battle of San Romano,* which translated Uccello's dialec-
tics of volume and action into an epic of New World discovery, destruction,
and redemption. Paradoxically, history plays the malleable and semiotic role
of form in Von Dangel's works, and what would ordinarily be form and im-
age function as the knotting and disentangling agents of a new syntax, as
dense and interlaced as the rain-forests he so loves to explore.

Von Dangel received one of the twelve $50,000 grand prizes at the 1992
EcoArt exhibition at Rio de Janeiro's Museum of Modern Art. In 1995 he was
honored with a watershed retrospective that completely filled the National
Gallery in Caracas. He is one of Latin America's quintessential contemporary
artists.

Born in Bayreuth, Germany, in 1946, he has lived in Venezuela since the

age of two. Von Dangel has adapted the rooftop of his home in Petare, a blue-collar municipality just to the east of Caracas, to function as his studio. The anti-paradigmatic nature of his work is reflected in his lifestyle. Home and studio have intermingled. Cages with tropical birds share the labyrinthine house with the artist, his family, and his hoard of Amazonian artifacts, indigenous pottery, found objects, and works in progress. An errant land turtle patiently traverses the scatterings of the sunlit patio. If there is an artist whose life, natural environment, sense of history, philosophical erudition and creativity are seamlessly integrated, it is Miguel Von Dangel.

With seemingly no effort Von Dangel moves between regions of cultural references which overlap in all Latin America, and in the catholic Caribbean most of all. On the day of my latest visit he was working on a series of sculptures that consists of diverse objects assembled in clay pots. These tropical vessels of plenty recall offerings common to many religions, but they are particularly reminiscent of the *sopera* of Santería and the *prendas* or *nganga* of Palo Monte, both syncretistic Afro-Cuban religions; Santería is derived from Yoruba beliefs, and Palo Monte from Congolese-Angolan practices. The "attributes" of deities, or the offerings made to them, that are held in Von Dangel's versions of these vessels rise, metaphorically transforming the sculpture into a complex statement that situates the vertical transcendent of the male principle within the wombed and vital containment of the female principle. For Von Dangel it is imperative to recover "the artist's role as shaman" in society, lest we lose "all ability to remember and to reflect upon ourselves."

The tension between organizing principles, such as an axis, and the apparent randomness and chaos of the phenomenal world is central to Von Dangel's work. This tension is carried to other wall-hanging assemblages he is working on, in which the supporting background is covered with fragments of maps. Some maps are of this hemisphere; others recall the holy land of the Crusades. "This fragmentation," Von Dangel says, "points to the need to transcend boundaries, to the formation of a new order by which to ponder the world, and eventually to the overflowing, going past order and time as we understand it in this fin-de-siècle, millennialist way."

Each of these works is ruled by a central, vertical orientation that traverses expressionist applications of paint, with objects affixed to the surface, as well as allusions to mountains, skulls, various rituals, and ships of discovery. The axis mundi [or polar core] alludes to the "ceiba tree of Santería and Palo Monte as well as to the cross of Jesus." The tensions between this axis and the "disorientation" generated by the collage of maps are rooted in the San Romano, the prendas, and other series by this artist who is a kind of Faust as shaman, the ultimate shatterer of neat temporal linearities and comforting cultural boundaries.

# 8. As a New Century Turns

# Cries from the Wilderness

**Lawrence Wechsler**

*Art News,* summer 1990

*T*he installations of Brazilian artist Cildo Meireles have received a great deal of exposure in international exhibitions. This article discusses several of his best-known projects.

Just before the opening of Cildo Meireles' recent installation at New York's Museum of Modern Art, the Brazilian artist's assistants were busy feeding the bones—which, in retrospect, seems entirely appropriate. Like peasants out of a Millet canvas, they were reaching deep into canisters, extracting fistfuls of grainlike pellets and flinging them across the field of dry white cow bones. It was a large field—hundreds, thousands of bones ("three and a half tons worth," Meireles subsequently noted, "all of them transported up here from Brazil, in crates"), spread out in a dense, even mesh across a wide circular space that was in turn girdled by a low retaining wall fashioned entirely out of white candles.

"Sixty thousand candles," Meireles said, as another of his assistants piled the last row of candles, like a peculiarly fanatic brick mason. "Two tons worth. And again, all of them shipped up from Brazil. There they cost me the equivalent of $3,000—here I would have had to pay almost $40,000." From the midst of this surreal landscape, a bit off center, rose the piece's central cle ment, a steep, elegant teepee, wrapped in a thick pelt of colorful leaves—or rather, on second glance, a thick pelt of money: thousands and thousands of paper bills shingled one upon the next. "Pesos," Meireles said. "Cruzeiros, cruzados, U.S. dollars, Canadian dollars, centavos, australes—bills from Guatemala and Costa Rica and Colombia and Peru and Chile, 6,000 of them altogether, bills from every country in this hemisphere where Indians once predominated, although in the years since, for the most part, they've all been wiped out." Meireles calls his piece *Olvido* (Oblivion).

Actually, Meireles explained, this was his second crack at the same theme. A few years ago he'd been invited to submit a piece in commemoration of the 300th anniversary of the first missionary expeditions into the Brazilian hinterlands in the south. The piece he eventually installed in São Paulo (it was also featured in last year's celebrated "Magiciens de la Terre" show at the Pompidou Center in Paris) consisted of a dense cloud of cow bones suspended from

the ceiling (strikingly backlit so that the bones seemed to hover, hauntingly blond), with a single narrow shaft of ghost-white Communion wafers descending from the bone cloud down to a square field, which was spread over with 600,000 sparkling silver coins. That one he had titled *How to Build Cathedrals.*

And yet his attitude toward religion—and in particular the Catholicism of his native Brazil—is more complex than these two macabre pieces might initially suggest. In 1973, near the end of one of the most repressive periods of Brazil's military rulers, he created an installation entitled *The Sermon on the Mount: Fiat Lux,* in which he assembled a large cubic mass of 126,000 matchboxes in the center of a room. The room's walls were lined with mirrors, above each of which he'd printed one of the Beatitudes. (To suggest at that moment in Brazilian history that the poor deserved to be considered anything other than merely wretched approached the height of sedition.) The floor was covered with sandpaper and miked, so that each step a visitor took into the space was amplified and sounded like a giant match being struck. The cache of matchboxes itself was protected around the clock by five sinister-looking gentlemen in dark glasses, actors decked out to look like the grimmest of security personnel. The piece was so transparently incendiary that it couldn't be shown for several years.

"There was a big problem with censorship when I was first getting started as an artist," Meireles now recalled. (He was born in Rio in 1948.) "By 1969 and 1970, for example, the regime was strictly monitoring all the standard means of communication—television, radio, newspapers, book publishing, galleries. So that in my earliest work I set myself the task of inventing alternative methods of communication—or rather, taking advantage of some of the alternate systems of circulation that already existed. Thus, for example, I began rubber-stamping political messages onto the faces of paper money that I happened to procure in the course of my day and which I then proceeded simply to spend.

"In 1970 I figured out a way to silk-screen subversive messages with white paint onto the sides of empty Coke bottles, which I then returned for deposit. With those light-green, tinted Coke bottles, you see, the famous Coke logo was likewise emblazoned in white paint; it was very visible when the bottle was filled with the dark brown liquid but virtually invisible when the bottle was empty. In the same way, my message remained secret and invisible until the bottle was refilled and once again shipped out for sale."

Meireles reached into his satchel and pulled out a photograph of some of those simple Coke bottles. Quietly displayed in such a context, they seemed as tame and merely ironic as some of the other Dadaist gestures that artists about the world were indulging in around the same time; in the Brazilian context of that moment, however, they must truly have carried a wallop.

The catalogue also includes a photo of Meireles himself during that period,

looking quite lean and radical and surly—a Latin Jean-Paul Belmondo. Today he's more well rounded, paunchy (his well-worn plaid flannel shirt straining against his midriff in a way it probably didn't years ago when he first bought it), self-ironic, his black hair going gray. His art is less overtly political. Or rather, his politics are more ambiguous, less polemical, more steeped in a sense of the tragic dimensions of the issues he addresses.

In the piece at the Museum of Modern Art, for instance, the various components of the installation keep performing subtle symbolic inversions; the bones are organic elements, tokens of life, and yet they also read as death; the candles, tokens of devout Catholic practice, encircle the installation like a protecting levee but then again like a prison wall, their waxiness opaque and yet potent with the possibility of light and redemption. The money pelt surrounding the teepee at first looks organic (and even when you realize what it is, it still insists on presenting itself as liveliness incarnate, all those playful faces); yet, as money it stands in for all the forces of greed and rapaciousness that have doomed successive generations of Native Americans, and the shelter of the teepee is transmogrified into a strangulating shroud. The interior of the teepee, for that matter (visible through a sashlike opening) turns out to be filled black with burnt-out charcoal—once-nurturing warmth run amok, furious holocaust guttered out to cold ember. (Both the charcoal inside and the paper money outside the teepee suggest disturbing transformations of the wood in the rapidly receding forest.)

Meireles has suffused the entire installation with an almost subliminal sound track, an eerie, initially indecipherable wheezing drone—the thrumming incantation of a gathering of native priests, perhaps? The intrusion of distant motorbikes? A fusillade of machine-gun fire? Chain saws nibbling away at the forest's edge? (In fact, explained Meireles, it's the latter). It was in this context that Meireles' assistants sowing their pellets fit in so perfectly; it turned out they'd been lavishing the bones with insecticide; a few stray cockroaches had apparently insinuated themselves amid the cow bones, so that the seeds Meireles' assistants were sowing were those of death.

"The problem of the extermination of Brazil's Indians," Meireles commented, "for they are in fact being exterminated as we speak, is not simply one of Indians versus whites. Rather, it's poor people being pitted against other poor people. In 1950, 70 percent of Brazilians lived in the countryside, with only 30 percent in the cities. The great majority of Brazilians subsisted by farming their meager plots. But over the years the big landholders swallowed up more and more of those plots, expelling the peasants, often at gunpoint, and converting their lands to monoculture—oranges, for example, or cattle, usually for export. This year we're doing a new census and we expect 85 percent of Brazilians will be seen to be living in the cities, the vast majority of those in truly wretched favelas. Some, however, instead move deeper and deeper into the hinterlands, out of desperation, where they of course begin

encountering the Indians who've been living there for centuries. And soon you begin seeing these terrible massacres."

Meireles recounted how during the '40s and '50s his uncle Chico Meireles had ranged the jungle, a famous *sertanista,* an explorer who was specifically seeking out the Indians. "He felt that contact would be inevitable," Meireles said, "and he saw it as his function to reach the Indians first and explain to them what was about to happen, to try to get them to secure economic control of their own lands, even though such a notion was a perversion of everything they, and he, believed in.

"Chico's son, Apoena, managed to set up a national park, an Indian preserve, in Aripuana, but he had a terrible time trying to convince the normally migratory Indians to stay within its confines, not to cross those arbitrary, invisible borders. The chief would complain to him about how when the season came his grandfather always used to lead them over to that mountain over there, on the horizon, and now here my cousin was telling them they could no longer go—how could that be?

"There are terrible tensions on the edge of the jungle nowadays," Meireles continued, as he watched his assistants making the final adjustments on his installation, rearranging a few bones here, realigning a few candles there. "Several years ago I was visiting my cousin, deep in the jungles of Rondonia territory (it's since become a state), where he had an outpost near an Indian encampment. In the distance you could hear the chain saws relentlessly clearing the jungle—closer by, you could hear the Indians, huddled in their anxious deliberations. And then suddenly you didn't hear them anymore. 'Oh no,' my cousin said, and he bolted out of the building and into the underbrush, with me in hot pursuit. We were running for a long time, but then we came upon a scene I'll never forget; a bunch of terrified Indians brandishing guns, pointing them at a little family of five blond-haired, equally terrified *boia fria*—white trash, the ones-who-eat-their-meals-cold, we call them. The Indians had already torched their hut, trashed their store of powdered milk. The babies were screaming, the mother clutching them, trembling. It was so pathetic—these poor wretched people at each other's throats. But that, these days, is the Brazilian reality."

# Everyone Needs a Madonna

## A Visit with Gonzalo Díaz

*Art News,* October 1991

*This article deals with the work of Gonzalo Díaz, one of Chile's leading concep-
tual and installation artists. The issue most of interest here is the impact of the
military dictatorship on his art.*

Gonzalo Díaz walked out of his house in the upper-class Santiago de Chile
neighborhood of Providencia. The brilliant sunshine that had greeted the day
had now, at noon, disappeared behind thick clouds. It was as if the atmos-
phere of Santiago, he thought, was responding to the bad news overtaking
the city. All morning he had been listening to the radio. Now, out on the
street, he looked up and saw a column of tanks, their headlights on, rolling
toward him.

It was September 1973, and Díaz's neighbor and family friend President
Salvador Allende was about to die in the military coup staged by General Au-
gusto Pinochet.

Over the next 17 years that event would play an indirect role in Díaz's art.
In his studio today, he still keeps a memento of the times, a pharmaceutical
urn given to him by Allende, a physician like Díaz's father. "Half my life was
lived under the dictatorship," says Díaz. "I am 45 years old. I have been work-
ing for 20 years as an artist, and 17 were under the dictatorship. It had an im-
pact on my production."

In 1989 Díaz presented an installation at Santiago's Galería Ojo de Buey
called *Lonquen: Ten Years.* That work represented his most overt response to
military rule. It was ten years earlier, in the town of Lonquen, near Santiago,
that the first mass grave of "disappeared people" was exposed. "It was discov-
ered," Díaz relates, "through a soldier's confession to a priest. The church
went there and found 14 bodies. It was a very precise point for the Chilean
bourgeois. There was real proof of what was happening."

Díaz's piece includes a stack of numbered stones pinned against a wall by a
wooden scaffold, with a ray of blue neon striking the stones. On the other
walls of the room are 14 identical paintings, which the artist calls "Stations of
the Cross," each bearing the printed phrase "In this house, on January 12,
1989, the secret of dreams was revealed to Gonzalo Díaz." Attached to the
frames is a lamp and a small shelf supporting a glass of water. But such specific

political commentary is uncharacteristic of Díaz. He is more interested in exploring "the relationship between art and power" than in directly criticizing a repressive regime.

Part of the link between art and power is popular mythology. Díaz illustrates the point by incorporating in his work icons that the church, the state, and commerce use to legitimize their authority. In a country that lived so long under military dictatorship, whose middle and upper classes are deeply conservative, and where the Catholic church is so powerful, myths tend to flourish.

"I am interested in revealing, investigating the kind of grand mediocrity that exists in this country," Díaz says, "a country that for some reason invents in its background qualities that it doesn't have. That Chilean women are the most beautiful in the world, that the national anthem is the most beautiful, that the wines are the best, that Chilean soldiers are the bravest. All these myths can never be touched. I believe this is what a part of Chilean art is doing—touching these forbidden things. Touching them, nothing more, putting them in a scene. It has the effect of disarming the common language."

In his installation *Bank of Evidence*—first shown in 1988 at the Galería Arte Actual in Santiago, and now in the collection of the Blanton Art Museum at the University of Texas at Austin—Díaz used the image of Chile's first saint, Sister Teresa de Los Andes, to examine the making of religious myth. Sister Teresa was a member of the Chilean upper class who died of tuberculosis at the age of 19. "People started generating a myth around her," Díaz explains, "until at last the church—the Vatican—decided that it would be good if, within the next ten years, each of the countries in Latin America would have its own saint."

"It's good for the politics of the church," Díaz says. "It's similar to President Kennedy's space program, whose goal was to put a man on the moon in 20 years. So now each country is looking for a person who fits into this program. And they will accommodate those who don't fit so well. I believe that is the case with Sister Teresa. I investigated her story. I read her letters. They are nothing."

Although he is one of Chile's best-known and most successful artists, Díaz struggles with the Chilean art market. "The artist here walks the tightrope, sells the entrance tickets, and later plays in the orchestra," he says. Díaz is not represented by any gallery. According to Fatima Bercht, director of the Visual Arts Program at the Americas Society in New York, his work is hard to market since "it is ephemeral, it deals with things in a very critical manner, and the subject matter is difficult." Nevertheless, he has had eight solo exhibitions in Santiago since 1969; has been in shows in Latin America, Spain, and New York; and has received several grants, including, in 1987, a Guggenheim. Last spring he was in the show "Contemporary Art from Chile" at the Americas Society and will be in the Fourth Havana Biennial next month. Díaz's paintings go for $2,000 to $3,000 in Chile and $7,000 to $10,000 in the U.S.A.

The third in a family of 12 children, Díaz attributes a certain gravity in his work—a sense of being pulled down—to the fact that he was stricken with polio when he was five and continues to walk with crutches. At 17, after attending a German-run parochial school, he enrolled at Santiago's School of Fine Arts. For 20 years he has been a professor of painting and drawing at the School of Arts of the University of Chile.

Nellie Ricard, a French critic living in Chile, saw Díaz and Chilean artists Eugenio Dittborn, Lotty Rosenfeld, Carlos Altamirano, and Carlos Leppe as constituting a group. She dubbed them the *Chilean Avanzada* (the politically engaged vanguard). "The most important movement in Chilean art in the late '70s and early '80s," says Bercht. Díaz's career is interesting, Bercht explains, "because he comes from a painting background and he has a quest, even if he moves into other mediums, to address the history of painting in Chile. I think he plays a seminal role for the younger generation."

Before the military coup, Díaz drew the inspiration for his paintings largely from classical literature and Chilean poetry. "My head was full of myths that appeared to have resonance in contemporary life," he says. One series of paintings, "Paradise Lost," depicted the mythological ferryman Charon bearing the dead to hell across the river Styx. "I started to de-mystify the imaginary world that had much to do with literature." But after seven years under the dictatorship, he found the boundaries of a canvas too limiting for what he had to express. He began working with extensions—shelves, objects—as in *Lonquen*.

In 1980 Díaz went to Italy for a year. His *Sentimental History of Chilean Painting* (1981) derived directly from that experience. In a sense, the work involves Díaz's own form of mythmaking. He uses the cartoonlike figure of a woman who appears on the label of a well-known brand of detergent. "I remember when I was a boy," he says, "this detergent was always in the bathroom or kitchen with this image on it of a very pretty woman, like a woman from Holland with pigtails—a Pop-like figure. I took this figure and I elevated her to the level of a Madonna," Díaz explains, "something that had been lacking in Chilean painting. All the great painters—Italian, Spanish, German, whatever—are established because they have a Madonna, a Virgin, a big subject. So this figure—domestic, industrial, comic—is carried to the art and transformed into the Madonna of Chilean painting."

# The Catherwood Project

### Leandro Katz

From *Leandro Katz: Two
Projects, A Decade,* 1996

*A*rgentine *Conceptual artist Leandro Katz literally retraced the steps of
nineteenth-century English explorer Frederick Catherwood as he visited
the Maya sites in the Yucatán peninsula. Katz's resulting works reframe and
reappropriate Catherwood's original images.*

One hundred and fifty years ago, John L. Stephens and Frederick Cather-
wood undertook a series of expeditions into the Maya area of Yucatan, Chia-
pas, Guatemala and Honduras, uncovering ancient monuments that rivaled
the famous ruins of Egypt. Stephens and Catherwood were the first English-
speaking travelers to explore the regions originally settled by the Maya.

John L. Stephens (1805–1852) practiced law in New York before he took up
his work as a writer and "antiquarian." Because of ill health, he began traveling
in the Near East, Greece and Egypt, and his first essays concern the ruins and
artifacts of ancient civilizations there. On a visit to London, he met Cather-
wood, whose drawings of digs in Egypt and famous map of Jerusalem he had
already admired.

Frederick Catherwood (1799–1854) was an Englishman who had been
trained as an architect but whose real talent lay in his ability to render views of
ancient monuments with great accuracy and insight. With the aid of a camera
lucida—an optical device that preceded the invention of photography—he de-
veloped a technique of drawing that he used while documenting Robert
Hay's expeditions in Egypt, drawings which became a marvel of the period.

The first collaboration of Stephens and Catherwood, *Incidents of Travel in
Central America, Chiapas and Yucatan,* was published in 1841 and ran to 12 edi-
tions in its first year. In 1843, they brought out *Incidents of Travel in Yucatan,*
the result of a subsequent trip to that part of Mexico. Both of these books are
composed of detailed descriptions of their extensive findings and many steel
engravings made from Catherwood's drawings, so excellent that even today
they are frequently referred to as perfectly accurate records of the objects they
document. In 1844, Catherwood published his *Views of Ancient Monuments
in Central America, Chiapas and Yucatan,* a book of 25 color lithographs,
reprinted in Mexico in 1978.

My appreciation of the drawings of Frederick Catherwood and the para-doxical elements that appear when these drawings are observed next to the re-stored monuments became a main area of concern in my work. During the summer of 1984, I had the opportunity to work in the Yucatan area, photo-graphing the Maya sites drawn by Catherwood from the same vantage points that he used when making his camera lucida drawings. In this way, I started to compile the elements of a work-in-progress called *The Catherwood Project,* a visual reconstruction of Stephens and Catherwood's expeditions. I continued this project in the summers of 1985 and 1986, covering other sites in Yucatan and the Chiapas region in Mexico. During December and January of 1987/88 I completed the itineraries of the two expeditions, photographing the sites of Quiriguá in Guatemala, and Copán in Honduras.

My intention when starting *The Catherwood Project,* which resulted in nearly 4,000 black-and-white photographs and 1,800 color, was not only to reappropriate these images from the colonial period, but also to visually verify the results of archaeological restorations, the passage of time, and the changes in the environment. In this "truth effect" process, issues having to do with colonialist/neocolonialist representation became more central, particularly during the last section of the project.

Three different approaches are used to produce the works in this project:

- The first approach attempts to adopt as closely as possible the same points of view used by Catherwood, which at times included lower or elevated perspectives. Each print in this method juxtaposes a reproduc-tion of Catherwood's published engraving side by side with my final photograph.
- The second approach incorporates a view of my hand holding Cather-wood's published engraving in front of the documented monument, making the comparison the subject of a single photograph.
- The third approach obviates the visual evidence of Catherwood's point of view and it follows his vision of the site directly and without visual quotation. At this stage, although the original structure is still being followed, the conceptual rigor of the project becomes more abstract.

In the process of covering the itinerary of the two expeditions, I became aware of Catherwood's struggle to depart from his Eurocentric style. It has been well documented that previous explorers could only manage to docu-ment the sites by merely reproducing the style and the vision of the Romantic period. The line in their drawings was wrong, their final results a fiction. In Catherwood's work, because of his Piranesi School training, or perhaps due to the aid of the camera lucida, the artist managed to enter the mind of the Maya architects, challenging his own Western hegemony.

During January of 1993 I completed my work with the monuments and their documentations by Catherwood, emphasizing the issue of architectural

rendering of which Catherwood's work presents an extraordinary example. While Catherwood's vantage point became the main reflexive aspect of my approach to the work produced in the first phase of the project, it became clear upon its completion that I should work further on the architectural aspect of the monuments.

Stephens describes Catherwood as standing on top of a crudely made scaffolding or standing in mud, veiled with a net and with gloves on to protect his hands from mosquitoes, having great difficulty in depicting the designs on the Maya monuments because they were so complex and their subjects so entirely new and unintelligible. Catherwood rendered these sculptures and buildings—so different from anything he had seen before—with such skill and openmindedness that his drawings are still useful today. He did not see in them vestiges of other cultures; he saw them as something new. And as much as his works manifest a clinical, profound accuracy, they also reveal moments of slippage and subjectivity, the result of malaria seizures perhaps, or of working in difficult locations to later reconstruct the views from sketches and memory. All these contradictions make his work even more fascinating.

Since Catherwood had platforms and scaffolding built for his vantage points, I went back to a few of the sites in the Puuc Hills of Yucatan with equipment that allowed me to get very close to architectural details and adopt a parallax-free perspective. I also concentrated on working in very dark internal chambers using a portable lighting technique that I had developed in the later part of the project in Honduras. The Institutes of History and Anthropology in Mexico, Guatemala and Honduras had previously facilitated the work on the sites, and since The Catherwood Project had already received serious recognition, access to the ruins during night hours was facilitated. This allowed me to control the light needed to record specific details in Maya architecture, and to use an "open flash" technique, lighting huge monuments in sections with a single flash unit.

# Miami No Es
# Los Estados Unidos

**Susan Valdés-Dapena**

From *ArtPapers*, November 1998

*T**his article deals with Alfredo Jaar's billboard work* This Is Not America, *a light-board installation that superimposed the title on a map of the United States. Originally shown in Times Square in New York City, it took on other meanings when shown in other cities as a billboard. This article discusses some problems that can arise when art work of a public nature is shown to different publics.*

"Miami is *not* the United States." That's not what the sign said, but that's what a number of Miamians thought it meant. What were they to make of the 16 identical billboards, which read "This is *not* America," that went up around their city on January 9, 1998? The signs were created by New York artist Alfredo Jaar, but, as is often the case with art billboards, nothing about them indicated to viewers that they were artworks. Jaar's work was part of the Miami Arts Project, which included 12 artists and consisted chiefly of billboards and bus shelter signage. The project was initiated and directed by New York curator Cristina Delgado. She described its purpose to me as "an opportunity for Miami and New York artists to explore Miami as both subject and site for public artworks." Many Miamians would argue that their city, especially its arts community, is already too closely linked to New York City. In our conversation and in the Project literature, Delgado was vague about what benefits might be gained from this connection from a curatorial perspective. Some Miami artists felt that their New York peers were included merely to lend the Project cachet. The fact that New York artists were not required to do residencies in Miami, nor to collaborate with their Miami counterparts, would seem to support this view. Certainly, no artist could understand any city as either subject or site without spending time there.

Some of the problematic aspects of Jaar's Miami billboard, then, might be deflected back onto the Project's administration and its lack of clearer curatorial goals. Jaar did not visit Miami to plan, install, or see his billboards in situ. His comments to me about his Miami billboard had nothing to do with Miami and everything to do with his identity as a Chilean artist living in the United States. He eluded my questions about what his billboard might mean

in Miami, preferring to discuss what he had intended it to mean in Times Square, where it was originally shown on a Spectacolor board in 1987 as part of the three-panel work titled *A Logo for America*. The first panel, the only one used in Miami, consisted of the text "This is *not* America"; the second stated, "This is not America's flag," superimposed on the U.S. flag; and the third contained the word "America," in which the "R" became a map of North and South America.

Jaar's primary intention with *A Logo for America* was to remind U.S. citizens that the United States is not all of America. To Jaar, the English usage of the term "American" for "U.S. citizen" reflects U.S. citizens' arrogant assumption that they are the only Americans. While U.S. self-centeredness deserves to be taken to task, the problem is also semantic. English, like most European languages, does not have a term for "United Statesian." Spanish does: "estadounidense," a term Jaar emphasized in our discussion of this artwork. Although it is relatively recent in origin, "estadounidense" is the preferred term of Spanish print media today, but its spoken usage varies regionally. In primarily Cuban Miami, the most common formal term for "U.S. citizen" is still the older, although less accurate, "norteamericano." By lumping his Hispanic audience together and assuming it shared his own linguistic frame of reference, Jaar was guilty of the regional arrogance that he attacked in his billboard.

Jaar's assertive electric signs were appropriate for Times Square—the brassy heart of an aggressive city. As a neighborhood, it is defined by commerce, transit, theater, cinema and arcades. In 1987, it was dominated by sex shops and gambling scams. In that context, Jaar's "This is *not* America" sign could have had a variety of interesting misreadings. In some ways, Times Square really isn't like any other place in the United States. Most important, though, is the fact that Times Square is not a residential neighborhood. Viewers would not have been likely to misinterpret Jaar's sign as targeting any specific group of residents in terms of income level or ethnicity. No negative public response to Jaar's work was recorded by either the Public Art Fund (the project's fund source) or the media. If Jaar had sited his "This is *not* America" sign in Bedford-Stuyvesant, El Barrio, or Harlem, this might not have been the case.

What did Jaar's "This is *not* America" billboard mean in Miami-Dade County, where the population is about 50% Hispanic and 6% non-Hispanic Latin American and Caribbean? In the last three decades, the County has become home to hundreds of thousands of immigrants from the Caribbean and Latin America, most of them seeking political asylum. Some arrived in great waves (the Mariel exodus brought 125,000 Cubans in five months), which temporarily overwhelmed the local social services, housing, and job market. Many Anglo residents, resenting the Hispanic incursion, "fled" to Broward County or points northward. Angry, xenophobic bumper stickers appeared during the 1980s: "Will the last American to leave Miami please take the flag?"

Hispanic immigration has transformed Miami from a "has-been" resort

and retirement town into a center for international trade and banking, and a flourishing, "hip," Caribbean city. Yet Miami remains divided. Some first-wave Cuban exiles do not accept Cubans who arrived more recently (the Marielitos or balseros) nor other Latin American and Caribbean groups. There are strong divisions between Haitians and U.S.-born African-Americans and between blacks and whites generally. The greatest division, however, is the one between Anglos and Hispanics, and today in Miami, Spanish speakers outnumber English-speaking whites. Although the bumper stickers are history, there are still many Anglos who resent competing in a bilingual labor force. It is not surprising, then, that some Miamians thought that Jaar's billboards were put up by an angry Anglo resident.

A.K. Media donated mostly unrented billboard space for the Miami Arts Project. One problem inherent in this approach is that there are more billboards, and hence more available space, in poorer neighborhoods. This kind of siting would naturally affect viewers' interpretations of the art billboards. Several artists in the Project did request specific locations in order to enhance their works' intended meaning or to engage a specific audience. For the most part, A.K. Media accommodated these requests. Jaar, however, did not specify any locations for his billboards, so they went up wherever space was available. Some of the sitings of "This is *not* America" gave the phrase disturbing implications. In residential neighborhoods, it could easily be misunderstood as a reflection on the people who lived there. The placement of "This is *not* America" primarily in poorer, non-white neighborhoods rather than in middle-class white ones implied that the former were not America but that the latter might be. "Liberty City is not America but Coral Gables is"? In Little Havana and Little Haiti, which are both poor and ethnic neighborhoods, Jaar's billboards could be read as a commentary on either the ethnicity or material success of the residents. His "This is *not* America" billboard on Calle Ocho (S.W. 8th Street in the heart of Little Havana) seemed intended as a truly ominous contradiction to a famous, oversized sign further east on the same street: "Republic Bank Welcomes You to Little Havana, U.S.A."

Some Miamians were disturbed enough about Jaar's piece to note A.K. Media's name on the billboard aprons (while driving), look up the phone number, and call. According to Jesús García, Director of Public Affairs, the company received about 25 calls concerning "This is *not* America" and no calls about any other Miami Arts Project signage. Most calls were from Anglos. Some were veterans, arguing that this was indeed America, a country for which they had risked their lives, and how dare anyone say otherwise! Many went on to acknowledge that, "Yes, Miami no longer seems like America, because there are too many foreigners here and everyone is speaking Spanish." One elderly Cuban caller thought that the billboard was directed against the newer immigrants, of which he thought there were too many. All the callers, regardless of their ethnicity, assumed that the billboards were intended to ex-

press dissatisfaction with some aspect of immigration in Miami. Most assumed that the billboard was anti-Hispanic. The majority of callers believed that the signs expressed an opinion on immigration that was identical to their own. Far from thinking that the billboard challenged their prejudices, most callers believed that it supported them. One Cuban American accused Jaar's billboards of "contributing to perceptions based on fear and xenophobia," an observation supported by the calls A.K. Media received.

When I asked Delgado and Jaar about these responses to Jaar's Miami billboard, both said they were pleased that his work "had created a dialogue." But did it create a dialogue or merely provoke its viewers? Provoked viewers often end up speaking only to their friends, people who are likely to share their opinions, rather than to those who differ. Thus, an artist can unwittingly feed prejudices rather than challenge them. Provocation isn't bad, but it isn't a reliable way to initiate dialogue or to undermine bias. Real dialogue around issues raised by a public artwork is more likely to ensue if viewers are provided opportunities to interact with one another and with the artist. Such educational or interactive components can be incorporated even into billboard projects.

Ultimately, the most productive dialogue, with regard to any public artwork, is the one that occurs between the artist and the community in which the work is sited. Because Jaar did not go to Miami, he was unavailable for this important dialogue, a human interaction with his viewers. Public artists, who rely on communities to host their works, owe it to those communities to become acquainted with them. Too often, the art world equates strong public reaction with an artwork's "success." A public artwork that generates a strong response because it taps into ugly, existing prejudices, and fuels rather than ameliorates them, is not successful in terms of its real effect on the life of a community. Yet it is in such terms that public artworks demand to be evaluated.

# Miguel Ángel Ríos
## Epics from the Earth

**Frederick Ted Castle**

*Artforum,* November 1988

*T*his article describes the modular constructions of Argentine artist Miguel
Ángel Ríos, whose work embodies a strong but not unquestioning relationship
to the land of his birth.

The issue of the connection between homeland (not nation) and art has to
a large extent been lost at the present time. Ever since the magnetization of
Paris in the late 19th century made the capital of France the capital of modern
art, and of its commercialization, it hasn't mattered where you come from or
where you're going as long as you remain in the capital. Today, artists from all
over the world seek to be homogenized in New York and to have the city's
commercial systems distribute their work everywhere else. Ethnicity has be-
come a much degraded concept. Originally, ethnic meant "the others," the
foreign, the godless; now it just signifies "minorities," as in "Let's eat Chinese
tonight." But there is an ethnic or generic aspect to all art, however hidden by
contemporary myths it may be. The art world tends to suppose itself immune
to nationality, and functions almost as if it, that is *we,* were our own separate
race, complete with international tourism, the bridges and tunnels of commu-
nications networks, and no need for a home base.

Miguel Ángel Ríos is a mature artist-of-all-mediums whose art disputes
these smug assumptions of international class complicity. He makes things re-
lated not only to himself, but also to his family, to the land where he was
born, to the culture that nurtured him, to various regional earths in all their
fecundity and variety, and also to the art of the present time. The work of Ríos
is frankly ethnic, strange, indeed otherworldly in a way that no science fiction
begins to approach. It is a language spoken by an alien in our midst. There is
some analogy if we could imagine what the people of Tahiti might have
thought about the many paintings, carvings, prints, and pots that they in-
spired in Gauguin, but Ríos is not making portraits of us natives. On the con-
trary, his work is completely abstract.

Ríos is now a New Yorker, but he comes from an Andean valley in the far
north of Argentina called Valles Calchaquíes, which includes part of the state

of Catamarca, where his hometown, San José Norte, is located. This was about the southernmost reach of the great Inca empire that covered much of the Andes before being driven out of business by the Spaniards in the 16th century, and Inca traditions persist among the people who still live and work upon the relatively unwelcoming, chilly, and arid mountains. Ríos grew up with llamas, and with the textiles that his mother wove from their wool as the Incas had, and with the old and local knowledge of the pigments secreted in the earth that could be used in craft. One series of his is called "Llamas," 1980–1985, because these progressively longer and larger rows of abstract figures are derived from the llama, though they don't actually look like those beasts, but more like five bars, one sticking up and four on a path or line. The figures are repetitive, but no two are exactly alike. Sometimes there is no llama where one expects to see one, and sometimes there are more than one, of different colors. These colors are earthy, literally, for Ríos' work is made out of the earth itself. Of course everything, even aspirin and automobiles, ultimately comes from the earth, but I mean that for the 12 years that I have known him, Ríos has hardly ever opened up a tube or jar of paint. He makes his own. There are many kinds of soils, sands, clays, and rocks on the surface of the planet, and he has investigated them wherever he has gone, mixing them with organic and mineral pigments to form an earthy paint. This is not to frame him as the practitioner of some ancient craft; Ríos is definitely a contemporary artist—a former art student and teacher in Argentina, a traveler in Europe and Asia. But it is to say that making the paint or clay to exactly the desired consistency and color is a clear part of his work, a part that many artists accept as a readymade without a thought.

A critic could talk about the grid in relation to Ríos, or about seriality, or about the llama as an abstract pattern of lines. But it seems to me that all artists use what they have to make what they do, and that in the case of Ríos what results in this process is ultimately unfamiliar and finally of its own genre, while inevitably being part of contemporary practice and, at best, enlarging the range and scope of art in general. Goethe once wrote of Dürer's visit to Venice that the city's effect on his art was slight, for "that excellent man can only be explained in his own terms." New York has made Ríos bolder, and it has inevitably enriched his experience of the whole range of his contemporaries, but he too can only be explained in his own terms, and his terms are shapes. It has been his custom to work a shape until he has exhausted it; he eventually lost interest in the llama sign, as he had earlier with a series of arrows. The shape that ensued was the egg—or the head, or a small melon, or anything else handsome and organic in that basic ovoid form. Ríos' current group of works is composed of eggs made of fired clay, sometimes plain and sometimes polished, in several colors. Ranged together row upon row on wood-and-canvas grounds, these forms become wall pieces that Ríos sometimes calls a "mural" and sometimes calls a "painting," rather interchangeably.

The eggs are all different, and the ones used in different pieces are very different indeed. "Muralized" like this, they become sometimes icons (almost like faces), sometimes symbols (but not in the degraded sense in which a symbol is thought to bear a clear one-on-one parallel with what it symbolizes), and sometimes characters as in writing. Such a "poem," as one is dubbed, is readable in the way that hieroglyphs may seem readable to the untutored.

*Pinté un poema con agua y arena o las huellas que deja el río* (I Painted a poem with water and sand; or, the tracks the river leaves, 1988) is made of four equal-sized panels in each of which rest 84 eggs, most of them made of white clay, some somewhat pink in tone, and a few with variegated pink and white skins. Many of them are slashed with purposeful cuts to reveal their hollowness and to suggest the presence of a scriptlike order to the "reader." The mural is almost 11 feet square, and the ovoids, as Ríos' ovoids go, are also big, about seven or eight inches high, which makes them more like heads than eggs; there is something facial as well as something alphabetic, then, in their sequences of slashes. But the cuts act more to give a direction to the reading of the poem than to suggest facial gestures. Another, more painterly work is one called *Los muertos se hacen cosquillas* (The dead tickle each other, 1988). Here the rows of predominantly whitish eggs are broken up occasionally by larger, dark-to-black eggs canted at different angles; colored diamonds, bars, and triangles are scattered throughout, and painted lines of clay connect some of the icons, if they are icons. The clay of *Camino largo a Coyotepec* (Long road to Coyotepec, 1988), and so the work as a whole, is very black, polished (Ríos never uses glazes), and inlaid with tiny bits of mica, the glasslike rock that gives this piece its fierceness, glowering toward the viewer.

Many of the current works have musical implications. The ovoids arranged in rows to form *Concierto de okarinas* (Concert of flutes, 1988) are uneven, resembling potatoes more than eggs; their meaning, though, lies not in their likeness to anything but in the musicality of their arrangement, as if in a concert of the sugar-cane flute (okarina), or of the other Andean instruments Ríos grew up with, like the ampolla, the shiku, the quena, the rondador, or the pinkuyo. Oddly, some of the shapes are absent from the beds prepared for them. The effect is of empty graves, and the whole work's presiding darkness contributes to its funereal air. Ríos has also produced a number of sculptures that have some eggness but are individual—large solitary heads, or headlike shapes, about three feet high, that have been given human names; conceivably extraterrestrial, these sculptures have huge slits at which one can listen for the seashell-like distortions of ambient sounds. Others, though retaining the basic ovoid shape, are sculpted with steplike indentations, and still others have indentations that make the shape more into a body of unknown species. Still, I prefer the big wall pieces to these smaller works, which may be merely a prejudice in favor of such things as thousand-page books and endless concertos.

One of the largest recent works, not actually an egg piece, has an appropri-

**Miguel Ángel Ríos** 239

ately large name: *Sinfonia del viento con las siete notas del rondador* (Symphony of the wind with the seven notes of the rondador, 1988). This huge, about nine-by-nine-foot mural of 12 ceramic panels bears no resemblance to the rondador, a flute composed of reeds of seven different lengths which are blown across in order to make the characteristic noise of Andean music. The panels have protrusions and depressions, none of which add up to seven, and some are fashioned to tilt outward so that the work thrusts into the room. Instead of being implanted into a wood-and-canvas background, these modules are mounted in steel frames that we can occasionally glimpse between them. I find the piece ominous, even sinister, like an unfriendly star-wars computer with a keyboard projecting outward for us unqualified users. This is perhaps because it is faceless or eggless. Nevertheless, it retains an epic scope and an uncompromised clarity.

This analogy of the epic, and with it of language, is I think appropriate to the work of Ríos, and probably preferable to that of music. It is grander, more inclusive. An epic thrives somewhere between repetition and uniqueness. In order to encompass all, the same and the different must appear together. Just as the unknown characters of an unknown alphabet may all seem alike at first, Ríos' eggs begin by seeming similar and then, with their varying shapes and colors and unlike patterns of holes and incisions, become more and more individual, more unique, as we begin to be able to "read" them. During the process of familiarization, any code, such as a language, loses its hermetic, secretive quality, but it does not lose its general quality—it is still German, Dutch, or Urdu, and has thoughts and manners of speaking that are unique to and inherent in it. While the metaphor of language has been applied to art in a number of different ways, I invoke it here because in his large ranges of egg shapes, Ríos achieves something that is analogous to language, and the analogy is not vague, it is precise. The work is no Esperanto or ersatz or substitute for language; like a language, it is itself only.

The ancient epics—Beowulf, the Odyssey, Gilgamesh—were heroic stories that certified mythology and codified language, and as such they're not made any more, but the epic sense is not outmoded or lost. Epic practice is alive, if as rare as it has always been, and the aim of the epic artist, as always, is to include everything within one thing. The epic embraces the world and attempts to demonstrate it. Looking at the paintings of Miguel Ángel Ríos, one enters a place that is everywhere and yet nowhere that one has been before. I don't know exactly where this world is, but I like it there. I don't think it is in Catamarca, nor is it in San Bartolo Coyotepec, the village in Mexico where Ríos works with a professional potter, Don Antonio Eleazar Pedro Carreño, and his family to create and fire his ovoid shapes. Neither is his world in history or prehistory, or in New York, Paris, or Madrid. In true epic form, it is everyplace, and at the same time only available in the work itself.

I think the terms of Miguel Ángel Ríos are best defined by two of the

larger works, *Requiem a Doña Romelia Nuñez* and *El aleteo de las parvadas*, both 1988. The first is in honor of the artist's mother, who died last year. In the single panel, the eggs are ranged in 12 horizontal rows, with 32 in each row. The objects are similarly sized and fairly regularly placed, but there are lots of irregularities: mica chips flash out here and there from the mural, and although most of the shapes are black, some are terra-cotta. The dark ground has a storm-cloud look. Miguel's mother brought him up to be an artist and encouraged him to go out into the world, far from Catamarca in the majestic and arid Andes. In wished-for prophecy, she even named him after the greatest international artist she knew of, Michelangelo. His homage to her is calm and emotional, moving and static, general and particular. This is how the planet Catamarca hooks up with the planet Art. *El aleteo de las parvadas* (The fluttering of the flock), nearly eight feet high and ten feet wide, is divided into two equal panels. As the title suggests—Ríos always uses suggestive titles, which are frequently poetic and sometimes witty—there's every type of "bird" here he can make, as well as more space between the rows for painting in the ground. Different things are going on in different parts of the aggregation—it's like society—but we can't tell what all it is. The clay is in many different colors, with many different cuts and extrusions in its surface. It's a muddle of races all of whom are foreign to us. Yet these "cabbages" or "kings" retain their handsomeness, their softness, and their accessibility, for all their grandeur. The flock flutters with significance, variety, sameness, color, blackness, and dumb alacrity, once again approaching language from another direction.

# Impossible Weavings

**Cecilia Vicuña**

From *Parkett* 52 (1998)

*T*his poem expresses two of the artist's basic beliefs: (1) that weaving is an organic activity which can connect people to natural forces; and (2) that connection to indigenous cultures that are almost exctinct can refresh art and life today.

*Waimiri Atoroari Warma Kaha,* a woven bracelet without beginning or end wraps itself around my wrist. The dryness of the loft air breaks it open and I begin

writing is a weaving of broken fragments

each letter a lost thread

Tara, the master of the impossible task, is invoked by a thread mansion of thought, a mandala constructed with threads.
"A mandala contains the architecture of the world," they say,

the word *contain* is to stretch with (a string), and *architecture* is the weaving of a first beginning, *arche.*
To think is to spin, to let it hang from a thread, *pendere, pensare, pesar*

(the first image of sadness, *pesar* comes
from the measuring act: to weigh)

The unspun wool, a ball of fleece, contains the energy of the cosmos.

A cloud of cosmic gas begins to rotate, matter coheres and a galaxy is born.

Playing with fleece, the hand begins to spin.

Thumb forward, it spins to the right. Thumb back, it spins to the left.

The energy flows down the hand like water in the irrigation canal.

*Handspun,* the thought of the hand.

Doing and undoing in place.

Only a tension keeps the thread from becoming undone.

A fiber of two strands (spun left and right) pulling against each other to make one.

Before spinning, the Mixtecos live with the fleece for many days and speak to it, "to impregnate it with thought." This is called: "the first caress."

The unformed transformed

Fleece in rainbows

Fleece in love

Streaming down the alpaca's ears, the dyed fleece increases the fertility of the herd

> by acknowledging the source,
> the energy that runs through their wool.

In the Andes they say "the rainbow has a motor," each tone becoming the next out of love. Blue in love with green, green with yellow, and so on.

"A color gradation is an effort of light to reach shadow, its other side . . . Each tone becoming the other out of love"

An ethical code derived from the behavior of light:

> to search for a common ground.

Green Tara and Pacha Tira. Tibetan and Andean concepts entwined.

Tara, the force of compassion, enlightened consciousness, is also "An Emerald Mountain Clothed in Rainbows."

The image of the Dalai Lama in rainbows over Lhasa, crushed and forbidden by the invaders.

Aymara men forbidden to wear their textiles since the rebellion of 1780. The women continue to weave K'isa gradations "to change perception imperceptibly."

> *Oh débiles, oh suaves ofendidos que Os*
> *eleváis, haceis y llenáis de poderosos débiles*
> *el mundo*—César Vallejo
> [Oh you weak ones, oh you gentle
> ones, offended ones who
> Raise yourselves, create yourselves,
> and fill
> The world with the powerful weak ones.]

IM pulse of the POSSIBLE

                    to weave is to cross,

and across dimensions they went by spinning the impossibly small
and the impossibly large.

Spinning the impossibly short vicuña's hair, hummingbird feathers,
and bat skins

            they spoke to the gods.

The art was to spin, the weaving almost an afterthought.
A dwelling in tension (intention)

A balance between

                being and not.

A thread around a Brahmin's neck in Benares, a Brazilian wrist or an
Irish grave

            speaks across.

Worn to pieces or interred with the dead, burnt or torn apart by the
wind, it dissolves and returns to the world.

Miniature garments placed at the top of the Aconcagna (Inca).

Nets of human hair (sixty-nine heads of human hair), forty miles
wide across the valley (Mogollón).
Miniature baskets, not half an inch across (Pima).

Shawls so fine the whole cloth could pass through a ring (India).

Rings of human hair, the warp and weft of the ancestors (Europe).

To inscribe the thread in its web.

A weaving not for daily life but for life itself.

A double act performed for the gods and for daily life at once.

A powerful and dangerous act, a distant echo of other processes.

In Lewa weaving is forbidden:

                Invisible threads attach the island to the bottom
of the sea and to the highest layer of the sky. Weaving would weaken
the warp and break the thread, and the island would sink to the bot-
tom of the sea.

In Rari, two towns are superimposed, the "real" one with its road, gardens, and mud houses, and the other: the woven world hanging from threads, minute creatures and gardens woven in horsehair. The hair brought by the invader, transformed.

The thread pushed into non threadness—comes alive.

The Ceq'e lines,

        not a line, but a gaze, a weaving of gazes, sight lines radiating from Cuzco. A quipu calendar of virtual threads.

        A measure of heaven and of themselves.

        A weaving that is not.

Weaving the landscape into invisible lines, the singers of the Dreamtime walked about singing the world into existence.

Each song a line of two words,

a foot fall,

a foot print that is not.

Fertilizing the earth

        "as a kind of musical sperm,"

"sacred bloody baloney"

        Bruce Chatwin says.

In the Huitoto dance of death a group of women dance naked with their arms braided in a line, forming an edge, a selvage. Their thighs aligned form a weaving alive, their painted bodies one design.

The thread is their blood passing from one to the next, from the old to the young.

In lake Titicaca, three girls play with a long, white loop of thread. Two girls create tension by holding it on their waists, as if their bodies were a loom. The third girl enters the loop and moves as in a trance, singing and laughing, creating geometric shapes as she pulls and swirls inside the thread.

Sitting by the fire, the Mbuti weave the shadows against the trees by rearranging the logs.

In New York, the cars weave sounds, criss-crossing the grid of the dark night streets.

The blood of ancient images runs through our words.

Perhaps our brokenness is a revelatory form of union.

*O    water-coloured red fleece*
  . . .

*Thinner you grow, less knowable,*
*finer.*

*Finer: a thread by which*

*it wants to be lowered, the star* —Paul Celan

# Nahum Zenil's Con Todo Respeto

**Eduardo de Jesús Douglas**

From "The Colonial Self:
Homosexuality and Mestizaje
in the Art of Nahum Zenil,"
*Art Journal,* fall 1998

*Contemporary artist Nahum Zenil is one of the few openly gay artists in Mexico. According to this author, Zenil's art "challenges notions of race, sex, and gender that consign him to society's edges."*

Like many of his generation, Nahum Zenil looks to Frida Kahlo as a model for the pictorial objectification of personal affect and narrative. *Con todo respeto* (With All Respect), a 1983 serigraph, presents Zenil in an amalgam of two Kahlo paintings (*The Bus,* 1929, and *The Two Fridas,* 1939). Zenil situates himself and his family in Kahlo's scene of passengers sitting on a bus, with a view through the windows onto factories at the point where city meets country. A reworking of Honoré Daumier's *Third Class Railway Carriage* (ca. 1862), Frida Kahlo's *The Bus* shows the racial and economic range of Mexican society, from the white and well-to-do figures at the right to the working-class mestizos at the left. At the center of *The Bus* sits a barefoot Indian mother cradling an infant in her arms, her head covered and body wrapped in a rebozo. Woman and child suggest an Indian Virgin—the dark-skinned Guadalupe, mother and patroness of Mexico—and Christ Child. The Indian mother anchors the image, serving as a pictorial and biological link between its two halves. European and Indian become Mexico, the mestizo nation, in her womb.

In *Con todo respeto* a simple thatch-roofed house is visible through the window at the left. It represents the isolated rancho El Tecomate in rural Chicontepec, Veracruz, where Zenil was raised by his maternal grandparents. Three figures—Zenil, Kahlo, and the artist's longtime companion Vilchis— occupy the center. Vilchis and Zenil, dark-skinned, Indian-featured mestizos in contemporary Western dress, frame the lighter-skinned, European-featured Kahlo, who wears an Indian folk costume. This Kahlo is the Tehuana from *The Two Fridas,* the self-portrait in which Kahlo the mestiza replicates herself

as European and Indian. As in *The Two Fridas,* the Tehuana's heart is extruded from her body, evoking private emotion and pain, in addition to the sufferings of the Virgin in her guise as La Dolorosa (The Sorrowful One), with whom Kahlo equates herself. Except for the heart, Zenil has bleached the Tehuana Frida and her costume of their original color, approximating the look of a sepia-toned photograph and thereby presenting her as if she were the portrait of a revered nineteenth-century forebear. One artery wraps around her left arm, as in the original, and ends at the childhood photograph of Diego Rivera in her left hand, which she holds in front of her groin. The Indian Kahlo metaphorically gives birth to Diego, her husband, and she thus paints indigenous female sexuality as self-willed erotic pleasure and the Virgin's grief and mourning as erotic pain. In Zenil's miscegenated pictorial genealogy, Kahlo, the sorrowful, sensual Tehuana who creates herself and her son-lover, fuses with Kahlo's "indigenous" Virgin whose womb bears mestizo Mexico.

Substituting himself for the working-class mestizo in *The Bus,* Zenil sits to Kahlo's right, with his left arm around her. With his left hand he touches the physical and conceptual heart of the image—Kahlo as autochthonous eroticized folk object. Vilchis sits to her left, a bag of tools at his feet, and grasps his penis with his right hand. Although he occupies the place of the well-dressed, upper-class white male in Kahlo's picture, his figure quotes and repositions that of the working-class mestizo in *The Bus*. Whereas Kahlo's upper-class white male holds a bag of coins in his right hand (capital), her mestizo holds a long, thick metal wrench between his legs (labor). In the picture's complicated skein of allusions, Zenil, the mestizo to the right of the mother, must in some way be a function of her sexuality and of the white male penis whose place is here taken by Vilchis. Zenil portrays himself as son and lover of the mestizo penis. At the same time, Kahlo as mother assumes the role of the Guadalupe, spiritual mother to all Mexico, thus transforming the central group into a homoerotic mestizo adoration of an incestuous Indian Virgin and Child. By substituting for and thus eroticizing Kahlo's Indian mother, Zenil indexes Vilchis's penis as an incarnation of desire, which, by analogy, is to Zenil what Rivera was to Kahlo. Embedding this relationship in the biological and spiritual genealogy of Mexicanness as accessed through Kahlo's art, Zenil at once naturalizes and nationalizes it.

The artist frames the central group with his blood family, leveling *The Bus*'s racially and economically constructed social hierarchy and locating Mexico in his family, himself, and their world. To the right, the artist as a child sits reading a book, in anticipation of his future career as a primary schoolteacher. Next to the boy the half-truncated but still recognizable figure of his younger sister holds a Mexican flag in her right hand. To the left sits Zenil's mother, wrapped in a rebozo. Next to her is a male figure, presumably Zenil's father, whose left arm and leg are visible. In place of Kahlo's representative Mexican

social types, Zenil describes from right to left a shift in time, an atemporal three ages of man in his own flesh and blood that moves both toward and away from the artistic and sexual epiphany at the center. He recasts Kahlo's visual catalogue of race, class, and nation in Mexico as autobiography, specified as mestizo, rural, and Mexican, but rooted in and expressed as subjective erotic experience and artistic materialization.

Eliding the nation as race into the gay male and the gay male into the image, Zenil, like Kahlo, creates a sophisticated pictorial fiction in which the artist himself functions as an authentic and transparent folk artifact. Artistic process and product become autobiography and mimic the lived disjunctures between individual and society, sex and gender, and race and nation. They do so in a form or a space where these disjunctures no longer exist. Because of its authenticity and transparency, indeed, its ethnicity, the folk artifact—as the image itself and as the artist objectified in the image—is politics by other means, as it critically manipulates the visual signs of race and nation, embodying, and thus advocating, radical social alternatives.

# Marks of the Journey

## Roberto Merino and
## Eugenio Dittborn

From *Eugenio Dittborn:
Airmail Paintings*, 2000

*T*his interview covers important aspects of Eugenio Dittborn's Airmail Paint-
ings, which have been widely exhibited in international shows. These works,
which the artist makes in his native Chile, are shipped across the world and dis-
played with all their packing and mailing material. Thus the artist highlights
his "peripheral" origin.

### Wednesday, 11 October 1989

Roberto Merino: One often speaks—in relation to your work—of a certain
precariousness of means, of your having turned away from wasteful
ostentation in works which are, after all, of large format. It strikes
me that precariousness is to some degree inseparable from necessity;
I mean, a principle of necessity operating in the choice of materials
and techniques. Precariousness, which is also a feature of our na-
tional life, is cited in your work, if not explicitly.

Eugenio Dittborn: You could say that precariousness, in my work, consists in
the fact that the elements connected together there are provisionally
connected. For example, in the Airmail Paintings, when one piece of
cloth is stitched over another, it can easily be unstitched and moved
to another position. With the materials I use, nothing can be fixed
permanently. That is what makes the things inscribed there, and
thus the connections, provisional.

Merino: So the meaning in the work is always pending . . .

Dittborn: The meaning is always there to be commented upon, but the com-
mentary must be continually renewed, never settled. The precarious
is something that can be dismantled at any time, something provi-
sional, therefore, and transitory.

Merino: Another issue that interests me very much, something I find very
moving, and one of the points of stress or tension in your work, is

this: the way the journey, or its theme, or the theme of the journey, is recorded, without being made explicit, as one of the elements of the work. First, in the choice of material (non-woven fabric) which we know is suitable for packing and sending, and then the folds, which I have compared with the shattering in Duchamp's *Large Glass*.

Dittborn: Which is the mark of a journey.

Merino: The meddling of chance.

Dittborn: Now, with the Airmail Paintings, it's the opposite: these marks—the folds—are the very thing that makes movement possible, they are the precondition for movement.

Merino: The body of the El Plomo mummy—which you have used in some of your works—also bears the permanent marks of a journey . . .

Dittborn: Of a final journey. As I read, the boy who ultimately became the mummy walked 7 or 8 miles from his starting point to the place where he was sacrificed, climbing all the way. This can be deduced from the marks on his feet, because the mummy's feet are still blistered, marked by his shoes which were ceremonial ones, slightly smaller than his feet. These shoes never stopped hurting him the whole way up. It's the same as with Duchamp, as we saw earlier: marks of the journey. You can work out the route which that Inca child followed, and the distance, by the marks on his mummified skin.

Merino: Turning to other things, what is the relationship between the faces which appear in Airmail Painting No. 70, *The Sixth History of the Human Face*? That is to say, between the child's pre-pictorial drawing, the police sketch or identi-kit, the ID photos, the photographs of Indians, the faces taken from "how to draw" books and reading primers, and those taken from anonymous drawings, which you found in diaries, notebooks and magazines.

Dittborn: The idea was to find faces as far apart from one another as possible. What you see are abysses, leaps between one face and another, between the techniques that brought them to light, and between the different places in which I found them. So, just as every Airmail Painting travels, there are journeys within the works themselves: antipodes brought sharply into contact.

Merino: When I referred earlier to points of stress, I had in mind the way in which that abyss of the journey is recorded in the works.

Dittborn: Like something sidelong. One could talk about the stress of the folds.

Merino: Or about the stress of the canvas. Do you remember that we talked about the English word *canvas*, which refers to the linen used for painting, the sail of a boat, and also the floor of a boxing ring?

**Roberto Merino and Eugenio Dittborn**    251

**Monday, 16 October 1989**

Merino: Your work, which crosses space, also freely crosses time and the signs of time. One might say that a dynamic system of references, a history of references peculiar to your work, has been unfolding since a period—1976–1977—which is somehow remote from the present. Your work excludes the idea of fashion or progress, or any need to be up-to-date.

Dittborn: My work excludes fashion. And yet, fashion is also there. Re-fashioned.

Merino: A few years ago, they had to close some of the ancient rock caves in France to tourists because the carbon dioxide they breathed out was ruining the paintings. This was shown on television, on the Ripley program. On the other hand *The Last Supper*, a work intended for posterity, has emerged unscathed from the damp which attacked it over centuries, caused by long periods of flooding in the hall where it's located. Again, during the Napoleonic invasion, the French soldiers enlivened their leisure hours by throwing bricks at the heads of the Twelve Apostles. Centuries before, another work of Leonardo's, the giant clay horse that was the model for the bronze equestrian statue of Francesco Sforza, was also destroyed by French soldiers. It is very odd when the closed world of an artwork is invaded like this—infiltrated so violently by the everyday world— and it is curious that dust—both domestic and metaphysical— should have painted over Rembrandt's famous work, turning *Night Watch* into a nocturnal scene. I imagine that the Airmail Paintings must have their defense systems, since they are intended to play a part in that outside world, to be moved about and manipulated by it, and they even enter the postal system—with its strikes, its delays, its carelessness and obstructiveness—and survive.

Dittborn: Fragile as they are, the Airmail Paintings manage to pass through the entire international postal network, and invariably arrive on time and totally unscathed at their destinations. What I am trying to say here is that the mail is not only as you describe it (strike-ridden, unpunctual, careless, obstructive) but it also has exactly the opposite qualities: promptness, efficiency and a sense of humor (one joke it always plays is to deliver the Airmail Paintings to their destination; then it plays the even better one of returning them to the sender). What can you say when you think of an Airmail Painting, tucked up in its envelope at 05.15 local time in Papeete airport in Tahiti, inside a Boeing operated by Qantas, UTA, or LanChile, while here in Santi-

ago it is 12.15 the previous day and in Noumea, the capital of New Caledonia, the next stopover for that Airmail Painting en route to Sydney, it is 02.15 the following day? Once the transfer is over, the recipient opens the envelopes and the paintings are unfolded, hung on walls, and exhibited along with their envelopes. And it is then that the entire journey takes place: when it is suspended. As bleeding follows a cut.

Merino: There has been so much discussion of marginalisation, in every possible area, and your work contains a huge gallery of marginal figures: muggers, petty thieves and swindlers, pickpockets, murderers, accident victims, aboriginals. In your case, you have very specific ways of avoiding the arrogance of the naturalist or the fetishism of the romantic in your choice of figures. We've discussed how what is reclaimed in your work is more properly speaking a relationship: the relationship between power and the individuals photographed.

Dittborn: By citing police photos of criminals from the 1930s, 1940s and 1950s in my work, I've tried to explore a specific and contradictory relationship: the collision between the police camera, a camera that is really the power of the state working visually, and the faces of small-time Chilean criminals, men and women, most of them impoverished rural migrants. The visual document of this collision is a photograph which, along with the name, all the aliases, a brief physical description and a few biographical notes, etc. make up the dossier of the person photographed. Such records were published in "El Investigador," a criminology and police science magazine produced by the Bureau of Investigations between about 1925 and 1950. How can you speak of marginality when you are dealing—in the case of the police records in question—not with faces in their outcast and extraterritorial immediacy, but with photographic plates attached to criminal records, all of this produced by the state in order to exercise a ubiquitous control? Putting it another way: might it not be marginality itself that the power of the state steals from these thieves? Without margin or center, they end up living and acting, paradoxically, in the only space they have left: the photos in their files. They are nothing but the photos in their files. I have not been well understood on this point. I have been working not with marginalized criminals but with the precise petrified moment when they are coerced by the power—the photographic power—of the state, and multiplied by it, in print. Isn't this also the moment when the face of the underworld is abruptly modernized?

**Saturday, 18 October 1990**

Dittborn: An Airmail Painting is the space where different times come together. In this sense, the hybridization in my work is a temporal one. Signs belonging to different and widely separated time strata finally meet there and, in meeting, throw light on one another. This also has to do with mediation, that is, with what it is that makes transfer possible and that travels in order to transfer particular questions. For example, in Airmail Painting No. 33, *Pietà (no Cor),* the first mediation would be the TV screen suddenly erupting with the image of boxer Benny Kid Parett dying on the canvas at Madison Square Garden. A UPI photographer photographed the scene from the TV screen, and later the UPI sent this photo to the Chilean sports magazine *Gol y Gol,* which reprinted and released it. Fifteen years later a copy of this magazine ended up in a second-hand bookshop, where I came across it in 1977. As we saw earlier, I have a particular fascination for images which contain a record of their movements, the marks of their journey. Benny Kid Parett on television, in photographs and in print: these bear the visible, visual record of all the mediations which contained and transported him: all his wrappings.

Merino: There is nothing else for it but to set this find in motion, so that it remains a find. The Airmail Paintings are not a final destination. Objects meet together in them and become visible, but at the same time they have to keep travelling . . .

Dittborn: Exactly, it's a kind of punishment, that's how they appear . . .

Merino: Like a penance . . .

Dittborn: The penance . . . to be perpetually in movement.

Merino: Souls in torment have no resting place . . .

Dittborn: They have no destination and no home . . . all destinations are the home.

Merino: There is another issue I would like to discuss. In the text for the catalogue to your exhibition (October 1989) at the Australian Center for Photography in Sydney, it is said of the Airmail Paintings that "evading the imperatives of the art market . . . they arrive to unfold and occupy a substantial amount of the hotly contested space of the cultural metropolis." Now, that is an important issue: the way in which the metropolis is turned by airmailness into a place of transit, because from there the paintings are always sent on to another place, which is also one of transit.

Dittborn: I think what you're saying is absolutely right. It also means that the Airmail Paintings, which are so small in their envelopes, presumably deceive the customs agents of large cities in Europe, Oceania

and the US. They say: "Is it a letter? Yes, obviously It's a bit big, but go ahead, no problem."

Merino: Dealing with letters, there is no problem at all . . .

Dittborn: These people say: OK, it's a letter. And when they are opened, unfolded and hung up, the Airmail Paintings actually do occupy a substantial amount of the space of the metropolis.

Merino: The vital space of the metropolis.

Dittborn: So, probably, what is peculiar to the Airmail Paintings is that they are a stratagem, as Von Clausewitz says. What's the stratagem? It's that the Airmail Paintings are paintings disguised as letters. That's how they can infiltrate. In that respect they have something viral about them. They have a viral approach to warfare.

Merino: What would be the opposite of viral warfare?

Dittborn: The opposite to viral warfare would be a declaration of war. Viruses don't declare war.

Merino: They just start it.

Dittborn: They don't just start it, they start it retrospectively (laughter). Yes, and then, when the Airmail Paintings come back, the agents of the metropolis say "Aaggh, it's too late" (more laughter).

# Bibliography

*T*his bibliography emphasizes widely available works in English. Exhibition catalogues with an institutional author are listed by title.

## General Works

*Abstract Art from the Río de la Plata: Buenos Aires and Montevideo, 1933–1953*. New York: Americas Society, 2001.

Ades, Dawn. *Art in Latin America: The Modern Era, 1820–1980*. New Haven: Yale University Press, 1989.

Barnitz, Jacqueline. *Twentieth-Century Art of Latin America*. Austin: University of Texas Press, 2001.

Biller, Geraldine P. *Latin American Women Artists, 1915–1995*. Milwaukee: Milwaukee Art Museum, 1995.

Bleys, Rudi. *Images of Ambiente: Homotextuality and Latin American Art, 1810–Today*. New York: Continuum, 2000.

Bois, Yve Alain. *Geometric Abstraction: Latin American Art from the Patricia Phelps de Cisneros Collection*. Cambridge, Mass.: Harvard University Art Museums; New Haven: Distributed by Yale University Press, 2001.

Canclini, Nestor García. *Hybrid Cultures: Strategies for Entering and Leaving Modernity*. Translated by Sylvia Lopez. Minneapolis: University of Minnesota Press, 1995.

Catlin, Stanton Loomis. *Art of Latin America Since Independence*. New Haven: Yale University, 1966.

Chaplik, Dorothy. *Latin American Art: An Introduction to Works of the Twentieth Century*. Jefferson, N.C.: McFarland, 1989.

Congdon, Kristin G., and Kara Kelley Hallmark. *Artists from Latin American Cultures: A Biographical Dictionary*. Westport, Conn.: Greenwood Press, 2002.

Craven, David. *Art and Revolution in Latin America, 1910–1990*. New Haven: Yale University Press, 2002.

Day, Holliday T. *Art of the Fantastic: Latin America, 1920–1987*. Indianapolis: Indianapolis Museum of Art; Bloomington: Distributed by Indiana University Press, 1987.

Fletcher, Valerie J. *Cross Currents of Modernism: Four Latin American Pioneers*. Washington, D.C.: Hirshhorn Museum and Sculpture Garden in association with the Smithsonian Institution Press, 1992.

Goldman, Shifra M. *Dimensions of the Americas: Art and Social Change in Latin America and the United States*. Chicago: University of Chicago Press, 1994.

Lucie-Smith, Edward. *Latin American Art of the Twentieth Century*. New York: Thames and Hudson, 1993.

Mosquera, Gerardo, ed. *Beyond the Fantastic: Contemporary Art Criticism from Latin America*. Cambridge, Mass.: MIT Press, 1996.

Perazzo, Nelly. *Arte Concreto en la Argentina*. Buenos Aires: Ediciones de Arte Gaglianone, 1983.

Puerto, Cecilia. *Latin American Women Artists, Kahlo and Look Who Else: A Selective, Annotated Bibliography*. Westport, Conn.: Greenwood Press, 1996.

Rasmussen, Waldo, ed. *Latin American Artists of the Twentieth Century*. New York: Museum of Modern Art, 1993.

Riggs, Thomas, ed. *St. James Guide to Hispanic Artists: Profiles of Latino and Latin American Artists*. Detroit, Mich.: St. James Press, 2002.

Shipp, Steve. *Latin American and Caribbean Artists of the Modern Era: A Biographical Dictionary of over 12,700 Persons*. Jefferson, N.C.: McFarland, 2003.

Sullivan, Edward J. *Brazil: Body and Soul*. New York: Guggenheim Museum; distributed by Harry N. Abrams, 2001.

———, ed. *Latin American Art in the Twentieth Century*. London: Phaidon Press, 1996.

Traba, Marta. *Art of Latin America, 1900–1980*. Washington, D.C.: Inter-American Development Bank; Baltimore: Distributed by Johns Hopkins University Press, 1994.

Turner, Jane, ed. *The Encyclopedia of Latin American and Caribbean Art*. New York: Grove's Dictionaries, 1999.

## "Classical" Latin American Modernists

Amaral, Aracy A. *Tarsila, Frida, Amelia: Tarsila do Amaral, Frida Kahlo, Amelia Peláez*. Barcelona: Fundació Caixa d'Estalvis i Pensions, 1997.

Balza, José. *Alejandro Otero*. Milan: Olivetti, 1977.

Cuevas, José Luis. *José Luis Cuevas: Intolerance*. La Jolla, Calif.: Tasende Gallery, 1983.

———. *Self-Portrait with Model*. New York: Rizzoli, 1983.

D'Alessandro, Stephanie. *Still More Distant Journeys: The Artistic Emigrations of Lasar Segall*. Chicago: David and Alfred Smart Museum of Art, 1997.

Gradowczyk, Mario H. *Alejandro Xul Solar*. New York: Rachel Adler Gallery, 1991.

Grove, Nancy. *Magical Mixtures: Marisol Portrait Sculpture*. Washington, D.C.: Smithsonian Institution Press, for the National Portrait Gallery, 1991.

Liscano, Juan. *El Erotismo Creador de Armando Reverón / The Creative Eroticism of Armando Reverón*. Caracas: Fundación Galería de Arte Nacional, 1994.

*Marisol*. Worcester, Mass.: Davis Press, for Worcester Art Museum, 1971.

Matta Echaurren, Roberto Sebastián. *Matta*. Cento: SIACA arti grafiche, 1974.

*Matta in America: Paintings and Drawings of the 1940s*. Chicago: Museum of Contemporary Art, 2001.

Ramírez, Mari Carmen. *El Taller Torres-García: The School of the South and Its Legacy*. Austin: Archer M. Huntington Art Gallery, University of Texas at Austin, by the University of Texas Press, 1992.

Reich, Sheldon. *Francisco Zúñiga, Sculptor: Conversations and Interpretations*. Tucson: University of Arizona Press, 1980.

Restany, Pierre. *Botero*. New York: H. N. Abrams, 1984.

Sims, Lowery Stokes. *Wifredo Lam and the International Avant-garde, 1923–1982*. Austin: University of Texas Press, 2002.

Spies, Werner, ed. *Fernando Botero: Paintings and Drawings, with Six Short Stories by the Artist*. Munich: Prestel-Verlag, 1992.

*Wifredo Lam*. Text by Michel Leiris. New York: H. N. Abrams, 1970.

## Mexican Art and Artists

Billeter, Erika, ed. *Images of Mexico: The Contribution of Mexico to Twentieth-Century Art*. Dallas: Dallas Museum of Art, 1987.

Conde, Teresa del. *Tamayo*. Boston: Little, Brown, 2000.

Folgarait, Leonard. *Mexican Art of the 1970s: Images of Displacement*. Nashville: Center for Latin American and Iberian Studies, Vanderbilt University, 1984.

Frank, Patrick. *Posada's Broadsheets: Mexican Popular Imagery, 1890–1910*. Albuquerque: University of New Mexico Press, 1998.

Genauer, Emily. *Rufino Tamayo*. New York: Abrams, 1974.

Goldman, Shifra. *Contemporary Mexican Painting in a Time of Change*. Austin: University of Texas Press, 1981.

Izquierdo, María. *The True Poetry: The Art of María Izquierdo*. New York: Americas Society Art Gallery; Tucson: Distributed by University of Arizona Press, 1997.

Kaplan, Janet A. *Unexpected Journeys: The Art and Life of Remedios Varo*. New York: Abbeville Press, 1988.

Lozano, Luis-Martin, et al. *Mexican Modern Art, 1900–1950*. Ottawa: National Gallery of Canada, 1999.

*María Izquierdo: 1902–1955*. Chicago: Mexican Fine Arts Center Museum, 1996.

*Mexico: Splendors of Thirty Centuries*. New York: Metropolitan Museum; Boston: Little, Brown, 1990.

Oles, James. *Frida Kahlo, Diego Rivera, and Mexican Modernism from the Jacques and Natasha Gelman Collection*. San Francisco: San Francisco Museum of Modern Art, 1996.

Paz, Octavio. *Essays on Mexican Art*. Translated by Helen Lane. New York: Harcourt Brace Jovanovich, 1993.

*Rufino Tamayo, Myth and Magic*. New York: Solomon R. Guggenheim Museum, 1979.

*Salute to Carlos Mérida*. Austin: University of Texas Art Museum, 1976.

## Mexican Mural Movement

Ades, Dawn, et al. *José Clemente Orozco in the United States, 1927–34*. Hanover, N.H.: Hood Museum of Art, Dartmouth College, in association with W. W. Norton, 2002.

Charlot, Jean. *The Mexican Mural Renaissance, 1920–1925*. New Haven: Yale University Press, 1963.

Folgarait, Leonard. *Mural Painting and Social Revolution in Mexico, 1920–1940: Art of the New Order*. New York: Cambridge University Press, 1998.

———. *So Far from Heaven: David Alfaro Siqueiros' "The March of Humanity" and Mexican Revolutionary Politics*. New York: Cambridge University Press, 1987.

Harth, Marjorie L., ed. *José Clemente Orozco: Prometheus*. Claremont, Calif.: Pomona College Museum of Art, 2001.

Hurlburt, Laurance P. *Mexican Muralists in the United States*. Albuquerque: University of New Mexico Press, 1989.

Manrique, Jorge Alberto. *Orozco, Mural Painting*. Mexico City: Fondo Editorial de la Plástica Mexicana, 1991.

Orozco, José Clemente. *An Autobiography*. Translated by Robert C. Stephenson. Austin: University of Texas Press 1962.

Pellicer, Carlos. *Mural Painting of the Mexican Revolution*. Mexico City: Fondo Editorial de la Plástica Mexicana, 1985.

Siqueiros, David Alfaro. *Lectures to Artists*. Chicago: Public Art Workshop, 1962.

———. *Portrait of a Decade, 1930–1940*. Translated by Lorna Scott Fox. Mexico City: Instituto Nacional de Bellas Artes, 1997.

## Diego Rivera and Frida Kahlo

Craven, David. *Diego Rivera as Epic Modernist*. New York: G. K. Hall; London: Prentice Hall International, 1997.

*Diego Rivera: Art and Revolution*. Mexico City: Instituto Nacional de Bellas Artes: Landucci Editores, 1999.

Downs, Linda Bank. *Diego Rivera: The Detroit Industry Murals*. New York: W. W. Norton, 1999.

Drucker, Malka. *Frida Kahlo*. New York: Bantam, 1991; Albuquerque: University of New Mexico Press, 1995.

Favela, Ramón. *Diego Rivera: The Cubist Years*. Phoenix: Phoenix Art Museum, 1984.

*Frida Kahlo, 1910–1954: An Exhibition Organized by the Museum of Contemporary Art, Chicago*. Chicago: Museum of Contemporary Art, 1978.

Hamill, Pete. *Diego Rivera*. New York: Harry N. Abrams, 1999.

Herner de Larrea, Irene. *Diego Rivera's Mural at the Rockefeller Center*. Mexico City: EDICUPES, 1990.

Herrera, Hayden. *Frida: A Biography of Frida Kahlo*. New York: Perennial Library; Harper and Row, 1983.

Kahlo, Frida. *Letters of Frida Kahlo*. Compiled by Martha Zamora. San Francisco: Chronicle Books, 1995.

———. *The Diary of Frida Kahlo*. New York: H. N. Abrams; Mexico City: La Vaca Independiente, 1995.

Lee, Anthony W. *Painting on the Left: Diego Rivera, Radical Politics, and San Francisco's Public Murals*. Berkeley: University of California Press, 1999.

Lindauer, Margaret A. *Devouring Frida: The Art History and Popular Celebrity of Frida Kahlo*. Hanover, N.H.: University Press of New England, 1999.

Lowe, Sarah M. *Frida Kahlo*. New York: Universe, 1991.

Marnham, Patrick. *Dreaming with His Eyes Open: A Life of Diego Rivera*. New York: Knopf, 1998.

Richmond, Robin. *Frida Kahlo in Mexico*. Rohnert Park, Calif.: Pomegranate Artbooks, 1994.

Rochfort, Desmond. *The Murals of Diego Rivera*. London: Journeyman, 1987.

Rummel, Jack. *Frida Kahlo: A Spiritual Biography*. New York: Crossroad, 2000.

Tibol, Raquel. *Frida Kahlo: An Open Life*. Translated by Elinor Randall. Albuquerque: University of New Mexico Press, 1993.

Wolfe, Bertram David. *The Fabulous Life of Diego Rivera*. New York: Stein and Day, 1963.

## Modern Architecture

Attoe, Wayne, ed. *The Architecture of Ricardo Legorreta*. Austin: University of Texas Press, 1990.

Buendía, José María. *The Life and Work of Luis Barragán*. New York: Rizzoli, 1997.

Burian, Edward R., ed. *Modernity and the Architecture of Mexico*. Austin: University of Texas Press, 1997.

Cavalcanti, Lauro. *When Brazil Was Modern: Guide to Architecture, 1928–1960*. New York: Princeton Architectural Press, 2003.

Eggener, Keith L. *Luis Barragán's Gardens of El Pedregal*. New York: Princeton Architectural Press, 2001.

Fraser, Valerie. *Building the New World: Studies in the Modern Architecture of Latin America, 1930–1960*. London: Verso, 2000.

Loomis, John A. *Revolution of Forms: Cuba's Forgotten Art Schools*. New York: Princeton Architectural Press, 1999.

Papadaki, Stamo. *Oscar Niemeyer*. New York: G. Braziller, 1960.

Quantrill, Malcolm, ed. *Latin American Architecture: Six Voices*. College Station: Texas A&M University Press, 2000.

Riggen Martínez, Antonio. *Luis Barragán: Mexico's Modern Master, 1902–1988*. New York: Monacelli Press, 1996.

Silvetti, Jorge, ed. *Amancio Williams*. Cambridge, Mass.: Harvard University, Graduate School of Design, 1987.

*Ten Houses: Christian De Groote*. Edited by Oscar Riera Ojeda. Gloucester, Mass: Rockport Press; Cincinnati: Distributed by North Light Books, 1999.

Underwood, David Kendrick. *Oscar Niemeyer and Brazilian Free-form Modernism*. New York: George Braziller, 1994.

———. *Oscar Niemeyer and the Architecture of Brazil*. New York: Rizzoli, 1994.

Villanueva, Paulina. *Carlos Raul Villanueva*. New York: Princeton Architectural Press, 2000.

## Cuban Art

*Ahora Mismo: Contemporary Art of Cuba*. Gainesville: University Gallery, University of Florida, 1995.

Balderama, María, ed. *Wifredo Lam and His Contemporaries, 1938–1952*. New York: Studio Museum in Harlem; distributed by H. N. Abrams, 1992.

Block, Holly, ed. *Art Cuba: The New Generation*. New York: Harry N. Abrams, 2001.

*Breaking Barriers: Selections from the Museum of Art's Permanent Contemporary Cuban Collection*. Fort Lauderdale, Fla.: Museum of Art, 1997.

Brown, David H. *Santería Enthroned: Art, Ritual, and Innovation in Afro-Cuban Religion*. Chicago: University of Chicago Press, 2003.

Camnitzer, Luis. *New Art of Cuba*. Revised Edition. Austin: University of Texas Press, 2003.

Cushing, Lincoln. *Revolución: Cuban Poster Art*. San Francisco: Chronicle Books, 2003.

Fernández, Antonio Eligio. *Tonel: Lessons of Solitude*. Vancouver: University of British Columbia Applied Research, 2001.

Fuentes-Rérez, Ileana, et al. *Outside Cuba: Contemporary Cuban Visual Artists*. New Brunswick, N.J.: Rutgers University Press, 1989.

*Journal of Decorative and Propaganda Arts* (Cuba Issue, No. 22). Miami, Fla.: Wolfson Foundation of Decorative and Propaganda Arts, 1996.

Kunzle, David. *Che Guevara: Icon, Myth, and Message*. Berkeley: University of California Press, 2002.

*Made in Havana: Contemporary Art from Cuba*. Sydney: Art Gallery of New South Wales, 1988.

Martínez, Juan A. *Cuban Art and National Identity: The Vanguardia Painters, 1927–1950*. Gainesville: University Press of Florida, 1994.

Power, Kevin, ed. *While Cuba Waits: Art from the Nineties*. Santa Monica, Calif.: Smart Art Press; New York: Distributed by D.A.P., 1999.

Veigas, José, et al. *Memoria: Cuban Art in the Twentieth Century*. Los Angeles: California International Arts Foundation, 2002.

Zeitlin, Marilyn, ed. *Contemporary Art from Cuba: Irony and Survival on the Utopian Island*. New York: Delano Greenidge Editions, for Arizona State University Art Museum, 1999.

## Caribbean Art

Brown, Karen McCarthy. *Tracing the Spirit: Ethnographic Essays on Haitian Art*. Davenport, Iowa: Davenport Museum of Art; Seattle: Distributed by the University of Washington Press, 1995.

Cosentino, Donald, ed. *Sacred Arts of Haitian Vodou*. Los Angeles: UCLA Fowler Museum of Cultural History, 1995.

Drot, Jean-Marie. *An Encounter Between Two Worlds as Seen by Haiti's Artists*. Paris: Afrique en Creations Foundation, 1994.

Fernández Olmos, Margarite, ed. *Healing Cultures: Art and Religion as Curative Practices in the Caribbean and Its Diaspora*. New York: St. Martin's Press, 2001.

Ferrer, Elizabeth. *Modern and Contemporary Art of the Dominican Republic*. New York: Americas Society and the Spanish Institute; Seattle: Distributed by the University of Washington Press, 1996.

*Haiti, Three Visions: Etienne Chavannes, Edger Jean-Baptiste, Ernst Prophète*. Mahwah, N.Y.: Ramapo College of New Jersey, 1994.

Poupeye, Veerle. *Caribbean Art*. New York: Thames and Hudson, 1998.

*Rafael Tufiño, Pintor del Pueblo: Exposición Retrospectiva*. San Juan: Museo de Arte de Puerto Rico, 2001.

Rodman, Selden. *The Miracle of Haitian Art*. Garden City, N.Y.: Doubleday, 1974.

Roulet, Laura. *Contemporary Puerto Rican Installation Art: The Guagua Aérea, the Trojan Horse, and the Termite*. San Juan: Editorial de la Universidad de Puerto Rico, 2000.

Stebich, Ute. *A Haitian Celebration*. Milwaukee: Milwaukee Art Museum, 1992.

Sturges, Hollister. *New Art from Puerto Rico*. Springfield, Mass.: Museum of Fine Arts, 1990.

Thoby-Marcelin, Philippe. *Art in Latin America Today: Haiti*. Washington, D.C.: Pan American Union, 1959.

## Contemporary Art

Amaral, Aracy A. *Ultramodern: The Art of Contemporary Brazil*. Washington, D.C.: National Museum of Women in the Arts, 1993.

Armstrong, Elizabeth. *Ultrabaroque: Aspects of Post–Latin American Art*. La Jolla, Calif.: Museum of Contemporary Art, San Diego, 2000.

Baddeley, Oriana. *Drawing the Line: Art and Cultural Identity in Contemporary Latin America*. London: Verso, 1989.

Brett, Guy. *Transcontinental: An Investigation of Reality*. London: Verso, 1990.

Brito, Ronaldo. *Neoconcretismo*. Rio de Janeiro: FUNARTE/Instituto Nacional de Artes Plásticas, 1985.

*Cartographies*. Winnipeg: Winnipeg Art Gallery, 1993.

Carvajal, Rina, et al. *The Experimental Exercise of Freedom*. Los Angeles: Museum of Contemporary Art, 1999.

*Crosscurrents: Contemporary Painting from Panama, 1968–1998*. New York: Americas Society Art Gallery, 1998.

Debroise, Olivier. *El corazón sangrante / The bleeding heart*. Boston: Institute of Contemporary Art; Seattle: Distributed by University of Washington Press, 1991.

Elliott, David, ed. *Art from Argentina, 1920–1994*. Oxford: Museum of Modern Art, 1994.

Flores, Juan Carlos. *Magic and Realism: Central American Contemporary Art*. Tegucigalpa, Honduras: Galeria Trio's, 1992.

Fusco, Coco, ed. *Corpus Delecti: Performance Art of Americas*. London: Routledge, 1999.

Grimes, Christopher, ed. *Amnesia*. Santa Monica, Calif.: Smart Art Press; New
    York: Distributed by D.A.P., 1998.

Kunzle, David. *The Murals of Revolutionary Nicaragua, 1979–1992*. Berkeley: Univer-
    sity of California Press, 1995.

Lindsay, Arturo, ed. *Santería Aesthetics in Contemporary Latin American Art*. Wash-
    ington, D.C.: Smithsonian Institution Press, 1996.

Mosquera, Gerardo, et al. *Ante America*. Bogotá, Colombia: Banco de la
    República, Biblioteca Luis-Ángel Arango, 1992.

Ramírez, Mari Carmen. *Cantos Paralelos: La Parodia Plástica en el Arte Argentino
    Contemporáneo / Visual Parody in Contemporary Argentinean Art*. Austin: Jack S.
    Blanton Museum of Art, The University of Texas at Austin; Buenos Aires:
    Fondo Nacional de las Artes, Argentina, 1999.

——, ed. *Re-Aligning Vision: Alternative Currents in South American Drawing*.
    Austin: Archer M. Huntington Art Gallery, University of Texas at Austin, 1997.

**Individual Contemporary Artists**

*Ana Mendieta: A Retrospective*. New York: New Museum of Contemporary Art,
    1987.

Basualdo, Carlos, ed. *Tunga: 1977–1997*. New York: Center for Curatorial Studies,
    Bard College, 1998.

Blocker, Jane. *Where Is Ana Mendieta?* Durham, N.C.: Duke University Press,
    1999.

Bowles, Paul. *Claudio Bravo*. New York: Abbeville Press, 1997.

Clearwater, Bonnie, ed. *Ana Mendieta: A Book of Works*. Miami Beach: Grassfield
    Press, 1993.

Dittborn, Eugenio. *Remota: Pinturas Aeropostales / Airmail Paintings*. Santiago,
    Chile: Pública Editores, 1997.

Duarte, Paulo Sérgio. *Waltercio Caldas*. São Paulo: Cosac and Naify, 2001.

*Hélio Oiticica*. London: Whitechapel Art Gallery, 1969.

*Hélio Oiticica*. Minneapolis: Walker Art Center, 1992.

*Hélio Oiticica: Quasi-Cinemas*. New York: New Museum of Contemporary Art,
    2001.

Herkenhoff, Paulo. *Cildo Meireles*. London: Phaidon, 1999.

*Juan Downey: With Energy Beyond These Walls*. Valencia: IVAM Centre del Carme,
    Generalitat Valenciana, 1998.

Kalenberg, Angel. *Ana Mercedes Hoyos: A Retrospective*. Bogotá: Villegas, 2002.

Lampert, Catherine, ed. *Francisco Toledo*. London: Whitechapel Art Gallery, 2000.

Mennekes, Friedhelm. *Luis Cruz Azaceta*. Cologne: Kunst-Station Sankt Peter;
    New York: Frumkin/Adams Gallery, 1988.

Moure, Gloria, ed. *Ana Mendieta*. Barcelona: Ediciones Polígrafa, 1996.

*Nahum B. Zenil: Witness to the Self*. San Francisco: Mexican Museum, 1996.

Orozco, Gabriel. *Clinton Is Innocent*. Paris: Museum of Modern Art of the City of
    Paris, 1998.

Princenthal, Nancy. *Doris Salcedo*. London: Phaidon, 2000.

Salcedo, Doris. *Unland / Doris Salcedo*. New York: New Museum of Contemporary Art, 1998.

Zegher, M. Catherine de, ed. *The Precarious: The Art and Poetry of Cecilia Vicuña*. Hanover, N.H.: University Press of New England, 1997.

## Latino Art in the United States

Barnitz, Jacqueline. *Latin American Artists in New York Since 1970*. Austin: Archer M. Huntington Art Gallery, University of Texas, 1987.

Beardsley, John. *Hispanic Art in the United States*. Houston: Museum of Fine Arts; New York: Abbeville Press, 1987.

Cancel, Luis R., et al. *The Latin American Spirit: Art and Artists in the United States, 1920–1970*. New York: Bronx Museum of the Arts in association with Harry N. Abrams, 1988.

*Chicano Art: Resistance and Affirmation, 1965–1985*. Los Angeles: Wight Art Gallery, University of California, 1991.

Cockcroft, Eva, John Weber, and Jim Cockcroft. *Toward a People's Art: The Contemporary Mural Movement*. New York: Dutton, 1977.

Cockcroft, Eva Sperling, and Holly Barnet-Sánchez. *Signs from the Heart: California Chicano Murals*. Venice, Calif.: Social and Public Art Resource Center; Albuquerque: University of New Mexico Press, 1993.

*Contemporary Chicana and Chicano Art: Artists, Works, Culture, and Education*. Tempe: Bilingual Press/Editorial Bilingüe, 2002.

Draher, Patricia. *The Chicano Codices: Encountering Art of the Americas*. San Francisco: Mexican Museum, 1992.

Gamboa, Harry. *Urban Exile: Collected Writings of Harry Gamboa, Jr*. Minneapolis: University of Minnesota Press, 1998.

Gaspar de Alba, Alicia. *Chicano Art Inside/Outside the Master's House: Cultural Politics and the CARA Exhibition*. Austin: University of Texas Press, 1998.

Goldman, Shifra M. *Arte Chicano: A Comprehensive Annotated Bibliography of Chicano Art, 1965–1981*. Berkeley: Chicano Studies Library Publications Unit, University of California, 1985.

Gómez-Peña, Guillermo. *New World Border: Prophecies, Poems and Loqueras for the End of the Century*. San Francisco: City Lights, 1996.

*La Frontera / The Border: Art about the Mexico–United States Border Experience*. San Diego: Centro Cultural de la Raza; Museum of Contemporary Art, San Diego, 1993.

Marin, Cheech. *Chicano Visions: American Painters on the Verge*. Boston: Bullfinch Press, 2002.

Noriega, Chon A. *East of the River: Chicano Art Collectors Anonymous*. Santa Monica, Calif.: Santa Monica Museum of Art; Seattle: Distributed by University of Washington Press, 2001.

———. *Just Another Poster? Chicano Graphic Arts in California*. Santa Barbara, Calif.: University Art Museum; Seattle: Distributed by University of Washington Press, 2001.

Quirarte, Jacinto. *Mexican American Artists*. Austin: University of Texas Press, 1973.

Rascón, Armando. *Xicano Progeny: Investigative Agents, Executive Council, and Other Representatives from the Sovereign State of Aztlán*. San Francisco: Mexican Museum, 1995.

*Rupert García: Prints and Posters, 1967–1990*. San Francisco: Fine Arts Museums of San Francisco, 1990.

Yorba, Jonathan. *Arte Latino: Treasures from the Smithsonian American Art Museum*. New York: Watson-Guptill Publications for Smithsonian American Art Museum, 2001.

# Index

# Credits